PAPER BULLETS

PAPER BULLETS

Two Artists

Who Risked Their Lives

to Defy the Nazis

JEFFREY H. JACKSON

Algonquin Books of Chapel Hill 2020

Published by

Algonquin Books of Chapel Hill

Post Office Box 2225

Chapel Hill, North Carolina 27515-2225

a division of

Workman Publishing

225 Varick Street

New York, New York 10014

Library of Congress Cataloging-in-Publication Data

Names: Jackson, Jeffrey H., [date]– author.
Title: Paper bullets : two artists who risked their lives to defy
 the Nazis / Jeffrey H. Jackson.
Other titles: Two artists who risked their lives to defy the Nazis
Description: Chapel Hill : Algonquin Books of Chapel Hill, 2020. | Includes bibliographical
 references. | Summary: "The true story of an audacious resistance campaign undertaken
 by an unlikely pair: two French women—Lucy Schwob and Suzanne Malherbe—who
 drew on their skills as Parisian avant-garde artists to write and distribute wicked insults
 against Hitler and calls to desert, a psyops tactic known as 'paper bullets,' designed to
 demoralize Nazi troops occupying their adopted home of Jersey in the British Channel
 Islands"—Provided by publisher.
Identifiers: LCCN 2020018040 | ISBN 9781616209162 (hardcover) |
 ISBN 9781643751122 (e-book)
Subjects: LCSH: Channel Islands—History—German occupation, 1940–1945. | World
 War, 1939–1945—Underground movements—Jersey. | Cahun, Claude, 1894–1954. |
 Malherbe, Suzanne, 1892–1972. | World War, 1939–1945—Propaganda. | World War,
 1939–1945—Art and the war. | Lesbian artists—France—Biography. | French—Jersey—
 Biography. | Psychological warfare—Jersey—History—20th century. | World War,
 1939–1945—Jersey.
Classification: LCC D760.8.J4 J33 2020 | DDC 940.53/4234109252—dc23
 LC record available at https://lccn.loc.gov/2020018040

10 9 8 7 6 5 4 3 2 1

First Edition

For Ellen

CONTENTS

PAPER BULLETS

PROLOGUE

"They Have Not Caught You This Time"

ON THE MORNING OF JULY 25, 1944, Lucy Schwob and Suzanne Malherbe went into St. Helier to do some shopping. The trip was part of their regular routine. Outside the offices of the *Jersey Evening Post*, they glanced up at the large clock at the top of the building. Suzanne leaned in and whispered to Lucy to keep watch. Then Suzanne scanned the long row of police cars the Nazi occupation forces always parked along Charles Street—a reminder of how heavily the Germans censored the island's only newspaper.

Suzanne took a small piece of paper out of her pocket and began moving carefully toward one of the police cars as Lucy stood by on lookout duty. Suzanne stuck the gummed paper on the windshield. "The cowardly bureaucrats of the police, who live on lies and shameful cruelty, will be destroyed by the Soldiers with No Names," the note read.

No one seemed to be paying any attention to the middle-aged women in Burberry trench coats with bright scarves tied around their heads. Suzanne quickly attached papers to a few more windshields and casually strolled away, her Wellington boots thumping on the pavement. If anyone asked the women what they were doing, their shopping bag would provide a ready alibi.

After finishing their secret mission, along with some mundane errands, they met up with their housekeeper, Edna Le Neveu, and boarded one of the wood-burning buses to head back home on the other side of the island. Lucy held a package of cigarette papers they had just bought at the newsstand. These papers were destined to become a new batch of notes for the Nazis. In her pocket, alongside more of their notes, Suzanne could feel the bright blue Milk of Magnesia bottle. It did not contain the digestive

medicine, however, but instead an overdose of the powerful barbiturate Gardenal, in case the Germans caught them in the act.

Jersey native Edward Le Quesne was also on board as the bus bumped along its route overlooking St. Aubin's Bay. Le Quesne had worked as a plumber for many years and served in the leadership of his union. He was elected as a deputy in the States, the island's governing body, where he rose to president of the Labour Committee and became a member of the Superior Council during the war. An avowed pacifist, Le Quesne remained one of the most popular politicians during the occupation because he was occasionally willing to run afoul of occupation regulations. Earlier in the war, he had been arrested by the Germans for possessing an illegal radio.

With no warning, the bus came to an abrupt halt, and a fair-haired soldier climbed aboard. *Everyone off the bus!*

Le Quesne, grandfatherly at sixty-two years old, with round glasses and a receding hairline, fumbled off the vehicle. Random inspections like these were "an experience we have to tolerate under Nazi rule," he noted with resignation in the diary that he kept on paper made from the covers of tomato packing crates. Most people were used to this treatment. Le Quesne had done nothing wrong, so he was more annoyed than fearful. Lucy clutched her parcel a bit tighter.

Outside, the soldier approached each commuter. Suzanne noticed his bright blue eyes. Le Quesne remembered the litany of commands and questions: Please show me your papers. How old are you? What is your occupation? Where were you born? Where do you live? How many children do you have? With his critical eye, the German carefully looked over each passenger's documents until satisfied, saying very little other than what was necessary to get his answers. If something was suspicious, or if passengers had forgotten their documents, Le Quesne observed, they were told: "Someone will visit you in your home."

Then the soldier approached Lucy and Suzanne. Lucy recalled the scene several years later in a scrapbook of notes that might have formed the basis of a memoir if she had lived long enough. She titled these reminiscences "The Mute in the Middle of the Muddle." Show me your registration card, the German demanded. He stood in front of Lucy, glaring at her. A look of recognition crossed his face when he saw a familiar name. Schwob. What kind of name is that? The document listed French as her national

origin. She explained nervously that she was an orphan and raised by a Frenchman. Perhaps you are Alsatian? Maybe, she replied, but admitted that she didn't really know. Lucy stated that she had been on Jersey for some thirty years.

Nearly everything she had just told the German about herself was a calculated lie. She invented a new backstory for herself, and not for the first time.

Her fabrication—perhaps planned, perhaps on the spot—was important because Lucy had a lot to hide. It obscured the fact that she and Suzanne had both grown up as the daughters of wealthy and prominent residents of the western French city of Nantes. Lucy's mother's family was Catholic, but her father's family was Jewish. The Schwobs had enjoyed coming to Jersey during regular vacations in Lucy's youth, and she and Suzanne had visited together in the early 1920s. But Lucy had certainly not lived on the island for three decades.

Her invention also left out the women's nearly twenty years of living in Paris as part of the cutting-edge art world, she as a writer and Suzanne as an illustrator. The two collaborated on experimental photography and photomontage, and their sometimes-alarming images challenged conventional notions of beauty and art, and expectations about how women were supposed to look. They worked alongside surrealists to push artistic boundaries and create what the Nazis would come to denounce as the "degenerate art" that supposedly undermined Western civilization. In those years, Lucy and Suzanne also befriended communists, immersing themselves in intense political debates about the fate of Europe.

By the 1930s, Paris had become a city roiling in the turmoil of the Great Depression and radical politics as right-wing groups chanted anti-Semitic slogans and fought with left-wingers in the streets. Artists took sides too, squaring off in the pages of journals and around the tables in cafes.

But the battles became too much, and Lucy's years-long struggle with illness—poor eyesight, a chronic kidney disease, intestinal problems, and recurring migraines—stressed her nerves to the breaking point. She had grown dependent on Gardenal to help manage her insomnia, although she frequently read or wrote her way through long nights and into early morning hours. Suzanne took good care of Lucy, but life in the French capital was overwhelming, and they decided to return to the island to find quiet.

Around fifty thousand people lived on Jersey's forty-five square miles when the women arrived in 1937 to make it their permanent home. For thousands of years, since at least the Bronze Age, people have resided on Jersey, the largest of the seven inhabited Channel Islands in the English Channel just off the Normandy coast of northern France. In the 1930s, much of its land was still devoted to tomato and potato farming. Lucy and Suzanne could open the back door of their newly purchased house facing St. Brelade's Bay and walk together through their lush garden. They gazed southward across the green waters, back toward France, only some twelve nautical miles away. The crisp sea air and the rolling fog soothed them, and they spent peaceful days tending the garden, swimming, writing, and painting. They could hear the waves lap against the shore only a few yards from their house.

Jersey had endured many conquerors and foreigners over the centuries, including Romans, Vikings, and Gauls. The Normans established some of the island's longest-lasting families after the conquest of 1066 brought Jersey into political contact with England. All the Channel Islands became essentially self-governing in 1204, although they remained under the English Crown. (In 1664, King Charles II gave his brother, the Duke of York, a swath of land in the New World. The duke deeded the territory to Vice Admiral Sir George Carteret to settle a debt, and he named the land New Jersey, after his ancestral home.) The French tried to invade Jersey in the 1780s, but British forces held them off, and the island eventually found peace with its closest neighbor through trade and tourism. When the Germans dropped their bombs on Jersey and nearby Guernsey in June 1940, they ended more than 150 years of peace.

Perhaps most important, Lucy's lie to the interrogating soldier hid the true nature of her relationship with Suzanne. By the end of July 1944, they had become well practiced in keeping secrets. Lucy, forty-nine, and Suzanne, who had just turned fifty-two, had fallen in love when they were teenagers. They had been lovers for several years by the time Lucy's divorced father married Suzanne's widowed mother in 1917, making them stepsisters as well. Although friends in Paris knew of their partnership, the two women kept their true connection hidden when they arrived on Jersey. They simply told the conservative island residents that they were sisters.

As the minutes ticked by, Lucy waited patiently next to the bus and watched the soldier scrutinize her documents. Suzanne and Edna were close by but could do nothing to help. Lucy, perhaps coughing or stumbling a bit, played sick for the German's benefit, brushing off her acting skills from her Paris days, when she took part in avant-garde theater productions.

The soldier noticed that her Alien Registration Card listed her occupation as independent and her marital status as single.

Are there any men living in the house?

One, Lucy replied, George Le Neveu, the husband of her "nurse," as she referred to Edna. George was a well-known local who worked for the Germans at their social club in the hotel across the street from Lucy and Suzanne's home.

Finally, the soldier handed back Lucy's papers. When he wrapped up his examination of all the passengers, everyone reboarded the bus. An acquaintance riding with them tried to break the nervous tension created by the ordeal. "They have not caught you this time," she said, laughing, unaware of what Lucy's parcel of cigarette papers was destined for.

I

LEARNING TO RESIST

1

"JEALOUS, EXCLUSIVE PASSION"

Paris in the 1920s

IN 1920, LUCY AND SUZANNE boarded the train heading for Paris, bags in hand, two women striking out on their own. As they watched the countryside roll by, they were surely thinking about the family they were leaving behind in Nantes. Lucy, twenty-six, and Suzanne, twenty-eight, carried with them the financial support of their wealthy families—Lucy's father was a newspaper publisher, and Suzanne's was a highly respected doctor and medical educator—along with the confidence that comes when heading to familiar territory. Paris had been a second home for many years. They traveled to see friends or go to museums or shows, and Lucy's uncle, Marcel Schwob, a well-known writer and influential literary figure, and his famous actress wife, Marguerite Moreno, had introduced them to the city's creative community. As comfortable as they were in Paris, Lucy and Suzanne knew this was their time to make a different life on their own, together.

Paris had turned dark, quiet, and cold during the years of World War I; fighting along the front lines raged only a few miles away. Bombs falling from German Zeppelins damaged parts of the capital, and the tight rationing of food and fuel made life extremely difficult for Parisians. With more deaths per capita in France than in any other combatant country, the war profoundly scarred the French psyche. France buried nearly an entire generation of men, and most who lived had fought at Verdun or the Somme, two brutal months-long battles in 1916 that left survivors suffering from shell shock. When Lucy and Suzanne's train pulled into the station

in Paris, two years after the armistice, they could see the changes the war had wrought on the city. The whole nation still suffered from a recession as businesses struggled to reorient themselves to a peacetime economy.

The war also touched the Schwob and Malherbe families directly. Their sons and brothers went off to the trenches, along with some seven thousand other men from Nantes. Lucy and Suzanne's hometown became a haven for many fleeing the war zone when the Germans invaded, and its hospitals treated the war wounded. Once the United States entered the conflict in 1917, this port city on the Loire River, just a few miles from the Atlantic Ocean, became a crucial site for unloading American munitions.

Yet the war opened new opportunities for women, who stepped into traditional male roles, including factory jobs and local political leadership. In going to Paris just after the hard-won peace, Lucy and Suzanne were not alone, and like many other women, they found even greater freedoms there. Although conservative critics did not like the social transformations taking place in the city, Paris in the 1920s was a place for women to be more independent than they had been before the war, and Lucy and Suzanne planned to take advantage of the progressive mind-set.

They quickly reconnected with friends, especially Sylvia Beach, a recently expatriated American who borrowed family money to start a little English-language bookstore on the Left Bank called Shakespeare and Company. In her memoirs, Beach remembered Lucy and Suzanne being present at the very beginning of her business as unpaid volunteers. One day, Lucy and Suzanne brought their camera to Shakespeare and Company and took a photo of a proud Beach, only a few years their senior. She posed in front of a bookshelf as the light from the storefront window brightened part of her face. Beach had taken the inspiration for her business from a nearby French-language bookstore run by Adrienne Monnier, La Maison des Amis des Livres. As Shakespeare and Company flourished and grew, Beach relocated directly across from Monnier's shop.

Beach and Monnier hosted wonderful evenings at their twinned bookstores where literary lights could meet, drink, and talk. Lucy and Suzanne were frequent visitors to these gatherings. Amid the hundreds of books stacked floor to ceiling and the convivial wine-fueled conversation, the women never knew who they might encounter, including some of the most famous writers living in Paris at that time. Here was James Joyce,

and over there André Gide. In walked Paul Valéry and Jacques Prévert. Now Gertrude Stein, the eminent American author and art collector, arrived. Stein recalled seeing Lucy regularly at Shakespeare and Company (although she referred to Lucy as the niece of Marcel Schwob rather than as a person in her own right). One night, Monnier introduced them to Tristan Tzara, one of the founders of the radical antiart movement known as Dada. Another night she brought them to meet André Breton, the artistic rebel with whom they would become close friends a few years later. Ideas discussed on those evenings helped Lucy and Suzanne think in new ways about art, beauty, and literature.

Despite her desire to drink it all in, though, Lucy remembered in a draft of her unpublished autobiography that she was always so nervous and timid on these occasions. Meeting such great writers and artists made her blush, and she felt exasperated because she never seemed able to be her real self. Suzanne was always the more social of the two, outgoing and confident. Lucy was laconic and deeply introverted, often seeking solitude. Suzanne was "firm ground, calm and light ocean," but Lucy was "tormented sky, deep agitated ocean," as one friend summed them up.

Their friendship with Beach and Monnier was important not only because it introduced them to other artists but also because Beach and Monnier were lovers. None of these women used the word *lesbian* to refer to themselves, perhaps not surprising since it was only one of several terms for women loving women and was not necessarily employed in the way it would be in later decades. Frequently, they used no term at all to describe the love between them.

Cafes, nightclubs, and restaurants provided a vibrant scene for women in same-sex relationships in 1920s Paris. In these years, the gay and lesbian community was more visible than ever before, especially in well-established entertainment districts like Montmartre, with its music halls, bars, and brothels. Yet women also formed supportive communities in more private spaces such as artistic salons and bookstores. Gertrude Stein and her partner, Alice B. Toklas—one of the most famous female couples in Paris—created an ongoing conversation about literature and ideas in their living room. Among such kindred spirits, Lucy and Suzanne could be open about their relationship, and pairs like Beach and Monnier or Stein and Toklas became role models for them. In their creative circles, Lucy and

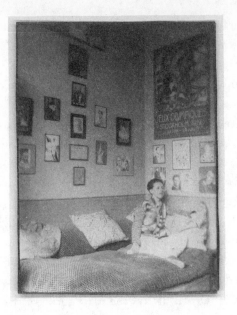

Suzanne also learned about the power of a new kind of personal and artistic resistance.

Two years after relocating to Paris, they moved to a new apartment in Montparnasse on rue Notre-Dame-des-Champs and furnished it luxuriously, combining pieces they inherited with items purchased with family money since neither really worked for a living. Despite their bohemian lives, they were never "starving artists." Lucy papered the bedroom from floor to ceiling with dark blue wallpaper covered in stars, believing that it would help her insomnia. Their two cats lurked around the flat. A photograph of the most famous gay man of the day, Oscar Wilde—who happened to be one of Uncle Marcel's friends—and his lover, Alfred Douglas, hung in a conspicuous location.

Lucy and Suzanne often hosted a growing group of friends in their parlor, leading conversations about art and ideas. Suzanne could open their address book, which still exists today, and run her fingers down a list of names that read like an artistic who's who of their day, deciding whom to invite—Louis Aragon, Salvador Dalí, Georges Bataille, the British writer Aldous Huxley, Jean Cocteau, the famous American lesbian writer Natalie Barney, the young psychoanalyst Jacques Lacan, and many others. When visitors entered the well-appointed apartment, they were overwhelmed by

the array of artwork on the wall—everything from photographs to posters to paintings by Max Ernst, Joan Miró, and other modernists—that nearly reached the ceiling. Cubist sculptures and exotic pieces were scattered around the apartment, along with a collection of glass ornaments and oriental tapestries. Sometimes Lucy brought out a large red mannequin, much to visitors' amusement and delight, or toured guests through their fabulous library, which contained numerous first editions.

Montparnasse provided other Left Bank pleasures. Le Café du Dôme, La Rotonde, and other famous hot spots, just steps away from the apartment, became frequent haunts. These were the meeting places for many expatriate Americans, especially artists and writers like F. Scott Fitzgerald and Ernest Hemingway, who were living cheaply on the strong dollar in the Great War's aftermath. Cafes and dance halls buzzed with wildly popular jazz music, a welcome release for Parisians who had endured the rationing and lights-out of the wartime capital. Montparnasse was also the home of one of the first lesbian nightclubs in the city, the Monocle. "All the women there dressed as men, in Tuxedos," writes historian Florence Tamagne, "and wore their hair in a bob."

Despite the fun, conversations inevitably turned to political events around Europe, including the takeover of Italy by a new ideology called fascism. In 1922, Benito Mussolini was engineering his rise to power through organized violence and grandiose promises of returning Italy to the greatness of the Roman Empire. Fascist movements across Europe, even in France, threatened to tear nations apart and send more men to their deaths in the trenches of another war. Right-wing groups plotting to overthrow democratic governments and end individual freedoms clashed in city streets across the Continent with communists and centrists.

AMID THE GROWING POLITICAL TENSION, in the summer of 1922 Lucy and Suzanne decided to travel to Jersey once again. The island was a safe and comfortable place for them. Back in 1916, the Schwob family had boarded the ferry at Saint-Malo for their first of several family getaways there. The white sandy beaches surrounded by dark rocky cliffs were wonderful for strolling. The fresh air was good for then twenty-one-year-old Lucy's poor health, and the sea made for invigorating swimming. The island's towns offered a blend of English and French culture. Although

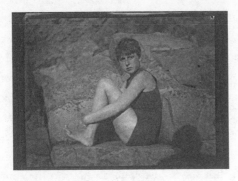

largely anglophone, many residents spoke French, and quite a few of the streets bore French names. Jersey's local dialect, also derived from French, and its distant Norman heritage and the persistence of many old French surnames among established Jersey families made the island seem familiar. Sometime that year, Lucy penned a never-published novel called "The Happy Island," suggesting that her first visit to Jersey was indeed blissful.

Jersey also provided the Schwobs some important psychological distance from World War I, which was still raging on the continent in 1916, but even on Jersey, the conflict was not quite so distant as the vacationers may have expected. A contingent of Jerseymen had volunteered to fight, and those who remained guarded the island's shoreline. The British army had also established a prisoner-of-war camp on Jersey and brought approximately fifteen hundred German soldiers to St. Brelade's Parish.

The Schwobs stayed at the St. Brelade's Bay Hotel, a gleaming white building overlooking the waves lapping the shoreline. Down the beach to the west, past a granite farmhouse and the parish church, lived several families of fishermen, including the Steels. A teenaged Bob Steel met Lucy, and the two developed a connection. Bob fished and worked as a farmhand, and although Lucy gave no physical description of him in her writings, it's not hard to imagine his muscles toned from physical labor and his skin deeply tanned from the hours on the boat and in the fields. "I'd have gaily thrown my soft, warm body into the merciless fire" for him, she recalled. "How obvious his royalty was to me!" she opined. "That love, so intellectual! To the point of debauchery, to the point of absurdity."

Lucy's attraction to Bob was aesthetic and idealistic, and a bit patronizing. She remembered him as authentic and primitive, a working-class

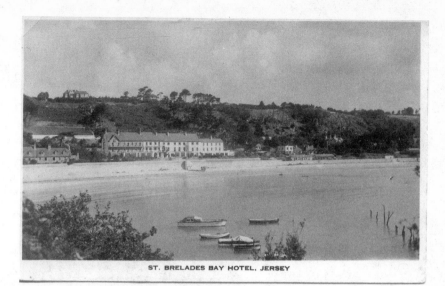

ST. BRELADES BAY HOTEL. JERSEY

Postcard showing the St. Brelade's Bay Hotel. To the far left in the photograph is the house that Lucy and Suzanne would purchase in 1937. COURTESY OF THE JERSEY HERITAGE COLLECTIONS.

contrast to her well-heeled bourgeois background. They flirted with each other, but both were shy about physical contact.

Bob was not the first young man to lavish attention on Lucy. Her cousin René was serving in the war at the very moment the family was on Jersey, and the letters he sent to Lucy from the trenches revealed his deepest thoughts. Later, in her unpublished memoirs, she would write about how one day, while at home on leave, he had confided to her how poor the military leadership was and of his despair of the war effort. René charmed Lucy with his strong personality and humorous antics, and she felt a deep affection for him. She soon realized that René wanted them to marry. Her father told René that his plan would not work, she recalled, offering a veiled hint that Lucy was not interested in men.

Lucy's complex attraction to Bob, and perhaps to René, may have revealed an evolving and fluid sense of sexual identity. By this point, she and Suzanne had been together for several years and were deeply in love. The two girls met in 1900 when Lucy was six and Suzanne eight; both families were part of elite society in Nantes. In 1908, Lucy returned from a year of school in England at the age of fourteen and reconnected with

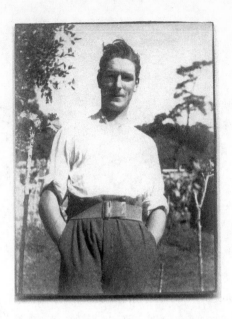

Bob Steel in an undated photograph. COURTESY OF THE JERSEY HERITAGE COLLECTIONS.

her old friend Suzanne. Lucy described their reunion as a lightning strike. Suzanne was beautiful, with long hair flowing over her shoulders and down her back and a wide bright smile across her face. Lucy captured Suzanne's vivacious spirit in a photograph that she treasured.

Suzanne was the daughter and granddaughter of influential doctors; another grandfather was a bookseller in Nantes. Her stable, peaceful background equipped her to provide a calming influence on Lucy, who suffered years of psychological abuse from a mentally ill mother who would soon be committed to an asylum. Their relationship was fueled with adolescent intensity. "A new feeling—troubling—animated me," wrote Lucy. "Jealous, exclusive passion. . . . Soon nothing existed for me except my relationship with Suzanne." They spent time together among family and friends, even traveling with each other on several vacations to Jersey and elsewhere. Lucy's house provided a mostly private meeting place, but for more intimate encounters, they snuck off to the countryside on their bicycles. "We, Suzanne and I, had to surmount difficulties that I prefer to leave to the imagination," Lucy wrote in a letter as she reminisced about the early days of being young and in love with another woman in a deeply conservative society.

Their connection, and their passion, strengthened over the next few years, but there were times when Suzanne could do little to help Lucy.

Suzanne Malherbe.
COURTESY OF THE JERSEY
HERITAGE COLLECTIONS.

After Lucy underwent an appendectomy and suffered from lingering physical effects, her persistent anxiety worsened. In desperation, she decided to take the powerful drug ether, which in addition to its anesthetic powers is also famously hallucinogenic.

The drug became a habit. In that same letter, she recalled a hope to "discover, after having breathed it, the secret of a certain detachment, of a wonderful happiness, in this form of drunkenness (the dreams which accompanied it)." She probably also drank it, with typically disastrous effects on her gastrointestinal system. Lucy's health began to deteriorate, and her appetite vanished. She hoped to cure herself from her addiction by practicing yoga, fasting, and even by writing to a Hindu astrologer. She contemplated suicide.

With his mentally ill ex-wife in an asylum, Lucy's father, Maurice Schwob, now had to face the possibility of putting his nineteen-year-old daughter in an institution too. Instead, he decided, with the advice of Suzanne's father, who was head of the medical school in Nantes, to let Suzanne help take care of Lucy. By this point, the families probably knew that the girls were more than simply close friends. Suzanne helped pick up the pieces of Lucy's scarred psyche.

In an article published in a Nantes-based literary journal, Lucy wrote

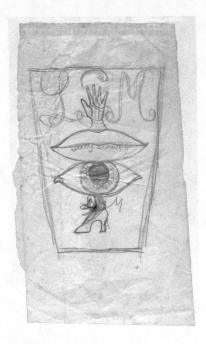

that her feelings for Suzanne were her "*idée maîtresse*," her "guiding principle." "I am in her; she is in me; and I will follow her always, never losing sight of her."

One day, she sketched a set of images: a foot inside a high-heeled shoe, an eye, lips, a glove, all stacked on top of one another. On the lips, she wrote her own name, Lucy Schwob, and in the iris of the eye, she inscribed Suzanne's. Behind these illustrations, Lucy wrote three large cursive letters with loops and flourishes: *LSM*. These were the initials L. S. and S. M., with the middle letter of their names shared. In this simple configuration, Lucy showed just how closely they were joined. Pronounced phonetically, the letters create the phrase "elles s'aiment" ("they love each other").

In the years before Lucy and Suzanne moved to Jersey—and especially during the 1920s and 1930s, when they lived in Paris—Lucy and Suzanne began to see themselves as outsiders, bound to each other and fighting the world around them. Unknowingly, they were cultivating a set of behaviors and attitudes that would help them confront the Nazi occupation.

LUCY'S FATHER HAD RECOGNIZED his teenaged daughter's intelligence and writing talent, and as the editor of one of Nantes's most important

newspapers, he could offer an outlet for her creativity. Suzanne demonstrated artistic abilities from an early age, and she enrolled in art school, studying painting, wood engraving, and illustration. Working in tandem, they created pieces that appeared first in Lucy's father's newspaper and later in other publications. Lucy wrote the text and Suzanne provided the illustrations.

Lucy's first major essay, published in 1914 in a high-profile literary journal that her uncle Marcel had helped found, was titled "Vues et visions." The "views" that she described evoked the ocean as seen from a beach resort town near Nantes. Those views led to "visions," which were set in ancient Greece, Rome, or Egypt. A few years later, just before moving to Paris, Lucy and Suzanne collaborated on a reprint of the essay, turning it into a small book. In this version, the words and images were striking and beautiful, each illuminating and balancing the other. The strong lines of Suzanne's modernist drawings took up at least half of each page, blending art nouveau's sinuous curves with an early art deco emphasis on geometric form and repeating patterns. One of Suzanne's illustrations, *Modern Night*, captured Lucy's "view" with a depiction of two women in an intimate moment; in a related illustration, *Ancient Light*, two embracing men represented Lucy's "vision." But in neither image are the figures stereotypically male or female. The women's hair was cropped short. Suzanne gave the faces of the men delicate, feminine features.

"Vues et visions" also marked what art historian Tirza True Latimer calls their "artistic coming out, since it undoubtedly raised their public profile as a couple while making their homophilia glaringly apparent to those aware of the codes involved." The appearance of both their names on the title page of the publication emphasized the collaborative nature of the work. Lucy lovingly gave her text to Suzanne: "I dedicate these childish words to you so that the entire book will belong to you and so that your drawings will excuse my text."

However, the names in print were not Lucy Schwob and Suzanne Malherbe. For their creative work, they chose to be known exclusively as Claude Cahun and Marcel Moore, respectively. Suzanne had been calling herself Moore for a while, but Lucy had gone through several pseudonyms over the previous years, even sometimes spelling her name "Lucie" before finally settling on the gender-ambiguous Claude, a name used by both men

and women in France. Cahun was her paternal grandmother's maiden name. Taking a name from another woman in the family allowed her to escape the shadows of her famous uncle and her influential father. It also, at least partly, let her pay homage to her cousin René Cahun, who had died in the trenches of World War I in 1917. That was the year she fully embraced her new moniker.

It was also the year that Lucy's divorced father married Suzanne's widowed mother, making the two lovers, now twenty-three and twenty-five, stepsisters.

Lucy and Suzanne went back and forth between their birth names and their artistic names, transitioning identities from wealthy bourgeois daughters to transgressive Parisian artists as needed. They were certainly not the first to do so. The famous nineteenth-century French author Amantine-Lucile-Aurore Dupin was better known in public and in print as George Sand, although family and friends called her Aurore. Many artists took new names to separate their artistic personae from their personal lives, to modify their public image, or to hide behind a different identity. In turn-of-the-century French literature, writers sometimes gave lesbian characters androgynous names. To play against stereotypes, the groundbreaking male artist Marcel Duchamp created a female persona named Rrose Sélavy.

Yet even when creating as Cahun and Moore, they often referred to themselves in personal correspondence as Lucy and Suzanne. By choosing new identities but also keeping their given names, Lucy and Suzanne remained somewhere between masculine and feminine, resisting either category fully and enjoying the freedom to float between the two when it suited them.

In addition to taking on a new name, Lucy also significantly modified her appearance. In the summer of 1920 on a Jersey vacation just before their move to Paris, the two women climbed onto the rocks near the beach at St. Brelade's Bay in search of good lighting and an intriguing backdrop for a photograph. Lucy wore a white sweater with a thick collar and dark knee-length shorts. Bare feet anchored her to the brown granite. Suzanne moved back, closer to the water, aiming the lightweight folding Kodak pocket camera. As Lucy looked off into the distance, Suzanne clicked the shutter.

Looking at the image, it is hard to tell whether this is Lucy in her midtwenties or a young boy. Her long, wavy mane from earlier years was

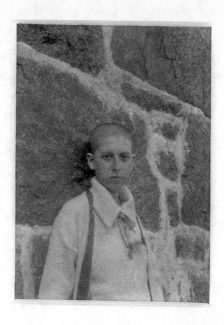

*Lucy standing against
a granite wall on Jersey.*
COURTESY OF THE JERSEY
HERITAGE COLLECTIONS.

gone. Except for a thin stubble, she had shaved her head bare, allowing the cool air to caress her scalp. They moved to another location in front of a seawall that held back Jersey's unusually high tides. Again, Suzanne lifted the camera and looked through the lens. When the shutter clicked, she captured Lucy's firm, serious eyes staring right at her. Lucy's nearly bald head made her more closely resemble the French soldiers who had recently returned from the battlefields than it did a wealthy woman on a vacation.

Ongoing struggles with illness may have been one reason Lucy shaved her head, but it was more likely an act of rebellion against traditional notions of feminine beauty. Later, when she published a book under the name Claude Cahun, based on her journals from the 1920s, she put it this way: "I shave my head, wrench out my teeth, my breasts—anything that is embarrassing or annoying to look at—stomach, ovaries, the brain, conscious and covered in cysts," suggesting that altering gender and sexual identity was part of the goal, and so was creating a new self.

Anyone observing Lucy might have associated her hairless head with images of "outsiders" from Western society: prisoners, the sick (a population of which Lucy was a member), those in asylums (memories of her mother), monastics who chose a life apart from others, those doing penance, adulteresses being punished, or the lower classes, including seamen

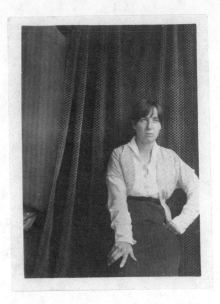

and dockworkers. The most famous Frenchwoman to have her hair cut radically short was Queen Marie-Antoinette on her way to the guillotine in 1793. Although Suzanne never shaved her head, she did cut her hair in a short, more masculine style.

Partly because of her shifting look, Claude Cahun (as she is always referred to now by scholars) has come to be viewed as a queer or transgender hero, although she would never have used either term since they did not exist at that time in the way that we use them today. Some have wondered whether we should now use the pronouns *they/them* rather than *she/her* to refer to Cahun or to Suzanne's alter ego, Marcel Moore. Both women always used the feminine pronoun since there was no alternative available, especially in the highly gendered French language. They always talked about themselves as women.

Lucy was nevertheless acutely aware of the flexibility of her identity. "Shuffle the cards," she wrote as Cahun in one deeply personal essay. "Masculine? Feminine? It depends on the situation. Neuter is the only gender that always suits me. If it existed in our language no one would be able to see my thought's vacillation." Gender was, for her, situational, conditional, possible (or impossible) at any given moment, but it depended on the moment.

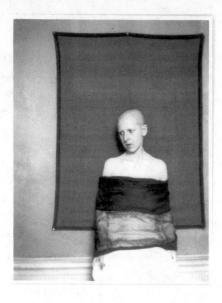

Lucy was working to understand what we now describe as gender and sexual fluidity by sorting through the terminology of her day and trying to find the right word. To a long prose poem, which she dedicated to Suzanne, she gave the title "Les jeux uraniens" (Uranian games). By the turn of the century, *uranian* was a term psychologists and medical doctors used to label a person who felt same-sex desire, often thought of as a female psyche in a man's body. For some, it meant a kind of "third sex," neither male nor female but somewhere in between. Scientists of the era wrote volumes analyzing whether such feelings were innate or acquired.

To help understand these issues, Lucy and Suzanne turned to the British psychologist Havelock Ellis. Ellis wrote about same-sex desire, especially in his 1897 book, *Sexual Inversions*, in which he posited that it was a natural expression and should not be a crime or seen as a moral failing. Sexuality should be studied rationally, he argued, and understood as a personal choice. Lucy called him a "doctor-philosopher-poet," and when she autographed a copy of her own book for him in the early 1930s, she wrote: "To Havelock Ellis who has been a warm light on my desolate path, to the master I admire and love, to the friend who never failed me. Claude Cahun (whom he has known more real perhaps under the birth name of Lucie Schwob—as a translator of The Task of Social Hygiene)." Lucy and

Suzanne had undertaken to translate the first volume of Ellis's book into French and had begun work on the second.

Although some women in the 1920s Paris artistic scene were lesbians, much of the avant-garde art world was highly masculine and engaged in discussions about the fate of manhood after so many men had died in World War I. Male artists were at best ambivalent toward homosexuality, especially among women, but sometimes openly hostile. An editor at an avant-garde journal called Lucy "a curiously somber person and a bit of a witch."

Detractors agonized over the inversion of sexual roles, worrying that lesbians were becoming inordinately powerful and sexually voracious. They evoked fears about the modern, independent woman who went out in public on her own, smoked, drove a car, and wore short hair and masculine clothing. One critic famously wailed that France was becoming "a civilization without sexes." Many conservatives in France feared that lesbians were everywhere, tempting women into vice and sapping France's strength and eroding its moral fiber just when the nation needed to rebuild.

With Lucy working through all her feelings in a society that was at once open to but also afraid of same-sex desire, it's not surprising that she wanted to maintain at least some privacy. On the title page of the unfinished manuscript of "Les jeux uraniens," she drew a picture of a small placard in the lower-right corner in which she wrote, in English and all capital letters, "TRESPASSERS WILL BE PROSECUTED."

In late 1924 and early 1925, Lucy and Suzanne were reading *Inversions*, the only magazine in France at the time addressing a readership interested in homosexuality. The title played on the term *invert*, another name doctors often used to describe individuals with same-sex desires. News kiosks around the city sold the title, which reported on theories of sexuality and the history of Oscar Wilde's obscenity trials. It even included a mention of same-sex behavior in pigeons.

Inversions also attracted the attention of authorities, who began to investigate it as an offense to public morality. The magazine changed its name to *L'amitié*, meaning "friendship," though in French the word has same-sex connotations. Editors invited readers to respond to the allegations of indecency, to address whether the magazine's freedoms of the press were being attacked, and to state their views on homosexuality.

Lucy was one of those who answered this call, and the editors published her response. In it, she offered her personal view of sexual identity, the only clear statement on the subject she would ever print: "My opinion on homosexuality and homosexuals is exactly the same as on heterosexuality and heterosexuals; everything depends on the individual and on circumstances. I demand a general freedom of morals, of everything that is not harmful to peace, liberty, of happiness, of the next person."

2

"A PROFESSIONAL SMILE-AND VOILÀ!"

THROUGHOUT THE 1920S, Lucy and Suzanne found success in Paris as working artists. Lucy published essays, usually under the name Claude Cahun. In 1923, Suzanne, as Marcel Moore, displayed her work at the Salon d'Automne, an annual exhibition founded to showcase young and innovative artists outside the more conservative and official art circles. She also created illustrations for various clients, including the actor Edouard de Max, the American expatriate nude dancer known as Nadja, and the stars of a production of Oscar Wilde's *Salomé*.

Both women also enjoyed photography. Although neither had any formal training nor ever developed their own film, the camera had been their primary means of artistic collaboration since they were teenagers back in Nantes.

Suzanne would click open the lens of the portable Kodak, pulling it forward a bit and extending the leather bellows that attached the lens to the body. It was the only camera either woman ever owned. They used it together for decades. Suzanne often set up the camera inside their apartment and opened the windows wide to provide lots of natural light. Lucy was almost always the one in front of the lens. In the camera's gaze, with Suzanne looking through the aperture and adjusting with a set of small knobs, Lucy could become another person. She transformed herself into someone else, took on alternative roles, and used clothing to explore different sides of herself. She could be free from her illness, her shyness, and the stresses of her life.

"The lens tracks the eyes, the mouth, the wrinkles skin deep," Lucy would write later about their photography. "The expression of the face is

fierce, sometimes tragic. And then calm—a knowing calm, worked on, flashy. A professional smile—and voilà!"

Many photographs, especially those of Lucy in costume, highlighted their love of acting. Both women became involved in avant-garde theatrical companies, working behind the scenes to make costumes, with Lucy sometimes appearing onstage. In one production, she portrayed the devil. In another, she and the actor/director cross-dressed. Lucy, with her hair cut in a masculine style, wore a jacket and tie.

In his book *Powers of Two*, Joshua Wolf Shenk highlights creative pairs as the truly powerful agents of innovation throughout history. Two people can move together, pushing and pulling each other in a mental back-and-forth that becomes difficult with more people in the mix. The dialectic of dialogue and the intellectual sparks that fly in a tête-à-tête, Shenk concludes, make the duo "the primary creative unit." Sometimes, he notes, one partner seems to be "off-stage," but frequently one is the "director" to the other's role of "star." That certainly describes Lucy and Suzanne—one the performer, always in front of the camera, and the other an off-camera, yet no less present, artistic force. That dynamic is at work in one of their photos in which Lucy (as Cahun) wears a black wrap covering her torso. A choker presses tightly around her neck, from which hangs an enormous,

Lucy (as Claude Cahun) dressed as the Buddha, ca. 1927. COURTESY OF THE JERSEY HERITAGE COLLECTIONS.

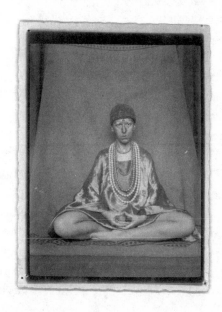

beaded six-pointed Star of David. One of the star's points disappears into the garment that hugs Lucy's body. Very faintly, with eyes barely visible in the upper-left corner of the photograph, Suzanne (as Moore) peers over the backdrop.

Often missing from the stories of artists and writers is the understanding of the intimacy in which artistic production happens. From Auguste Rodin and Camille Claudel, to Gertrude Stein and Alice B. Toklas, to Man Ray and Lee Miller, artists and their spouses, partners, or lovers have often formed creative teams, even though one partner (usually the woman in a heterosexual partnership) tends to get downplayed.

Many scholars who write about Lucy and Suzanne's photographs still usually attribute them to Claude Cahun alone, erasing Suzanne's contribution despite the fact that she was nearly always the one behind the camera. Normally, it is the photographer who is considered the artist. In their case, however, the artistic vision is nearly always imputed to Lucy (as Cahun).

But their work clearly was, and always would be, a partnership. When Lucy and Suzanne took multiple exposures of a photograph, they surely examined the prints together, deciding which ones worked best. Their camera created a stage where Lucy could star in a kind of "show," which they had discussed and prearranged, but it was Suzanne who chose the moment to snap the shutter, when the light was perfect or the expression on Lucy's face was right.

CAUGHT UP IN THEIR LIVES IN PARIS, Lucy and Suzanne hadn't visited Jersey in eight years. While they always had fond memories of the island and could revisit it through the many snapshots they had taken on the beach, they were just too busy to tear themselves away from their daytime creative work and their evenings spent hosting their artistic and intellectual friends. Now, in 1930, they were ready for a vacation. They moved into the St. Brelade's Bay Hotel in early August, where they could sit on one of the balconies and watch the water lap against the shore. Lucy and Suzanne always had their little Kodak with them. As they had done many years earlier, they climbed on the brown Jersey granite, looking for interesting vistas to shoot and posing among the palm trees that decorated the landscape. Their restful holiday lasted until late in September, when the weather started to cool and their art and friends beckoned them back to Paris.

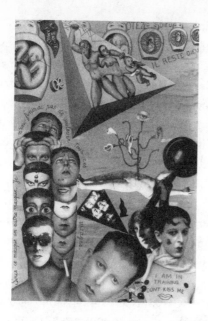

Image of photomontage illustration from Aveux non avenus, *ca. 1930.*
COURTESY OF THE JERSEY
HERITAGE COLLECTIONS.

There was much to do at home. That same year, Lucy and Suzanne (working as Claude Cahun and Marcel Moore) finally published a book they had been preparing for some time. Based on her journals from the 1920s, Lucy had authored a strange and complex memoir that explored the depths of her identity with all its twists and turns. She called it *Aveux non avenus*, a title difficult to translate but which was later published in English as *Disavowals*.

Lucy's words were not alone on the page. Suzanne painstakingly cut up dozens of the photographs she had taken in previous years, rearranging the bits and pieces, with Lucy's input, to form new dream-like images. Each of the book's chapters begins with one of these photomontages. Often composed of human faces—nearly always Lucy's—which sometimes repeat in intricate patterns, the images are disturbing, sometimes violent, but they capture Lucy's many inner struggles.

Even while she was still working on this book, Lucy's world began falling apart. Her beloved father, Maurice Schwob, died in 1928. Shortly afterward, Lucy discovered that her mother had been released from the asylum where she'd lived for years. Lucy's estranged brother had removed their mother from the doctors' care without Lucy's knowledge and had taken her to his home. She died only a short time later.

Although only in their late thirties, age was beginning to catch up with the women. Lucy needed two surgeries, the first to remove ovarian cysts, a procedure that was performed for free by a student of Suzanne's father at the medical school in Nantes. The other was to take care of abscessed teeth, which had caused her cheek and jaw to swell with infection. She then underwent a root canal without any form of anesthetic, although she still had plenty of drugs of her own. Cigarettes, alcohol, and opium—all on hand in their apartment—remained vehicles of artistic revelation as well as convenient ways of coping with Lucy's ongoing illnesses and insomnia. Adding to the stress, Suzanne had a cancer scare, and doctors operated to remove what was ultimately determined to be a benign tumor. By this point, despite the success she had found in Paris as Marcel Moore, Suzanne had largely given up her solo illustration work.

AS LUCY INTENDED, *Aveux non avenus* captured the interest of many in the avant-garde art world in Paris. She described the book as an attempt at "black humor, provocation, challenge," whose purpose was to make her contemporaries "leave their smug conformism and their complacency behind."

One of the people who paid attention was André Breton, a founder of surrealism. A World War I veteran, Breton was famously bristly, with a combative personality. He was also a notorious misogynist and homophobe. At first, he had been standoffish and arrogant toward Lucy and Suzanne, even after being introduced to them by Adrienne Monnier, a mutual friend, at one of her bookstore events. When Lucy and Suzanne showed up at his favorite cafe, Breton fled so he would not have to speak with them.

Surrealism tried to depict what was above or beyond that which was real—the literal definition of the word *surreal*. Breton and his colleagues wanted to see behind people's masks and outward appearances so that they could liberate the inner life of the mind. Inspired by Sigmund Freud's discussions of the unconscious and belief in dream interpretation as the key to unlocking it, surrealists depicted dreamscapes and engaged in "automatic writing" and "automatic drawing." They aimed to free themselves from the constraints of rationality and linear thinking.

Breton's group also relished the notions of surprise, discontinuity, and spontaneity. Sometimes they handed out jolting notes to passersby about

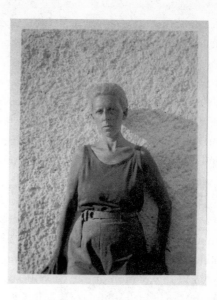

Lucy on Jersey, ca. 1932.
COURTESY OF THE JERSEY
HERITAGE COLLECTIONS.

political or social issues—which they called "butterflies"—or they posted them around Paris. Some of the messages offered funny statements that were simply intended to grab people's attention or make them think. One read: "If you love love, then you'll love Surrealism. Parents, tell your kids your dreams." Lucy and Suzanne paid close attention to the technique.

Initially, Breton hated *Aveux non avenus*, but eventually he became enamored of it, realizing the book's similarities to surrealism. He encouraged Lucy to use the "magic powers" he saw in that book to the fullest. "You are well aware that I consider you one of the most curious spirits (among four or five) of our times," he wrote to her.

Breton was also a member of the French Communist Party and committed to a revolution that would release society from what he saw as the slavery of capitalism. Along with many of the surrealists, Breton joined the Association of Revolutionary Writers and Artists (l'Association des Écrivains et Artistes Révolutionnaires, or AEAR), the French branch of the International Artists' and Writers' Union founded in Moscow in the early 1930s. Art must always be engaged in an ideological battle on behalf of human liberation, the AEAR asserted.

Breton soon drew Lucy and Suzanne into his left-wing politics. Lucy had long advocated for individual freedoms and wrote in *Aveux non avenus* of the need to shake people out of their complacency: "I want to scandalise

the innocent, little children, old folks with my nudity, my raucous voice, the obvious reflex of desire." To express her opposition to the Spanish Civil War of the late 1930s, Lucy, as Claude Cahun, created a papier-mâché doll using pieces of the communist newspaper *L'humanité*, which she showed at a surrealist exhibition in London. Lucy was an especially active participant in political debates about current events, sometimes hosting them at home, frequently taking notes. She signed on to highly charged manifestos published by the AEAR and other groups protesting fascism and attacking government corruption in France.

There was much to protest. Mussolini had been in power since his March on Rome in October 1922. Hitler took advantage of Germany's deep economic upheaval to take the reins of authority in January 1933, promising to make it a strong and powerful nation once again and put millions back to work. In violation of the Versailles treaty that ended World War I, he began a massive buildup of soldiers and materiel, clearly gearing up for another conflict.

BUT EVEN AS EUROPE SEEMED TO BE COMING APART at the seams, and despite the serious political commitments that Lucy and Suzanne shared, the two women kept returning to Jersey each summer between 1930 and 1936, always to the beauty of St. Brelade's Bay, where they could look south toward France, a homing beacon in the distance. The several relaxing weeks they spent in August and September during those six years took them away from the deepening trauma of the Great Depression that made life harder for millions back home. Such an escape was the privilege of the leisure class.

On those trips, they spent time with the few Jersey friends they had made, in particular Vera Wimshurst, whom they met in 1921 on one of their earliest vacations from Paris. Vera was a few years older than Lucy and Suzanne, unmarried with short black hair and dark eyes. She had been born in Waterloo, near Liverpool in the north of England, where her father was a solicitor, but after he died, she moved to Jersey with her mother.

The shy Lucy, who was also quick to judge, took an instant dislike to Vera and tried to avoid her. For reasons she never stated, even the normally outgoing Suzanne had trouble warming to her. But Vera worked hard to engage them both in conversation, asking to take their photographs and following them when they went fishing and swimming. Later, Vera wrote

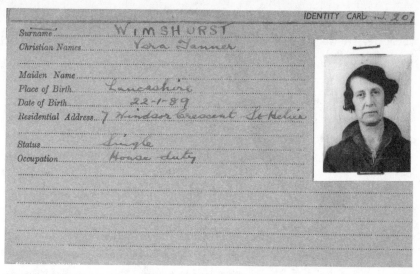

Occupation Registration Card for Vera Tanner Wimshurst, ca. 1940. COURTESY OF THE JERSEY HERITAGE COLLECTIONS.

to them of her time in London working for a window designer, a tidbit that made her seem slightly more interesting. Vera's words on paper made her somehow more compelling than she was in person. She even traveled to visit them in Paris, and Lucy and Suzanne showed her the city. Each summer when Lucy and Suzanne went to Jersey, they saw Vera again, their friendship growing despite Lucy's preference for solitude and her continued bristling at Vera's personality.

Yet even with Vera's somewhat trying presence, Jersey was a much more pleasant place than Paris had become. Throughout the 1930s, political tensions mounted every day as Parisians became angry and bitterly divided. Right-wing proto-fascist groups called for a coup d'état by a strong leader while left-wing groups plotted a Bolshevik-style worker's revolution like the one that rocked Russia in 1917.

In 1934, disgusted by a series of political scandals embroiling officials, a crowd of right-wing Parisians critical of the system rioted in the streets, nearly overthrowing the government. The spread of fascism throughout Europe emboldened ultranationalists, and they marched through Paris screaming for the expulsion of Jews and foreigners. Communists and socialists fought back with their own rallies but remained divided over tactics.

Artists and intellectuals, including Lucy and Suzanne, debated the role their creative work might play in engaging the important questions of the day.

When the new socialist prime minister of France, Léon Blum, himself the first Jew to hold the office, was about to take power in 1936 to form a coalition against the growing strength of the Far Right, anti-Semitic and anticommunist militants dragged him from his car and beat him. Once Blum assumed office, right-wingers began to shout, "Better Hitler than Blum!"

After some fifteen years in Paris, Lucy was growing tired of the fray and began to think about establishing a permanent new life outside the city. Partisanship was not the only reason. The struggles of her continuing illness made a quieter place to live seem all the more attractive. She would later remember those years as the start of a creative crisis. Despite Breton's praise of *Aveux non avenus* and their political work together, an oppressive self-doubt continued to undermine her confidence in all her abilities.

The relatively open sexual atmosphere they had experienced in 1920s Paris was also turning hostile. Several public scandals again raised the question of sexual morality, and the city's notoriously vigilant police chief cracked down on the gay community. Many people in post–World War I France saw gay men and lesbians as particularly threatening because they were not doing their duty of having children. That failure was especially worrisome for nationalists, who feared a declining population and asked how France would be able to field an army should there be another war.

LUCY AND SUZANNE HAD ALWAYS HAD PLENTY OF MONEY from their families, but Suzanne's mother recently passed away, leaving her daughter a large sum. They could now make a significant change in their lives.

Lucy's first thought was to head for England, where she and her family had long-standing ties, having vacationed there in the past. British house-keepers had served the Schwobs, and they helped teach Lucy the language. She had also spent a year at the elite Parsons Mead girls' school in Surrey, distinguishing herself in writing and acting in English.

But she knew Suzanne would not want to stray too far from Paris and the busy friendship-filled life she enjoyed. How could Lucy ask the woman she loved to leave that world behind? Lucy struggled with her feelings

alone, expressing them only in her journals; she refused even to mention her growing malaise to Suzanne.

Then she thought of Jersey, the place they both knew so well. Lucy finally broached the subject, confessing to Suzanne that she just wanted to get away from it all. Suzanne was flatly uninterested. A life in the country will not suit you as much as you think it will, she told Lucy. There was too much in Paris for them both.

Over the coming weeks, they talked more about it, probably fought, the pain of such a fundamental disagreement straining their relationship. Gradually, eventually, Suzanne relented. By early 1937, Suzanne couldn't stand to see Lucy suffer any longer, and they began to plan their move.

3

"I SENSED THE WAR COMING
(without Wanting to Believe It)"

JERSEY HAD LONG BEEN A REFUGE from battles elsewhere. French Huguenots found sanctuary there during the Wars of Religion in the sixteenth century. King Charles II fled to Jersey twice during his tumultuous rule amid the English Civil War, as had various factions during the French Revolution. After Louis-Napoleon Bonaparte staged a coup and changed his name to Napoleon III in 1852, his political enemy Victor Hugo made his way to Jersey, along with dozens of others fleeing the new emperor's reign. Hugo stayed there until 1855, then moved to nearby Guernsey, although he supposedly said that Jersey was the prettier of the islands. Now it would be Lucy and Suzanne's refuge as well.

It took Lucy a while to work up the nerve to tell André Breton about her impending move, but in the spring of 1937 she went to a favorite cafe, where the surrealists often gathered, to break the news. She purposely waited until right before she and Suzanne had packed up their apartment and were scheduled to depart. Her announcement caught the artists off guard, and some seemed genuinely upset, especially when Lucy told them that she and Suzanne had already bought a house there. In their friends' view, the women appeared to be abandoning the political and artistic causes they'd all been fighting for together for years.

"You're emigrating?" one in the group put it plainly. "Can you tell us why?"

Lucy didn't proffer much of a defense. "We're leaving our money in France!" she declared, as if the blow might be softened because some part

of them would still remain in the fight. She did not remind her friends that Jersey was a well-established tax haven and that leaving their money behind would be a kind of loss for them.

IN MID-APRIL 1937, Lucy and Suzanne, aged forty-two and forty-four, boarded the ferry in the French port of Saint-Malo for their two-hour journey out into the windy English Channel. Protecting themselves against the sea spray and spring chill with their Burberry overcoats and closely tied scarves, Lucy and Suzanne could see the high cliffs of dark granite in silhouette against the light sky. Sailboats and fishing vessels dotted the waves in St. Aubin's Bay.

Safely docked in the harbor in St. Helier on the eastern side of the bay, they disembarked into a familiar world. Stevedores called out to one another as they loaded the local potato harvest onto ships and unpacked goods brought to the island. Birds overhead watched for a loose tomato from one of the island's many export shipments. The fronds of palm trees rustled in the breeze. Lucy and Suzanne could look up to count the houses that climbed the rocky hills. The fog that often rolled in quickly across the island sometimes obscured the beautiful views. When the tide in St. Aubin's Bay fully receded—Jersey has some of the highest tides in the world—it exposed a hidden world of craggy rocks and allowed Lucy and Suzanne to walk out hundreds of yards along the wet sands to Elizabeth Castle, a fortress island normally surrounded by water.

In St. Helier, people moved through the small winding lanes, many of which looked—and sounded—like the thoroughfares the women had just left behind in Paris. With the island between England and France, both languages flourished.

Vera Wimshurst met Lucy and Suzanne near the dock. They climbed into Vera's car and rode a few miles to the farmhouse they'd bought. Most houses on the island had a name, and theirs was called La Rocquaise, meaning "rocky" or "mountainous." The heaviness of the deep brown local Jersey granite lent their new home the feel of a stone fortress, and they soon got out of the habit of locking their doors. Surveying the rooms, the women surely discussed what furniture would go where. Cross-hatched leaded windows stretched across the long southern side of the house, which faced St. Brelade's Bay. Throwing open the back doors and stepping out into the

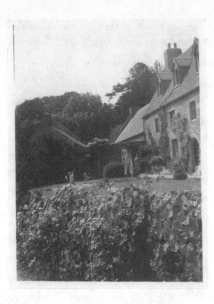

The Garden at La Rocquaise.
COURTESY OF THE JERSEY
HERITAGE COLLECTIONS.

bright sunshine, they could see the garden beginning its springtime bloom, the mimosa bushes a bit overgrown. The unwieldy plantings inspired Lucy to joke that their house should be called "the farm with no name."

In the weeks to come, as the weather warmed into summer, they planted a small kitchen garden. The secluded backyard was perfect for sunbathing, and the salt air enveloped them. The enormous seawall that formed the boundary of their property protected the house from storms and the high tides on the beach below. Over that wall and across the bay, they could look past the fishing boats toward France.

Some things had changed since they started coming to Jersey. Lucy noticed the increase in people, houses, and traffic along that stretch of the bay. Fortunately, La Rocquaise was nestled behind retaining walls and large plantings that separated it from the road.

The house was almost exactly across the street from the St. Brelade's Bay Hotel where they had vacationed so many times before. On those previous trips, whenever they went to the beach, they passed the very structure that was now their new home. Lucy and Suzanne moved back into the hotel temporarily while extensive repairs on the house began.

At least one old memory lurked in the neighborhood. Lucy had met her old flame Bob Steel on this beach many years ago. The Steel family residence, just down the curve of the bay, was the only one she and Suzanne

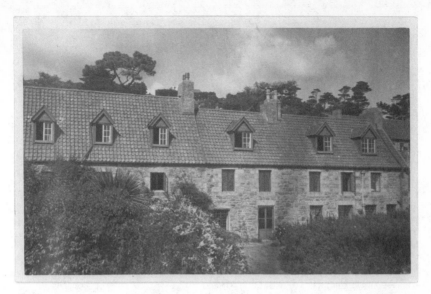

La Rocquaise, its south facade facing St. Brelade's Bay. COURTESY OF THE JERSEY HERITAGE COLLECTIONS.

could see when they looked out their window at La Rocquaise. Bob was no longer there, they found out. He had become a stonemason and moved to another part of the island with his wife and children.

During the months that followed, Vera traveled from her home in St. Helier to visit Lucy and Suzanne at St. Brelade's. Sometimes the three women drove to the northern part of the island to take tea or to go swimming or bird-watching, and Vera taught them the names of local species.

But Lucy prized her privacy above all else. "We don't want to be social at all, is that difficult on Jersey?" she asked Vera. She was really speaking only for herself, not for Suzanne.

"Perhaps people will pay you some visits," Vera told her. "You don't have to visit them. Nothing is formalized. It's just the traditional way."

After a year's worth of renovation and another trip back to France, they moved into the house in May 1938, the pieces of their new life finally in place. As they filled La Rocquaise with all the furniture and belongings shipped from Paris and from their family homes in Nantes, it now contained many layers of their lives. Their once-indoor cat, Kid, whom they had smuggled through customs in a Hermès bag to avoid quarantine, had the run of the place and quickly became accustomed to spending time on the beach.

Surname...... *LE NEVEU*
Christian Names...... *Edna Jeanne*

Maiden Name...... *LANGTRY*
Place of Birth...... *Holywood, Ulster, Ireland*
Date of Birth...... *8 · 8 · 1915*
Residential Address...... *La Rocquaise, St Brelade's*

Status...... *married*
Occupation...... *House Keeper*

Occupation Registration Card for Edna Jeanne Langtry Le Neveu, 1940. COURTESY OF THE JERSEY HERITAGE COLLECTIONS.

With the house set up, Lucy and Suzanne hired a maid, Edna Langtry, a round-faced twenty-three-year-old with auburn hair and a friendly smile. She had come to Jersey from a town near Belfast. Only recently had this area come to be called Northern Ireland. Soon several young men were routinely visiting La Rocquaise to court Edna, chatting with her in the kitchen. Edna had a tendency to drink quite a bit, a trait that both Lucy and Suzanne thought could be problematic. Later, they would at times wonder just how far they could trust her.

AFTER YEARS OF USING THE GENDER-AMBIGUOUS PSEUDONYMS Claude Cahun and Marcel Moore for their artwork, on Jersey the women returned almost exclusively to their birth names, Lucy Schwob and Suzanne Malherbe. They would use Cahun and Moore only when corresponding with artist friends or when people from Paris came to visit.

On Jersey, they often both used the name Schwob because Lucy thought the English-speaking Jersey residents had a more difficult time pronouncing Suzanne's French last name. Since many place and street names on the island were French and many residents were of French descent, Suzanne's name does not seem as though it would have presented too much of a challenge, so why Lucy thought so remains unclear. The choice may have had

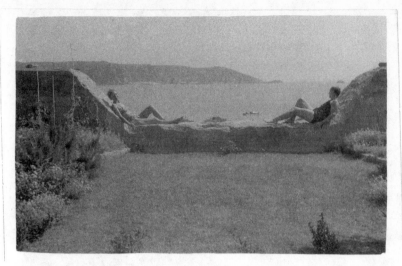

Lucy and Suzanne reclining near the water. COURTESY OF THE JERSEY HERITAGE COLLECTIONS.

more to do with reinforcing their status as sisters in order to conceal their true relationship. The conservative Jersey residents would probably not be as accepting of a same-sex couple as some Parisians had been.

In truth, many people on Jersey saw Lucy and Suzanne as slightly eccentric women who sunbathed in their yard or even on the beach, wearing little or nothing, according to some accounts. When they sported men's clothing and took their cat for walks on a leash, skeptical islanders surely looked askance.

"They were nature lovers," one Jerseyman remembered years later. "They were fond of fish, and I used to supply them. I know they used to write poetry and articles [for] French papers and journals—they dressed, let's say, very modern," by which he possibly meant in trousers. "I do not think they mixed very much with the locals."

Their doctor on Jersey, John Lewis, described Suzanne in his memoir as "the practical down-to-earth one." It was Suzanne "who ran the house, saw to all the business affairs, spent as much time as she could in the garden, and looked after Lucille," as he called her, "with a breezy but tender solicitude. She was thick set with an out-of-doors complexion, and short-cropped black hair, whose favourite garb was slacks and a bulky sweater, and who

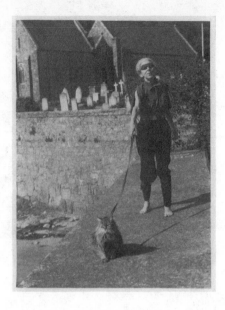

took an early morning bathe for at least eight months of the year." Lucy, by contrast, was "thin, elegant, highly intellectual, widely read, and a first-rate hypochondriac" who wore "rather peculiar clothes, surrounded herself with every sort of avant-garde objet d'art and was in the habit of sitting in rooms during the day with the curtains half drawn, and the light on."

At first, out of the hurly-burly of Paris and in their accustomed leisure spot, life had the feel of a permanent vacation, innocent and carefree. According to Lucy in her postwar unpublished memoir, "It seemed that all that was left for us to do was to tame the trees, the birds, the doors, the windows, and to pull from the trunk something appropriate to wear, the shortest and lightest possible, and to plunge into the sun and the sea."

Jersey made the perfect photography studio, and they frequently set up the Kodak in the garden or on the beach to take advantage of the abundant sunlight. One bright day, Lucy and Suzanne ventured into a field of poppies. Lucy stripped off her clothes and stood behind the tall stalks with her arms stretched wide, her body blending into the field of flowers that surrounded her. Behind the camera, Suzanne clicked the shutter. On their next trip into town, they took the film to a commercial photo lab. When they got the pictures several days later, Lucy and Suzanne looked at them together, reliving the fleeting beauty of the moment. When the women

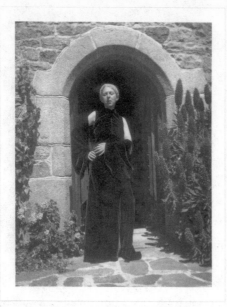

Lucy standing in a doorway at La Rocquaise.
COURTESY OF THE
JERSEY HERITAGE
COLLECTIONS.

weren't taking photographs, they spent their days writing, painting, fixing up the house, filing papers, and sorting books.

They also regularly listened to the BBC on their radio, and what they heard on the broadcasts was not at all pleasant. Hitler's belligerence now threatened the Continent as he announced his intention, backed by an army rebuilt to massive proportions, to annex Austria and the Sudetenland in March 1938. Reports coming out of Germany for the previous few years had been increasingly horrific, especially for the Jewish population, which suffered greater persecution every day. By November 1938, waves of violence coalesced into Kristallnacht—the night of broken glass—a massive state-sponsored pogrom against Jewish synagogues, businesses, and individuals that foreshadowed much worse to come.

THE NEWS FROM GERMANY WAS SHOCKING for many reasons, but for Lucy it was intensely personal and undoubtedly brought back some of the most painful feelings of her life. The nearly forty-year-old memories may have been a bit fuzzy since she'd been only a child when she first experienced the powerful hatred of what some scholars today refer to as "Judeophobia," but they stayed with her for years.

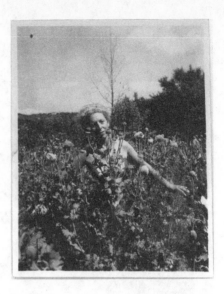

Lucy among the flowers of Jersey, ca. 1938. COURTESY OF THE JERSEY HERITAGE COLLECTIONS.

In 1898, the year Lucy turned four, her hometown of Nantes had erupted with rage. "Down with the Jews!" crowds shouted around the city as hooligans attacked businesses and stormed the synagogue where the small Jewish community worshipped. A heckling mob gathered outside the offices of her father's newspaper, which was located in the same building as the family's apartment, and taunted him with their nasty slogans and bellowing hatred.

The vitriol behind these riots had been building in the previous four years, ever since the French army sentenced Captain Alfred Dreyfus to life in prison for supposedly giving classified documents to Germany. In fact, the court-martial was a face-saving cover-up for the military after it discovered secrets had been leaked. For the generals, Dreyfus was a convenient scapegoat for a military intelligence failure. Playing on old stereotypes popular in France at the time, Dreyfus was easily and believably cast as an outsider and an enemy, someone whose Jewishness meant that he was not truly French. Now, in 1898, the famous novelist Émile Zola openly accused the government of covering up the wrongful conviction of an innocent man, and throughout France people took sides, fighting—sometimes even dueling—over the merits of the case.

In the political chaos of what became known as the Dreyfus affair, Lucy's father, Maurice Schwob, took the side of Dreyfus, arguing in his

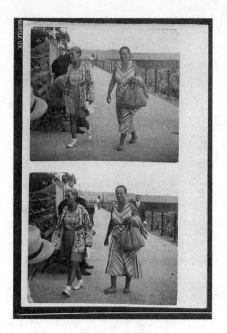

newspaper on behalf of the captain's innocence. Nothing less than justice and the rule of law was at stake, he believed.

For Maurice Schwob, the Dreyfus case was also personal since the condemned officer had been his former school classmate. And although Maurice had since abandoned his faith, assimilated, and married a Catholic, he had been raised a Jew. Taking up Dreyfus's cause was his way to fight against a deeply ingrained anti-Semitism that was never far from the surface of French politics.

Years later, Lucy confided in a letter about her love for her father. He was her pillar of strength, even though as a child she hadn't fully understood the unfolding political crisis. He was also the one barely holding her increasingly turbulent family life together. Just as the newspaper was coming under attack, Lucy's mother, Marie-Antoinette Courbebaisse, began sinking into a profound mental illness, and she took her growing anguish out on her young daughter. She berated Lucy for being ugly, telling her that her nose was too big and not the right shape for her ears. Lucy would frequently think about her "Jewish nose" over the years. Her mother sometimes physically assaulted her or screamed out when she could no longer hold back her demons.

The questions raised by the Dreyfus affair tore apart families all across France, and Lucy's was no different. While Maurice supported Dreyfus's innocence, Marie-Antoinette's Catholic family attacked him as guilty. Maurice soon became so consumed by the work of the newspaper in the midst of the political whirlwind that he began leaving Lucy in the care of his blind mother, Mathilde Cahun Schwob.

Mathilde was a smart, powerful, strong-willed woman with a world of experience gained first from her time teaching in England, before she married, and then, later, from travels with her husband to Egypt during his stint as a diplomat. Mathilde regaled Lucy with stories from those years spent abroad as well as with tales from ancient mythology and the scriptures. She also taught Lucy to appreciate her Jewish heritage. Their family included several rabbis and a prominent scholar of Jewish life, Mathilde's brother Léon Cahun.

Lucy's sharp mind and curiosity made her "a child of astonishing intelligence," according to Mathilde. "She would write pages without making any mistakes." Inside their richly decorated apartment, Lucy's father had filled the shelves of his large home library with hundreds of books, which she had at her fingertips. Reading empowered her to go on voyages through history and literature and gave her solace and comfort when her introversion or the stresses of family life became overwhelming.

However, politics was never far away in the charged environment of France at the turn of the century. In 1906, the French Supreme Court, following another reexamination of the case, finally exonerated Captain Dreyfus. Not long afterward, while twelve-year-old Lucy was jumping rope by herself in the schoolyard one day, she felt a powerful yank. A few schoolmates had caught her off guard and grabbed her. She struggled to get free, but they managed to tie her up. Soon Lucy's peers towered over her, raining down rocks on her while she lay helpless on the ground, her hair matted with dirt. As they pelted her, the children shouted horrible anti-Semitic taunts.

By this point, her grandmother had recently died, so Lucy had no one to whom she could turn for solace other than her overworked father. Her mother had been sent to a mental asylum in Paris, and her parents were now divorced. She spent her next school year in England.

Some years later, in 1917, when Lucy decided to abandon her other artistic pseudonyms in favor of the name Claude Cahun, the choice not

only allowed her to explore a new gender identity, but it also embraced her Jewishness. Cahun is the French version of *kohen*, the Hebrew word for priest. Cahun was "the name of my obscure Jewish forefathers ... with whom I felt more of an affinity," she declared, clearly identifying herself with religious outsiders in an overwhelmingly Catholic country. The name was "incontestably *'youtre'*"—a deeply derogatory slang term for Jewish— which she appropriated proudly. It also kept her connected to her beloved paternal grandmother.

NOW, IN 1939, on an island in the middle of the English Channel, she was hundreds of miles away from the Nazis, but she still must have wondered what events like Kristallnacht meant for someone like her with Jewish heritage. "I sensed the war coming (without wanting to believe it)," she recalled. In March, just one day after Germany took over Czechoslovakia and incorporated it into the Reich, Lucy and Suzanne left Jersey for one final trip back to France so that they could tie up loose ends from their move.

Lucy continued to push back against the threat of fascism as much as she could. In 1939, along with over forty other artists, she cosigned an article—once again using the name Claude Cahun—in a journal run by the newly created International Federation of Independent Artists. The

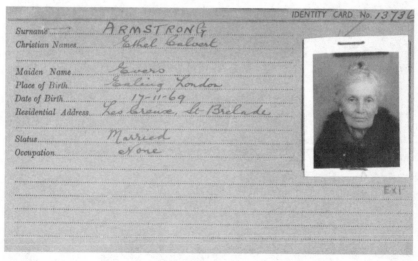

Occupation Registration Card for Ethel Calvert Armstrong, 1940. COURTESY OF THE JERSEY HERITAGE COLLECTIONS.

manifesto of this group, founded by Breton, was coauthored by Leon Trotsky and Diego Rivera. The statement expressed a commitment to leftist politics, criticism of the rise of a militant French nationalism, and a fear that the growing anger against immigrants in France would spell a new kind of hatred and violence.

Even on Jersey, the specter of anti-Semitism was close by. Heading farther south from La Rocquaise along St. Brelade's Bay lived Ethel and Cecil Armstrong. Mrs. Armstrong was sixty-eight with a strong, square jaw framing her sunken cheeks and a mass of white hair piled up on her head. She was a woman of the world, having been born in London and reared in France. In addition to French and English, she spoke Italian, Spanish, German, and Russian fluently. Yet Lucy sensed that Mrs. Armstrong did not like her, and she decided to test her new neighbor's attitudes.

One day in conversation, Lucy mentioned her Jewish heritage, partly to see how the older woman would react. "I suspected as much," Mrs. Armstrong told Lucy bluntly. "And I am anti-Semitic, but not like the Germans!"

Lucy could only wonder what Mrs. Armstrong had meant.

II

FIGHTING THE NAZIS

4

"IT WILL TAKE MUCH, MUCH LONGER THAN YOU THINK"

IN THE LATE SUMMER OF 1939, Lucy and Suzanne often sat in armchairs by the fireplace in their parlor, the sound of the BBC filling the room. A large round mirror hung over the mantel. As a reminder of their Paris days, on the wall hung one of the dream-like photomontages they had created together.

The preceding months had been full of dramatic events. The Japanese assault on China continued to advance. By now, Hitler seemed an unstoppable force, and the world appeared destined for war again. European nations were preparing their arsenals to fight Germany. On the evening of September 1, 1939, the calm, matter-of-fact voice of BBC newsreader Lionel Marsden announced the words they had been expecting for months: "Germany has invaded Poland and has bombed many towns. General mobilization has been ordered in Britain and France."

Two days later, Britain and France declared war on Germany. The battle Lucy and Suzanne dreaded, begun by the Nazis they feared and fought against in their political work, had finally come.

The outbreak of the conflict upset the residents of this archipelago of seven inhabited islands in the English Channel—Jersey, Guernsey, Alderney, Sark, Herm, Jethou, and Brecqhou—but in the fall of 1939 most of them still felt relatively safe. Some British commentators started referring to a "phony war" since the fighting remained a thousand miles away on the battlefields of eastern Europe. In London, the War Office confirmed its belief that the chances of the Channel Islands coming under attack were "somewhat remote." Officials in Britain thought it far more likely that the

Suzanne and Lucy. COURTESY OF THE JERSEY HERITAGE COLLECTIONS.

islands would offer the possibility of a peaceful vacation spot should the war turn westward.

Still, Alexander Coutanche, a World War I veteran and longtime public servant on Jersey who had been appointed as the island's bailiff by King George V in 1935, gathered other local leaders to ask for a more definitive response. For added security, Coutanche, along with the governments of the other Channel Islands, requested that the War Office send antiair-craft weapons and guns to support the contingent of troops defending their otherwise vulnerable coastlines. Coutanche, perhaps furrowing his bushy eyebrows in disappointment, received word from the British military that no weapons would arrive anytime soon. For the next eight months, until May 1940, Coutanche and everyone else on Jersey could do nothing but speculate about their fate.

Lucy and Suzanne remained in La Rocquaise throughout the colder-than-usual winter months of early 1940. After the war, Lucy wrote to a friend about how she had watched the most beautiful plants in their garden die that season. She'd seen it as an eerie omen of mortality.

AS HITLER FINALLY TURNED HIS TANKS WESTWARD in the spring
of 1940 to begin the blitzkrieg against Holland, Belgium, and France,
Channel Islanders' calm quickly transformed into outright fear. "Just try
to imagine the tremendous effect on the morale of his people," wrote one
concerned Jersey resident to the local newspaper, "were Hitler able to tell
them not only that he had commenced to attack England, but that the old-
est part of the British Empire—Jersey—was in German hands." Remarked
another: "Jerseymen would do well to look at a map of France and do some
hard thinking."

Nervous discussions took place across the island. When Vera came to
La Rocquaise for tea one day, the women shared their worries about what
might happen. Vera had nothing positive to offer. I'm resigned to war, she
said. What can we do? Lucy, still easily annoyed at Vera, grew increas-
ingly upset at her friend's defeatist attitude. Lucy herself was pessimistic by
nature, but she had spent too much time immersed in radical politics with
her Paris compatriots to simply throw up her hands. Although most of her
engagement with political action had been intellectual—signing manifes-
tos, attending meetings, writing essays—she believed deeply in the cause
of freedom.

But Vera was no fighter. "Do you think we will lose the war?"

"No!" Lucy barked sharply. "I only think that it's far worse than you
realize, that it will become much more difficult and take much, much lon-
ger than you think."

With the conflict having come to the Western front, Bailiff Coutanche
again contacted the War Office in London, reiterating his concern about
the lack of men and materiel on Jersey. The lieutenant governor, the Crown's
official representative on the island, was Major General James Harrison, a
former artilleryman who had served in India. Like Coutanche, Harrison
was a World War I veteran. Just after the Belgian government surrendered
to Hitler in late May 1940, Harrison painted a bleak picture in his report to
London. Only 150 militiamen and fifty navy men, mostly mechanics, were
stationed on Jersey to defend some fifty thousand residents. Harrison and
Coutanche redeployed students from the Army Technical School to the
airfield. Every night, the students placed wagons and other objects over
the grass-covered runway to block potential landings by enemy aircraft;
in the morning, they took them away.

Within weeks of combat commencing, France was on the verge of falling. By the end of May, the massive and complex evacuation of over three hundred thousand Allied troops from northern France at Dunkirk consumed the British military. London could spare no additional protection for Jersey, located as it was some two hundred nautical miles from that theater. Closer to home, powerful explosions rattled windows as Channel Islanders heard bombs falling on nearby Cherbourg, France, and watched billowing smoke rise in the distance. Men from Jersey and Guernsey launched their own boats to help rescue Allied soldiers escaping the Norman coastal town of Saint-Malo.

Meanwhile, General Charles de Gaulle flew to London. On June 18, Lucy and Suzanne listened on their radio as de Gaulle issued his famous call over the BBC to French soldiers to fight back: "Whatever happens, the flame of French resistance must not and will not be extinguished."

The day after de Gaulle's speech, the exodus from the Channel Islands began. Between June 19 and June 22, hundreds of tourists still on the islands for a holiday, along with thousands of Channel Islanders—around ten thousand from Jersey—left their homes in a chaotic, hastily organized evacuation. Everyone now realized that the islands were clearly an afterthought for the overtaxed British military. Families debated whether to go and what might happen if they didn't.

Lucy and Suzanne went to the dock in St. Helier. There, they and others who were staying watched a mournful drama unfold. In a long queue, thousands waited to register their names on the list and board escape boats for England. People who had made the hard choice to leave were selling off their belongings for a pittance—everything from small items to automobiles—to those who planned to remain.

Rumors were already spreading through the crowd that those staying on Jersey were looting from the homes of the evacuees. Even the most basic items might soon become scarce, and therefore valuable, if the Germans did arrive. Jersey resident Anthony Faramus—who would later be deported to the concentration camp at Buchenwald—stated in an interview after the war that at the suggestion of the BBC, he and some colleagues sold off the linens and silverware from the hotel where they worked for gold sovereigns. These "minor acts of sabotage" would deprive the Germans if they came. He and his fellow workers would also have money in case times got tough.

Lucy read more about the evacuation in the local newspaper. When she mentioned how one article compared those fleeing the island to rats, Edna chuckled, but Lucy became deeply indignant at the comparison and at the maid's response. Lucy had witnessed firsthand the anguish of so many families deciding whether to go and what they could take with them.

Edna's blithe reaction upset Lucy for another reason too. She hadn't told Edna, but Lucy herself was struggling with and actively considering leaving. There was, of course, a concern for safety, but Lucy also hoped she might be able to somehow join the fight against the occupation, although she had no idea how. She eventually suggested the idea to Suzanne, whose response was typically practical: "You can't do anything. You don't have any qualifications. Do you see yourself as a nurse? Or driving a truck? You would only be a burden, an obstacle."

Maybe staying on Jersey truly was the better option. Lucy realized as much when she saw a car filled with people driving down the road past La Rocquaise. In it was Vera, who was returning to Jersey. She had apparently left for England in such a hurry that she had not even waited to collect a set of false teeth her dentist was making. Once she got to London, Vera told Lucy, she realized that she had nothing to contribute to the war effort and nowhere to go. So she came home.

As people on Jersey prepared for the worst, the stress of not knowing what would happen bore down. Despite her willingness to fight, Lucy's pessimistic disposition often got the better of her, and those feelings, combined with her ill health, repeatedly led to thoughts of suicide. Now a "tidal wave" of despair, as she phrased it, overtook her. She would probably not survive this war, she feared, whether because of the Germans or by her own hand. Suzanne watched Lucy's growing anxiety. But all she could do was provide love and support.

LONDON, UNABLE TO SPARE EQUIPMENT OR MEN to defend the Channel Islands, left Jersey on its own. Winston Churchill argued that it would be "repugnant now to abandon British territory which [had] been in possession of the Crown since the Norman Conquest," but military advisers convinced the prime minister that the islands would require too many resources needed elsewhere, and Churchill eventually conceded. Jerseymen old enough to serve left the island and joined the British military. As the

few British troops who remained on the island were redeployed to fight elsewhere, they cut the underwater telephone cable that stretched back to the mainland, so if the Germans arrived on Jersey, they would not be able to use it.

King George VI sent a message to his loyal subjects: "For strategic reasons it has been found necessary to withdraw the armed forces from the Channel Islands. I deeply regret this necessity and I wish to assure my people in the Islands that in taking this decision my Government has not been unmindful of their position."

Ironically, London argued that the Channel Islands' defenselessness was their last, best hope for defending against the Nazi advance. As a demilitarized zone, the remaining islanders would, presumably, be spared a direct assault. The Germans would have no reason to use force against unarmed civilians. However, the British government did not tell the Germans that the islands had no weapons, either because they refused to admit abandoning them or to avoid tempting the German air force with an easy target.

During the last week of June 1940, islanders heard the humming engines of a Luftwaffe plane—a Dornier Do 17 P light bomber, sometimes called a "flying pencil," with two wing-mounted engines—flying overhead to take reconnaissance photos. This aircraft was the tip of the spear for Operation Green Arrow, the German takeover of the Channel Islands. When the German command developed the images, they saw large vehicles in the fields. These were farm trucks taking part in the tomato and potato harvest, but the analysts mistook them for troop carriers. The "fortifications" they saw in the photos were old castles and towers from the previous century that had no current military purpose.

On the evening of June 28, three Heinkel He 111 bombers—the workhorses of the German air force in the early years of the war—buzzed on a low approach, the sound of their engines getting closer every second. Then explosions shattered the quiet evening. The planes released some 180 bombs on the defenseless populations of the Channel Islands. Scores of buildings caught fire, and people ran for cover. Gunners strafed the capitals of St. Helier on Jersey and St. Peter Port on Guernsey with bullets, leaving holes throughout both towns.

When the aircraft headed off again, residents came out from hiding, scrambling to rescue the wounded and recover the dead. Many moaning

victims lay in the street for a long while until help arrived. With so many men away serving in the British armed forces, there was a shortage of hands to assist. Everyone felt powerless. "There was no air raid warning. Nothing," remembered one angry Jersey resident.

Lucy, Suzanne, and Edna heard the explosions as bombs rained down on the island. When the booming stopped, they ran out into the garden and gazed eastward across the bay toward St. Helier to watch the plumes of smoke rising just a few miles away. There was instant nervous tension. Edna wanted to make phone calls. She was tremendously upset at the sight of the island on fire and needed to find out what was going on and whether friends were all right. Lucy wondered if they should shut off the gas as a precaution.

Back inside the house, they continued to wait for news. Just a few yards to the west of their property sat St. Brelade's Church. Lucy noticed that the rector had planted a white flag in the middle of the cemetery. The notion that the dead needed protection from bombing raids made her laugh to herself. A little while later, a bus stopped near the house. Lucy, Suzanne, and Edna again ran out, this time to talk with the passengers fleeing

View of St. Brelade's Church and cemetery from the garden at La Rocquaise.
COURTESY OF THE JERSEY HERITAGE COLLECTIONS.

St. Helier, who told them of the horrible destruction in the island's capital, including numerous dead and wounded.

Early on July 1, 1940, another German aircraft flew low overhead, again raising everyone's fear level, but this time the plane dropped only an official message at the airport addressed to Jersey officials. The ultimatum gave the island twenty-four hours to surrender or face the threat of further bombing. The Germans instructed Jersey leaders to raise white flags and paint white crosses at specific locations, including at the airport and the harbor to show that they accepted the terms of surrender. In addition, the directive advised the local population to prepare for the arrival of German troops by raising white flags on every building and house. Soon white flags dotted the island landscape.

Then the Germans arrived in person. Another Dornier Do 17 P, its twin tail fins gleaming in the morning sun, landed on Jersey. Oberleutnant Richard Kern climbed confidently down the plane's ladder onto the tarmac in full uniform, revolver in hand. The plane's guns were trained on the airport building, where he met the local man in charge of the airfield. I wish to speak to Herr Governor, Kern announced.

Alexander Coutanche rode to the airport—just down the road from La Rocquaise—along with the attorney general, Charles Duret Aubin, to greet the Germans. Bailiff Coutanche, dressed in a somber black suit and wearing a blank expression, could do nothing but shake Kern's hand and peacefully surrender the island to his control.

Other German troops, dispatched from now-occupied northern France, soon arrived by air, bringing with them light antiaircraft weapons. A young Jersey policeman named Joe Berry received orders to drive a double-decker bus filled with enthusiastic Germans from the airport to the Grand Hotel, where they would be billeted. "They were singing and stamping, you know, full of beans," he recounted in a postwar interview.

A few days later, onlookers wept as a column of German troops marched down King Street, the main commercial thoroughfare in the heart of St. Helier. The German high command posted an entire infantry division, along with technical support from the army, navy, and Luftwaffe, to oversee the Channel Islands. Jersey's first German military commander, Erich Gussek of the 216th Infantry Division, established his headquarters in the town hall. This was not Gussek's first trip to Jersey. He had been held in

German soldiers marching through St. Helier, Jersey. COURTESY OF THE SOCIÉTÉ JERSIAISE PHOTOGRAPHIC ARCHIVE.

the POW camp there during World War I. Don't worry, Gussek assured Jersey leaders. The occupation won't last more than six weeks!

He couldn't have believed his own lie. To accommodate the influx of Germans, Gussek took over hotels as well as the residences of those who had evacuated. All the property inside was for the taking.

Gussek remained on Jersey only for a few weeks. In early August, Feldkommandantur 515 was dispatched from Munich to set up its head-quarters at Victoria College House in St. Helier and oversee, alongside the military forces, the civil administration of Jersey. Civilians in uniform rather than career military made up the bulk of FK515. Lawyers, clerks, and accountants, they would perform the bureaucratic tasks of administration and generate huge quantities of paperwork. "Now the paper war begins," Gussek quipped to Bailiff Coutanche as he departed the island.

In charge of FK515 was Colonel Schumacher, whom historian Michael Ginns describes as "a portly, middle-aged officer who kept in the back-ground and let his staff get on with the day-to-day business of running the island." Schumacher and his men worked alongside the new military

leader, Colonel Rudolf von Schmettow, who arrived as the commander of the British Channel Islands in October 1940. Von Schmettow set up offices in St. Helier and issued guidelines for defending the islands. Eventually, the military would number around ten thousand men in addition to the hundreds of staff of the *Feldkommand*. The Germans crowded together with the locals on the little piece of land that was largely cut off from the Continent.

For Jersey residents, the differences among all these Germans meant very little. Regardless of who was in charge, islanders would still have to cope with life under occupation. For many residents, at least at the beginning, the German presence seemed nothing more than an inconvenience.

Shortly after the Germans arrived, Lucy and Suzanne were walking in front of the St. Brelade's Bay Hotel across from La Rocquaise, a summer breeze blowing off the bay. A group of men stumbled out from an evening's revelry, or perhaps, dismayed by the sorry state of affairs in which they and their fellow islanders now found themselves, they'd been drowning their sorrows in what remained of the island's alcohol supply.

Among the crowd, Lucy was surprised to spot Bob Steel. Even though his parents still lived just down the road, she had not gotten back in touch with him after arriving on Jersey. Perhaps the memory of their youthful flirtation was too awkward all these years later. When Bob saw Lucy, he reached out his arms with emotion heightened both by nostalgia and drink. Will you join us on our stroll? Lucy asked him, and he readily agreed. He lit up a cigarette, and they began to ruminate about their younger days, feeling the years melt away.

The conversation soon turned to the war, but Bob said he didn't want to talk about that. What about your family? How are they? Lucy asked. But Bob didn't want to speak about them either. It seemed he wanted only to dwell on days long gone.

What do you think of the Nazi invasion? she asked, steering the conversation back to pressing matters of the moment. Although the Germans had only just arrived on the island, Lucy was already beginning to think about what she might do to resist now that she and Suzanne had made the deliberate choice to stay rather than to evacuate. Lucy secretly hoped Bob would share her dawning desire to act against the invaders somehow. But instead he replied that the Germans didn't bother him too much. They are

like a big old tree that's hard to chop down, he said jokingly. No matter how hard someone might try to get rid of them, he seemed to be conceding, the Germans were here to stay.

Lucy was crestfallen. "I was shaking with the hope that we could work together, that we could plot together," she wrote years later. This was someone to whom her heart had once felt close, and now she was deeply disappointed when she realized that he had no fighting spirit. So much time had passed since they were young.

The conversation finally turned to more mundane matters. Bob mentioned that he had left his job as a stonemason and was returning to St. Brelade's to fish. Suzanne asked him to bring them some of his catch. Of course, he agreed. A mutual acquaintance joined the conversation. Then it was dinnertime, and they all went their separate ways.

Disgusted, Lucy never wanted to see him again—a response typical of how dismissive she could be. He seemed just like the rest of the people on Jersey when it came to the occupation. She wanted to be different.

Lucy, often so quick to judge, believed the worst about most of her fellow islanders and admitted as much in her postwar notes. Like Bob, the remaining residents were putting all their faith in being rescued by the British, she thought, rather than doing anything about the situation themselves. Worst of all, in Lucy's mind, the islanders called the Germans "visitors," using the same term for the Nazis that they had always used for tourists.

To some extent, Lucy's assessment of the situation was right. In practical terms, the German presence offered Jersey's men and women paying jobs (wages were in occupation marks), which allowed them to buy food and have a semblance of a normal life. Many went along, hoping to survive or even advance their own position. Islanders went to work for the German military in support roles as plumbers, electricians, truck drivers, clothing makers, or cleaners.

Men were needed to repair and expand the airport in preparation for sending planes to the Battle of Britain, which had begun in mid-July, only weeks after the occupation started. Many of the aircraft Jerseymen serviced flew sorties to drop bombs on the very nation to whose monarch all the Channel Islands remained fiercely loyal. The Hague Convention of 1899 protected people in occupied territories from being compelled to perform

work that would aid in attacks against their own country. But the Germans enticed many islanders with money. In other cases, local officials technically employed the laborers but then sent them to the airport to work for the invaders.

Accommodation was part of a larger strategy by Bailiff Coutanche and Jersey officials. They believed they could win the Germans' trust and create a peaceful coexistence so that Jersey could wait out the war in relative comfort while also preserving existing political and legal structures. Jersey's leaders aimed to create a buffer between civilians and the occupation force.

With this strategy in place throughout the Channel Islands, eventually around three-quarters of the population of all the islands were working for the Germans in some way, either directly or indirectly. Many were willing because the occupation forces seemed quite nice—so nice, in fact, that a myth began to circulate that these soldiers had been handpicked for their good looks and gentlemanly manners. More than a few Jersey residents repaid the soldiers' apparent politeness with their own solicitous attitude, frequently socializing with Germans in local venues or attending church services side by side with the very men who also raided their banks to remove deposits of gold and jewelry. Such strapping young men were irresistible to many women on the Channel Islands, and they soon formed romantic relationships, in some cases resulting in children who were caught between two worlds.

With such friendly locals, Germans saw the occupation more like a holiday than a war. One officer told his men that they were entering "a country where milk and honey are flowing day and night." French prostitutes staffed an official brothel at the Maison Victor Hugo, a hotel located in the former home of the famous author. The Germans "were enchanted by the islands' little coves, the steep cliffs covered with wildflowers and the bright blue sea," writes historian Madeline Bunting. "They responded with a touching romanticism, describing in detail the landscape and sunsets in their diaries, in poetry and in paintings." After all, Nazi ideology proclaimed the British as good racial stock and highly civilized, in contrast with the peoples of eastern Europe who were supposedly good only for forced labor or extermination.

Yet such easy relations between the occupiers and the locals looked pleasant just on the surface. The ever-present fear of violence facilitated even

the willing cooperation of the population. German soldiers rarely terrorized people in day-to-day situations, but the unspoken threat always hung in the air. They were, after all, an armed occupation force with complete control over Jersey and the ability to detain anyone for any reason they saw fit. Just because the Germans explicitly preferred a "velvet glove" to hide their iron hand did not mean they were not prepared to use force if necessary.

Soon many residents began to feel like they were living inside a fortress—or a prison—with no way out. New regulations forbade anyone from leaving the island, a measure designed to prevent locals from supplying the British intelligence with information about the nature of the military presence.

The *Jersey Evening Post* published a series of German orders governing life on the island. A curfew was in effect from 11:00 p.m. until 5:00 a.m. Clocks were to be moved one hour ahead to match the time in Berlin. Weapons were to be turned in to the German authorities, and boats were forbidden to leave the harbor without German permission. Cars could no longer be driven for personal use to save gas and prevent any plotting. Radios were to be tuned only to German and German-controlled stations. Banks and shops could open as normal but were not allowed to raise prices. No one could buy, sell, or consume alcohol except for what they already had in their homes. The Germans wanted to keep everyone sober to avoid any fights or mischief. If these and other regulations were obeyed, the occupation forces promised to "respect the population of Jersey." But they warned, "Should anyone attempt to cause the least trouble, serious measures will be taken."

Anyone with knowledge of German was ordered to register with the occupation authority. Suzanne spoke the language fluently thanks to her Alsatian governess, Lotte, who had helped raise her as a child. This woman "had taken charge of me when I was ten months old," she recalled years later, "and given me during eleven years such intelligent and devoted care." Despite the obedience Lotte may have instilled in her young charge, Suzanne now defied the order.

Lucy had been quick to criticize her fellow Jersey residents, and her exchange with Bob had only reinforced her doubt about people's willingness to fight back. However, she did not know the whole story.

In the early days of the occupation, Lucy and Suzanne hunkered down behind the granite walls of La Rocquaise, largely keeping to themselves until they could decide how to respond. Sealing themselves off from others

on the island, however, meant that they could not see how their fellow islanders were beginning to resist. Many just gave Germans the cold shoulder and ignored them; they refused to shake soldiers' hands or would leave the theater when German newsreels started up. One informant told British Military Intelligence (MI-19) about a woman who had answered her door to find a German soldier standing on the other side. Either she could not understand his language or refused to try, so she shut the door in his face. Moments later, she opened the door again, this time with her bucket and scrub brush, and she proceeded to clean the doorstep where he had stood. Some sat by and watched the soldiers with silent disdain or disbelief; others grumbled in private or made insulting comments behind the Germans' backs. Hundreds of individuals and small groups engaged in much more daring acts, including theft, sabotage, black marketeering, hiding contraband, distributing leaflets, deflating tires on German bicycles, trying to escape Jersey by boat (which led to arrest unless passengers drowned), "going slow" at work, and writing anti-Nazi graffiti. The local Jèrriais dialect eluded the soldiers and allowed locals to communicate in secret.

These efforts never culminated in any large underground or organized movement like the French Resistance. Residents realized that they were cut off from the rest of the world and any possibility of help from the outside. With little potential for foreign intervention to aid their cause, an organized fight against the German forces on Jersey seemed out of the question.

Still, approximately four thousand Channel Islanders were sentenced during the occupation for violating German regulations. Few of the offenses were serious—most involved a breach of a specific regulation—and punishments were not severe. But that number represented a cross-section of society, including some of the island's leading citizens, demonstrating that the desired local cooperation was spotty at best. Many people went to jail for a few months for insulting a German officer or other small infraction.

But added up over time, these small acts had a significant effect on the German troops. The soldiers became increasingly paranoid that the Channel Islands were infested with British spies. German commanders believed that should the residents of Jersey not cooperate fully, the Schutzstaffel—more commonly known as the SS—would arrive to take charge.

5

WAR WITHOUT END

DURING THE FIRST WEEKS OF THE OCCUPATION, much of Lucy and
Suzanne's routine—tending their small garden, swimming at the beach,
and listening to the BBC in the evenings—continued as normal. But there
were noticeable changes. Cars driving past La Rocquaise on La Route de
la Baie now used the right side of the road rather than the left. The local
paper the women read, thanks to military censors, now toed a German
line. At least it was useful for learning about the new decrees issued by the
occupation government.

One day as the women looked out an open upstairs window, they saw
a startling sight. On the beach below, a detachment of soldiers patrolled
St. Brelade's Bay where the soft white sand met the water. The men were
likely doing reconnaissance or searching for potential security threats.
Watching the Germans come so close to their home, Lucy and Suzanne
realized just how intimate this occupation would be.

All cameras were supposed to have been surrendered, but they had
refused to give theirs up. It had been such an important part of their lives
for so long. Quietly, Suzanne opened the Kodak and moved it into position.
She stood a few feet back from the open window so that the soldiers would
be unable to see what she was doing. When the shutter clicked, Suzanne
captured an image of the German soldiers on the beach near the waterline;
in the foreground Kid perched on the windowsill basking in the warm sun-
shine. The photo, one of only a few surviving shots they took during the
war years, documents the juxtaposition of domestic bliss with the fear of
an unknown future under Nazi rule.

Soldiers on the beach at St. Brelade's Bay, just outside La Rocquaise. COURTESY OF THE JERSEY HERITAGE COLLECTIONS.

The Germans in the picture were distant, faceless blurs, much as they were viewed by islanders during those first weeks of the occupation. Over time, these men would come more into focus. Officers began lounging on the terrace at their new social club across the street from La Rocquaise, the posh five-story St. Brelade's Bay Hotel. A soldier standing on one of the upper balconies could peer down into Lucy and Suzanne's garden. Sometimes during the night, Lucy and Suzanne heard revolvers firing off a few rounds after the officers had had too much to drink. They would find the bullets in and around La Rocquaise the next day.

The physical nearness of the Germans meant that Lucy and Suzanne always needed to be careful about what they said and to whom, especially since they were keeping so many secrets. If the soldiers found out that Lucy and Suzanne were lovers, the women would come under deep suspicion with unknown consequences. Although Nazis were generally less worried about female same-sex behavior than they were about male homosexuality, lesbians in Hitler's Germany still often found themselves the victims of persecution.

Exactly what Edna knew about their relationship remains a mystery. Undoubtedly, Lucy and Suzanne introduced themselves to her as sisters, or possibly as stepsisters, and Edna had no immediate reason to doubt the

claim. Lucy and Suzanne maintained separate bedrooms. Such an arrangement was not uncommon at the time for wealthier opposite-sex couples with plenty of space. But of course no one would question why the women did this. Lucy's chronic insomnia probably made having her own room a practical consideration so that she could stay up late without disturbing Suzanne. A small connecting passageway linked their bedrooms, permitting easy access. Most nights, Edna was asleep in her room upstairs and would not have heard any movement between the two rooms.

THEIR RELATIONSHIP WAS NOT THEIR ONLY SECRET. According to Jewish tradition, Lucy would not have been considered Jewish because her mother was not a Jew. However, Nazi racial law made no such distinction.

Most of the Channel Island Jews had emigrated during the evacuations. By the end of 1940, official records created by the cooperative Jersey police noted that only twelve Jews remained on the island. As a self-identified atheist, Lucy was not counted among them because she had simply refused to register as such. If the Germans discovered her background, she would be in serious trouble. Within two months of Jersey's occupation, the German regional headquarters in Paris ordered implementation of the Reich's anti-Jewish measures on all the Channel Islands to bring them in line with policies that had been in place in Germany for several years. For any remaining Jews, identity cards were marked with a large red J. Jews were required to wear a yellow Star of David, and soldiers publicly labeled all Jewish businesses. Jews were excluded from public places, and eventually the Germans confiscated Jewish businesses. Over the next few years, the Channel Island Jews would be deported.

Lucy and Suzanne felt safe enough behind the stone walls of La Rocquaise to discuss what might happen in the coming months. Yet it was clear that each had different ideas about how to handle the situation. Suzanne wanted to play it safe and wait out the occupation. She had lost her brother in 1920 following his service in World War I, and she still bore her grief. She was always the one with her feet on the ground, the one who had convinced Lucy to stay on Jersey after the Germans arrived because it was the practical option and because there was really nowhere else to go. She certainly hadn't expected that they would throw themselves into the fray.

Lucy wanted to take some kind of action to build on the political activism they had begun in Paris, but she still did not know what to do. She tried to persuade Suzanne to help her devise a strategy to push back against the occupation. In her reminiscences after the war, Lucy recalled the bitter fight over the issue. "You're free, idiot," Suzanne had bellowed at her in disbelief, reminding her that should they get caught doing something illegal, the punishment was prison or worse. "Where will this all lead? A martyr never meant much, and that's especially so these days. And you won't accomplish anything, sick as you are. . . . Have you forgotten what they are? I don't understand you."

Such words must have stung coming from the most important person in Lucy's life. Perhaps they reminded her of how disappointed she had been with Bob's unwillingness to fight back and of Vera's fatalistic attitude about the occupation. But Suzanne pressed even harder, charging that Lucy wasn't guided by some principle or her faith in humanity but merely wanted to be in the middle of the action. It was almost as though she wanted to hurt Lucy in order to shake her back to reality. "You really miss Paris," she said. "At bottom, isn't that what this is really about?"

In her notes years later, Lucy claimed that she realized just how high the stakes were at that point: "We saw, from the beginning of Hitler's regime, how those who opposed it fared . . . when they escaped . . . our German Jewish friend . . . her husband tortured. . . . We knew, as much as anyone can imagine these things, what the concentration camps were. I knew the risks I would run with Suzanne."

Whether she truly knew what might happen is not clear since so few across Europe were aware of precisely where the German policies and actions were heading. Although Jews had long been victims of systematic violence under the Nazi regime, by 1940 no one had yet planned what Hitler and his men would later call "the Final Solution to the Jewish Question"— what we now call the Holocaust. Prison (or "concentration") camps had been in use for years and were widely known, but the extermination camps in eastern Europe, explicitly designed for the purpose of systematic mass murder, did not yet exist. Whatever she did know at that moment, Lucy certainly appreciated that she was asking Suzanne to take some very serious chances. Suzanne simply wasn't willing to join her in this fight.

The weeks passed, and Suzanne watched from the sidelines, still worried

about the danger Lucy was seeking out. Eventually, though, Suzanne set aside her doubts because she loved Lucy too much. She could no longer ignore Lucy's passion.

"You can't go into this adventure without any plans. I'm here for you," Suzanne finally told Lucy, relenting just as she had about their move to Jersey. She would bring her pragmatism and calm demeanor to their joint efforts, whatever they would be. As in their artistic collaborations, each would complement the other.

THEIR EFFORTS STARTED SMALL. A poster displayed by the Germans reminded islanders that the same command overseeing the Channel Islands had executed a Frenchman in Brittany for sabotage. It made for a tempting target. Looking around to make sure no one was watching, Lucy reached up and tore the poster off the wall, quickly jamming it into her shopping bag. Whenever she and Suzanne walked, they ripped down other similar announcements, tucking them away for some later use. Occasionally they twisted road signs the wrong way to confuse the Germans who were still learning to navigate their way around Jersey.

Lucy's insomnia kept her awake into the early morning hours. She often fantasized about driving German cars over cliffs into the ocean. On one of those sleepless nights, she picked up an old issue of the French satirical magazine *Le crapouillot*, dated January 1931, two years before Hitler came to power. The journal had started during World War I—the title referred to the soldiers' nickname for mortar shells—and it kept alive the spirit of wartime black humor and muckraking born in the trenches and the fields of Flanders. Lucy flipped through the pages of this special issue that focused on events in Germany, and she found more than one essay about the rising Nazi Party.

She stopped at an essay on politics and the danger of war. A photograph of Hitler mockingly captioned "Hitler (the Beautiful)" ran alongside the text. Reading through the article, she discovered a lengthy exchange with one of Hitler's supporters who debated the terms of the Versailles treaty with the interviewer and denounced the postwar reparations scheme. He further argued that France's foreign policy toward Germany placed the Reich in a difficult situation: "This clumsy stubbornness of wanting us to respect the clauses of a treaty imposed by violence will inevitably lead to a

popular uprising in Germany. You are putting us under the obligation of preferring a terror without end (*Schrecken onhe Ende*), to an end with terror! (*Ende mit Schrecken*)."

The last sentence, with the German phrases reprinted alongside the French translation, jumped out at Lucy "as though it were written in italics," she remembered. She put the magazine down and meditated on these words. "Terror without end" seemed to be an accurate description of what they were living through now. The sound of guns firing through the darkness across the road at the hotel made the point even clearer.

Sometime around dawn, she grabbed a pencil and wrote her own version: "Victory? No: War! Without end!" Such a phrase might be useful, she realized. They could scrawl that slogan anywhere, and quickly, reducing the chances of being caught. As a writer, Lucy decided that her best weapon would be words.

On their next walk, Lucy wrote the phrase *OHNE ENDE*, "without end," in capital letters on a cigarette packet she found and then tossed it in a place where a German might pick it up. This is ridiculous, Suzanne said, laughing. And not a very good idea. You'll get in trouble, she warned. On later outings, Lucy scribbled the words on bits of packaging or on pieces of wood that she found as they walked. She alternated between purple and red ink but almost always used capital letters.

As time went on, Suzanne joined in. Since she was a fluent German speaker, she could add other phrases. As both she and Lucy became bolder, they wrote on walls and buildings, always looking over their shoulders and keeping watch for each other. Walking north from La Rocquaise, they passed the airfield. Despite the presence of so many Germans, Lucy and Suzanne graffitied their message there too.

Coupling their efforts with routine errands meant they could always say they were on their way to the market or to the doctor. When Germans approached, they blended back into the crowd, acting as though nothing happened, even as their hearts beat so quickly.

The phrase *ohne Ende* declared a simple truth about the war, which the Germans wanted to obscure. Although Hitler preached that the glory of combat demonstrated Nazi greatness to its fullest, even if victory came, it would lead only to more war, and ordinary soldiers would pay the price. This idea formed the core of Lucy and Suzanne's message to the troops

from then on: because the soldiers could not win but would only die fighting, they should end the war now. The women were appealing directly to the soldiers' self-interest, and in their own language.

In a postwar letter, Lucy described the day that she and Suzanne came upon a photograph in a German magazine that showed a regiment of soldiers on the march. This presented them with a new kind of opportunity. When they got home, they unwrapped the scarves from around their heads, unbuttoned their overcoats, and placed the photo on the table. "The soldiers in the photo are marching vigorously," Lucy wrote. "They're swinging their arms as they move, but their legs are very boring, and their boots are covered in mud. It's as though they are stuck in the mud."

They decided to cut the picture in half, keeping the bottom portion and turning an image of Nazi strength into one of a muddy mess. Then, with red paint, Lucy wrote what she called "our jingle"—*ohne Ende*—across it, rendering the soldiers as endlessly trudging through the muck. Not satisfied, she removed an old photograph she had of Oscar Wilde and his lover, Alfred Douglas, from its cherished frame. She replaced this photo with that of the cropped soldiers and beheld the ironic contrast between the lovely frame and the grimy image it now held.

Edna had heard that the Germans were about to commandeer a nearby abandoned house as sleeping quarters for the soldiers. It was the perfect place to complete the joke, Lucy thought, and that night Suzanne crept inside the dark, empty house and found the perfect spot to bang in a nail. The next day, the light from one of the windows would hit the photograph just right.

The soldiers might not immediately see the image, but when they did, each would likely think that perhaps one of the other men had hung it. Such a thought might sow confusion and mistrust in their ranks, Lucy and Suzanne hoped. A few days later, they went back to the house and found a place where they could discreetly observe the German soldiers. From their nearby hiding place, the women watched the occupiers going in and out of the house, and they couldn't help giggling, not quite believing that they had gotten away with their very serious joke. What did the soldiers inside the house think about the mysterious photograph of endless, meaningless marching? they wondered. Were these men contemplating the thought that Hitler's war would never end?

This little adventure gave the women the taste for doing more with photographs. When they went shopping in St. Helier, Lucy bought copies of the glossy illustrated propaganda magazine, *Signal*. It came in an English version for the civilians, but Lucy chose the German-language edition produced for the troops. They flipped through page after page until something jumped out—an image, a map, some text. Once they had collected enough material, they cut the pages up and put the pieces back together as a photomontage, like the sort Suzanne had made in Paris for Lucy's book. Lucy believed that working with the German words might also help her learn a bit of the language, making it easier to create more slogans or jokes. "The work was long, very bad for my eyes," Lucy remembered about her poor vision. "I could not read with one of them, not even with any kind of glasses."

Once they finished the photomontage, they went back to town and looked for a newsstand. Here, teamwork was essential. Suzanne would pick up a copy of *Signal* and begin leafing through it, acting as though she were simply reading the magazine. Lucy kept an eye on the newsagent and the other customers while also watching for police. There were too many ways to draw suspicion, so the timing of the drop was crucial. When Lucy gave her the sign, Suzanne pulled the photomontage out of her bag, quickly slipped it in between the pages of the magazine, and placed it back on the newsstand. Then they walked away casually, not looking back until they were at a distance.

Sometimes, if they were being watched or if too many other customers were around, they had no choice but to buy the magazine, even though the newsagent might wonder why they were interested in a German-language publication. They would then carry it to the toilet of a nearby cafe. Once behind the locked door, Suzanne put the collage between the pages. Then they left the cafe, went to another newsstand or bookshop, found the stack of identical magazines, and placed their creation underneath several other copies.

ONCE THE GERMAN SOLDIER who later bought that magazine recovered from his surprise, he likely turned it over to the Geheime Feldpolizei (GFP; the secret field police). The GFP was the military's secret police force in German-occupied territories. Although its work was similar in many ways

to that of the more famous Geheime Staatspolizei (secret state police, or Gestapo), it was a separate organization under military command rather than an internal security force. The GFP engaged in counterespionage and counterpropaganda and uncovered possible treason within the German ranks. Officers, often recruited from civilian law enforcement, operated like undercover intelligence-gathering police and spies. Many came from the professional ranks and were recruited because of their language skills or other desirable abilities. In Germany and France, they rooted out resisters and partisans. On the Eastern front, they tortured and executed civilians who collaborated with the Soviets. Later, GFP men were deeply involved in the Holocaust, working with the SS units who rounded up, transported, and murdered Jews, Romani peoples, and others.

When the occupation began, the GFP quickly went to work on Jersey, first taking over the local prison in St. Helier, which was located on the corner of Gloucester and Newgate Streets. Assisted by Jersey police, the Germans now handled all criminal matters, from traffic infractions and property crimes to violations of occupation regulations. The GFP also

HM (His Majesty's) Prison at the corner of Newgate and Gloucester Streets, St. Helier, Jersey. COURTESY OF THE SOCIÉTÉ JERSIAISE PHOTOGRAPHIC ARCHIVE.

kept their eyes open for "political" crimes, especially any actions or words that might undermine German authority, including attempts to escape the island or demoralize the troops.

GFP agents didn't have long to wait before they swung into action against subversive speech. Only a few months after the occupation began, they arrested a young man who worked as a dishwasher in a Jersey hotel for swindling. The military court that convicted him added one full month to his six-month sentence because he was found carrying an anti-German leaflet.

These police agents sometimes dressed in gray field uniforms with dark green collar patches and "GFP" emblazoned in white on the shoulder straps, but they more often wore plain clothes, such as a long overcoat and trilby, in an attempt to blend into civilian populations. Nevertheless, everyone on Jersey soon knew them by sight.

In particular, they recognized Captain Bode, head of the GFP on Jersey throughout the war. Although he rarely dealt with the public directly, instead preferring to unleash his agents, he could not go unnoticed on such a small island. Bode was short with a pudgy face, but his deep-set eyes in the large round head jutting from his collar, along with his stocky frame, somehow made him look powerful. His wrestler-like appearance added to his growing reputation for being dangerous. Bode, often clenching a cigar between his teeth, liked everyone to know how tough he was, even higher-ups in the chain of command. When one of his superiors—who referred to him as "our worthy and much feared chief of the Field Police"—once questioned his judgment, the captain became furious, flying into a rage and referring to mysterious orders from the SS. I am a good Nazi! Bode proudly informed his superior.

Given his unpleasant demeanor, perhaps Bode's preference for remaining in the background was just as well. Regardless, he and his men were so efficient at their jobs that the Gloucester Street prison was quickly filling up with people who had broken curfew or stolen German supplies. To aid in this police work, the Germans issued the Registration and Identification of Person (Jersey) Order, which officially documented the population of the island. Everyone over the age of fourteen was issued an Occupation Registration Card, which served as their identity papers. These small cards, each with a photograph attached, helped the Germans keep track

Chief of the GFP on Jersey, Captain Bode. COURTESY OF IMAGE LIBRARY, THE NATIONAL ARCHIVES.

of civilians and distinguish island natives from immigrants or expatriates living on Jersey.

Bode was also tasked with dealing with any local resistance, detecting foreign spies, and uncovering conspiracies. Anxiety among the German officials ran high, so Bode always had his ear to the ground. Colonel Rudolf von Schmettow, in command of all the Channel Islands, feared that the territory was vulnerable to raids. The British, hoping to reconnoiter and possibly retake the islands they had abandoned earlier in 1940, had already launched several incursions to put the Germans to the test. Von Schmettow beefed up defenses, and soldiers began constructing along the Jersey beaches a series of bunkers and fortresses, most of them containing K331(f) field guns, which fired 10.5 cm shells. These weapons, developed during World War I, were taken from the French army when the Germans occupied northern France in 1940 and transported to Jersey. New antitank gun shelters, air raid shelters, mortar bunkers, and tunnels for storing supplies and protecting troops were reshaping every corner of the island.

YOUNG EDNA WAS POPULAR with the local men, and her boyfriends often came into the kitchen at La Rocquaise, helping themselves to food. Edna made up for it by tending the vegetables and fruit trees in the garden, an

important task given wartime rationing. She was also resourceful. Even with wartime scarcity, if you knew the right people, you could always get a drink, Edna told Suzanne. And Edna always seemed to know the right people.

For Lucy and Suzanne, foraging quickly became an art, especially as GFP agents occasionally searched houses for black-market food. But once, after eating some wild mushrooms, Lucy and Suzanne became sick and quickly realized they had gathered the wrong ones. Edna called the doctor, who purged the toxins from their stomachs.

Tobacco was also in short supply, and the price on the black market kept rising. Edna grew a small tobacco plant in the garden, but it was not enough. Wherever Lucy and Suzanne walked, they scanned the road for cigarette butts and the stubs of cigars smoked by officers, picked them up, and slid them into their pockets. At home, they placed these treasures in the sun to dry out so that they could use the unsmoked tobacco. Pulling apart the dried butts, Suzanne then stuffed the powdery tobacco into her pipe; Lucy preferred to roll a homemade cigarette, crafting a filter out of pleated paper. When they ran out, they made their own "tobacco" out of flowers, plants, and herbs.

After considering several suitors, Edna married George Le Neveu, a fisherman and friend of Bob Steel, and in September 1940 he moved into La Rocquaise. Times were becoming hard for fishermen like George. The Germans had requisitioned the island's boats and regulated fishing so that most of the catch would go to the occupying army. Fortunately, George had other plans. He took a job as a cook at the St. Brelade's Bay Hotel, where the German officers often went to relax. Taking a huge risk, he frequently stole food from the restaurant kitchen and snuck it across the road to La Rocquaise. He also brought information that he happened to overhear.

George wasn't the only workingman struggling to adjust to the occupation. Fishermen, farmhands, handymen, and other laborers, many of them George and Edna's friends, were frequent visitors to La Rocquaise, where Lucy and Suzanne fostered an ongoing hub of activity. Quite a few of the men who gathered in their kitchen worked for the Germans in some capacity—as carpenters, masons, cooks, painters, whatever jobs they could get. Like George, they took chances and pilfered from their military employers. To repay Lucy and Suzanne for their hospitality, visitors often brought gifts, like waste coal to use for fuel, or they arrived with cake, coffee, or

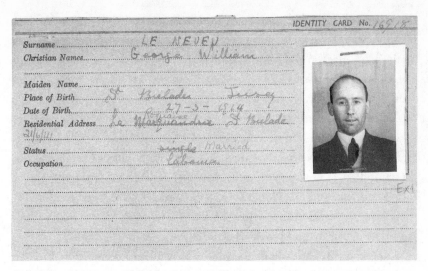

Occupation Registration Card for George William Le Neveu, 1940. COURTESY OF
THE JERSEY HERITAGE COLLECTIONS.

cheese. Someone even gifted them the great prize of a chicken. Lucy and
Suzanne took wicked pleasure in supporting their friends' thieving habits
at the Germans' expense and greatly enjoyed the booty.

Living under occupation was forcing Lucy to overcome her desire for
complete privacy. She and Suzanne had the only telephone in the area, and
people from all along St. Brelade's Bay came to use it. Edna's friends also
dropped by, and in direct violation of occupation regulations, they listened
secretly to the BBC on the radio. Throughout the summer and fall of 1940,
they all paid special attention to coverage of the Battle of Britain and the
start of the infamous Blitz. They heard the reports of Churchill's famous
rousing words to Parliament that August, rallying the British in the face
of an impending German invasion and lauding the men of the Royal Air
Force who fought to defend Britain from the Luftwaffe: "Never in the field
of human conflict was so much owed by so many to so few."

Although they could not have realized it, Lucy and Suzanne's defiant
activities mirrored a grassroots resistance that had emerged to fight the
German occupation in northern France. Frenchwomen, by gearing their
day-to-day domestic activities toward the work of the resistance, became the
crucial support staff for these movements. They supplied food and shelter
and did laundry for the men who were fighting. They stored weapons, tended

the wounded, provided meeting places, and stockpiled supplies. Women secretly swapped information in food queues, bought and sold necessities on the black market, and sometimes openly protested the German presence. Some couriered messages and gathered intelligence as they went about their routines—generally, women were searched less frequently. Professions that by the early twentieth century were largely populated by women provided special opportunities under the cover of their ordinary lives. Secretaries and clerks typed documents, smuggled paper out of offices for making illegal pamphlets or newspapers, and used official paperwork to supply forged ration coupons and false identity papers. Concierges warned residents in their apartment buildings when the police were asking questions. They passed information and provided clandestine shelter.

Lucy and Suzanne's daily lives did not conform to traditional female roles, but they nonetheless provided a similar support network for others. La Rocquaise became a place where Jersey residents from St. Brelade's Bay could meet, and the women shared food and supplies when they could. Their ability to hide in plain sight came in part from the fact that the Germans did not expect women to engage in this kind of activity.

Jersey celebrated the holidays in late 1940 and early 1941 as usual. George had been secretly raising a pig on the property, fattening it up for the first occupation Christmas at La Rocquaise. When he slaughtered it, they shared the pork with friends.

The Germans were celebrating too. One night during the holiday season, long past bedtime, Lucy heard heavy boots thumping up the staircase inside the house. Her heart racing with fear, she got out of bed, hastily dressed, and swung open her bedroom door. In the hallway stood a German. Face-to-face with a soldier in her own home, Lucy screamed for help. Suzanne heard Lucy's panicked cry and ran from her own bedroom, shouting at him in German: What are you doing here? Get out of here!

Fortunately, he was only a drunk from the party at the hotel who had wandered into the house by mistake. With the Germans on the island, they had started locking the doors at night, but earlier this evening, Edna, herself having had too much Christmas cheer, stumbled home to La Rocquaise from a holiday party and left the kitchen door unlocked. After they chased the soldier away, Lucy and Suzanne gave Edna a stern lecture. Her drinking remained a reason not to trust her fully.

6

"NEWS SERVICE" FOR THE GERMANS

DURING THE WINTER OF 1941, Lucy and Suzanne began discussing how to escalate their actions. Lucy told Suzanne that she would like to do something serious, regular, and systematic. She wanted their actions to have a bigger impact.

They considered their options. What if they wrote more complicated and sophisticated notes, addressing them to the soldiers directly? They could type messages and somehow get them to the occupying troops. Maybe they could create posters or newsletters. What about fictional confessions or poems? Or objects? Anything to get the attention of troops. In any form, these messages had to describe the world from a very different point of view than what the soldiers normally heard. Instead of glorifying war as Nazi ideology did, the women would talk about the beauty of peace.

Lucy and Suzanne locked the door, drew the curtains, and pulled their black Underwood typewriter from beneath a rosewood dressing table in Lucy's bedroom. Lucy liked the Underwood because she thought its action was "subtle and precise." She fed several pieces of colored tissue paper with carbon in between through the roller, as many as ten or twelve sheets at a time, pulling them up and snapping the restraining bar across them. She pressed down on the Underwood's round letter keys, the type bars swinging up to tap Suzanne's German words onto paper, but not so loudly as to attract the attention of a passing patrol or a nosy neighbor. Even with so many pieces of paper crammed against the roller, the words were still legible on each copy. Suzanne realized that the Underwood's quotation marks could make an umlaut, the two dots above certain vowels, indicating pronunciation. Sometimes they would retype a document to produce

numerous copies, alternating between two ribbons, one red and green, the other red and black. Suzanne proofread it for errors, perhaps throwing those with syntax or typing mistakes, which might give them away, into the fireplace. For their scheme to work, the notes had to seem as trustworthy and authentic as possible.

If we pretend to be soldiers, Lucy told Suzanne, we could "convince the soldiers (Germans) to turn against their officers (Nazis)." There was a big distinction between the men and their leaders, and she believed that the "real" Germans would not only see sense but would also feel compelled to do something about it. A cast of characters with their own voices and points of view began to emerge from the women's fingertips. Each message tried to convince soldiers to lay down weapons, desert, and go home. A variety of materials might give the impression that there were many note writers at work, so they used cigarette papers and sheets from an old ledger that had belonged to Suzanne's father. They typed on scraps they found around the house or on the island. Each note appeared on a different color of paper depending on its message: red for messages aimed at prisoners on the island, white for "serious texts" or poems, pink for local news or dialogues between soldiers, green for messages about the army, light blue for messages about aviation, dark blue for the navy, a different shade of green for "news and commentary" directed at the army, brown for the military prison, yellow for German news. Applying different amounts of pressure to the keys reinforced the fiction that there was more than one typist, each with his own style. Inventing several authors also created the appearance of a conspiracy within the German military, calling on their brothers to rethink the war effort. Any reader who found such a message and felt the same way would realize he was not alone.

> HITLER leads us. . . .
> GOEBBELS speaks for us. . . .
> GÖRING gorges himself for us. . . .
> LEY drinks for us. . . .
> HIMMLER? . . . Himmler murders for us. . . .
> But nobody dies for us!

Such a message, Lucy and Suzanne believed, would help soldiers reflect on the gap between men on the ground and the elite in Berlin who exploited

them for their own purposes. Maybe it would move a German reader to desertion or sabotage.

Other notes satirized Hitler by claiming he was not interested in his people but only in himself: "Fool! One asks of you just a small thing! That you should die so that the Führer may live a little longer!"

"I wanted to achieve an impression of mystery," Lucy reflected in later years as she looked back on their work, "to give the impression that these manifestos were not created on the island, that they had perhaps been brought from Europe . . . by a soldier on leave . . . by a sailor?" To do so, the two women sprinkled their messages with imaginary secret codes and slogans, handwritten in different colors. Such meaningless annotations might fool the Germans into thinking that Allied or other forces were trying to communicate with the soldiers. They also carefully added designs, patterns, and "typographical montages" to decorate the messages, just as Lucy had done with some of her prewar writing. Unusual spacing and layout of the message made for a strange visual play of letters, words, and symbols on the page. In all cases, these notes were designed to catch the Germans off guard.

Their imaginary conspiracy soon became international. Lucy and Suzanne identified words or phrases from publications in other languages, including a journal with a side-by-side Czech-to-French translation, which they cobbled together into a new document. Once they typed the message in makeshift Czech, they rerolled the paper through the machine and used various characters to create diacritical markings. To make the accents look right, they sometimes inserted the paper upside down. When finished, the Germans might think that the author was attempting to reach a Czech audience or perhaps might even be a secret agent trying to make contact.

Such an effort was all consuming. "I did not write 'for myself' during the war from the time that our wartime activity was in full swing," Lucy remembered. The task at hand was too important.

As with Lucy and Suzanne's personal relationship, just how much Edna and George knew about the notes is unknown. Lucy and Suzanne would later remark that they only worked alone and never wanted to endanger anyone else. La Rocquaise was a sizable house, so it is certainly possible that Edna and George never heard the frequent sound of the typewriter from their upstairs bedroom, or if they did, Lucy perhaps reminded them

that she was an author. Even if they found one of the notes, Edna couldn't read German, and George's German-language skills were likely limited to a smattering of phrases that allowed him to do his work in the officers' social club.

According to Lucy and Suzanne's postwar reminiscences, only Vera knew their secret.

DESPITE HER NATURAL CAUTION AND EARLIER ATTEMPTS to stop Lucy from taking such risks, Suzanne quickly honed her skills at making drops. Strolling through the streets of St. Helier, the women sized up their targets, and once they had one in their sights, they drew alongside him. Suzanne inched a hand into her pocket, past the bottle of Gardenal, and took out one of the pieces of paper. Reaching out toward the soldier, she gingerly placed it into the pocket of his gray tunic. A stumble or slight bump could easily lead to an arrest. With the note secure in the soldier's coat pocket, they moved away quickly into the crowd unseen. Suzanne called this their "news service" for the Germans.

Suzanne undertook most of the missions—slipping notes inside a German helmet, boot, or even a briefcase. When they walked past a cafe that soldiers frequented, she would place a letter, with a deft sleight of hand, onto one of the tables. She kept her normal pace as she walked away, then blended into the crowded street while breathing a sigh of relief. Lucy marveled at how Suzanne managed to look completely innocent and calm while carrying out these jobs.

When the unsuspecting German soldier thrust a hand inside his pocket, he discovered a small colorful piece of paper that he didn't remember putting there. Reading the message in his own language, he was surely confused. "Down with Hitler! Down with the non-German vampire who guzzles the blood of our young people! Down with war!" one message read. Who could have put something so dangerous on his person? If his superiors discovered this note in his possession, he could be imprisoned or executed. He was probably quick to shove the message down into the deepest part of his pocket or destroy it so that no one else could see the damning words.

Or perhaps the soldier would turn it over to Captain Bode, who had begun collecting these slips of paper. Bode ordered his GFP agents to catalog each piece with the exact date, time, and location where they

discovered it. Many of the notes started coming in from the most unexpected places around the island. One, containing a snippet of dialogue, was found attached to a fence post. They discovered a sick joke on a cafe table. Someone discovered a photomontage inside a magazine. Here was a bawdy song insulting German women, and here was a poem making terrible fun of Hitler and other leaders. Some notes called for an outright mutiny. Others featured satirical drawings with funny captions.

From Bode's perspective, the authors of these notes must have appeared to be disgruntled Germans who hated the occupation on Jersey and prayed for the defeat of their own army. They didn't seem to believe the Nazi rhetoric that warfare was a magnificent endeavor. The messages showed a creative flair, and their dark humor might have made Bode chuckle had the circumstances been different. Because the notes frequently included "please distribute" or "please pass on" instructions, the Germans must have assumed that whoever read these papers would want to share them with others who might also be receptive to such defeatist ideas. Did the writers know something about how the troops were feeling that Bode didn't?

Then again, although the notes were written in German, sometimes the grammar or wording was not quite right. German-speaking civilians on this English-speaking island were supposed to have registered with the authorities. Was the author really a German after all? Bode must have wondered as he puffed on a cigar.

THE TYPEWRITER WASN'T THE ONLY ADVANTAGE Lucy and Suzanne possessed. In the quiet of their home, they still listened to the radio in their living room. Lucy moaned that Radio Paris was not worth much since it had become part of the German propaganda machine. Suzanne kept turning the dial until she reached the forbidden BBC broadcast directly from England, only ninety miles to the north. Even though it gave a biased version of events favorable to the Allies, the women trusted the station. The London broadcasts created for Channel Island audiences were designed to keep up morale and let islanders know how some of the evacuees were faring. Messages broadcast from Britain by the Free French—the troops and the London-based government-in-exile led by Charles de Gaulle, which supported the French Resistance—provided listeners with a measure of comfort by giving voice to their compatriots.

Lucy and Suzanne did not realize, however, that a deeply ingrained anti-Semitism among the leadership of the BBC meant that listeners were not getting much news about growing Nazi racial violence on the Continent. BBC producers actively avoided the subject when they could, believing that most Britons were not interested in such details, since saving Jewish lives was not one of Britain's war aims. One senior BBC executive said of covering the full extent of what the German army was doing: "What is the point in piling atrocity on atrocity? To me they cease to have any meaning, and I understood that the Ministry of Information had reported that atrocity stories were quite definitely not believed by the British public."

Nevertheless, the radio helped Lucy and Suzanne imagine themselves as part of a bigger fight, and it provided raw material for some of their notes. When they started spreading simple summaries of various battles that they heard on the BBC and then translated into German, they were openly defying occupation authorities who worked hard to limit the amount of information coming from sources other than the German military.

From time to time during the first year of the occupation, the Germans banned radios, but for the moment, they remained legal. Just to be safe, though, Lucy and Suzanne hid theirs. Their doctor remembered that they put it inside a large ottoman in the living room. The hinged lid could be closed and covered with cushions. Sometimes they lifted it out to listen. Other times, Lucy would rest on the ottoman but leave the activated radio in its hiding place. The colorful cushions on top of the ottoman muffled the sound.

Rounding out their tool kit were some military binoculars and two revolvers that they had inherited from Lucy's father, although they had bullets only for one. Lucy wanted to try them out.

Testing the guns is too much trouble, Suzanne protested. Besides, it's dangerous. If the police find out we have a weapon, they will surely arrest us, she warned.

But Lucy once again persuaded Suzanne to go along. They went for a walk to the top of a cliff along St. Brelade's Bay, which looked out over the English Channel. Lucy placed a target against a rock and walked back several paces. She raised the gun and took aim as best as she could. When

she pulled the trigger, the sound echoed across the bay. With any luck, the German soldiers didn't hear it, or if they did, they might think it was one of their own. The weapon had worked, and Lucy was satisfied.

With the gun still in her hand, she harbored a secret thought about what might happen if the Germans discovered their notes: "If necessary, we can kill ourselves with one shot to the roof of the mouth, the quickest and surest way."

7

THE INDIRECT EFFECT

"WORKERS! FELLOW SOLDIERS! COMRADES!" exhorted the voice of a German soldier through Lucy and Suzanne's fingertips as they pressed down on the Underwood's letters. "Do not wait until the flames of hell have burnt our houses to ashes! Slow down your machines. . . . Tamper with them in a clandestine manner. . . . PUT a STOP to them . . . if you want to put a stop to the war!"

By mimicking the tone of a revolutionary manifesto or an impassioned rallying cry, the women hoped to jolt their readers into action. Their use of "workers" conjured the language of class conflict. It appealed to soldiers toiling away at their jobs, those who had more in common with one another than with Hitler or military leaders. The grunts—the workingmen of combat—would pay the price for this war. Yet they had it in their power to stop what was happening through a rebellion or sabotage. The note ended, as their communications often did, with a request for solidarity: "Please distribute."

Such a message also appealed to feelings about home. You should think about what is happening back in Germany, Lucy and Suzanne told their readers through the voice of their fictional author. Don't believe the official line. Your homes are burning; they are being destroyed in the flames of battle while you are somewhere else.

More than one of their communications began with the phrase "sinister laughter," a kind of opening stage direction that set a scene's tone of dark humor. Notes with this title always repeated the same bit of dialogue:

—Why is Erich not allowed to go on leave?

—He does not know yet that his house has burnt down, that his children are dead. And our merciful masters want to go easy on him.

Life on the front was "easier," the note told its readers, because there a soldier like Erich wouldn't have to know the truth about the death of his children and the destruction of his house. The punch line of the message's black comedy revolved around the phrase "merciful masters." True mercy would not detain Erich on the front, but no one should expect such kindness from Hitler's army. According to Lucy and Suzanne, keeping Erich away from the disaster back in Germany was the twisted Nazi version of compassion. It reinforced their idea of the never-ending war.

By talking about home, Lucy and Suzanne exposed a deep-seated tension within Nazism. Hitler and his cronies preached that German males were conquering heroes and breeders of a so-called master race. At the same time, the vision of the traditional, respectable family man who provided for his wife and children was a powerful ideal in both German culture and Nazi rhetoric. Lucy and Suzanne were arguing that real men were peacemakers and protectors, not warriors. You should be at home defending

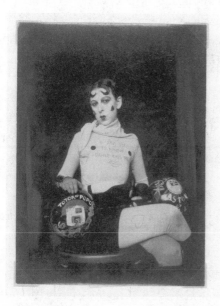

Lucy (as Claude Cahun) dressed as a strongman, ca. 1927. COURTESY OF THE JERSEY HERITAGE COLLECTIONS.

your family, not here on Jersey, they asserted. Only by performing the role of a German soldier could two Frenchwomen point out the paradox at the heart of Nazism's toxic masculinity in a way that might have a real impact.

Gender-based humor like this had long been part of Lucy and Suzanne's repertoire. Back in Paris in 1927, Lucy (in her Claude Cahun persona) donned a white full bodysuit with black shorts and a large white belt. A scarf circled her neck, and black dots were glued to her chest over her nipples. On her face and her thighs were painted hearts. She powdered her face and covered her lips with dark lipstick. The curl in her slicked-back hair added a feminine touch to the short masculine style.

The chest of the bodysuit read in all capital letters, "I AM IN TRAINING. DON'T KISS ME." Underneath this English text, a pair of lips joined with the false nipples to form a face speaking the phrase. Cahun was playing the role of a cartoonish strongman or a weight lifter. Creating a series of photographs, Suzanne (as Marcel Moore) snapped the shutter time and again as Cahun changed her pose.

Boyish and girlish all at once, the images struck a comic tone. The curious outfit, the slightly coy look on her face, and the strange sexuality of a full bodysuit with nipples all made the viewer want to laugh. By dressing Cahun as a weight lifter, the women mocked the idea of manly strength. They also turned the notion of "training" on its head. Cahun was clearly not learning to do anything athletic; she was merely imitating a manly activity. She either was a woman "training" to be a man or a man "training" to be a woman, but her character in the photograph hadn't quite gotten it "right" yet.

Now, during the war, and still playing with gender expectations, the women targeted Hitler as the subject of their humor. "Die Lorelei," written by Heinrich Heine in 1824, was one of Germany's most famous poems. It was a Romantic-era classic based on a much older folktale, which was eventually turned into a popular song. "Die Lorelei" was so much a part of German culture that when the Nazis tried to ban it because Heine was Jewish, people continued singing it anyway. The official response was to allow the song but to "forget" who had written it. Every soldier on Jersey would have known it.

In the original poem, a golden-haired siren sits atop a famous promontory on the banks of the Rhine River. Her singing casts such a deep

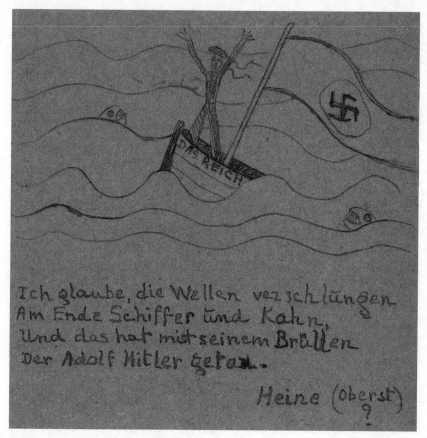

Lucy and Suzanne's version of "Die Lorelei." COURTESY OF THE JERSEY HERITAGE COLLECTIONS.

spell over the men sailing below that they look up to see her rather than paying attention to the course of their boats amid the dangerous rocks around them. The distraction of her beautiful voice costs the sailors their lives when they crash and sink beneath the water's surface.

Many other authors had spoofed or rewritten "Die Lorelei" over the years. Now it was Lucy and Suzanne's turn. They produced their own version of the last stanza and made Hitler the butt of the joke:

> I believe in the end the waves
> Devoured both sailor and boat
> And that was brought about
> By Adolf Hitler with his screaming.

In these few lines, they put Hitler in place of a seductive river goddess, emasculating him in the process. Rather than singing, he screeched at the passing sailors. Through their parody, Lucy and Suzanne unmasked Hitler's real purpose: luring German sailors and soldiers to their deaths, not for a beautiful song but for a rant.

Dark and satirical humor is common among soldiers during wartime, since jokes can sometimes ease the pain and anguish of war when little else can. This type of comedy became a recurring element in many of Lucy and Suzanne's notes. It was another way they worked to connect with the soldiers.

"Against the Waffen-SS : : the Waffen-oo," they wrote. In Germany, toilets found near the stairwell or the elevator in nineteenth-century hotels were often designated with two zeroes so that room numbering could follow. "Waffen-oo" suggested that to counter the Waffen-SS (the armed section of the SS, which engaged in combat), a more powerful weapon—the toilet—was needed to flush the SS away. The British had long used toilet humor against the Germans, including the slang *jerry*, a term often used for chamber pots, which (when capitalized) they applied to German soldiers during World War I, since their helmets were similarly shaped. The term easily carried over to the invaders on Jersey. Another note called on the "Waffen-oo" as a revolutionary force: "OUR REVOLUTION SHALL BE UNDERTAKEN NOT BY ONE . . . BUT BY ALL. Organize the Waffen-oo."

To sound like German soldiers, Lucy and Suzanne needed to use the language of the Nazis themselves, but they also turned that language back on itself in a funny way.

"Strength through Joy" was a recreation and travel service designed to gain the German people's loyalty by offering them cheap vacations while also organizing the vacationers' free time to suit Nazi ideology. Now that the war had come, the idea of feeling joyful was something of a tragic joke, and Lucy and Suzanne used that disillusion to their advantage. They twisted the phrase "Strength through Joy" and put the words into Joseph Goebbels's mouth:

GOEBBELS: No! Now we want to say: . . . joy through . . . despair.
STRENGTH through DESPAIR
STRENGTH THROUGH DESPAIR . . .
Call it quits! Call it quits! Call it quits!

They also parodied, with biting satire, the notion of struggle, which Hitler had made famous in his biography *Mein Kampf* (My struggle):

VICTORY and STRUGGLE, STRUGGLE, struggle, STRUGGLE,
STRUGGLE, STRUGGLE, STRUGGLE, STRUGGLE,
STRUGGLE, STRUGGLE, STRUGGLE, STRUGGLE,
STRUGGLE, STRUGGLE, STRUGGLE, STRUGGLE,
STRUGGLESTRUGGLESTRUGGLESTRUGGLESTRUGGLE
STRUGGLESTRUGGLEANDSTRUGGLEand pff, ppfff, pff.

In German, "pff, ppfff, pff" stands in for the sound of air escaping or of something deflating, giving the sense that all this talk of struggle was merely hot air—especially since "pf" is the last syllable of *Kampf.*

LUCY AND SUZANNE HAND-DELIVERED multiple copies of messages like these throughout the island, traveling on foot or by bus, sometimes disembarking earlier than their destination so they could walk a while and plant their colorful missives along the way. They stuffed them into abandoned cigarette packets, dropped them inside churches, tucked them on the windshields of parked cars, and jammed them into mailboxes. They always made sure to bring the blue bottle with Gardenal.

They also began using a technique they had watched their surrealist friends employ in Paris: they typed short slogans on gummed paper—"butterflies," André Breton and his friends had called them—and stuck them wherever they went. Along the roadside, they also hung their papers on the barbed wire the Germans had installed.

Back in Paris, amid the political tumult of the 1930s, Lucy, Suzanne, Breton, and others had engaged in lengthy conversations about how artists could effectively address the issues of their day. Could an artist really make a difference and change people's minds? Could "butterflies" make a difference?

In 1934, Lucy—writing as Claude Cahun—staked out her own position in an essay titled *Les paris sont ouverts* (often translated as "all bets are off" but with a meaning closer to "it's anybody's guess"). There, she laid out her theory of "indirect action."

Art that tried to be revolutionary on its surface—in other words, propaganda—didn't work, she claimed, and was a waste of effort since no artist

could guarantee a particular outcome. But a poem, story, or photograph could have a profound psychological effect on its audience, because it could change how people looked at the world, provoking them to think. The message could then burrow inside their minds and germinate into a new perspective. The result would be revolutionary. She called it the "indirect effect."

Breton loved the essay, repeatedly praising Lucy's work and ideas as "conclusions that for a long time will be the most valid." But the war put Lucy's ideas to the test. Now the fight was not abstract or hypothetical, but real and present.

The notes that she and Suzanne wrote were far more forceful than her theory seemed to imply. They were clear condemnations of Nazi values, actions, and leaders, not subtle suggestions. However, they still followed Lucy's logic of the indirect effect. Their artistic acts of psychological warfare were creative expressions—poems, songs, drawings, dialogue, provocative but cryptic phrases—designed to linger in readers' consciousness, causing them to meditate on larger questions and provoking them to reflect on why they were really on Jersey. They were a bottom-up effort to win the hearts and minds of German soldiers one at a time.

Unfortunately, Lucy and Suzanne had no way of knowing whether the notes were working. They could hardly walk up to a soldier and ask if he had read one of their messages. By mid-1941, after several months of distributing their missives, the Germans certainly hadn't packed up and gone home. The women could only continue their work in secret, not knowing whether they were merely yelling into the void. There were certainly no public signs that German morale was flagging.

In late June 1941, Operation Barbarossa took the German army into Russian territory. A few days later, the soldiers on Jersey celebrated the first anniversary of the Channel Islands occupation. A German newspaper noted how fearful island residents had initially been, but now, the writer concluded, "one can only hear the greatest praise of the Germans' conduct." He believed that the German army was "caring" for island residents. Residents of the Channel Islands would surely have begged to differ with the author's assessment, especially since supplies were running low and rations growing smaller. The propaganda that cast the occupation as benevolent care came alongside overt attempts at racial indoctrination. The

infamous film *Jud Süss*, now considered to be one of the most anti-Semitic films of all time, was playing to audiences at West's Cinema in St. Helier.

One day, Lucy and Suzanne ambled along the island's shoreline. From their shopping bag, Suzanne pulled out a green champagne bottle, one that perhaps George had stolen from the hotel where he worked. She uncorked the bottle and poured out the contents, then rolled a note into a tight twist and pushed it into the narrow neck, shoving it all the way down. The message told of the successes in the French Resistance, which they had recently learned about from the BBC. It also included some lines of a fake code. If the Germans eventually found the bottle, they might waste their time trying to decipher the code rather than doing other police work on the island. Careful to make sure no one was watching, Suzanne threw it out as far as she could into the bay, now at high tide.

8

THE SOLDIER WITH NO NAME

ALTHOUGH LUCY AND SUZANNE did not necessarily know, they surely suspected that the GFP was aware of their notes. Agents brought more and more of them to Captain Bode's office, which he added to a rapidly growing file. Bode also knew that there were many people on the island writing similar messages. Although Lucy and Suzanne worked alone, they probably took inspiration from other leaflets they saw once the occupation started. Homemade English-language bulletins of BBC news reports passed quietly from hand to hand throughout the Channel Islands. Two Jersey brothers produced a clandestine newsletter titled "The Bulletin of British Patriots," which they inserted into doors or left lying around for locals to find.

Throughout occupied Europe and in Germany, members of resistance movements knew that the written word was essential to the fight against Hitler. Jewish groups maintained underground newspapers to sustain their communities, including forty-seven such periodicals in Nazi-controlled Warsaw.

In occupied France, several groups created secret publications, printed leaflets and flyers, and pasted small pieces of paper with slogans to walls or lampposts or in urinals. Their posters rallied French citizens, encouraging them to fight the German invaders. Agnès Humbert belonged to a group of intellectuals working in a Parisian museum. In addition to helping British soldiers escape France and passing on intelligence to the Allies, Humbert and her colleagues wrote pamphlets and notes, often with information garnered from the BBC, leaving them in cafes and public toilets throughout Paris. This group went on to join with others and create an underground newspaper, *Résistance*, which Humbert typed and carried through the streets

of the occupied capital in a briefcase. When the Gestapo arrested a betrayed Humbert and others in 1941, they put her in a forced labor camp for years. Though she survived the war, many of her compatriots lost their lives.

Within Germany itself, resisters were also fighting back in print. In 1942, the Germans executed a seventy-three-year-old man for inking "Hitler must be killed to end the war" on a wall in a public toilet. In 1942–43, a group of German students calling themselves the White Rose scrawled graffiti and left leaflets in phone books or sent them through the mail to inspire domestic opposition. Their actions created such a serious uproar that Hitler dispatched the Gestapo to search for them through the streets of Munich, whose city walls were plastered with their slogans, such as "Freedom" and "Down with Hitler." The Nazis executed the students in February 1943.

For nearly three years, a working-class couple, Elise and Otto Hampel, conducted a secret campaign in which they wrote hundreds of postcards, then dispersed them throughout Berlin for others to find. The Hampels created so many cards and were so good at distributing them that the panicked Gestapo believed that a significant clandestine resistance movement was at work in the capital of the Nazi empire. For their crimes, the Hampels were beheaded.

Welcher Mann hat das Recht ein Volk zu opfern um eine Regierung zu retten ?

Die Revolution in Deutschland ? - Gewiss. Und je laenger der Krieg, desto laenger und verwirrter die unausweichliche Revolution, desto schlimmer die Leiden unserer Frauen und Kinder.

Also sprach der Soldat ohne Namen.

One of Lucy and Suzanne's notes. "Who has the right to sacrifice a people in order to save a government? . . . And the longer the war, the longer and more confused the inescapable revolution, the worse the sorrows of our women and children. Thus says the soldier with no name." COURTESY OF THE JERSEY HERITAGE COLLECTIONS.

According to sociologist Jacques Semelin, who has studied popular resistance against German conquest, most note writers in occupied territories targeted civilians. The goal of these authors was to keep up morale. They knew they did not have the power to force out the invaders, so they fought back by trying to drive a wedge between the Nazis and the occupied population.

By contrast, Lucy and Suzanne did not address the residents of Jersey, nor did they even write in English. Instead, they spoke directly to the soldiers themselves, appealing to them in their native language as good German men. They hoped to divide the soldiers from their leaders so that the rank and file would desert or even mutiny.

NOT ONLY WAS BODE UNABLE TO PREVENT MESSAGES from circulating, whether written by Lucy and Suzanne or by others, but he also could not keep islanders from secretly listening to the BBC. In the late spring and early summer of 1941, the opening notes of Beethoven's Fifth Symphony coming over the radio made Lucy and Suzanne stop what they were doing. The familiar music, with its quick and forceful sound, meant one of their favorite programs was under way. They heard the firm, smooth voice and posh accent of Douglas Ritchie, known by his on-air alias, Colonel Britton. He taught his audience living in occupied territories a new way to fight back against the Germans. He had chosen Beethoven's Fifth for his program because the roman numeral for 5 is rendered as a V. Lucy and Suzanne paid careful attention as Ritchie instructed them how to greet one another by knocking the letter V in Morse code—dot, dot, dot, dash—which also replicated Beethoven's opening notes. He encouraged them to paint the letter V in public places and to slow down the pace of their work in order to undermine the German war effort. Soon the V sign was everywhere.

"All over Europe, the V sign is seen by the Germans," Ritchie informed listeners, "and it's beginning to play on their nerves. They see it chalked on the pavements, penciled on posters, scratched on the mudguards of German cars. Men salute each other with a V sign, separating their fingers."

Ritchie's "V for Victory" campaign stirred up a popular resistance across the occupied parts of Europe. When people behind enemy lines participate in the effort, Ritchie told the audience, they "create a frame of mind in which our listeners will feel themselves part of a great army."

The V for Victory campaign was a kind of psychological warfare aimed at both the occupied and the occupier. The V sign gave the civilian population a sense of comfort and a belief that everyone was in the struggle together, and it provided people with a specific action they could take to fight back. When people on Jersey chalked the bicycle seats of German soldiers with the symbol or pinned a V-shaped badge made from an old penny underneath their lapel, they felt they were taking a stand. It also made them coconspirators in a coordinated effort. Ritchie told his listeners that the campaign proceeded "in the hope of making their [the Germans'] flesh creep." With so many V signs in view, the Germans might believe that an entire occupied population was against them.

On Jersey, the GFP considered the V sign not merely graffiti but a defiant expression of anti-German sentiment. To Captain Bode and his agents, this campaign was no small matter because it showed just how powerful the BBC was at getting through. These broadcasts, they feared, might be helping organize a resistance movement despite the day-to-day seeming cooperation of Jersey residents. The success of the V for Victory campaign revealed a deep and ongoing resentment of the Germans on the island. As a result, the GFP increased its countermeasures. Agents began scouring the Channel Islands for those responsible for the V signs, even visiting schools to warn children against participating in such foolish and dangerous efforts.

The lone voice of Colonel Britton inspiring listeners living in the wilderness of occupation now gave the women a new idea. Beginning sometime in mid-1941, they melded their many mythical authors into a single aggrieved soldier and gave him an identity with his own signature. Deciding on the moniker wasn't easy. Suzanne thought Namenlos would be the most correct. Fluent in German, she pointed out that it translated as "Nameless" or "Anonymous." But Lucy countered with her own preference: Der Soldat ohne Namen—the Soldier with No Name. The word *ohne*, because it connected with the earlier phrase they had spread across the island—*ohne Ende*—and served like a distinctive brand. They debated back and forth but ultimately went with Lucy's suggestion. As long as the reader believed that another angry grunt suffering through the same war as everyone else had written the note, then the signature would have done its job.

The persona of their singular Soldier would not be a generic German but a specific, if still anonymous, frustrated man. He was distinct, but he

could be anyone. In essence, the Soldier with No Name was an "unknown soldier." After World War I, tombs to unknown soldiers became sites of tremendous national emotion across Europe, especially in Germany, condensing the horror of the war experience into the fallen body of one comrade who stood in for all the rest.

In a postwar letter, Lucy expounded on her "relationship" with the Soldier: "I wanted not only to give to this Soldier with No Name, which at the beginning I identified with (and me with him as far as I could 'see' him), a fictional existence, I wanted to give him a real existence, to bring him to life—and to erase myself, to hand myself off to him. He was better qualified than I was at knowing what to say."

In other writings after the war, Lucy expressed that same fantasy of fully assuming the identity of the Soldier with No Name—of somehow becoming him—so that she could leave Jersey and head for the Continent. Although she realized that such a voyage under a masculine alter ego was not truly possible, she continued to think about the prospect of escape. One dream, she recounted, was "to pass into France and then head for England." Another was "to disappear into a camp of deported nonpolitical Jersey residents and . . . to hope for an opportunity to act along with those people with whom [she] finally felt a solidarity."

Creating new identities was common among those involved in resistance movements during World War II. Many in the French Resistance, for example, took on noms de guerre, along with false papers, new hairstyles, and new clothing, in order to disappear. "To enter into resistance," historian Robert Gildea writes, "meant not only taking on a new character and new role but entering into a world of shadows behind the real world," complete with drama, danger, and the kind of intrigue one might find in a mystery film. Some assumed new names when carrying intelligence, conducting sabotage, or communicating with Allied forces from the occupied zone. For Jews, a new, false identity could mean finding the path from death to life.

Women who belonged to secret resistance cells took masculine names to fit in with their fellow fighters, while men wrapped themselves in the relative protection of women's clothing to conduct secret activities. Historian Paula Schwartz points out that there were many cases of "gender scrambling," in which men and women took "intentionally ambiguous" names for their wartime activities, including "Claude."

WRITING IN GERMAN and posing as a male soldier not only masked Lucy and Suzanne's involvement, but it also provided another instance of crossing gender lines. In Paris, Lucy as Claude Cahun and Suzanne as Marcel Moore were always, to some extent, performing. Given her fluid self-presentation, Lucy knowingly acted out numerous personae as Cahun, with Suzanne/Moore as her audience. In their work together, especially with their camera, they raised questions about sexuality, with Lucy sometimes appearing to be without gender and, at other times, a masculine/feminine hybrid.

Pushing beyond these traditional boundaries was something Lucy and Suzanne had both been interested in for some time. When she was seven or eight, Lucy became fascinated with her father's neckties, which she called "black butterflies." Suzanne's turn-of-the-century early fashion illustrations routinely depicted women wearing trousers, foreshadowing a "boyish" look, which would soon become all the rage.

By the early 1900s, new leisure activities like bicycling and boating allowed women to choose looser-fitting clothes. Jackets, ties, and trousers were all acceptable options for a weekend outing. After World War I, women embraced less form-fitting clothing and shorter, more "mannish" hairstyles as a further freedom from the fussy constraints of corsets and long hair. Postwar designers such as Coco Chanel created fashions made of softer fabrics, like jersey cotton, that deemphasized the female figure.

By the time they got to Paris, Lucy's mix of men's and women's clothing helped create her own signature style. One night, she might don an evening dress with heavy pleats, and on another outing she might reveal a star-studded jacket with a shirt and tie. She accessorized with a muslin veil and a gray felt hat. Sometimes she paired expensive high heels with thick velvet pants. In colder weather, she preferred the large Burberry coat, which would eventually make its way to Jersey.

Wearing men's clothing actually posed a risk. Although same-sex behavior was legal, beginning in 1800 French law forbade women from wearing men's apparel without a permit from local police. Yet cross-dressing was part of the avant-garde world. Author George Sand and painter Rosa Bonheur dressed in men's clothes throughout the 1800s. At the turn of the century, actress Sarah Bernhardt—some of whose most important roles were as male characters—inspired daring women to refuse women's

fashion. American expatriate artists Gertrude Stein and Romaine Brooks sported masculine attire too.

Some men also crossed clothing gender lines. Marcel Duchamp, France's best-known artistic rule breaker of the early twentieth century, was photographed numerous times dressed as his feminine alter ego, Rrose Sélavy, and he painted a mustache and goatee on a copy of the *Mona Lisa*. Each year, Parisian art students wore opposite-gender clothes at their infamous dance party, the Bal des Quatz'Arts, then spilled out into the city's streets to strip nude. The Magic-City amusement park hosted Mardi Gras and mid-Lenten balls, which men attended in extravagant drag.

Lucy embraced the masculine look, laughingly revealing in her book *Disavowals*, "Instinctively I looked for the buttons of my 'fly' on the right (men's side), but the tailor (you have to tell them everything!) had sewed them on the left for me." She also began to dye her hair, eyebrows, and eyelashes pink, and she used metallic powder to turn them gold or silver, fashion statements that had become popular with many daring women by the 1910s. Many years later, the surrealist writer Henri Pastoureau linked Lucy's appearance in her Paris days with her sexual identity, noting that she "fully asserted her desire to be different, with her shaved and golden skull. She announced her homosexuality and lived with Suzanne Malherbe."

In what has now become their most famous photograph, made in 1928, Lucy (as Claude Cahun) appears with hair clipped short and shimmering with metallic powder. Her face is bronzed with theatrical paint, and she wears a long checkered coat, which she holds shut to hide her body completely. The coat's diamond checkered pattern is reminiscent of the coat of the harlequin, the famous male comic character from Italian commedia dell'arte, a witty but also buffoonish trickster famous for his acrobatic physicality. Though Italian in origin, the harlequin had a long association with French theater and art, and numerous artists painted harlequins, including Edgar Degas, Paul Cezanne, and the Spaniard Pablo Picasso, who lived in France.

Picasso also linked the harlequin both with his own art movement, cubism, and with the invention of camouflage during World War I. French artists were deeply involved in the war effort, painting camouflage on tanks, guns, vehicles, and soldiers' battlefield outfits. The goal of camouflage was to break up the enemy's field of vision through abstract designs, confusing

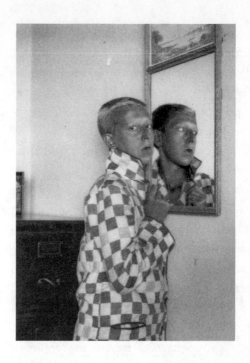

Lucy (as Claude Cahun) in the harlequin coat, 1928. COURTESY OF THE JERSEY HERITAGE COLLECTIONS.

his eye so that he could not see what was really there. It was a sophisticated form of visual trickery and deception.

Similarly, cubist painters broke apart figures and bodies into their geometric components, and Picasso pointed out what he saw as the similarity between cubism and camouflage, at least on the surface. According to Gertrude Stein, when Picasso saw a camouflaged cannon rolling down the Boulevard Raspail in Paris, he quipped to her, "C'est nous qui avons fait ça . . . it is we that have created that."

To writer Jean Cocteau, he remarked, "If they want to make an army invisible at a distance, they have only to dress their men as harlequins." Discussing Picasso's comment, British surrealist painter and writer Roland Penrose—himself an acquaintance of Lucy and Suzanne's—noted that "harlequin, cubism and military camouflage had joined hands. The point they had in common was the disruption of their exterior form in a desire to change their too easily recognized identity." Penrose would know. He helped train the British military to paint camouflage during the war and wrote a book describing the best techniques to deceive aerial reconnaissance photography.

Lucy and Suzanne, who would have seen Picasso's work and likely met him in artistic circles, now played with the harlequin as well. Their goal in their 1928 photograph also seemed to be a kind of visual deception. Lucy, as Claude Cahun, in the harlequin coat is a kind of humorous, playful disruptive performance, intentionally confronting the viewer with something that is not what it appears to be.

The Soldier with No Name would also be a kind of camouflage.

ALONG THE SIDE OF THE ROAD ONE DAY, Lucy and Suzanne found an invitation to a German cultural meeting. A soldier had either lost it or thrown it away. For the women, it was inspiration. Feeding a clean piece of paper through the Underwood, Suzanne typed out another, nearly identical invitation, working hard to match the style and layout of the original but changing a few key words: "Rendezvous at Plémont Grotto."

Located on the northern end of the island, Plémont Grotto was part of a popular beach that harbored a series of sea caves often used by smugglers. It was also a strategic site in the German defense of the island. Originally built to protect Jersey from invasion by Napoleon, the old military structure on the bay now boasted German machine guns, mortars, and searchlights. Lucy and Suzanne carefully chose this location for their invented meeting. A whole group of imaginary Soldiers with No Names would supposedly gather there to plot against the occupation.

The invitation found its way to Captain Bode and surely stunned him. This summons to a secret meeting of disgruntled soldiers bore a signature that was fast becoming familiar to him: Der Soldat ohne Namen. It also contained a secret password: *Liebknecht-Frieden-Freiheit*. These were red flags. The first was an incendiary reference to the revolutionary German Karl Liebknecht, leader of an infamous communist uprising and vehement opponent of Germany's entry into World War I. The other words were part of a slogan from the 1918 German revolution: "peace and freedom."

Bode undoubtedly took men away from other duties and sent them to scout Plémont Grotto for traitors. They found nothing there.

Captain Bode regularly read a wide range of subversive messages and underground flyers spewing the locals' hatred for the occupation, but notes by this new author were especially troubling.

—So, have we lost the war?

—Certainly.

—But you are happy about it?

—Most certainly.

—I don't understand that. Why?

—Because I do not wish to squander my entire life in uniform!

Thus spoke the Soldier with No Name

Thus spoke Zarathustra!

oooooooooooooooooooooo

please distribute

Such a leaflet gave Bode plenty to ponder. The Soldier with No Name was probably well educated, judging by his reference to Friedrich Nietzsche's book *Thus Spoke Zarathustra*, which was turned into a famous tone poem by composer Richard Strauss. But what were the zeroes— some kind of secret code?

One of the Soldier's messages must have truly frightened him:

—Alas, I rather wish I were captured!

—If you surrender, then you will be shot dead by the officer.

—Let him come then! With such an officer, I will be the first to shoot!

In Bode's eyes, this was a clear call to mutiny, something that could not be tolerated at any cost. His file, and his frustration, continued to expand as his men found more and more of these dangerous notes bearing the Soldier's signature.

IN SEPTEMBER 1941, a new commander arrived on the island. Colonel Friedrich Knackfuss replaced Colonel Schumacher as head of FK515 to oversee the administration of Jersey. He would stay on the island for the next two and a half years. Middle aged, clean shaven, and short, Knackfuss often wore a monocle. Jersey politician and labor leader Edward Le Quesne sized him up this way: "a true overbearing kind of Nazi who seems to consider his especial duty to be as nasty as possible to those he has at present at his mercy." Knackfuss very possibly harbored old resentments against

Jersey since he had been imprisoned there in a British POW camp during the last war.

Fortunately, Edna regularly was able to glean lots of local knowledge from around the island, and George's job in the hotel allowed him to over-hear German conversations. To help keep everyone in La Rocquaise a step ahead of the troops, the couple shared what they learned with Lucy and Suzanne. George and Edna likely still knew nothing about the notes.

In the autumn of 1941, Edna reported that Germans were going house to house looking for places to stable their horses and grooms. Soldiers finally arrived at La Rocquaise and let the residents know that the old barn would be ideal for their animals. Could they see the empty rooms in the house as well? Lucy and Suzanne could hardly say no, so the Germans toured the house, indicating which rooms would be suitable for quartering soldiers. They gave the women a day to prepare for the arrival of their new, unwanted tenants. Lucy stood in front of the bookshelves, closely scanning back and forth so she could find and remove anything of value. They hauled blankets, curtains, and an electric heater into their bedrooms for safekeeping, but the furniture and rugs were too heavy to move.

Four soldiers—two more than expected—arrived the next day with their kits. Lucy remembered one of them immediately flipping the lock to make sure it worked. Then he strode over to the bookcases and inspected them for secret passageways but found none. The Germans put their horses in the barn. One soldier kept watch.

When these new boarders invited friends over, the house got even more crowded. Lucy and Suzanne did their best to keep their new house-mates at a distance. Edna had a harder time avoiding the men, who were often in the kitchen. Many of the soldiers were from working-class or farm families themselves and had much in common with George and Edna, so at least they had something to discuss if the soldiers spoke any English. Perhaps information they learned might help the household in some way. Meanwhile, the horses ate the plants in the garden.

Before the Germans arrived at the house, Lucy had packed their mes-sages into a suitcase and hid it under the desk in her bedroom. When the men were not around or had fallen asleep, she and Suzanne quietly pulled out the case and continued their work.

Fortunately, these soldiers moved out after only a few months, although neither Lucy nor Suzanne mentioned why in their writings.

THE OCCUPATION BROUGHT PEOPLE TOGETHER in unexpected ways. Before the war, Lucy and her neighbor, Mrs. Armstrong, had been suspicious of each other, in large part because Mrs. Armstrong had declared that she was anti-Semitic. Yet Mrs. Armstrong was no fan of the Nazis either.

Suzanne recalls in her postwar writing how one day the three women were having tea together at La Rocquaise, and Mrs. Armstrong told Lucy and Suzanne a bit of local gossip. A gardener had found an envelope with a strange German message on it pinned to the back door of the Somerville Hotel, one of the many local buildings used for troops and administrative offices. The beautiful resort overlooking St. Aubin's Bay was not too far from La Rocquaise. Since this man could not speak the language, he had no idea what it said. So he took the paper to his boss, who knew some German. After reading the words, he proclaimed, "This is dynamite!" Then he threw the note into the fire. He surely did not want the soldiers to find it in his possession.

But still, leaving notes at the Somerville Hotel and other places used by the soldiers meant their work would have a better chance of being seen by German eyes. Greater visibility, though, brought greater risk. All it would take was one curious German catching them with notes in their shopping bag as they headed out for the day. Or someone deeming their behavior unusual and turning them in to the GFP.

AS THE WAR WENT ON, many fearful residents voluntarily turned in fellow islanders to protect themselves or to gain an advantage over their neighbors. The Germans exploited people's anxieties, encouraging informants with monetary rewards. Everyone on Jersey knew about the snitching and often who was doing it. The notorious Alexandriene Baudains, nicknamed "Mimi the Spy," would overhear a bit of conversation and then call the Germans, who would come around to question or arrest people. Some informants sent letters to German authorities, denouncing a person they didn't trust or simply disliked. Whether based on an old personal feud or

a new resentment that the occupation had created, these letters meant the possibility of time behind bars.

The Germans were particularly interested in using informants to glean information about conspiracies and resistance movements. Their fears of disorder on all the Channel Islands grew by the day. On December 7, 1941, the German high command in Berlin issued the Nacht und Nebel (NN; Night and Fog) decree to expedite trials against resisters. Its harsh terms, which dictated that people under suspicion could be secretly spirited away under the cover of night or fog to face trial, were designed to frighten civilian populations throughout all the occupied territories into compliance. NN prisoners were cut off from everyone, denied anything resembling due process, and usually sentenced to death or transferred to a concentration camp.

With this tougher approach to discipline than the Germans had used during the previous year, the stakes for Lucy and Suzanne's resistance actions rose. The Germans had arrested a group of French citizens as political prisoners, so as French nationals, Lucy and Suzanne would have been wise not to take any chances, especially with the GFP always on the lookout for contraband or suspicious behavior.

For the two women, keeping all their secrets and avoiding suspicion was an enormous task, especially with so many curious people around the island.

9

THE DEPORTATIONS

SINCE THE OCCUPATION STARTED, Lucy and Suzanne could feel the military trucks rumble past, because La Rocquaise sat so close to the road. By early 1942, those vehicles were routinely stopping just a few hundred yards from their home.

Out climbed POWs: a mix of older men and teenaged boys rounded up in Russia, Ukraine, and elsewhere in eastern Europe, as well as in North Africa and other conquered lands. These hundreds of forced laborers landed at the dock in St. Helier and were packed into vehicles destined for one of several sites across Jersey, including St. Brelade's Bay. The bedraggled men unloaded materials used to build the forced labor camps where most would spend the rest of the war—if they weren't worked to death first. Their overseers would only ever take them beyond the camp's barbed wire to help build the island's fortifications.

They were there to create Hitler's Atlantic Wall. In part as a response to British raids on German military sites in 1941, Hitler decided to make the Channel Islands into a floating military citadel, one piece of a larger defensive system along the western European coastline. The wall, which was actually to be a series of large concrete machine-gun bunkers, antiaircraft artillery, minefields, and watchtowers along this line of defense, would free up soldiers who could be deployed elsewhere. Hitler gave construction along the Norwegian coast top priority, but the Channel Islands were next in importance.

The Führer vowed that the Atlantic Wall would be an essential line of defense for as long as the war went on. "Fortified areas and strongpoints will be defended to the last man," he proclaimed in the March 1942 directive

initiating the project. "They must never be forced to surrender from lack of ammunition, rations, or water." The Atlantic Wall was so important and Hitler was so obsessed with it that he received regular updates on its status. One of Hitler's leading generals recalled that the Führer wanted the islands to become "the strongest sea fortress in the world."

One German newspaper article glowed about the strength of the Channel Island fortresses, whose coasts "bristle with iron and concrete" to form a "ring of steel." "Only in this small section of the Atlantic fortifications," the author opined, "a whole trainload of concrete is treated every other day." The result was "an extraordinarily dense system of strongholds protected on every side and ready to strike back in every direction."

The Atlantic Wall was a great source of Nazi pride, and the task of building it fell to the engineers of the Organisation Todt (OT)—the German military's engineering group—which routinely exploited men taken from occupied territories. The approximately fifteen hundred OT forced laborers on Jersey would break their backs building these crucial defenses because the Germans didn't trust the locals. German commanders worried that islanders might smuggle details of the fortifications to the Allies or try to sabotage the efforts by dragging their feet or not showing up to jobs. For such an important project, the OT needed a workforce it could easily control. This lent a certain strangeness to the whole arrangement. As historian Paul Sanders puts it, "Quite literally the situation was surreal: the world had seen few occupying powers carrying out prestigious military projects commissioned expressly and supervised attentively by their venerated chief, and with no other choice than to employ thousands of mistrusted enemy civilians and POWs. Naturally, paranoia thrived."

Despite the importance of these workers to the completion of the Atlantic Wall, OT camp conditions were miserable. With rations already tight and the Germans displaying little concern for the prisoners' lives, these men barely subsisted on a thin diet of turnip soup and bread with only an occasional bit of meat to add protein. "On the rare days when they did not work," historian Louise Willmot writes, "they were not fed." Furthermore, "beatings for minor infractions of regulations, and for failing to maintain the required work rate, were frequent and savage." Medical care was almost nonexistent. The Germans treated the black French colonial workers from sub-Saharan Africa particularly badly.

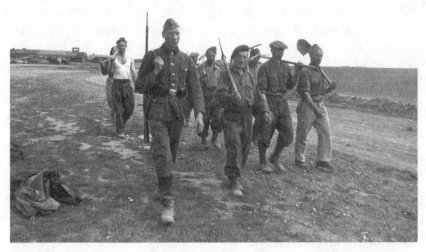

Organisation Todt (OT) workers on Jersey, possibly Algerians and Moroccans.
COURTESY OF THE SOCIÉTÉ JERSIAISE PHOTOGRAPHIC ARCHIVE.

One escaped prisoner told British intelligence in his debriefing: "We were treated worse than cattle. Our term of usefulness was generally accepted by the Germans to be six months. After that we were expended. They tried to get out from us every ounce of labour and energy they could on as little food as possible."

The OT camp brought even more activity—and unease—to Lucy and Suzanne's corner of Jersey. They watched the forced laborers shore up the tall granite seawall that held back Jersey's extraordinarily high tides along the beach of St. Brelade's Bay just outside their home. But being so close to the OT camp, a site with such obvious political significance, also offered new opportunities for their secret work.

Under the cover of cold winter darkness, long past the 11:00 p.m. curfew, Lucy snuck out alone. Suzanne was usually the one to make a drop, and they had always worked together, but tonight, for some reason, Lucy was on her own. She passed through the gate from their garden, crossed the slipway that headed toward the beach, and moved silently toward the road. In her hands, she gripped a packet containing some new photomontages and summaries of recent BBC news reports about the Russian victory

at the Battle of Rostov a few months earlier. Neither the German guards nor the Russian prisoners in the OT camp would have heard any accurate information about the war in quite some time. That's where she headed.

Approaching the compound, Lucy's nervousness heightened. Her poor eyesight and the darkness compounded her fear, but even as her heart pounded, she pressed on. She encountered a lone guard but evaded him. Leaving her package where a prisoner might find it, she turned toward home in the darkness.

The plight of the forced laborers in the OT camps, especially in contrast with the Germans' relatively lenient treatment of the local Jersey population, moved many islanders to secretly supply these men with food or clothes or to slip little luxuries to a work detail. They did so at great risk to themselves; if caught, they would likely be jailed or themselves deported to a prison camp. In the occupation's early days, Lucy had railed against the residents of the island as passive, even collaborationist, but she took note of these small acts of kindness growing across the island. She found out that Mrs. Armstrong gave small gifts to some of the OT workers when she was able to. Mrs. Armstrong even taught Lucy a little Russian so that she might communicate with the prisoners.

THE GERMANS SOMETIMES MARCHED forced laborers down the road near La Rocquaise on the way to a worksite, encouraging them to steal from gardens and houses along the way. The guards would usually join in the looting too.

Before dawn one day in early 1942, a contingent of North Africans from the OT camp trekked to a point just beyond the seawall that separated La Rocquaise from the beach below. The guards ordered the men to dig a trench.

We need to climb on your roof, a German soldier barked at Lucy and Suzanne. Why? Suzanne asked him. So we can watch these workers under our command, he replied.

Suzanne observed that the laborers' old clothes were torn and ragged. Many covered their heads with blankets to stay warm as the snow started to fall. Their emaciated bodies vividly revealed their starvation.

Winter rains fell over the coming weeks, but that didn't deter the guards from bringing the OT workers back to St. Brelade's beach. Lucy

watched one detachment use heavy equipment to move sand. She believed these men were Russians and decided to try out the few Russian words she had learned from Mrs. Armstrong so that she might make a connection.

Nervous and working to overcome her shyness, Lucy rehearsed the lesson in her mind as she tied her scarf and put on the Burberry overcoat. She approached the beach from a direction beyond the house so that if the Germans saw her talking to the men, they would think that she had come from somewhere other than La Rocquaise. Fortunately, the guards were off in the distance, trying to keep out of the cold rain, so Lucy was able to move about undetected.

She approached slowly, tentatively, trying to catch the attention of one of the wet, shivering prisoners. Her mind raced through the Russian words, but despite having rehearsed them repeatedly, she froze up and suddenly could remember nothing. All she could do was quickly hand one laborer a chocolate bar—six months' worth of her ration—turn, and walk away silently.

That evening, most of the OT workers had gone back to the camp, but a few stayed behind storing their tools, including the one with whom Lucy had made contact. She snuck down to the beach, and he recognized her through the darkness. This time, though still jumpy, she was at least able to get a few words of Russian out of her mouth. He looked at her with puzzlement but eventually explained that he was Ukrainian.

Lucy turned back toward the house and gestured to Edna, who saw the signal and ran down to the beach with a small parcel. His eyes began to fill with huge tears of joy and gratitude when he saw a piece of cake inside, and he ate heartily. Then Suzanne appeared with other gifts, including a handkerchief and a pair of socks a friend had left behind. The Ukrainian reached out, grabbed Suzanne's hands, and kissed them repeatedly as he held them in his own huge, calloused mitts. He took hold of Lucy too. "Comrade!" he declared. On subsequent nights, Lucy and Suzanne stole down to the shoreline and found him again, offering soap or oil. Each time, he expressed his deep thanks for their compassion.

The work on St. Brelade's beach continued for months. When winter had turned to spring, Lucy and Suzanne observed a group of Spanish OT laborers. These men, they assumed, were captured Republicans who had opposed General Francisco Franco during the Spanish Civil War. As the

Spaniards headed back toward the camp, Lucy attracted the attention of one and pulled him toward the house. The German guards were out of sight and not watching the prisoners closely. Lucy and Suzanne offered him a bit of food and tried to communicate with him. He took a piece of paper and wrote in Spanish: "Who will win the war?" Then he listed the names of the leaders of the major powers. The words were close enough to French for them to understand what he wanted to know. But neither woman could answer his question.

If they were not being held on Jersey, many of the forced laborers employed in building the Atlantic Wall defenses were imprisoned in one of four work camps on the nearby Channel Island of Alderney, which began operating in January 1942. The SS ran two of those camps as brutal concentration camps, including one with Jewish slaves.

Alderney also served as a place of punishment for Jerseymen. One local man, Gordon Prigent, was sent there when he walked out on his construction job after a fight with a German soldier. Living among the forced laborers brought from the Eastern front, he toiled long hours. Guards beat them if the pace of work slowed. A swift blow with the butt of a rifle came just for talking with another man. Prigent planted cabbages and carrots to feed the troops. In the field, the Germans "used to put lumps of sugar in the rows of carrots," he recounted in an interview after the war. When the laborers saw the sugar, they would "work twice as hard to get to it." But the prize was always just out of reach. Again and again, a guard would move the sugar a little farther down the row. "And probably at the end of the day," said Prigent, "you might be lucky to get one lump of sugar." Once, in the field, when one of the guards thought that the holes being made by a prisoner named Walter weren't in the right place, the guard "just took the spade away from Walter and broke it on his back . . . and of course you'd go and help him, but I wasn't allowed to help him at all, so they just kicked him in the ribs till he got up."

IN JUNE 1942, COLONEL KNACKFUSS, as the head of FK515, was still in charge of administering Jersey. Because of the Atlantic Wall, the island was now strategically vital, so Knackfuss made a crucial decision. With Lucy and Suzanne's notes, among others, as evidence, he declared that BBC broadcasts were too damaging to the occupation efforts because

they allowed those on the island to hear a different story about the war's progress. He also feared that coded messages in the radio programs coming from London might be helping coordinate a resistance movement. The presence of heavy German fortifications meant that the island had become too important to leave anything to chance, and acts of defiance growing across Jersey amplified his fears. To stem the flow of information, Knackfuss outlawed radios from this point forward. Residents were required to hand theirs in immediately.

This was worrisome for Lucy and Suzanne. They relied on their radio for information they could use to directly contradict the German military's official line. It is what made their notes so powerful when read by the soldiers. However, when the time came, they reluctantly surrendered their two radios.

Shortly after the radio ban went into effect, Edna discovered a surprising leaflet. Someone on Jersey had written a message calling for islanders to resist and keep their sets. Lucy loved the note. She thought they should reproduce it on the Underwood and distribute copies, even though they did not normally distribute tracts written by others.

When Lucy sat down at the Underwood to duplicate the note, she decided to put her own twist on it. Its style was different from the messages they were writing as the Soldier with No Name. His work needed to remain unique. A new version finished, she placed copies in a random mailbox, hoping that the postman would deliver them. Shortly afterward, Lucy and Suzanne learned that the Germans had arrested and jailed the author of the original message.

Bode kept the Gloucester Street prison filled, especially in the second half of 1942, when the banning of radios backfired. Despite the risk, most people were unwilling to cut themselves off from the rest of the world and hear news only from the Nazi point of view, so they either kept their wireless or purchased a new one on the black market. The radio ban frayed already-tense relations between occupier and occupied; islanders resented this deep intrusion into their lives. Even Jersey residents who, out of necessity, cooperated with the Germans in other ways disobeyed this particular rule.

Dozens of people with illegal radios were either caught and immediately jailed by the Germans during random inspections or were ratted out to the GFP by local informants. Turning in the owner of an illegal radio would

earn someone £100—which could purchase more than twenty-five hundred pounds of bread at the fixed occupation price; today, that sum would have amounted to around £5,500 (US$7,100) of purchasing power. An escaped Jerseyman told MI-19 that the notorious informer Mrs. Baudains was widely known on the island for giving information about radio violations to the GFP. She claimed the £100 reward so many times that she was eventually beaten and thrown through a plate-glass window by her neighbors.

Lucy and Suzanne bought a Philips radio on the black market and smuggled it into La Rocquaise, where they locked it in a cabinet next to Lucy's bed. Edna and George also listened to the news on it. To guard the secret, when Lucy or Suzanne talked with anyone about the progress of the war, they never mentioned the radio, saying only that their information came from gossiping with the mailman or that a friend may have passed along a word or two. The risk was grave: if the Germans knocked on the door in search of an illegal radio, they would quite possibly find the Soldier with No Name's notes too.

With tensions heightened by growing local defiance of the radio ban, Knackfuss issued a new document requiring every household to clearly identify all residents. Suzanne sat down at her desk with the Declaration of Members of Households form. She wrote down each name on a separate line: her own name, Lucy's, George's, and Edna's. She hung the list just inside the front door of La Rocquaise, as required.

BY MID-SEPTEMBER 1942, as the Battle of Stalingrad raged on the Eastern front, the Nazi war machine seemed invincible and the island's worst fear came true: Hitler wanted to use Britons as hostages in retaliation for the capture of German soldiers in British-controlled Iran. Knackfuss announced to Bailiff Coutanche, the head of Jersey's government, and officials on the other Channel Islands that he would deport twelve hundred British citizens without permanent residency status to prisons in Germany. In addition, men who had not been born on the Channel Islands and who were between sixteen and seventy years old would also be sent away, along with their families. Paranoia about foreign spies, combined with the desire to rid themselves of so-called useless eaters—those taking resources from local laborers and the Germans themselves—made this move necessary in the eyes of the German command.

The speed of the order, which came from Hitler himself, caught local Jersey leaders off guard. Coutanche had only about twenty-four hours' notice; the German ships were already waiting in the harbor. Those designated for deportation were to present themselves on September 16. Jersey residents had only a few hours to pack, decide what to do with family pets, and organize their affairs. Despite the GFP's assistance in the arrangements, the deportation was poorly organized, and the fast timetable confused even some German officers. British born but not a permanent resident of Jersey, Vera should have been sent away. She prepared herself but was never ordered to report to the dock. Lucy and Suzanne knew of others who somehow slipped through the deportation dragnet as well.

In St. Helier, a crowd gathered at the harbor to watch friends and neighbors board the waiting vessels. A German soldier filmed the deportation from a nearby hilltop to document what was happening. Bystanders talked in hushed tones, wondering what this meant for their friends and for themselves in the weeks to come. Who might be next? As a foreigner on the island, the potential for being shipped off to a German camp made Suzanne apprehensive, especially with Lucy's Jewish heritage.

By the time of the deportations, Joe Mière, a dark-haired Jersey teenager with a boyish face, was already deeply involved in resistance activities on the island. Years later, he remembered seeing his sister with tears rolling down her face as she stood at the dock watching friends board. Through the sound of sobbing, Mière heard music. His sister and her friends had started singing the rousing patriotic song "There'll Always Be an England," which had been written at the outbreak of the war. "Soon the two hundred or so people around her joined in," Mière recalled in *Never to Be Forgotten*. "Then, as we were singing, across the harbour came the many voices from the deportees on the ship. It seemed that all of us had lumps in our throats. This was followed by 'Jersey, Jersey,' then 'God Save the King,' the deportees' voices blending with our voices."

Several German soldiers, alarmed by this show of defiance, started to break up the gathering, chasing members of the crowd. Joe Berry, a Jersey policeman in St. Helier, arrived with his wife at the pier amid the singing. A German officer threw down the bike he was riding to confront Berry and his friends with a pistol. The soldier lashed out and smacked one of the nearby kids who had angered him. Berry feared for his life, grabbed his

wife, and fled. Soldiers rounded up demonstrators and moved them away from the dock as the deportees sailed away.

The soldiers took Joe Mière and a friend into custody, not for the first time. They threw the boys in the Gloucester Street prison and demanded to know what resistance group they belonged to. "We know how you feel about your people being deported," an officer told them, "but we have our orders to carry out, and we will not tolerate any interference in our military orders. Do you both understand?"

Mière and his friend were eventually released, but in the days that followed, other demonstrations against the deportations broke out. The Germans arrested more people for disorderly conduct. Like the radio ban, the deportations pushed people on Jersey past the breaking point. Local residents became far less cooperative with the Germans whom they had tolerated for the past two years. "From that time on," remembered Jersey native and resister Bob Le Sueur, "there was an attitude of burning hate and an attitude by everybody to be as awkward as possible . . . which hadn't existed to such a degree before."

That new loathing began to boil over in encounters with people who openly collaborated with the Germans. Joe Mière and a group of his friends went to a dance one evening at the Chelsea Hotel in St. Helier. Soon he heard the doorman, an Irish boxer named Eddie O'Connor, shouting at someone: "You are not welcome here!"

Mière looked around to see O'Connor throwing a man in his early thirties, John Lingshaw, out into the street. Lingshaw was a well-known collaborator who worked for the German police as an informant. His identity card even recorded that at one point his home address was the GFP headquarters.

Mière and his friends danced for a while until the military police arrived at the hotel with Lingshaw in tow. Lingshaw identified O'Connor to the Germans. The dance is closed, Mière remembered the police announcing to the disappointed crowd. Everyone go home! Lingshaw left and walked up the street until O'Connor spotted him again.

"Let's get the sod!" O'Connor yelled to Mière and his friends.

Lingshaw sprinted off, leading the group of disappointed dancers on a chase through the streets of St. Helier. Eventually, they caught up to the collaborator.

"Joe, you are a Jersey boy," O'Connor said to Mière, panting. "Give him a good thrashing. And my boy, if he lays a hand on you, I'll break his jaw."

Mière hesitated. Lingshaw was not very big, and the fight hardly seemed fair despite what Lingshaw had done. Lingshaw panicked and took a swing at Mière.

"That does it!" Mière now felt the adrenaline surging inside him. He swung and connected with Lingshaw's face, smashing the informer in both eyes. Lingshaw wobbled, shaken and in pain.

Through the darkness, Mière and O'Connor heard German boots running toward them. O'Connor took one last shot at Lingshaw, delivering a solid right hook and knocking Lingshaw flat. Mière and O'Connor ran off into the night.

When he got home several hours later, Mière's mother scolded him for being out after the curfew. Be quiet, she told him. She didn't want him waking up any of the people staying in the guesthouse that the Mière family operated. One of the occupants had been mugged by six large men, she said. He couldn't get home since he was out after curfew, so he was spending the night here in the upstairs bedroom.

The next morning, Mière caught a glimpse of the man who claimed to have been mugged. It was Lingshaw, his two black eyes almost completely swelled shut. Mière ducked into the bathroom to avoid being seen by the collaborator he had beaten only hours before. If Lingshaw noticed him, he would run to the police, who would surely arrest Mière. He would be tried, then sent to jail—or worse.

Despite his association with the Germans, Lingshaw would eventually be convicted for profiteering. In early 1943, he was deported to a Nazi prison.

THE DEPORTATION ORDER FOR NONRESIDENTS came from Berlin, but Lucy and Suzanne knew that Colonel Knackfuss executed it. To protest what they saw as his crime against the people of Jersey, they decided to put their wicked comedic sense to use.

Lucy and Suzanne had been creating alternative versions of German periodicals so that soldiers might absorb rebellious messages before realizing that something was amiss. The women labored for some time on one illustrated magazine, reproducing images, mimicking the text, and then

cutting out material from other publications and pasting it into their version. The painstaking work was hard on Lucy's eyes, but they ultimately fabricated an entire issue of their fake magazine. All their artistic talents—photomontage, design, writing, humor—were on full display. In it, Suzanne drew some illustrations, which took the form of advertisements for products to help with tired feet. These were a special pun designed just for Colonel Knackfuss, since *knacken* in German means "cracked" and *Fuss* means "foot."

With their counterfeit magazine wrapped inside a package addressed to the colonel, they entered the St. Mary and St. Peter Church. This English-speaking Catholic church was Vera's parish, close to her house in St. Helier. Some German soldiers also attended mass there. When Lucy and Suzanne left the church, they pretended to forget the package. Someone would find it and take it to Knackfuss. But even if the magazine didn't reach the colonel, the women were certain that someone else would discover it and perhaps have a laugh at his expense.

By the beginning of 1943, only a few months after the deportations from the Channel Islands, the tide turned as the Nazi war machine started to falter. Allied forces pushed back German troops commanded by General Erwin Rommel in North Africa. In February, the Battle of Stalingrad ended in a devastating defeat for Hitler's army. Soldiers on Jersey were beginning to realize that the war might not end well for them, and many feared they would be sent to the horrors of the Eastern front, where they would surely die. Jersey residents sensed the significant decline in German morale. Unsubstantiated rumors circulated that a few had even killed themselves rather than receive orders to relocate from peaceful Jersey to the hell of the Russian battlefields.

Stalingrad gave the resistance efforts among Jersey residents a new courage. In the wake of the German defeat in Russia, a small communist group called the Jersey Democratic Movement (JDM) began printing its own anti-Nazi leaflets on a flatbed duplicator. As Lucy and Suzanne had been doing, the JDM used different typefaces and sorts of paper to fool the Germans into thinking that multiple authors were composing these notes. These messages surely made Bode and the GFP even more anxious.

In February 1943, the British attempted to raid the nearby island of Sark in order to recover prisoners and reconnoiter the territory. Although

the mission was unsuccessful, it added to the growing sense of dread among German military leaders. That incursion provided the Germans with the pretext they needed for conducting a second round of deportations from the Channel Islands. This time, according to historian Madeline Bunting, "the categories of those to be deported included islanders judged to be workshy or politically suspect, former army and navy officers, [any remaining] Jews and high-ranking Freemasons, as well as their families." By the end of this second round of deportations, some twenty-two hundred more men and women were forced to prison camps on the Continent.

LUCY AND SUZANNE were still not among the deportees, but a few weeks later, Lucy received a notice in the mail to report to Silvertide Guest House, a hotel overlooking Havre-de-Pas beach in St. Helier, where the GFP had recently moved its headquarters. She and Suzanne read and reread the letter, trying to determine how serious this was. Perhaps the Germans have discovered my Jewish origins, Lucy speculated. Or perhaps they discovered our notes, or my German-sounding name intrigued them. Suzanne worried about rumors she'd heard that French citizens would be deported.

Everyone in the house was anxious that soldiers would also come to inspect La Rocquaise. Working in the hotel where he could overhear conversations, George had learned how the Germans conducted their searches, where they looked and where they didn't. He thought of a good hiding place for all the things that they could not allow the soldiers to find. The night before Lucy's interview at Silvertide, they all helped carry the contraband to one of the three small outbuildings on the property.

George and Suzanne lugged the illegal Philips radio and Lucy's suitcase out of the house. Lucy had always been something of a pack rat, and the valise contained her personal archive of old papers, letters from friends, books, and documents from the surrealist days. It was also where she stored drafts and copies of the leaflets they were working on, although George and Edna likely did not realize what was inside.

Edna, who was now eight months pregnant, helped Lucy, Suzanne, and George gather up branches and sticks from the garden and pile them on top of the suitcase, the radio, and anything else they needed to keep out of sight. Such debris would not seem out of place on a property with so much greenery. If the Germans did come to search the house, they would never

look there, George assured them. Now the only thing protecting Lucy and Suzanne from the real possibility of arrest was a pile of garden clippings. Although they had discussed burning this mountain of incriminating evidence and agreed it would be their safest bet, Lucy couldn't bring herself to light the match.

The time came for her trip to Silvertide—but how should Lucy travel and what tone should she strike? Edna called a doctor, probably Dr. Robert Noel McKinstry, Jersey's medical officer of health, with whom she was friends. Like Edna, he had been born in the north of Ireland. McKinstry had used his position as the island's primary public health official to assist people in receiving Red Cross packages. He treated OT escapees, even helping some of them obtain identity cards.

McKinstry came to La Rocquaise to accompany Lucy to Silvertide. He supported her thinning frame as they walked outside to the waiting taxi. McKinstry justified the use of strictly rationed fuel by providing a medical excuse. Lucy had no problem playing up her illnesses to emphasize her frailty to the Germans, and she perhaps even carried the bottle of Gardenal with her. "I look tired, and can look sick if I want," she had noted a few years earlier in *Disavowals*. Now, at Silvertide, her acting skills would be put to the test.

Lucy took in the building as the taxi pulled up out front. She and Suzanne had secretly photographed the GFP headquarters one day, sneaking up quietly and hiding behind the bushes, as closely as they dared, with their illicit camera. The large windows let in lots of light for the men of the GFP to enjoy. They could stand on the hotel's balconies looking southward across the English Channel, perhaps wondering what was really happening to their comrades who faced Allied bullets on the Continent.

The meeting at Silvertide went reasonably well. Her performance must have been convincing since Lucy remembered the episode only as "a rather bureaucratic interrogation." By the end of her questioning, the GFP "had made their excuses to the old lady in black who seemed so ill," as Lucy referred to herself in her postwar recounting, despite the fact that she was only forty-nine years old at the time. She returned to La Rocquaise breathing a sigh of relief, happy to be back home with Suzanne. A few weeks later, Edna and George welcomed their first child, Mary, into the world.

Shortly after the baby came, during Holy Week in April 1943, Lucy and Suzanne were back at the St. Mary and St. Peter Church. They slid some of their notes onto the white wooden table in the back so that the soldiers who worshipped there during the Easter season would find them. Occupation coins they had covered in nail polish and scratched with the words *Nieder mit Krieg!* ("Down with war!") clinked as the women dropped them in the collection plate.

10

"JESUS IS GREAT—
BUT HITLER IS GREATER"

SUZANNE HAD AN IDEA. In secret at La Rocquaise, she and Lucy took a large panel of white fabric and stretched it out. They had somehow gotten hold of paint—black, red, and gold—and started drawing enormous letters on the sheet. They wanted to make sure the slogan could be read at a distance. After the paint dried, they rolled up the banner and hid it.

Later, carrying the heavy cloth between them, they shuffled just a few yards down the road, then turned into the driveway of the St. Brelade's Church, the oldest Christian site on the island. The modest-sized sanctuary was made of the same brown granite that was used to build La Rocquaise. A cement of crushed limpet shells taken from the ocean and dissolved in boiling seawater held its walls together. Next to the main church was the small Fishermen's Chapel that looked out over the bay, a testament to the importance of seeking God's blessing for those who sustained the island's life with the fruits of the ocean.

The women peeked into the darkened church. When they saw no one inside, they carried their canvas down the center aisle. Approaching the altar, they steadied it so they could lift it up high. Somehow, perhaps using a ladder or a piece of furniture, they climbed carefully up to the Gothic arch overhead. They hoisted the banner and secured it to the walls. When they unfurled the painted cloth, the German national colors of black, red, and gold letters proclaimed, "Jesus Is Great—but Hitler Is Greater. Because Jesus Died for People—but People Die for Hitler."

When daylight came, the church's stained-glass windows cast colorful light across their words. The text of Proverbs 25:11, carved into the pulpit

in French, seemed to offer comment: "A word fitly spoken is like apples of gold in pictures of silver."

They aimed this larger-than-life message squarely at the sense of morality and decency of German troops, but its dark, ironic humor ultimately pointed to the basic truth they repeated in many of their notes. Hitler had become "greater"—supposedly more powerful—because a new "god" had convinced men to die for him rather than sacrificing himself on their behalf. Hitler is duping you, Lucy and Suzanne were shouting to the troops in huge letters, because you will pay the price with your life while he continues to live.

This was their riskiest move to date, a recklessly dramatic act that spoke to their growing boldness as the occupation dragged on. They needed to turn up the heat.

In that same spirit, one powerful note Lucy and Suzanne typed, likely in mid-1943 in the wake of the German loss at the Battle of Stalingrad and the German failure during the North Africa campaign, tried to frighten soldiers into realizing the sinking reality of the war.

> Alarm! Alarm! ALARM!
> —Why?
> —Because our masters, the officers—afraid
> of being captured here, like in Stalingrad, like in Tunis—
> count on your corpse
> to protect their aerial escape.
> Alarm! ALARM!
> Alarm! ALARM!!
> —You endure ENDLESS war games, times of need,
> you worry deeply about your loved ones.
> —For what purpose?
> So that you don't have time to THINK AND REFLECT!

The repeated "alarm" attempted to rouse soldiers out of a sleep that hid the real consequences of the war on them and their families.

ONLY A HANDFUL OF LUCY AND SUZANNE'S NOTES SURVIVE, but of those that remain, none engages directly with Nazi racial ideology. They did not make the case against Hitler's hate-filled rhetoric or his anti-Semitic

policies, even though Lucy and Suzanne had certainly known about both since the early 1930s and had spoken out against fascism in all its forms. Early in 1942, at the secret Wannsee Conference outside Berlin, Nazi leaders met to create a formal plan for the extermination of the European Jewry, and in the months that followed, soldiers systematically murdered people in extermination camps. Lucy and Suzanne would not have known the details about this, and the BBC continued to downplay coverage of anti-Jewish violence. Yet they might have heard a report on the radio about a December 1942 speech in the House of Commons made by Foreign Secretary Anthony Eden, who declared that Germany was "now carrying into effect Hitler's oft-repeated intention to exterminate the Jewish people in Europe."

Neither Lucy nor Suzanne wrote about why they omitted these issues, but one real possibility is that they simply thought such an argument would not be convincing. Their words aimed to shock Germans into thinking about their own day-to-day actions, not broader ideological notions. They tried to meet each man where he was on Jersey and focused on fomenting resentment against the war and the German leadership.

In his studies of power relations, political theorist James C. Scott analyzes communication strategies between rulers and the ones they rule. In daily life, both the powerful and the powerless speak the language of "public transcripts," Scott argues. Rulers display their authority through language, symbols, and rituals. Those who are ruled openly accept the system by agreeing with the people in charge and telling them what they want to hear. For Scott, these words are part of a "script"—a daily performance in which both sides publicly restate the relationships of power.

However, these scripts are deceptive. Those in power self-consciously discuss the dilemmas and limits of their rule while hoping to keep their goals and methods a secret. Meanwhile, the powerless find ways to fight back through gossip, grumbling, rumor, and criticism of those in charge. Try as they might, not even the strongest rulers can always penetrate the most private thoughts of every person they seek to control. Scott calls these behind-the-scenes conversations between both rulers and ruled their "hidden transcripts." By masquerading as the Soldier with No Name, Lucy and Suzanne's notes became part of the hidden transcript of the occupier. The Soldier's words inserted a dangerously subversive set of ideas into the private conversation of the Germans—like a virus—so that when other

men read these notes, they might believe that the words were from someone inside their own community, someone who harbored a secret set of doubts and fears meant for German eyes only. Lucy and Suzanne's leaflets, and the lack of reliable information on Jersey, which made the Soldier's words seem more believable, might cause the Germans to wonder whether the occupation really was failing.

By trying to turn soldiers against the hardship of war, Lucy and Suzanne's leaflets unwittingly bore a strong resemblance to propaganda produced by the Allied psychological operations effort. Psyops blanketed German and Italian front lines with millions of leaflets from airplanes, and patrols distributed many more. Others were placed in special mortar shells and shot toward enemy front lines. Occasionally they could be delivered by balloon or even kite. The Allied-produced newspaper *Nachrichten für die Truppe* (News for the troops) looked like a German newspaper but told the story of the war from the Allied point of view. Of course, the German propaganda machine also created its own messages to demoralize Allied troops.

In a draft for a confidential internal manual titled "Confetti," the Allied Force Headquarters Psychological Warfare Branch described propaganda leaflets as "the outer edge of battle force," "the cutting-edge of psychological warfare," and "paper bullets." Leaders called them indispensable to contemporary warfare: "Stone-age strategy ignores leaflets but no modern army does." The document even described the effort in gendered terms lest any soldier feel that he was not fighting in a "manly" way by dropping leaflets: "But the dissemination of leaflets is not of secondary importance—and there is nothing ladylike about it."

The psyops leaflets aimed to erode German soldiers' morale and encourage surrender by undercutting what Axis governments told their own troops. It also provided a counternarrative for occupied populations. Some of those pamphlets landed on the Channel Islands and possibly provided inspiration to Lucy and Suzanne.

Most of the Allied tracts discussed the failures of the German army, telling troops on the ground they were near defeat. Many gave practical advice about how to surrender and offered safe passage, promising that a German soldier who showed the leaflet to Allied troops would be disarmed and given medical treatment and food. Like Lucy and Suzanne's notes, they

usually spoke to the Germans as fellow soldiers, appealed to their sense of self-preservation, and reminded men of home and family.

One Allied tract, which hit some of the same themes that Lucy and Suzanne's did, declared: "Frontline soldier: Ask the people at home—it concerns them. Ask the people at home, your wife, your mother, if they really want you to sacrifice your life for Himmler and Goebbels in hopeless resistance." Another, titled "The Choice," asked soldiers to decide whether they preferred peace or a future where "the war continues until all of Germany becomes a battle-ground; until chaos reigns in the entire country; until money is de-valued; until the fields are ravaged and the towns entirely destroyed, and women and children experience the full horror of war on native soil." Soldiers needed to be good husbands, sons, and fathers, the leaflets emphasized. They should protect those at home rather than die for no good reason. They needed to trade in the Nazi vision of men as conquering soldiers for one of men as protectors and peacemakers. A two-panel illustration from the North Africa campaign put the case bluntly. It showed rows of graves marked by crosses and helmets on the left side, while the right panel depicted a happy reunion of a man returning home from battle; his wife and child run toward him with open arms.

Other Allied leaflets insisted that Nazi leaders were lying to German soldiers about the progress of the war effort when, in fact, they were nearly defeated. To drive the point home, these tracts used the words of anonymous (probably fictional) German soldiers and leaders in an attempt to convince their comrades to surrender. One pamphlet, titled "Common Sense," offered quotations from specific German soldiers, giving their rank and unit but blacking out their names. "All of a sudden," the first quotation began, "it was said that we were surrounded by the enemy. We might have been able to escape to the left or the rear, but there was that order: 'Who retreats will be shot.' So we were taken prisoner by a group of 250 Americans. And certainly it was better to be taken a prisoner than to have died for no purpose in that barrage."

Another soldier's quote told the story of a failed battle with American troops calling for surrender: "The Non-Com [noncommissioned officer] for a second seemed to hesitate. Says a comrade, 'Man alive, you don't want to let us die here, do you? After all you have a family yourself!' So he ordered us to lay down our arms."

The voices of fellow Germans—these soldiers with no names—might be able to convince their peers, just like the dialogues and statements Lucy and Suzanne typed on their Underwood.

Allied propaganda leaflets did not target the deeply devoted Nazi ideologue. "Nothing can be done, unfortunately, with Nazis but to shoot the hell out of them," pronounced the psychological warfare experts. So instead, they aimed their messages at "the great majority of enemy soldiers and civilians, who have been dominated by Nazis—and are showing signs of disillusion." Like Lucy and Suzanne's notes, these Allied messages did not discuss atrocities or anti-Semitism but instead focused on the soldiers' practical concerns.

Allied soldiers interrogating POWs were eager to find out whether the prisoners had read and believed what the messages said. Reports from the Psychological Warfare Branch noted that many men did accept most of or all the claims in the pamphlets. Some even surrendered directly because of them. German leaders certainly took the threat seriously. General Albert Kesselring, commanding all German troops in the Mediterranean theater, issued orders to his men: "All propaganda literature and leaflets dropped by enemy planes must be turned over to the German authorities immediately. Those failing to do so will be imprisoned or, in more serious instances, punished by death." Orders on Jersey were likely very similar.

DR. ROBERT NOEL MCKINSTRY and other local health officials, disturbed by the declining amounts of food and medical supplies, reported their troubling findings to the Jersey government. Stealing food became more common, especially from the island's potato crop and the German supply of tinned food. Residents repeatedly violated occupation regulations when they snuck down to the water in search of a few mussels or winkles. There were almost no pets left on any of the islands—Lucy and Suzanne's cat, Kid, was one of the few exceptions—because very hungry people turned to them as a source of food. Studies done after the war would show that children on the Channel Islands had not grown as tall or gained as much weight during the war as their peers in London because severe food shortages had deprived them of calories required for normal development.

German troops were suffering too. One German recalled, "We got so hungry we collected limpets and minced them and made them up like

hamburgers; they were like chewing gum or gristle, but they stopped the hunger pangs for a bit."

Lucy looked at Suzanne's thinning body, thinking that she had lost thirty, maybe forty, pounds. Lucy herself ate very little because her medicines and the stress of the occupation made her lose her appetite. She regularly tried to give at least some of her meat ration to Kid. No longer able to find rabbits to hunt because the local population had killed them all, the cat had somehow learned to fend for himself.

As she held Kid in her lap, stroking his fur, Lucy realized that the cat's resilience had become a source of inspiration. She ruminated about how so many aspects of the occupation had deeply frustrated, even angered, her. The lack of basic items she had always taken for granted and the presence of Germans everywhere grated on her nerves. Edna dealt with the black market, and she continued to drink. What if she slipped up and brought undue attention to the activities at La Rocquaise? The dread that she and Suzanne might be caught and sent to prison permeated every moment of the day. Kid's peaceful, meditative demeanor showed Lucy how to keep herself outwardly calm amid so much fear.

Despite the worry and terrible strain on her weak eyes, Lucy took great satisfaction in their work. It also kept at bay the darker thoughts that often threatened to intrude. "I had my papers to console me, my crazy enterprise," she reflected in a letter after the war about her state of mind in those days. "I can't possibly tell you what this meant to me." This work was at least "something that was mine, an open door, a hope and at the same time an obsession."

Thankfully, by this point the Germans had stopped using the hotel across the street as their evening social club, so Lucy and Suzanne could sneak out in the dark to collect materials they might use in their creative efforts. But the German officers continued to lounge at the hotel at other times, and with so many soldiers still very close to La Rocquaise, the women always had to remain on guard.

THE GERMANS MADE ST. BRELADE'S CHURCH CEMETERY their burial ground for most of the soldiers who died on Jersey during the war, whether from disease, accident, or shipwreck. By war's end, over two hundred Germans would rest in Jersey's soil. They were not the first Germans buried at St. Brelade's, which was why the German command had chosen this

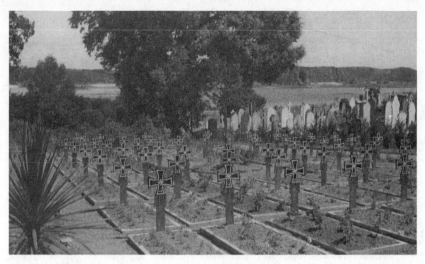

The German Heroes' Cemetery at St. Brelade's Church, only yards from La Rocquaise.
COURTESY OF THE SOCIÉTÉ JERSIAISE PHOTOGRAPHIC ARCHIVE.

burial ground. Seven German POWs from World War I were interred there, some of whom had died during the Spanish influenza epidemic of 1918. Now those older headstones were rotated so they faced east, back toward Germany. Then the Germans took over a large section in the northeast corner of the cemetery for their Heldenfriedhof, or Heroes' Cemetery, relocating the Jersey coffins already buried in that spot. A black-and-silver Maltese cross, decorated with a swastika, adorned each new grave. Friends came to cover the crosses with flowers and leave notes for their fallen comrades. Whether to watch over the dead or to take advantage of the line of sight from the cemetery out over the bay, Germans placed an antiaircraft cannon near the graves, much to the rector's horror.

The burial ground was located just across a boat ramp that led to the beach. Lucy and Suzanne could stand at their window or in their garden and watch the interments at close range. They soon realized that this proximity provided another opportunity for action. When they saw cemetery workers preparing for a burial the next day, they knew they could strike soon. After dark, they moved among the gravestones, around the church, or along the fence, surreptitiously placing their notes for soldiers to find.

During some funerals, they stole out of La Rocquaise and toward the line of staff cars parked along the road. While prayers were being said and

tributes offered to the fallen soldier at a graveside only a few yards away, Suzanne cracked open a car door, flung a pamphlet inside, and silently guided the door back in place until it latched. They scurried back to La Rocquaise and bolted the door.

In early November 1943, from the safety of La Rocquaise, Lucy, Suzanne, and Edna watched the full military funeral of Oberleutnant Walter Zepernick. Charged with keeping up troop morale, he had served as special assistant to the island's commandant. With his excellent command of English, Zepernick spent a lot of time partying with local Jersey residents and fellow officers into the wee hours of many mornings. He and his Jersey girlfriend often zoomed around the island in a convertible. Despite the deepening tensions after the radio ban and the deportations, Zepernick was the one German whom people seemed to respect. One young Jerseyman remembered "Zep," as he was known to many locals, as "very intelligent and good looking. He loved himself and his hat was always set on an angle. He was not feared on the island—he went out of his way to make friends with the islanders."

On October 31, 1943, on his way home for leave, Zepernick was killed when British planes bombed the train carrying him through the French countryside. Zepernick had fallen in love with Jersey and wanted it to be his final resting place. When the German military returned his body a few days later, he was the talk of much of the population. The funeral in November became a huge event. A cortège departed the port at St. Helier and made its way across the island; the coffin rode on a gun carriage. Special buses crisscrossed Jersey, taking mourners to the St. Brelade's Church cemetery, where large crowds of German officers, local officials, and residents gathered for the ceremony. Those who could not attend sent wreaths to show their grief.

That night, after the body was buried and the graveyard empty, Lucy snuck out, a dim moonlight barely illuminating her path. The sound of the waves in the bay crashed onto the beach below. Suzanne watched her run toward the cemetery, carrying something in her hand. Lucy darted among the headstones until she found Zepernick's freshly dug grave in the Heldenfriedhof. She laid a small black cross on the dark, moist soil. This cross, which Suzanne had made of wood, mimicked the ones the Germans used to mark the graves of their men. But Suzanne's carried a different

message. In Gothic script, she had written, *Für Sie is der Krieg zu Ende* ("For you the war is over"). Nazi ideology glorified war and honored the fallen dead as heroic martyrs to the nation, but this homemade wooden declaration challenged observers to think that perhaps this man was not a hero, just a lucky one who had escaped further suffering.

The widely known image of the wooden cross as a temporary grave marker on World War I battlefields may have influenced the project. Lucy and Suzanne had probably read Parisian writer Roland Dorgèles's *Wooden Crosses*, the 1919 prize-winning antiwar novel that humanized the pain and anguish of battle and was based on the author's own experience as a machine gunner and pilot. "All along the steep bank wooden crosses, slender and bare, made of boards or of branches crossed and fastened together, looked at the water as it ran," Dorgèles writes. "One might have said that these dead men were fleeing from their forgotten tombs, and the endless file of the other dead men watched them set forth, their crosses so close together that they seemed to be shaking hands with one another."

The cross placed on Zepernick's grave was the first of many Lucy carried to the cemetery. Carrying these totems to the cemetery became a regular covert action whenever there was a German funeral. At first, Lucy laid the crosses flat on the ground. Later, she plunged them into the earth. At the St. Brelade's Bay Hotel, just yards from the cemetery, the German officers were clearly vexed about the mysterious objects. George still worked there, and he overheard them discussing what to do and wondering who was behind it all. The message painted on the crosses was scandalous, the officers all agreed. Whoever is leaving them is suggesting that the living should envy the dead! How is that good for our morale?

One day, Lucy and Suzanne noticed that the crosses had disappeared. A police officer now stood guard at the cemetery.

BY EARLY 1944, the Allies continued advancing on Axis powers. If the Allies launched an assault in northern France, as many expected, it would cut off supply lines to Jersey and stop any prisoner transfers to the Continent. As a result, the Germans moved ahead the timetable for deporting convicts to camps. Stepping out of line would now have more immediate consequences, but Lucy and Suzanne believed that their work was too important for them not to press on.

Neither of the women received much mail during the war, but their mailman routinely stopped by with local news of interest, and they all exchanged bits of information they had heard on the BBC. One day, the mailman brought Lucy a postcard from an old friend living in Vichy, the capital of collaborationist France. To her surprise, it was addressed to Claude Cahun. Whether anyone on Jersey knew Lucy's artistic pseudonym from her days as a Paris radical is unclear. She certainly did not use it in daily practice on the island. The Jewishness of the name and the fact that a French citizen was using an alias might easily have aroused police suspicions. The German army constantly monitored the island's mail, so even a brief note like this was alarming.

Luckily, the censors had not noticed the card. Perhaps by this point they were too lazy to care, Lucy speculated. Once through the censors' hands, the postman then had to decide what to do with it. Even if he didn't recognize the name, he possibly knew that the women were French; maybe he even figured out that Cahun and Lucy were the same person. In any event, he delivered the postcard without incident.

Lucy sat down at her desk right away and wrote back to her friend. She made sure to use coded language, writing as though addressing a close family member and referring to "family secrets." Her friend would need to read between the lines. Framing the message as family correspondence meant that it could go out through the Red Cross rather than through the regular mail.

One day, the postman's son showed up at La Rocquaise with a Ukrainian man, Pyotry Botatenko, who had escaped from the OT camp multiple times—something that was easier to do than the Germans liked to admit. As punishment, the soldiers had flogged Botatenko and left him tied to a pole with the skin on his back flayed open and burning with pain. When he escaped again, he found a family who offered to help him.

For the next few weeks, he moved between some ten other families on Jersey. Each fed and clothed him and tended to his wounds. He also received gifts from many more people, all of them part of an informal network of Jersey residents assisting escaped OT workers. He ended up with the postman's family, and now he asked for Lucy and Suzanne's help in hiding from the GFP.

They willingly took him in, just as they had done for several others in the previous months. Lucy and Suzanne ushered Pyotry to one of the

outbuildings so that he could hide more easily and make a quick escape if the Germans came. They asked him, in return, to do some of the housework, including tending the fireplace—so George and Edna had to know he was there.

Despite the increased risk with Pyotry hiding on the property, Lucy and Suzanne decided the time was right to create a new leaflet. This one would specifically insult officers of the GFP, which they and most others on Jersey inaccurately called the Gestapo. Years later, in her postwar writing, Lucy could not recall the exact text Suzanne had translated into German, but she remembered that its angry words went something like this: "The lords of the Gestapo are feasting and keep themselves well—as soldiers—to defend the Fatherland. They are afraid of their own spies, of their shadows. . . . Soldiers with No Names, comrades, all are against these cowards, these pigs and their spies. The end of the war is near."

That spring of 1944, Lucy was talking to George in the garden, overcome with a sense of impending doom. Perhaps the presence of George and Edna's child, almost a year old now, raised the stakes. With Pyotry in the outbuilding and her resistance work with Suzanne escalating, she decided that she needed to warn George. She knew that plenty of people had been arrested on the island for ever-expanding acts of defiance. No one on Jersey had any idea about the full extent of German killing in the extermination camps in eastern Europe, but they knew about prison camps from those who had come back from Alderney. "I should tell you there might be danger for you to stay with us," she said. "I cannot say more. But . . . well think about it . . . hadn't you rather live somewhere else? It won't last long now. I felt I must warn you. That's all there is to it."

George and Edna had already run plenty of risks on their own at La Rocquaise. They smuggled food into the house beyond the allowed rations, some of which George had stolen from the hotel where he worked. They regularly listened to the illegal radio and helped Lucy and Suzanne hide both it and the typewriter. They must have known about the several escaped OT workers who had taken refuge in the shed, including the one there at that very moment. Edna had helped feed an OT worker on the beach. Still, George and Edna very likely were ignorant about the extent of what Lucy and Suzanne had been doing for the past several years with their notes.

"Don't worry about us," George told Lucy.

III

ARREST AND TRIAL

11

"COME IN . . . GENTLEMEN"

"THIS IS LONDON. London calling in the Home, Overseas, and European services of the BBC and through United Nations Radio Mediterranean. And this is John Snagge speaking."

On the morning of June 6, 1944, just after 10:30 a.m., listeners on Jersey (which, as an occupied territory, remained on Berlin time, one hour ahead of London) heard the news bulletin begin. "Supreme Headquarters Allied Expeditionary Force have just issued Communiqué Number One. And in a few seconds, I will read it to you," Snagge intoned, his voice emanating from illegal radios hidden around the island.

After a dramatic pause, Snagge's steady voice and upper-class British accent heralded the dramatic words everyone had been longing to hear for years: "Under the command of General Eisenhower, Allied naval forces, supported by strong air forces, began landing Allied armies this morning on the northern coast of France."

If Lucy and Suzanne didn't hear Snagge's wondrous announcement in the morning, they may have heard him give the good news that evening, beginning with this proclamation: "D-Day has come. Early this morning, the Allies began the assault on the northwestern face of Hitler's European fortress."

By the time these words rang out across the island, more than 150,000 American, British, and Canadian troops had begun to breach the Atlantic Wall, scaling the beaches on the eastern shores of the Cotentin Peninsula in Normandy, France. The 82nd Airborne and the 101st Airborne Divisions of the US Army passed within just a few miles of Guernsey and Jersey as they flew into battle.

On Jersey, the Germans weren't entirely sure how to respond to D-Day. Soldiers grew increasingly tense, and the commanders extended the curfew one hour earlier and one hour later than before. At first, troops went to battle stations and closed the beaches, but a few days later the beaches were reopened. Patrols decreased but became more thorough. Outside the military post office, German troops began packing files and documents into carts, perhaps for safekeeping or possibly to begin destroying them.

The leadership seemed generally satisfied with the island's defenses, and at first the only visible sign of improving them after D-Day was a squad cutting eight-foot lengths of timber. Eventually, soldiers transported guns from Alderney and Guernsey to bolster Jersey's defenses. Soldiers placed land mines around the island at strategic points and enforced a blackout to deter bombings. For now, the Allies were concentrating all their energy on France, leaving the heavily fortified Channel Islands untouched as they charged west.

About a week after the Normandy landings, the *Jersey Evening Post* ran a story from Berlin asserting that the island would be defended to the last man. However, a Jersey informant interviewed by British military intelligence reported that by this point, German morale was desperately low and, with no extra rations, had been since the previous Christmas. "Many individual Germans have announced to the British their intention to surrender as soon as the Tommies come," he told MI-19 agents in his debriefing. In the meantime, "their sentries are strained and jumpy, officers on patrol in the streets are more bloody-minded than usual, while other ranks make vain efforts at fraternisation with the civilians."

This informant believed that the time was right for the Allies to drop leaflets on the German soldiers, "graphically showing the Germans by maps and diagrams how hopeless [was] their position and how complete [was] the blockade." This kind of psychological warfare, he insisted, would lead them to surrender and not fight a lost cause. "The Germans in the Channel Islands have for long regarded themselves as lost men."

Lucy and Suzanne clandestinely followed the BBC coverage of the two million Allied soldiers converging on northern France, the largest invasion of its kind in human history. They trusted it would be the beginning of the end of the German empire and the occupation of Jersey, and they quietly cheered when they heard about Allied advances. Most people on the island

were cautious and did not want to get too emotional in case things took a turn for the worse. Even this good news, Lucy and Suzanne agreed, would not stop them from distributing their notes. After all, Jersey was still occupied territory.

After D-Day, the GFP stepped up its surveillance activity, especially against those listening to illegal radios, and pressed their network of informants for names of people who might be secretly tuning in to the news from London. Philip Pallot, the superintendent of St. Helier's cemeteries, often went to a friend's house to listen to the nine o'clock broadcast. One evening in June 1944, someone told the GFP of his activities. Around midnight, Pallot's mother heard a noise downstairs in their house and sent her son to investigate. "Needless to say," he recalled, "I was escorted back upstairs, feeling the cold revolver in my back."

The fighting raged on through the month of June. French Resistance operatives sabotaged bridges and railroads behind the front lines. The Germans launched the first generation of their secret weapon, V-1 rockets, several of which killed civilians when they hit London. In late June, the Soviet army began its rapid, massive assault on the German forces, launching 1.7 million men and throwing the Nazis off stride. In the wake of mounting defeats, a group of civilians, assisting high-level German officers, conspired to assassinate the Führer with a bomb. On July 20, 1944, they made their attempt but failed.

Four days after Hitler's brush with death, Lucy and Suzanne were talking with Vera over tea at La Rocquaise. As Suzanne remembered the conversation years later, they confided in Vera about the work they had been doing and recounted their risks for the past several years. You have been extraordinarily lucky, Vera told them. "If there is anything in the law of averages," Suzanne replied, "our luck must be wearing thin."

The next day, Lucy and Suzanne went shopping. Along the way, they distributed more notes. As always, they had taken the bottle of Gardenal with them. On their way home, a soldier with bright blue eyes stopped the bus they were riding. In her arms, Lucy clutched a parcel of cigarette papers intended to become a new series of the Soldier with No Name's notes.

Everyone off the bus!

The soldier inspected identification papers and interrogated each passenger until he was satisfied. Once back at home, Lucy and Suzanne put the

cigarette papers into the suitcase where they kept writing supplies, Lucy's diary, and many other personal items. They tucked it into the corner. Their Underwood typewriter sat nearby, underneath the dressing table, and the illegal Philips radio was locked in the cabinet. Some copies of the messages they had distributed that morning were still in the bottom of Lucy's handbag.

Later that night, during a quiet dinner, a fist pounded at the door of La Rocquaise. It was the moment Lucy and Suzanne had been expecting every day for nearly four years. The only question was whether the Germans were clever enough to have discovered the women on their own or if someone had ratted them out.

Suzanne got up from the table, walked to the door, and pulled it open. Having studied these men carefully from afar for a long time, Lucy and Suzanne knew that they would not be smiling.

Five men stood on their doorstep, including Captain Bode and a fair-haired man with bright blue eyes who wore mustard-colored plus fours. They were joined by a rough-looking man ("the American gangster-type," Suzanne later wrote) along with "a chinless NCO" (noncommissioned officer) and another man. Suzanne greeted them with a simple "Good evening." With a surprising graciousness, the fair-haired man clicked his heels and made a deep, respectful bow from the hips. "German Secret Police," Suzanne remembered him announcing politely. "We come to search your house."

Holding open the door, Suzanne looked at them in silence for a few moments, but she could not hide her lack of surprise. "Come in," she stated matter of factly. Then, after a beat, she added "gentlemen," commenting many years later that she'd held "a forlorn hope that the word might create the thing."

Suzanne noticed Bode's ears sticking out, and she thought he had "the mouth of a degenerate, but without having the air of a congenital idiot." Lucy thought his shiny, round head looked like a sugarloaf but that he had the ears of a beast and a thick neck and fingers.

Bode strode to the window seat and made himself comfortable, perhaps puffing on his cigar, while the fair-haired man, whom the others called Karl, started to run excitedly back and forth throughout the house. The gangster and the others ransacked every corner, pulling out all the drawers, prying into every nook and cranny of Lucy and Suzanne's lives. From his

perch, Bode watched with suspicion as the two tired women, their faces slightly wrinkled and hair graying, stood by.

"Too late," Lucy announced in English, knowing that these men did not speak French and herself unable to speak much German. "Germany has already lost the war."

Lucy and Suzanne remained calm, but Edna panicked as the men ravaged the house. She knew everyone at La Rocquaise had been breaking German regulations by hoarding food. Perhaps she worried that she had let something slip about the radio or that George—who was not present during the raid—had misspoken at his job. With a young child to care for and many friends and family members on the island, these crimes could ruin her life and the lives of those close to her.

Karl came over to Lucy and stared down at her. "And what do you think will happen to you? You tell me that!" he shouted, his calm and polite demeanor at the door now gone as the adrenaline from the thrill of the chase pumped through him. He accused them of "extremely serious crimes," at which Suzanne merely smiled. Karl had the "mouth of an elephant," Lucy thought, and the "bald head of a stillborn intellectual."

"I think that probably you will torture us and shoot us afterward," Lucy replied flatly, as though she always had known and accepted that this would be the outcome.

Karl was stunned silent. These women were not hysterical or even surprised by a raid on their house but were already anticipating their own deaths. "I believe until that moment he had thought us unaware of the risks we had been taking," Suzanne reflected.

Karl looked at Bode and the gangster, then back at Lucy and Suzanne. "But we never do that kind of thing!" he proclaimed indignantly. "That is BBC propaganda." Lucy glanced back at him, raising her eyebrow in disbelief.

Observing from the window seat, Bode could tell this was no ordinary home. It was filled with nice furniture, books, and works of modern art by Picasso, Dalí, and Miró. There were photographs of Lucy, sometimes in strange dress or poses, and bizarre photographic collages with symbols and sayings, including one hanging next to the fireplace. These women were not ordinary French expatriates. Suzanne watched him eyeing their belongings. "He was obviously coveting our house, and our garden, and very likely our maid."

"Aaah!" Karl shouted from elsewhere in the house. "I see there is a loft."

"Yes, there's nothing in it except the water tanks," Suzanne replied. She took the lead in dealing with the Germans since she spoke the language. Lucy sat largely in silence, watching.

"We shall see!" Karl bellowed, and he ran off to investigate.

The gangster was squatting nearby, searching a large chest and listening to the exchange.

"If you told me what you are looking for," Suzanne said with a bit of impatience to Karl when he reappeared, "we should have finished sooner."

Karl, half astonished, half suspicious, stared at Suzanne silently for a few moments. "I prefer to find it myself."

"As you please," Suzanne said with a shrug.

The gangster turned and stared at Suzanne with his deep-set dark eyes. Suzanne remembered his expression as "malevolent." She lit a cigarette. The men searched methodically for a half hour and still did not find much. "Perhaps they were too busy looking at the view," Suzanne thought later. Had they looked at just the right time, they might have noticed the escaped Ukrainian OT prisoner, Pyotry Botatenko, fleeing the outbuilding where Lucy and Suzanne had still been sheltering him up until that very moment.

Suzanne reached for Lucy's bag and passed it to her secretly, trying to prevent the men from finding the copies of the notes they had stuck onto police cars that morning, but one of the soldiers saw and snatched it. He let out what Lucy called the "habitual 'Ach!'" The tracts discovered inside were clearly familiar.

Karl went upstairs. Suzanne went with him, followed by the gangster. When they reached the next floor, he opened the door and asked, "What is this room?"

"My sister's room," Suzanne replied.

Karl left the door open and continued to climb the stairs. On the next floor, he paused at the first door, and Suzanne indicated it was "the servant's quarters," Edna and George's room. She moved past him and continued down the hall as the men followed. They arrived at the studio, and Karl asked Suzanne to be seated. She sank into a chair, her back to the window, and finished smoking her cigarette. "The gangster sat on the floor in front of the green safe and started to examine photographs," Suzanne

remembered, while Karl pulled out the little drawers in their roll-top desk. He immediately found documents relating to the communist artists' group to which they had belonged back in Paris, and he tucked them into his portfolio. From there, he went into the library and began to examine their books. Suzanne stood to throw her cigarette butt out the window, and Karl looked up, his eyes following her every move.

He did not scrutinize much in the library, but one thing in particular interested him, a file marked "Havelock Ellis." "Please, what is this?" It was their translation of the famous psychologist's book, which Lucy and Suzanne had continued to work on in Jersey. He riffled through several of the pages, then slid the boxed papers back in their place.

"Karl! *Wir haben es alles!*" Bode called out from the floor below. We have it all.

The policemen had finally found the suitcase—the one that had been previously hidden in the outbuilding—tucked into a corner of Lucy's bedroom. The notes inside matched the ones they had in their file back at GFP headquarters. "It had seemed incredible that two men had searched so long to find a suitcase which stood practically in the middle of the room," Suzanne later wrote, especially since it had been visible from every point in the bedroom, the black case contrasting against the kingfisher-blue carpet and drapes. To top it off, the soldiers also discovered Lucy's wartime journal in which she described their activities in great detail.

Suzanne, Karl, and the gangster headed down from the studio to the bedrooms. There, they ran into Bode in the small passageway between Suzanne's room and Lucy's. Bode's face, according to Suzanne, "expressed a deep concentration, which puzzled [her] until he spoke." Apparently, he had been preparing for the past few minutes to say something in English, which required all his mental effort. A few feet away, the "chinless NCO," whom Suzanne also referred to as "the abortion," was on his hands and knees, still searching Lucy's bedroom.

"Do you know what we haf found?" Bode said, speaking slowly and carefully. When Suzanne recorded his words in her notes after the war, she tried to capture his heavily accented English. She had promised herself that she would remain dignified and polite while these men were in the house, but forgetting the calm demeanor she kept throughout the ordeal so far, she replied sharply, "Of course I know it! I'm not an idiot!"

Bode looked at Karl who translated. "*Nein,*" Bode said, nodding. These women were definitely not idiots. They knew exactly what they were doing.

At that moment, from the bedroom, "the abortion" shouted at the top of his voice in what Suzanne called "a truly Teutonic howl of triumph."

"*Die Schreibmachine! Die Schreibmachine!*" He had found their Underwood typewriter.

The Germans rushed to Lucy's bedroom, crowding around the long nineteenth-century mahogany dressing table. That table, inlaid with rosewood and standing on tall, carved legs, had been in Lucy's childhood home in Nantes. The women had simply, carelessly perhaps, pushed the typewriter underneath it.

With all their notes already in German hands, Suzanne knew that she and Lucy would be placed under arrest, but the discovery of the typewriter shook her further. "I leant against the chest of drawers and tried to collect myself," she wrote. "I had to fight down a feeling of dreamlike unreality which threatened my presence of mind."

Karl emerged from the scrum gathered around the typewriter. "Now," he demanded, "tell us where the wireless is or we will break everything!"

Suzanne was surprised that the men hadn't already found it. "It is in the glass-fronted cabinet near the bed, and the key is in the lock." She remembered what happened next:

> His mouth tightened, but he covered up his annoyance by taking
> immediate action. He strode to the cabinet, threw open the double
> doors with a theatrical gesture, and exclaimed AAAH! with such
> a genuine note of personal triumph that my amazement knew
> no bounds. He brought forth the old black market Phillips [*sic*],
> which had given us faithful service since June 1942, when the
> Germans had ordered all wireless sets to be handed in.

"Is it a good one?" Karl asked her.

"It is a very old one," she said. "I'm afraid you won't get much pleasure out of it."

The GFP now had everything they needed: notes, typewriter, camera, illegal radio, Lucy's journal, documents from their Paris days. But Karl wanted to make sure.

Suzanne tried to give Edna some money so she could take care of herself

and her child, but Karl grabbed the bills out of her hands. "I only want to examine the notes," he said, "and to make sure there is nothing written on them." He went over to the window and held them up to the light, looking for secret messages. Finding nothing, he gave the money to Edna.

"May I tell my sister to come up and change?" Suzanne asked Karl. Lucy had remained downstairs the whole time. "I suppose you want us to go with you?"

"Yes, you will sleep in jail tonight," he replied.

Suzanne went down to the dining room to fetch Lucy. After climbing the stairs, Lucy put on blue velvet corduroy pants, a striped jersey, a blue jacket, and her beige Burberry overcoat, and then she went to the toilet.

After helping lead the search of La Rocquaise, Karl was filled with pride. While Lucy was still out of the room, he felt the need to gloat to Suzanne.

"You do not recognize me?" he asked.

Suzanne eyed him carefully. "I have never seen you before."

"Oh, but you have!" He seemed delighted to reveal the truth about what had really happened the previous day. "It was I who examined your identity cards on the bus."

"That was a soldier," Suzanne protested.

"It was me in uniform," he announced gleefully, his blue eyes flashing at her.

Suzanne was thinking about other things, including instructions to give Edna and the fact that she and Lucy would possibly be dead within mere hours, but Karl persisted.

"You know, when I met your eyes, I knew at once that it was you," he said with a noticeable excitement in his voice.

"Do you mean that we looked guilty?" Suzanne asked. She and Lucy had worked hard to affect an air of detachment. Had they utterly failed? "I hated to think that our mask could have been so transparent," she later recounted.

"Oh no," he replied, "no more than you do now. But you see, I knew the two women I wanted were on that bus, and you were the only ones who looked intelligent enough to have done that work." He did not explain to Suzanne why he had been looking for two women specifically.

As the police prepared to lead their prisoners out of the house, Suzanne asked Captain Bode to wait just a moment. Lucy had a heart condition, she

claimed, and they couldn't leave the house without her medication. Would he permit her to fetch it? He would. When she returned, no one seemed to notice that Lucy's "heart pills" were in a little blue bottle labeled Milk of Magnesia. Suzanne clutched it tightly as the police showed them outside to a waiting car.

"I looked out as we drove towards town," Suzanne wrote in her postwar notes, "intent on taking in all that shone through the deepening dark of a landscape I would not see again."

The car proceeded east, tracing the bright shoreline of St. Brelade's Bay, and then turned inland along the hilly, winding road surrounded by trees. After a few minutes, they passed through the village of St. Aubin and continued eastward, curving around the water of St. Aubin's Bay toward St. Helier. Lucy and Suzanne perhaps turned their heads to look southward, knowing that the coast of France was off in the distance, along with so much of the life they had left behind. For all they knew, their ultimate destination would be a German concentration camp.

IN ST. HELIER, the car pulled onto Gloucester Street and slowed in front of the island's prison. "I had seen it, and noticed it," Suzanne later recorded, "every time we had gone to the Opera House, or to the Hospital, or to the . . . Shop. The huge wooden gate painted a glossy, dark green studded with big, black iron knobs." In each of those studs was a wrought-iron ring twisted into a shape that reminded Suzanne of a Celtic torc. Outside the prison, both soldiers and Jersey policemen patrolled, watching for escapees.

From these cells, dozens of Jersey residents had already been transferred to prison camps on the Continent, including twenty people who had been shipped out only days before the Allies cut off the island's link to northern France and just seven weeks before Lucy and Suzanne were arrested.

Once inside, Karl took the lead in the interrogation. Lucy and Suzanne learned that his full name was Karl Lohse. Before the war, he had been a businessman who worked for an export firm in Hamburg. The plus fours were part of his normal attire, but sometimes he also liked to dress in the style of Alpine Germany and would even wear a Tyrolean hat with a little feather on the side.

In addition to Karl and Captain Bode, the room was packed with police and a translator. Lucy was having difficulty standing up, and with great

*Karl Lohse, Lucy and
Suzanne's chief interrogator.*
COURTESY OF IMAGE
LIBRARY, THE NATIONAL
ARCHIVES.

relief, she sank into a chair. Presumably exhausted, her eyes closed and her head rocked back.

Suzanne was also struggling to stay awake. "I was beginning to drift away," she recalled, "and I foresaw the approach of that unforgettable feeling of detachment I had known thirteen years before when I had been given an injection of pentothal before an operation."

One of the soldiers who had searched their house—"the gangster"—had been particularly rough with them since they arrived at Gloucester Street, and he was in the interrogation room as well. "He's a beast," Suzanne complained to Bode.

His name was Karl-Heinz Wölfle, one of the most notorious Nazis on the island. According to historian Paul Sanders, he was known as the "face of the GFP in Jersey," even though most people understood that Bode was in charge. Still, many believed Wölfle was actually running the police, since Bode tended to spend more time at headquarters, leaving Wölfle, who was fluent in English (thanks to having lived for many years in Canada), to deal with civilians. To play up his own power, Wölfle often introduced himself as "Wolf, of the Gestapo," helping contribute to the myth that the Gestapo was enforcing the regulations on the islands, when in fact, there were never any such agents on Jersey. Saying he was from the Gestapo likely made

Karl-Heinz Wölfle of the GFP.
COURTESY OF IMAGE LIBRARY,
THE NATIONAL ARCHIVES.

him seem more intimidating, and it surely helped him become a successful black marketeer.

Underneath his carefully parted hair and thick eyebrows, Wölfle seemed to have kind eyes and a gentle expression, but after the war, British intelligence would call him "a nasty piece of work." He routinely threatened suspects, shouted, pounded the table, and shined bright lights in the eyes of those who had been arrested. "Fist marks on the eyes, broken teeth—victims, boys twelve and fourteen years old from Jersey that I saw in prison," Lucy wrote later of Wölfle's reputation. After the war, many others offered accounts of Wölfle's brutality. Joe Mière remembered Wölfle's men beating him—"Three Germans had a go at me and kept knocking me down with nearly every blow"—and how he spit out blood and teeth afterward.

The minds of the men who gathered to interrogate Lucy and Suzanne were surely filled with questions. Who were they working with? Who had put them up to this? Were German soldiers involved in their subversive activities? Who was the Soldier with No Name?

Given the sheer size of the file containing the notes, the Germans could likely not fathom that two women had written them all on their own. Nazi ideology taught that women were best suited for calm domestic tasks, not

daring acts. The interrogators wanted to begin extracting names from Lucy and Suzanne so that they could make more arrests. With the German war effort collapsing, Bode and his men were deluding themselves about what they might be able to accomplish. Allied forces were swiftly advancing on Paris, and the Soviets were moving westward toward Berlin. But as long as the Germans held Jersey, their work would go on.

With Lucy unable to stay awake in the interrogation room, the initial questioning was fruitless, so the policemen banished them to separate cells. Suzanne was also stumbling like a sleepwalker. "My last clear memory of that day," she recalled, "is being helped up a flight of stairs by two men. It was a strenuous business, dragging in slow motion." As she climbed the stairs, "Le carnaval des animaux" by Camille Saint-Saëns played in her head.

By the time Lucy got to her cell, she apparently had wounds on her scalp and was covered in bruises. Her coat was bloodied, and she thought her nose was broken. She wasn't exactly sure what had happened, and her postwar recollections are extremely vague on the matter; Suzanne did not record any violence in her writings. Whatever took place, Lucy feared that the brutal Wölfle or one of the soldiers would "wake [her] with his boot." When she entered what would be her home for the next few months, Lucy found a ragged, graying Russian prisoner sweeping the floor.

As the doors clanked shut, the women found themselves locked behind thick granite walls plastered in white. Light came from a high, barred window that could not be easily reached. A metal can served as a makeshift toilet.

Deep into a long night, the guards made their rounds, checking on the inmates. Their boots echoed through the corridors. During one check, a German guard and a young Jersey prisoner who was working as a sentry peered into Lucy's cell through the small window in the door and saw her lying unconscious on the floor. They swung open the door and ran to Lucy, shaking her, but were unable to revive her despite their best efforts. If the Germans ever wanted to uncover what they believed to be the active conspiracy on Jersey, they needed to continue interrogating Lucy, so they lifted her, limp and lifeless, and carried her to the hospital just across Gloucester Street. A few hours later, they discovered Suzanne collapsed on the floor of her cell and took her to the hospital as well.

The pills inside the blue Milk of Magnesia bottle were neither heart medicine nor the digestive medicine that the label indicated. Despite being in the presence of German soldiers every minute between their arrest and the moment they were locked away, both women had managed to ingest an overdose of Gardenal, probably while they were riding in the car.

They always planned for suicide to be their final act of joint resistance if necessary. Now they had put the pills to their intended use.

12

"IT BECOMES QUITE IMPOSSIBLE TO TRACE BACK THE ORIGIN OF A PARTICULAR IDEA"

FOUR DAYS AFTER INGESTING THE GARDENAL, Suzanne regained consciousness. But she remained in a daze, believing she was still at home in bed.

"I woke suddenly and lay quite still in the dark," she recalled (after 10:00 p.m., the hospital was lit solely with candles). She didn't know what had stirred her. She listened carefully for noises and then decided to get up and investigate. "Someone may have broken in," was Suzanne's hazy thought. "I reached for the lamp on my bedside table and touched the rough surface of a wall." Then she realized that she was not in La Rocquaise.

After downing the pills, more than one full week passed before she and Lucy regained their right minds. No one questioned them until they had.

The dose of Gardenal they ingested was not enough to kill them despite the advice they had received from some medical students who shared their belief in suicide as a personal option. "Yes, that's the right dose," Lucy remembered one of the students confirming. "Better to take too much than too little." Apparently, what the students believed was too much was too little. "In a way," Suzanne reflected, "it is easier to adjust oneself to the idea of death than to the idea of survival. It is so much more simple."

Their St. Brelade's neighbor, Mrs. Armstrong, found out about their arrest and was so outraged that she and her husband marched into Gloucester Street to protest what they saw as a wrongful detention. Mrs. Armstrong could empathize, since she had also come under suspicion. She frequented a cafe on Jersey run by an Italian so she could practice speaking

*Interior of a prison cell
in Gloucester Street.*
COURTESY OF THE
SOCIÉTÉ JERSIAISE
PHOTOGRAPHIC
ARCHIVE.

the language. During their conversations, she had made some insulting remarks about Mussolini. The police became aware of her comments but decided not to arrest her. But now that she was at the prison raising such a ruckus and insisting on seeing Lucy and Suzanne, the guards threatened to put her behind bars after all.

Mrs. Armstrong defiantly told the soldiers it would be an honor to be arrested by men like them as a matter of principle because she hated them so much. "Of course I told them what I thought of them and their nincompoop of a Führer!" she said. Lucy remembered her raging at the Germans. "A non-com as a field marshal, a vulgar person not even good enough to be a common workman!"

Once Lucy and Suzanne were both strong enough to be discharged from the hospital, the soldiers escorted them back to their separate solitary cells. Suzanne went to cell 3 and Lucy to cell 5 on the same side of the hallway in C Block (formerly Gloucester Street's women's wing). Suzanne remembered "WOMEN" carved in the keystone over the door. According to one former Jersey guard, C Block was where the Germans housed most political prisoners, both men and women, as well as German soldiers who had committed serious crimes such as desertion.

Drawing of interior of a prison cell on the back of a cigarette package. Whether Lucy or Suzanne created the image is unclear. COURTESY OF THE JERSEY HERITAGE COLLECTIONS.

They used B Block largely for local criminals and ordered Jersey wardens to oversee it. Inmates who violated occupation regulations and who were under direct GFP jurisdiction were not to mix with those accused of local crimes, but as the number of military prisoners grew, many ended up on the civilian side of the jail. When C Block became too crowded, "politicals" went to B Block as well. A Block, notorious for the harshest conditions and the most violent guards, held political prisoners on the top floor and criminals on the ground floor. Causing trouble in B or C Block meant a swift transfer to A Block. In between the complex's several buildings was an exercise yard and a lodge with its own little garden, where the warders, or prison guards, stayed. A little cherry tree grew nearby.

AS SHE CLIMBED THE STAIRS BACK TO HER CELL, Suzanne noticed that the middle of each tread on the iron staircase was worn so thoroughly by the feet of guards and inmates over the decades that the metal shone brightly through.

After resting inside her cell, Suzanne woke up. "My first conscious feeling was that I was still alive," she recalled. "I tried to push it away, suppress it. It refused to be suppressed. I gave in and opened my eyes to the gray

light of a new dawn. . . . The place where I found myself looked so exactly like a prison cell—I had never seen one before—that it could not possibly be anything else."

In the dim light, Suzanne could see that a former occupant, a soldier, had written on the wall a rhetorical question: *Wer wurde mein Führer dazu sagen?* What would my Führer think about this? She would watch that wall for months, observing how the light played across it, and she "came to know every pattern at every hour of the day."

At seven o'clock every morning, a plodding guard with a pear-shaped head named Otto woke them up when he turned the ten-inch-long key in the massive lock and pulled open the door to C Block. The heavy gate made "harsh creaks that suggested medieval dungeons," according to Suzanne. "After the creaks came Otto's heavy footsteps down the ground-floor passage. Then his bark: 'Aufstehen!' Get up!" Otto sometimes tried to anglicize the German command, but it came out sounding like "Hopschtandt!" (Up stand!)

Although Otto spoke some English, he did not do so very often. At first, he greeted Lucy as "Lady Schwob," and Lucy tried to correct him. "*Nicht* correct, *nicht gut* English," she said teasing him in a half-German, half-English stew. "Otto, say 'Miss Schwob' if you will be correct." He decided to stick with *Fräulein*. Lucy tried to tell him he should say "Debout les morts" ("Stand up, dead people") to rouse the French prisoners instead of "Aufstehen," but he didn't get the dark humor.

Otto and another guard carried a homemade wooden soup trolley very carefully up the stairs so as not to spill the tin mugs that were filled with the political prisoners' soup. They pushed the cart through the corridor three times a day, at 8:00 a.m. and 6:00 p.m. with meals and at 5:00 p.m. with ersatz coffee and bread. Suzanne heard the doors clang as guards served the food or took people out of their cells. "So this [is] institutional life," she mused, thinking about how she would have to adapt. The guards peered into each cell through the hole in the metal door. "To see an eye staring at you through the spy-hole . . . is—the first time—a rather unnerving experience. The eye looks larger than life and you cannot relate it to any likely owner."

Otto's face would be the most frequent one peeking through these spy-holes, and because she spoke German, Suzanne came to know him well. She even found that he "had a sense of modesty." He brought a small round

piece of cardboard, a rare item in a time of shortage, which fit over the window in the door, along with a piece of brown paper to cover the glass pane over the lightbulb. "I was to use these aids . . . when I wanted to wash or use the chamber pot," she recalled, "so that the men could not look in if they happened to be in the corridor, but on no account at any other time."

Once, not long after Lucy and Suzanne came back from the hospital, Suzanne overheard Otto thinking out loud: "A woman . . . trying to kill herself. A soldier, that's understandable. . . . But a woman?" Later, in her writings, Suzanne reflected on this: "Did he consider the soldier's lot so unbearable that any attempt to get out of it was justified? Or did he mean that suicide was the privilege of the uniformed male which no woman should presume to usurp?" Either way, Otto did not seem to glory in the thrill of death.

When it was time for exercise, Otto kept a close watch on the women. "My orders are that I must not take my eyes off you," he told Suzanne. The Germans were not going to risk another suicide attempt.

Lucy had long suffered from insomnia, which was exacerbated when the occupation began. Prison was different. Despite the hardness of the bed, she would easily fall into a deep sleep, although thanks to the loud banging of the doors and the shouts of the guards that startled her awake, she could never remember her dreams.

After ten days behind bars, Lucy complained that she had not brushed her teeth for some time and that she didn't even have so much as a handkerchief in her pocket. "You've left me here to die like a dog!" she scolded the Germans. In addition, they gave her the wrong glasses, which was especially problematic given her bad eyesight.

One day, the guards and Lohse escorted Edna, pregnant with her second child, as a visitor to the cellblock. She brought soap, a toothbrush, and some clothes. Lucy recalled that Edna was in tears and disheveled from all that had happened during the previous days. She rushed to Lucy's bed, embraced her, and wept as Lohse stood by and watched. The Germans had arrested George and charged him with the distribution of their leaflets.

"I am sorry about George," Lucy soothed Edna.

"Oh! . . . damn George!" Edna blubbered, according to Lucy's account. "I'm not worried about George! It's about you, Man'moiselle [sic] . . . and oh! oh! about Man'moiselle [sic] Suzanne."

Edna's emotion worried Lucy, and she turned to Lohse. "You can easily make sure that we told you the whole truth about George when you arrested us. That notebook in the suitcase—my diary of the distributions—should make it clear enough." There could be no charge against George, she told Lohse. "Neither he nor Edna knew that we were writing leaflets or anything of the kind. It is quite obvious they would not be willing to help us in a thing they could not understand."

"But you will understand, Miss Schwob, that we had to make certain inquiries. However, George will not be detained much longer, that I can promise." He paused. "But I did not come for questioning. You look very ill. You must rest." Lucy asked whether she could have her medicine. She may not have had a heart ailment, as she and Suzanne claimed at the time of their arrest, but she did have illnesses—uremia, a kidney condition, and gastrointestinal distress—which needed a variety of medications.

"Anything else you want? Are you well treated here? Is everything correct?"

"Quite," Lucy replied. "The warder seems most human."

Otto was nearby and heard Lucy's compliment. Lohse laughed and turned to him, slapping him on the shoulder. "Did you hear that, Otto?" he asked the guard in German. "You are a good man!" Then, turning back to Lucy, he said, "You are right, Miss Schwob, Otto is a good man—and a good warder."

Lucy remembered that Otto was a name used in one of the fictional dialogues signed by the Soldier with No Name. Now the name had come to life in the form of her humane jailer.

The soldiers did release George, as promised, but soon after, they arrested Edna despite her being pregnant. The police charged her with hiding a revolver and a camera and put her in a cell on the ground floor. Otto reunited her with Suzanne in the exercise yard one day. Edna could do Lucy and Suzanne's washing for them in one of the kitchens while she was imprisoned, he told Suzanne. Then he left the two women alone to talk.

The news wasn't good. "The Gestapo chaps helped themselves first," Edna said, describing the looting of La Rocquaise that happened almost immediately after Lucy and Suzanne's arrest. "They took your furs and most of your clothes away in their cars. Bode came over the very next morning after they arrested you to fetch Mademoiselle's traveling rug. I bet he'd been dreaming about it all night."

So Bode *had* been scoping out their belongings during the search of the house, just as Suzanne suspected.

"After them," Edna continued, "the chaps of the *Kommandantur* came, and the doctor. They took mainly books and small things they could put in their pockets. After that, they sent army lorries for the furniture and bedding, and more books—a proper removal. Of course they took all the house linen." Such items were precious now that they were in short supply.

Back in her cell, Suzanne thought about all the things she and Lucy had now lost for good, the family heirlooms and souvenirs of their lives gathered through the years. Despite the news, she remembered feeling numb. It was, she later wrote, "as if I had secreted a protective mental shell against the conditions in which I now lived."

ONCE LUCY AND SUZANNE FULLY RECOVERED from the effects of the Gardenal—now about two weeks after their arrest—the Germans resumed the questioning, but they continued to keep the women separate.

Lohse came to escort Suzanne from her cell to a waiting car that would take them to the GFP headquarters at the Silvertide Guest House, a short ride across St. Helier. On the way to the car, Suzanne decided to mention Edna's arrest, hoping to convince Lohse to release her. Edna needed to be back at La Rocquaise, helping George taking care of things. "If the house stays empty, people will break in. You know what it is like nowadays." Wartime necessity had made looters of many normally law-abiding people.

"All your property will no doubt be confiscated," Lohse replied, glancing at Suzanne.

"Oh well, in that case, if the house is burgled, it's your headache." She was almost taunting.

Lohse looked at her, puzzled. He could not resist delivering a lecture. "It is a great pity that you ever undertook this propaganda. If you had not done so, you could have lived on happily in your beautiful house and your lovely garden. You could have carried on just as usual. You could even have kept your wireless. We wouldn't have bothered you. . . . In this matter we only acted when we received information." They walked on toward the waiting vehicle. "You would like to know how we found out?" he asked, eager to gloat.

"I know," Suzanne retorted. "The woman from the shop where we bought the newspapers." Suzanne did not indicate in her postwar notes how

she knew this information, if she had suspected anyone else, or whether she was simply guessing.

Lohse was quiet for a few moments, neither confirming nor denying her suspicions. "You will understand that I cannot tell you anything."

"I'm not asking you to."

"You are not interested?"

"I don't want to be interested. We've had plenty of time to get used to the idea that there are informers in the island. This woman is just one of them. If I thought about her, I might be tempted to think that she is worse than the rest of her kind simply because it was us that she got into trouble. I should hate my mind to work that way."

"We did not bring them with us," he announced defensively.

"No," Suzanne came back at him. "The bad seed is always there. You only provided the favorable environment." She remembered Lohse grimacing at her unexpected smile.

"So you see," he said, steering their exchange back to his initial lecture, "it was very foolish of you to do this propaganda. If only you had kept quiet."

"Yes, I am sure it would be much more convenient if everybody kept quiet in all occupied countries."

By this point, they reached the car sitting in the warm August sun. Lohse helped Suzanne into the back "with perfect courtesy," as she recalled. He climbed into the front seat next to the driver. They headed east toward Silvertide, passing pedestrians who were surprised to see a woman in her early fifties in the backseat of a German staff car.

THE SOURCES ARE UNCLEAR, but Lucy probably rode to Silvertide in a different car. Each woman was interrogated separately, Lucy first and then Suzanne. During their questioning, in what can be viewed as another act of self-presentation, each crafted a version of herself for the GFP officials, emphasizing her own views about why their work was justified. They also described their interrogations differently in written reminiscences. These moments in their story were performances, both in the moment and after the fact.

Lucy's account of questioning by the Germans is the shorter of the two. When she entered the room where the questioning took place, she recognized several familiar items. The soldiers had taken the silver chandeliers

and the barometer from La Rocquaise. She noticed the antique Boulle clock, dating from the late seventeenth or early eighteenth century, which the occupiers had now put to their own use. "All your things will be sent to Germany," Lohse told Lucy in English.

"And what do you intend to do with the house?" she asked.

"It will also be confiscated," he announced, pursing his lips. "Unfortunately, it cannot be sent to Germany."

Lohse tried to read Lucy's journal, but he could not understand the French. "Karl made me translate several phrases word for word into English," she remembered, "and gave up."

He presented Lucy with the piece of paper she and Suzanne had put inside the empty champagne bottle and thrown into the bay. He also showed her one of their fictional dialogues between two soldiers, one of whom was named Otto. He had underlined the name.

"Did this Otto represent someone you knew at the time?" Perhaps he was the Soldier with No Name?

"No," Lucy replied.

"Well . . . now, thanks to the good man Otto, the good warder, you can appreciate what a real German is like."

He asked about the Armstrongs. In her typically blunt way, Lucy spoke her mind about her neighbors, but she also likely took care to make sure they would not fall under suspicion. "Conservative, most conservative, a British type of fascist," she told him, though she stressed that they were still good people.

Did Lucy tell them what she and Suzanne had been up do, Lohse wanted to know.

"Good gracious no! We could not dream of telling [them] about anything we did. Yes, we had tea at [their] house. That was all. Mr. and Mrs. Armstrong are very old and, having no servants, have no time to spare. They had nothing to do with us except as good neighbors."

Lohse then presented her with the fake invitation for the gathering at Plémont Grotto, signed by the Soldier with No Name. How did you distribute this and other messages to the northern part of the island? Lucy remembered him asking. Easy, she replied. We used a pushpin to attach an envelope full of leaflets to a wooden cart that was guided by a German soldier heading in that direction.

"I alone was the cause of all this," she suddenly confessed. "The type-writer belongs to me, and Suzanne doesn't know how to use it. The photomontages were mine. I wrote all the texts. I organized everything. Suzanne only translated the texts into German and accompanied me when I distributed the papers."

This statement was not true. Suzanne had been just as involved and just as complicit as Lucy in creating and distributing the texts and other items. Lucy herself recalled as much in her postwar reminiscences. But now, she was trying to take the fall.

"You must understand this," she pleaded, trying to convince him that she was the sole actor. "My family suffered in the war of 1870 and that of 1914–18." This, she claimed, was her motive—and hers alone—for revenge against Germans.

Then Lucy made a stunning admission, which put her in grave danger. Remembering the moment years later, she described it with characteristic understatement as "imprudent." But saying it would maybe help her prove that she, and not Suzanne, had good reason to undertake all the things they had done.

"Finally, I am, on my father's side, of Jewish origin."

Lucy did not record Lohse's reaction, but surely he was at the very least curious as to why she had not registered as Jewish, which was required under the Nazi regulations. This confession meant that Lucy was putting her own life on the line for Suzanne.

"I am completely certain," she continued, "that without me, Suzanne would have waited peacefully—like the Jersey loyalists—for liberation from without—the victory of the Allied armies, which she never doubted." Suzanne didn't have any reason to resist, Lucy lied.

Lohse did not buy Lucy's performance. He pulled out a carbon copy—one of the hundreds they had produced—of a manuscript of a song, which Suzanne had written in old German script. He asked Lucy to tell him what any of it meant or to reproduce the letters, but she just shrugged her shoulders.

The truth—"It was more often me who accompanied Suzanne, she who took the initiative that required the most sangfroid"—was something Lucy revealed in her later writings but never to Lohse.

SUZANNE'S POSTWAR REMINISCENCES of her interrogation—although fragmented, often scribbled in short bursts, scattered among accounts of other episodes from her life, and partially written on the back of a calendar—are far more detailed than Lucy's and richly describe her initial conversation with her German examiner.

When her turn came, Suzanne sat in the comfortable armchair across the table from Lohse. As he did with Lucy, he conducted her questioning in English. Captain Bode was in the room as an observer—despite his inability to understand very much of what was said unless Lohse translated it for him. A portrait of Hitler stared down at them from the mantelpiece.

According to Suzanne's memory, "Lohse sounded casual, almost absentminded." The conversation was confrontational but not overly aggressive. He seemed to be most interested in simply figuring out her motivations, but he was also trying to trap her into admitting to more than just distributing notes.

Leafing through Suzanne's papers, Lohse remarked, "We need not go into the question of identity since we have all your papers. By the way, I see that you were born in Nantes. You are not really French at all. You are Breton." Hitler had been trying to break French unity by supporting regionalist movements in Brittany, Flanders, and elsewhere. The Nazis argued that Bretons were an ethnically pure Celtic racial group, which had kept its superior Nordic characteristics.

Suzanne wasn't taking the bait, and she advised Lohse not to place his hope in the separatist movement, which she said was "quite artificial." Their ensuing conversation about the historical relationship between Brittany and France surely reinforced to Lohse that Suzanne was extremely intelligent and perceptive. This would not be a simple interrogation.

"Tell me, Miss Malherbe," he said with a smile, "have you ever taken cocaine?"

"Never."

"Morphia?"

"Yes," she said, and now it was her turn to smile. She was, as she put it, "eager to show that [she] was quite willing to cooperate," although that eagerness was an important part of her performance.

"Aaah!"

"At least I think so," she hedged.

Lohse's eyes widened. "You think so?"

"That was over ten years ago. I had an injection to make me sleep after an operation, and I am pretty sure it was morphia."

"But that is not what I meant."

"Isn't it?"

"No, no! I meant have you ever taken any drug regularly as a habit?"

Suzanne thought for a moment. "Well, before the war, I did take Epsom salts fairly often. But I still would not call it a habit."

"I mean dangerous drugs. Narcotics." A frustrated Lohse was looking for some reasonable explanation for why she would have engaged in such dangerous acts of subversion.

"Never. Do you really think I look like a drug addict?"

"Oh, not at all."

"In that case, why did you ask me these questions?"

Lohse seemed to be bursting with indignity and impatience as Suzanne toyed with him. She could see him preparing in his mind what he'd like to shout: "You are here to answer questions, not to ask them!" But he seemed to think better of it in the end and regained his composure. He was trying to perform a role as well.

"We have been astonished to find such a large quantity of drugs in your bathroom cupboard." (Most of these were for Lucy's numerous ailments.)

"Is that all? Have them examined by a chemist. He will tell you there are no dangerous drugs among them."

"Yes, that's what we have been told."

"Well then, what more do you want?" Suzanne was now giving way to frustration.

"I want to understand," Lohse replied in what Suzanne described as "a curiously childish and querulous tone." "Where did you learn German?"

"I was brought up by a German governess."

"Eine Deutsch Erzieherin," Lohse translated for Bode, who nodded and pursed his lips. "Did she ill treat you?"

Suzanne looked at him, astonished at the idea. Her devoted and beloved Lotte?

"We are trying to understand why you hate us so much," Lohse explained.

"But I don't," Suzanne replied. "I am not a good hater, and I could never hate a nation as a whole. I only think it is high time you learn to manage with your share of the world and stop invading your neighbors' lands. Anyway, those of you who feel too cramped can always emigrate individually and peacefully like civilized people."

Lohse changed the subject. "You did not go in for a profession?"

"I should have probably if I had been born ten years later," she said. But Suzanne had finished school in 1910, and women of her social class going into the professions, she reminded Lohse, "was not encouraged in those days."

"What was your father's profession?"

"He was a doctor. He ended his career as head of the Nantes medical school and chief surgeon of the hospital." She added, "As his father had done before him."

Lohse looked up at her with a look of deep respect on his face. In her later notations, Suzanne wrote: "I do not often boast of the family's achievements, perhaps because I am too well aware that I have added nothing to them. But considering my predicament, and knowing the Germans' deep reverence for titles, hereditary or acquired, I thought now was the time when a little reflected lustre might come in useful." She was trying to play Lohse as much as he was trying to play her.

"Where did you learn to use a transmitter?" Lohse asked. Of course, neither she nor Lucy ever had used a transmitter, and the soldiers certainly did not find one at La Rocquaise. The question was a standard interrogation technique, designed to catch Suzanne off guard and see if she would reveal more than she wanted, but it produced no results for Lohse.

He asked about Mrs. Armstrong. "When did you last see her?"

Were the Germans trying to implicate her neighbor as a coconspirator? Did Lohse suspect her of something else?

"What gave you the idea of signing these leaflets as if they were written by a German soldier?" he continued.

Suzanne's reply was impulsive. "But you did. Your 'Man in the Street' in the *Evening Post*. We thought it was such a good idea." Since the Germans censored the local island newspaper, Suzanne was suggesting that all the content in its pages was ultimately theirs, including the recurring column that supposedly captured the opinion of Jersey residents. This was a lie,

though, and one that she immediately regretted. "Our mythical soldier started his career long before their mythical 'Man in the Street,'" she recalled later, "and they almost certainly held some earlier leaflets of ours that could prove it."

However, Lohse seemed pleased with the answer, apparently flattered that Lucy and Suzanne had not come up with the idea themselves but had been inspired by German propaganda. "I comforted myself with the reflection," Suzanne remembered, "that people seldom bother to disprove the authenticity of that which flatters them." It didn't really matter since this interrogation was not a judicial exercise in fact finding but a military inquiry that would only help determine how guilty they were, not whether they might actually be innocent.

"Did it not occur to you that you might have more scope for your activity in France?"

"We thought of it at the beginning of the occupation. But we decided against it. . . . We would have had to obtain permission to go. That would have brought us to your notice, and we should have found explanations difficult since we had no home in France, and we did not wish to mention our families, of course."

"Why not?"

Suzanne explained that she and Lucy were determined to keep their families safe and not involve them in any way in their actions. "I believe that most people who did not know us well would have thought that we were too old to be much use in resistance work." She had just recently turned fifty-two, and Lucy was forty-nine. "Moreover, we are accustomed to working together," Suzanne explained. "Besides, it would not have been much use because we are not good group material."

"What makes you think so?"

"You can't have a good working group without discipline, and we have been brought up to decide for ourselves."

"But you might have been giving the orders."

"Never. We would not be responsible for other people's lives. We can only work on our own."

Lohse pressed further, trying to find out whose idea the notes were in the first place. In her interrogation, Lucy had confessed that she was behind it all.

"Of course she would say that," Suzanne said, "and I cannot deny that she was the first to formulate a workable plan. . . . But things aren't so simple." Suzanne was more than willing to take her share of the blame. "When it comes to people who have played and worked together from childhood, and made a habit of discussing everything together, it becomes quite impossible to trace back the origin of a particular idea to one of them rather than the other."

Lohse seemed rather taken aback at the statement since Suzanne had now implicated herself completely. But she was not going to let Lucy take the fall alone. She remembered how Bode just watched and silently nodded.

"Did you think that England would reward you for the work you were doing?"

"No. I have felt from the beginning that we would not survive the war." Suzanne admitted to herself later that she had not thought much about the future once the occupation began. During the war, she concerned herself with how to survive with food from their garden and how they might buy what they could not grow, but she could not imagine herself and Lucy "alive in a postwar world."

Lohse was not expecting such a forthright answer, but he pressed on. "Germany is the only country who really looks after those who work for her," he ventured. He saw Suzanne's smile and perhaps read the suspicion in her mind that he was trying to get under her skin. "You don't believe me?"

"Funnily enough, I do. But then you must consider the motives."

"Motives?" Lohse raised his eyebrows.

"Motives," Suzanne repeated. "When there is a war on, you Germans, I mean the bosses, are already thinking of the next one. So naturally you look after the people who have been useful once and may be useful again. But the English and the French, too, like to think they are fighting the war to end all wars. It is wishful thinking, and it tends to make them ungrateful. Nevertheless, I find it a more likable attitude."

"Is there one of our regulations that you have not broken?" he asked, changing tack.

Suzanne contemplated the question, sure that there must have been several, especially since the occupation command had issued so many rules, including some relevant only to specific trades or groups to which they did

not belong. But in the heat of the moment, she could think of just one. "We never went out after curfew," she said. The imposed curfew was between 11:00 p.m. and 6:00 a.m.

"Oh? Why not?"

"We had no reason to do so, and we are too old to break regulations just for the fun of it."

That claim was likely not true since Lucy had placed the crosses on soldiers' graves at night.

Suzanne was beginning to tire from all the questions and the stress of the situation.

"You did not feel tired when you worked on your propaganda until midnight or later," Lohse jibed.

"That's quite different. We had better food, and the work was interesting."

"I suppose Edna heard the typewriter at night?" Lohse suggested. (Suzanne did not indicate whether she agreed with his statement.) "Naturally we have questioned your maid. That girl seems to be devoted to you." His voice dripped with suspicion, perhaps hoping that Suzanne might implicate Edna and confirm their beliefs that this was part of a larger conspiracy.

"I don't see why you should find that so surprising."

"I beg your pardon," Lohse said, blushing. "But according to our experience, believe me, it is not often the case."

The gossipy nature of Lohse's remark surprised Suzanne. "No," she said. "I have never had that kind of domestic trouble. But then I would much rather do the work myself than keep under my roof someone I disliked or who disliked me."

"You trusted her?"

"On some points, entirely. On others, not at all."

"For instance?"

"I could trust her to look after us and after all the animals we kept. And that means a lot in times like these. I could not trust her with money because she drinks. Nor could I trust her with anything I would keep secret. It stands to reason that when you do things that you know can endanger your life, you don't confide in a dipsomaniac."

By emphasizing Edna's demons, Suzanne thought she might save the

life of her housekeeper. There was no reason for the GFP to hold her if she was not a reliable witness to what Suzanne and Lucy had done. It seemed obvious that Edna was not the source of the leak to the Germans.

As the interrogation drew to an end, Lohse pushed a prepared statement—a confession of their misdeeds for the past several years and a clear admission of guilt—across the table and asked Suzanne to sign it. She had already admitted her participation in writing and distributing the notes, but after reading the statement, she refused to attach her name. Suzanne surely realized this document would have no effect on their fate. She told Lohse that she did not agree with the way it described what they had done. Since she had not authored it, she would not sign it.

"Of course, you can put things your own way," she told Lohse, "but then you will have to sign the statement yourself."

"Do you believe I have tried to mislead you about . . . your statement?" Lohse acted hurt.

"I am sure you would never do such a thing," Suzanne replied. "It has been drummed into my head from childhood that one must never sign anything one has not carefully read and examined. I am not going to break the habit of a lifetime."

Suzanne pointed to one particularly objectionable paragraph, so Lohse took the typewritten declaration, which was several pages long, and began to modify that section. "If we allow you to take your statement so that you can read it over quietly," he said, "you must not show it to anyone at all."

"Good heavens," Suzanne replied. "There's only Otto. He would have a fit if I offered to let him read that. I mean he would be afraid. He would dare not touch it." Even after only a couple of weeks behind bars, she felt she knew her jailer well enough to anticipate how he would react.

The interrogation now over, Lohse rose to take Suzanne back to Gloucester Street. As she stood up from the armchair, she couldn't help but think that with only a small wooden stool back in her cell, she would not experience such a comfortable place to sit again anytime soon.

She turned to address Captain Bode. "Auf Wiedersehen, Herr Inspektor."

Bode was taken aback, not accustomed to people whom he had just watched being interrogated politely expressing the wish to see him again. "Auf Wiedersehen, madame," he mumbled.

Back in her cell, Suzanne looked over the typewritten pages Lohse had given her, concluding that it was "a sketchy, but on the whole correct account of the main points of [their] conversation." She put the pages on the small shelf and lay on the thin, hay-filled mattress to rest.

THE INTERROGATION BROUGHT UP some old memories and feelings, "as when you stir some quietly simmering brew, and bits and pieces that were lying at the bottom of the saucepan slowly float to the surface," she recalled, her mind traveling back to the years of her youth.

Five years old, Suzanne was spending a summer afternoon with her grandmother, who was talking with another old woman while Suzanne sorted through rocks, looking for pretty ones to add to her collection. Grandmother was lamenting her daughter's favoritism for Suzanne's brother at the girl's expense.

"But I have Lotte!" Suzanne protested, interrupting the grown-ups' conversation. Her Alsatian governess was so special to her.

"Nothing can replace a mother's love," her grandmother countered.

Suzanne realized that she had better not protest too much or her grandmother would cease to take pity on her as a "deprived" child, and this might threaten her supply of candies, which her grandmother liked to dole out.

Now, in her cell, her mouth watered as she remembered the rough sensation of her grandmother's "acid-fruit drops" against her hard palate. "I drifted off at a tangent, wondering about the innumerable physical memories dormant within a human body."

13

"I WOULD LIVE ONE DAY AT A TIME"

LUCY ASKED THE GERMAN GUARDS for some of her medications, but Bode was not as generous as he had been at La Rocquaise. He had fallen for that trick once before. Her medical condition was monitored by an elegant but haughty German military doctor who spoke fluent French in a way that, Lucy believed, revealed his special distaste for the French themselves. The physician examined Lucy and, "enjoying [her] weakness," ordered her to swallow five pills for her gastrointestinal ailments. "A perfect laxative—extremely mild," he told her. The effect was far from what Lucy—or the doctor—expected.

Guards once again found Lucy slumped over in her cell. Lucy recollected the doctor's attempts to justify himself to the guards: I have treated an enemy of the Reich just as I would have treated my own men. Medicine is in short supply. I have given her drugs reserved for soldiers in the Wehrmacht. I have acted in good faith!

Lying on her cot, Lucy finally regained consciousness and found the doctor hovering over her while she shivered with a fever. I believe I understand my error, Lucy recalled him saying matter of factly. I gave them to her by mistake and did not take into account that she had neither the size nor the stomach of a soldier. She is a member of a weak race.

Lucy swore never to open her mouth in his presence again. She did not trust the Germans with her medical care any further. When the doctor tried to give her the antidote to the previous drug, she kneeled down and slipped it into the cracks in the floorboards.

Suzanne heard the muffled commotion and realized that Lucy was in danger again. She could only fear the worst.

Locked inside the loneliness of solitary confinement without the love of her life, Suzanne was unsure of what was to come. At any moment, the cell door might open and she would meet her fate at the rough hands of a guard. "Considering what lay ahead of us, there was nothing more I could do for Lucy, and nothing more I wished to do for myself save put an end to this unpleasant situation. It was simply a question of ways and means," she later recalled.

"For the first time in my life," she reflected, "I was on my own. No one depended on me." This was a far cry from the years of caring for Lucy and running their household. "There was no one I could either help or harm, only myself and the enemy."

Suzanne had already resolved that if the Germans tried to deport them, she would throw herself from the top of the wide iron staircase onto the cold cement below. She knew that "it would probably make a mess," so she decided that she "would only enlist the law of gravity as a last resort." Alone in her cell, she lingered over her deepening thoughts of suicide: "I have no quarrel with death. It is a friendly hand, held out in the dark, and the knowledge that it is there for the taking is a good safeguard against fear and despair."

Uncertain of Lucy's fate, Suzanne finally reached a point of no return. Late in the night, she grabbed the shard of glass she had picked up in the exercise yard and pressed hard until she was slicing into the flesh of her wrists, thinned by several years of a poor, occupation diet. Her blood flowed all over her pallet, into the heavy pewter washbasin, and onto the dirty floor. She later wrote that the sight of her own blood had left her unaffected. It "simply went on dripping monotonously from my fingertips. What I wanted was to see it welling out from the wrist with each pulsation." She had tried to reach the artery but fainted before she found it.

Suzanne lay unconscious all night long, slowly bleeding out. The next morning, as guards stirred the prisoners and fellow inmates distributed morning coffee, someone discovered her. Once again, the soldiers rushed her to the hospital.

"As a suicide, it was a dismal failure," Suzanne reflected in her writings after the war, "but I found some compensation in the fact that the [guards] immediately became more amenable. I had not realized how much they wanted, at least for the time being, to keep us alive." And because of this, she realized, her suicide attempts held a thin silver lining: the guards

brought her linens, extra clothes, and blankets, all of which helped make life a little more bearable. Although she did not say how she knew, Lucy claimed that the entire island began talking about the scandal of their attempted suicides. Perhaps Vera was spreading the word.

Meanwhile, Edna had been fortunate to procure a laxative for Lucy's bowel condition and some sleeping pills from a local pharmacist. Lucy refused to take the sedative, however. She thought it would come in handy for another suicide attempt in case she was deported.

BACK FROM THE HOSPITAL, Suzanne tried to settle into prison life again. "Three steps—turn—three steps—turn—to and fro." Suzanne paced across the creaky wooden floor, measuring out the dimensions of her nine-by-nine-foot cell. "We are kept behind steel doors like valuables in a safe."

Lucy could hear the echoes of her partner moving around in her cell down the hall and took note of what she called Suzanne's "calm courage." Of the repeated marching, she recalled, "Barely making three steps, then turning suddenly, like a pendulum, it stunned me, and made me crazy." By contrast, Lucy preferred resting on her cot.

The guards kept a close watch on them both, regularly shining flashlights through the holes of the doors into the darkness of their cells to make sure nothing was amiss. They would have no more suicide attempts.

Like other inmates, Lucy and Suzanne received regular care packages from friends, including Vera and Edna, containing books or food. The Germans tried to remove any contraband from the parcels, such as letters, pencils, or jotted-down news from the BBC, but some forbidden items still slipped through. When Otto accused Lucy one day of having some illicit items, she just shrugged her shoulders, and he went away grumbling.

Lucy and Suzanne had grown up wealthy and lived their entire lives in luxury. Now they were deprived of nearly everything. Lucy had only matches and the striking paper torn from a matchbox, the stub of a pencil, a piece of a razor blade, a bit of twine, a cigarette butt, and some geranium petals. Suzanne did not fare much better: "Apart from the clothes I stood in, I owned a wristwatch, a pocket comb, a lipstick, and two handkerchiefs, by now extremely dirty. Also a cake of soap and a carton of toilet paper. I had never imagined such a degree of destitution." This life inside Gloucester Street was so different from anything the women had known.

Suzanne had learned the new routines of prison life, but not knowing how long she would be there required her to adapt. "I had long thought that the two real luxuries in our overcrowded and overbusy world were time and space. Space I had had in plenty, and now I had lost it. But, on the other hand, I now had an awful lot of time to dispose of—that invaluable commodity I had hitherto found in short supply. It was up to me to make the most of it. . . . I would live one day at a time and let the more than usually uncertain morrow take care of itself."

Somehow, not being able to do anything about the situation made her feel better. At least now, in August, it was warm in her cell. She knew that colder weather would arrive soon. "I had a lightning vision of what the situation would be like in winter. Well, no need to worry about that," she reasoned. "I would be dead."

Except for daily exercise in the yard or inside the hallway of C Block when the weather was rainy, Lucy and Suzanne saw only the inside of their cells. Their beds were made of wooden planks covered by a meager hay-filled mattress, which grew thinner by the day. Suzanne's was wrapped in a purplish material that, she speculated, might have been a repurposed curtain. Hay poked through the cover, tearing the fabric and prickling her skin. At times, the bed's hardness woke her up. "The pain became sharp enough to reach me through the cocoon of sleep," she remembered. "I transferred the burden from my lower spine to my right hip bone or vice versa."

When Suzanne complained to one of the guards about the bed, he reportedly replied, "You have acted like a man, you must expect to be treated as a man."

One day, following Suzanne's suicide attempt, a German Red Cross nurse wearing a dark blue cape visited her cell to check on her condition. As Suzanne was getting dressed, the nurse picked up Suzanne's tweed coat and began to run her fingers along the seams. She turned the thick leather buttons between her fingers. She appeared to be checking for contraband.

"You could have poison hidden in these," she explained.

"Don't be silly," Suzanne scoffed. "If I had, I should have used it instead of messing myself up." Poison was far more efficient than a shard of glass.

Suzanne and the nurse stared at each other in an awkward silence. Finally, the nurse put the coat back where she had found it.

Suzanne lay down on the mattress and pulled the coat up over herself

like a blanket. She was exhausted and ready for the nurse to leave, but this unwelcome visitor continued to poke around the cell. She moved toward the small shelf where Suzanne kept a few possessions and examined each one in turn. Suzanne worried that the nurse might discover her small pencil that she had hidden behind a piece of cardboard covering an old air vent. She had also squirreled away some cigarette butts and matches left behind by previous tenants of the cell.

"If you please," she told the nurse, "do not handle the food. It is not hygienic." The nurse quickly stepped back, embarrassed at having been caught fondling Suzanne's belongings.

She moved closer to Suzanne. "The police will question you. You must tell the truth because the good God will be listening," she implored. Standing out in the dimness of the cell was the nurse's shining white armband with the Red Cross symbol.

"This strange exhortation startled me out of my tiredness," Suzanne remembered. "For the first time I looked at this woman with interest."

"Do you actually think there can be a good god watching the interests of the Gestapo?" Suzanne asked the nurse. That "anyone could carry the *Gott mit uns*" ("God is with us") this far was astonishing.

The nurse gasped. "Don't you believe in God?"

"Not in that one."

"But you must believe in something."

"Oh, undoubtedly," Suzanne replied, then closed her eyes, trying to signal that she was finished with this conversation.

The nurse stood silently for a few moments, then tried again. "What do you believe in?"

"Simple things. Rules of conduct. I believe in keeping one's word and in respecting contracts, whether in private life, in trade, or in politics. And above all, I believe that we should carefully avoid harming our neighbors—and even help them if we can."

"But if you truly believe that," the nurse argued back with a note of triumph, "you must be sorry for the poor young soldiers who are in prison because of what you have done."

Suzanne laughed. "Those poor boys who are locked up here have a far better chance to survive the war than their comrades who have been sent to the front."

The nurse's jaw dropped, and her eyes went wide. She took two quick steps to the cell door and knocked repeatedly until Otto opened it. She hastily made her way down the corridor away from Suzanne's cell.

Suzanne's attention turned to her cherished pencil and other forbidden items. "As soon as I heard Otto shut the heavy door, I began to look for a safer hiding place."

SINCE D-DAY, deporting prisoners to the Continent had become extremely difficult, making the jail even more crowded. Conditions in the already filthy C Block deteriorated. Even a small brush up against one of the white-washed granite walls sent "a storm of plaster spreading a dry fog, irritating the throat and the eyes," according to Lucy. Though she avoided the walls, the white dust invaded her cell, triggering her cough. The small wooden vent near the floor must have been blocked, she thought, because no fresh air came in through it. Such conditions were certainly not good for some-one with her history of illness.

On one end of the first floor was a small lavatory. Its powerful stench usually overcame the smell of the plaster dust. Each morning, prison-ers went downstairs to rinse out their "jerries" and collect water in their bowls for the day. There was only one toilet, and the single sink was always blocked. Prisoners gathered around the faucet, leaning against the disgust-ing bathtub, and gossiped in quick whispers to share what they knew about life on the inside and the outside. They took turns teetering on the edge of the tub as they tried to catch a whiff of fresh air between the bars protect-ing the high window.

Sometimes a trip to clean out the chamber pot afforded an opportunity for Lucy to slip a letter to a Russian named Volkoff. He was the man she had seen sweeping out her cell when the guards delivered her there for the very first time. One morning she handed her letter to Volkoff in the hall-way. Suddenly he dropped it to the ground, and with one quick motion of his broom, he swept it under Suzanne's door.

After the mistake with her medicine, Lucy refused to eat out of fear that the soldiers were trying to poison her, further weakening her already frail body. All she wanted was tea and rice, which Otto said could not be found, and he chastised her for being unwilling to take any-thing else. He tried bringing her food that was normally reserved for

the troops. He cut it up into small bites for her, but still she would not accept it.

Nervously, Otto continued to watch Lucy waste away. If she died in his care, he would have to answer to his superiors. After noticing some blood mixed with her urine in the chamber pot, he somehow found rice for Lucy. "Little by little, I forced myself to swallow it," she remembered.

Lucy would not drink cold water, so Otto ordered a Russian prisoner named Wassili to heat up a quart of water on the stove in the warder's lodge and bring it to her before it got cold. This little luxury brought her back to life. When Wassili came into her cell with the steaming pot, they shared bits of information as best they could, even though they did not speak the same language.

If Wassili didn't bring Lucy her hot water, then sometimes a Ukrainian named Mikhail did. He had been born on Christmas Day in 1919, he told his fellow inmates, and fought as a tank driver in the war. He was captured by the Germans, escaped, recaptured, escaped again, and made his way to Poland disguised as a woman. The Nazis picked him up and deported him to Germany, then to France, where he slipped from their grasp. After being detained once more, the Germans beat him with a rubber truncheon, threw him in jail, and sent him to one of the camps, first on Alderney and then on Jersey. He escaped from the OT camp and roamed the Jersey countryside for some three months before he was seized and returned to the OT camp. Again he fled, this time hiding in a Jersey farmhouse. Visiting a neighboring farm, he seduced the much younger wife of a very old farmer. When the old man found out that his wife was having an affair with an escaped prisoner, he informed the troops.

"I was arrested by the Germans as I was going to church," he told Lucy.

When Mikhail came to Gloucester Street, he was gaunt with a face that Lucy thought looked like a death mask, but Otto found some mashed potatoes for him. The other prisoners, including the Jerseymen with whom Mikhail shared a cell, helped him eat and regain a little strength.

As both Lucy and her mattress got thinner and thinner, she developed abrasions along her spine where the boards underneath the pallet rubbed causing her to bleed. Some of the blood got into her hair, matting it down. Otto let one of her fellow Jersey prisoners enter her cell to help clean her face and untangle her hair. The warm water felt so good against her skin.

In the mirror Otto loaned her, Lucy could watch as the Jerseywoman brushed her hair, straightening out the tangles and washing away the blood. Some strands still possessed their natural color, others had been lightened by the Jersey sun, and still others were grayed with age. Although only forty-nine, life seemed to be slipping away. Everything was so fragile. She realized that was probably why Otto never left her alone with the mirror—it could easily be broken and one of the pieces used to slit her wrists.

Lucy and Suzanne continued to hear bits and pieces of information from the outside, although they couldn't know the full extent of what was happening just a few miles away in France. On the night of August 26—just over a month since their arrest—Suzanne stuck her hand out through the window in her door and made a V sign with her fingers in hopes that Lucy might be peering out the hole in her door and somehow able to see. She had just found out that Allied troops had liberated Paris the day before. Soon they would race across western France, reaching the German border by mid-September. The Channel Islands remained firmly under Nazi control. But for how long?

One night, Lucy, lying on her cot after dinner, heard the metal of the lock on her cell door grinding as the key turned. Lohse opened the door slightly. He was ghostly pale and angry. Lucy believed he was drunk.

"You get back home," he told her, "and I shall take your place here. Yeah! In a month or two."

Lucy's heart raced as she tried to make sense of Lohse's words and why he seemed so disturbed. Was he playing with her head, some kind of psychological torture? Perhaps he had heard news from the collapsing war effort. Lucy was never sure.

AS SUMMER TURNED TO FALL, Suzanne believed she would soon be dead, so there was no point in making these last few days or weeks more difficult than they had to be. "I decided to try and find out what kind of behavior was expected from a model prisoner," she remembered. "Not necessarily in order to comply but to avoid sinning out of ignorance."

She saw herself as practical, as someone who took things as they came. Of course, that was often more outward appearance than anything else, she admitted in her writings: "My assumption of indifference to circumstances was sometimes very far from my inner feelings, but it was deliberate and

calculated. I believe that outward attitudes react upon our feelings and can therefore be used to modify them, so that we can—up to a point—make ourselves happier or unhappier than actual circumstances would warrant." It helped make Suzanne appear calmer, but inside she was still frightened.

Life in Gloucester Street had a regular rhythm—eat, sleep, visit the lavatory, exercise, do chores. Years later, Suzanne wrote about learning the prison routine "without having any part in it save for the fact that the [food] trolley stopped at my door on its regular rounds. . . . Since I had nothing to do and nothing to read, I listened." At dawn, she often heard the rhythmic footsteps of "a marching squad on the paved walk leading from the big outer gates of the prison to the small gates of the German quarter. They came to a stop with a perfectly synchronized stamp."

Over time, the regular sounds of C Block became familiar, which provided some sort of comfort, but when patterns changed, even Suzanne's cool exterior could not hide the anxiety that welled up. "There was something disquieting in any departure from routine. Footsteps in the passage, the low murmur of voices, the slamming of a door. I realized that I was holding my breath."

Occasionally, though, the break from routine offered a sense of encouragement. She could hear a rhythm coming from the heating pipes, "irregular taps that might have been Morse code, sometimes monotonous groups of taps that sounded like the [psychic] medium system where you go on tapping until you reach the letter's place in the alphabet." The inmates were communicating with one another.

Part of adjusting to prison life was getting to know the men who were watching them. The head warder was Dr. Heinrich Koppelmann, but in all their postwar writings, Lucy and Suzanne called him the Chef—the French word for boss or chief. He had a scar across his face; it was, Suzanne recalled, "the type of face upon which a scowl sat more naturally than a smile." Yet the Chef was not without his charms, and he found himself talking to Suzanne with a certain candor. She developed a good rapport with him. The Chef sometimes addressed her as *Gnädige Frau*, a term of deference and respect, and he brought Lucy a woolen blanket to make her more comfortable through the coming winter months.

Other guards also treated Lucy and Suzanne with respect because of their social standing and tended to call them "Miss Schwob" and "Miss

Drawing of soldiers and imaginary figures on the back of a cigarette packet. Whether Lucy or Suzanne created the drawing is unclear. Could the large soldier in the image be Otto? COURTESY OF THE JERSEY HERITAGE COLLECTIONS.

Malherbe," although Lucy and Suzanne always called these men by their first names. Otto frequently demonstrated remarkable thoughtfulness. He eventually started calling Lucy by the endearment *die Kleine*, "the little one." He quickly became an unexpected companion, their most frequent human contact, and a source of both uncertainty and amusement. Suzanne's ability to speak German meant that she could talk with Otto and try to find out from him what was going on inside the prison.

He hesitated to say much about himself, but Suzanne learned that Otto was from Pomerania, in northeastern Germany near the Baltic Sea. He liked to follow the rules, at least most of the time. On one occasion, she offered him the chocolate bar from her Red Cross parcel. "He looked at the chocolate bar with childish greed," she remembered, "but made no move to take it."

"I must not accept," he told her, clearly saddened by the requirement not to accept gifts from inmates.

Another of the guards, Ludwig Pitz, an orchestra leader in civilian life, now conducted concerts at a theater on Jersey. Suzanne noticed him for his big black eyebrows. Lucy thought he had a "hard face." He was in charge of the German soldiers who had tried to desert or mutiny; because they shared C Block with political prisoners like Lucy and Suzanne, Ludwig spent time around them too. Suzanne remembered his boyish glee when he showed her a photograph of his fiancée, a woman from Aachen who

was both buxom and mannish. Suzanne thought that she "would do for a *Walküre*" in a production of Richard Wagner's *Ring of the Nibelung*.

The soldiers performed a concert one evening in the Forum—the largest and grandest movie theater on the island, now decorated with swastika flags—for the Germans and their guests. With great excitement, Ludwig told Suzanne about it while they were in the exercise yard.

"What did you give them?" she asked.

Ludwig struck the conductor's pose with his arms raised ready to lead an imaginary orchestra. He started to wave his arms about, conducting the music in his mind, which he then began humming aloud.

"*Tannhäuser*," Suzanne said, one of the few pieces she could recognize. Ludwig was delighted at her knowledge of one of Wagner's famous operas and laughed with excitement. "For a moment we beamed at each other, radiating goodwill, as though we had discovered a mutual friend," she remembered.

"An English critic wrote about our concert in the paper," he told Suzanne with pride, "but there are words I do not understand. Perhaps you can translate them for me?" Then he looked over at the warder's lodge where the Chef and others were working, worried that some of his colleagues might be watching or listening. "Not here," he said. "I will bring you the paper this afternoon."

Another guard with whom the women developed a kind of rapport was Heinrich Ebbers, a farmer from the Frisian coastal region along the North Sea. "Tall and thin, a narrow face, high-bridged nose, blue eyes, and sleek, fair hair," was how Suzanne described him. Heinrich had fought on the Eastern front, and his bitterness toward Russian soldiers showed. Whenever he encountered a Russian prisoner, Heinrich called him "Ivan" regardless of his name. "To him," Suzanne remembered, "Ivan was the only name suitable for Russians. It showed they were merely a species, not real human individuals." To Suzanne, Heinrich looked so British "that one was surprised to find how bad his English was," yet he worked hard to learn the language. Lucy thought Heinrich was the most nationalistic of the guards, perhaps not surprising after the brutality of the Russian campaign. But she also found him to be the most lenient. He allowed forbidden family visits and let in packages with suspicious content that other guards would have confiscated.

Suzanne's assessment of these men is almost jarring to read today because the language is opposite of what one expects to hear about German soldiers during the war: "They were kind. They undoubtedly at times ran a certain risk in disobeying orders. They were all obviously men who by temperament would prefer to be kind if it were not made too dangerous for them. Would they have been as kind if it had not by then become apparent that Germany would most probably lose the war? Any answer to that would be purely a matter of conjecture." Warders in a military prison are not professionals, Suzanne concluded, trying to understand how they could be so humane while running a Nazi jail. "Their mind is not warped by a lifetime spent in one of the most unnatural relationships between human beings."

The German guards may not have been professionals, but they received assistance from the regular Jersey staff in running Gloucester Street. The political prisoners from the island viewed these men as traitors and greatly resented their presence. Teenaged resister and Jersey resident Joe Mière remembered, "We did not like being guarded by our own people wearing the British Crown on their caps."

Mière met Lucy and Suzanne while behind bars, but later the Germans moved him and his cellmates to a wooden hut built in the yard because of overcrowding. One night, Mière and his cellmates snuck out and found their way to a yard with a large open pit. This place had been the site of executions throughout the prison's history, even long before the Germans arrived, and the hole was where men had been hanged. On one side of the yard were gravestones of those who had been executed over many years past. The prison, it seemed, was haunted by ghosts.

TWO JERSEYMEN HAD RECENTLY ESCAPED from Gloucester Street by climbing onto the roof and over the wall, so the guards decided to build a six-foot barbed-wire fence to discourage further attempts. Suzanne watched the soldiers hanging a yellow sign with a black skull-and-crossbones and a capitalized warning: "ACHTUNG! MINEN!" Are there really any mines beyond the barbed wire? Suzanne asked the Chef. I don't know, he replied with a shrug.

The guards also decided to install barbed wire in the hallway inside the cell block, crisscrossing it along the corridor windows. When Otto was

away in the exercise yard with another prisoner, the two local Jerseymen who were working on the barbed wire inside the prison took the opportunity to whisper to Suzanne underneath her door, asking her how the jailers were treating her and Lucy. We're fine, she replied.

One of the workers also spoke to Lucy. She asked him for a pencil, and somehow he was able to slip one to her. That night, she wrote a letter to Suzanne on three pieces of toilet paper and smuggled it out to her.

Lucy knew that many of their Jersey friends were praying for them, especially Vera who had converted to Catholicism during the occupation. Edna remained especially protective. After Edna's release, she told Lucy during a visit that she had seen a woman in town wearing some of Lucy's clothes, probably given to her by a German boyfriend. Edna confronted the woman, who angrily replied, "I'll report you to the Gestapo!"

Lucy also heard reassuring whispers from other prisoners. The last boat of deportees has already left the island, they said, so Lucy needn't worry. The American army was supposedly liberating the French coastal town of Saint-Malo. But these were rumors, and there was no way to know what was really going on with the war. Lucy still felt the threat of deportation or execution to be near. Pessimistic by nature, she always expected the worst.

Most stressful of all, she was alone. Suzanne was only a few feet away but locked in a separate cell and out of reach. After the war, Lucy recalled how the daily burden of the secret they kept between them weighed on her. She believed she must be very careful and not reveal the true nature of her relationship with Suzanne. They had worked so hard to make sure everyone thought they were merely sisters, although it's impossible to know whether Vera, Edna, or anyone else suspected the truth.

When talking with the guards, Lucy tried to convey a practiced indifference toward Suzanne. "Even if I can't make them believe that, at least they will not be able to know the depth of my real feelings," she reasoned.

If she couldn't keep the secret, she feared that the Germans might no longer show any mercy.

14

"I AM PREPARED TO ACKNOWLEDGE ANYTHING OF OURS"

THE GFP STILL WORRIED that Suzanne might be unstable. On a routine inspection of her cell, she lay in bed while a group of soldiers poked around. One of them snatched up a piece of paper, crying in alarm, "She has written with her blood!"

Suzanne worked hard to suppress a laugh.

"No, no. It is only lipstick," the other one said.

Suzanne dozed off shortly afterward, but when she awoke, the prison doctor was there, decked out in his "lavishly braided uniform," as she recalled. He had come to check on her ongoing recovery following her attempt to slash her wrists. The Chef, an interpreter, and an orderly accompanied him.

Suzanne asked the men for some of her belongings. She needed her belt because she was having difficulty keeping her trousers up. She, like Lucy, was continuing to lose weight.

"Perhaps," the interpreter interjected, trying to be helpful, "it could be arranged with a needle and thread?"

"Believe me, if I had a needle and thread, I would have fixed it long ago."

"Of course," the doctor said. "I will see to it."

Despite this small kindness, Suzanne did not like the doctor, although at least she continued to deal with him, unlike Lucy, who refused even to speak to him. Suzanne's estimation of him sank further once she had learned that he had stolen from La Rocquaise two portfolios of beautiful antique anatomical charts that had been her father's.

Suzanne pulled back her shirtsleeve so that he could see her self-inflicted wounds, "discolored with bruising and caked with blood," as she described them. While he examined her wrist, she mentioned a more pressing concern: "And I need some insect powder, because the pallet is alive with fleas."

He flashed a contemptuous smile, clearly not believing her, so she pulled her sleeve all the way up, exposing "a riot of pink polka dots encroaching upon each other, each one with an angry red pinpoint at its center." Shocked at the sight of Suzanne's flea-bitten arm, the doctor turned a dark, accusatory look on Otto. Otto's face turned ashen and his body trembled, frightened that the doctor would report him for allowing unsanitary conditions.

Suzanne realized that the interpreter and the orderly, obeying rank and protocol, would say nothing on Otto's behalf, so she took his defense upon herself. "It's not the warder's fault!" she declared in a loud voice.

Her shout surprised the doctor, who was unaccustomed to being spoken to in that manner, especially by a female prisoner. "They haven't got any insecticide, and they cannot obtain any," she told him. "What do you want them to do? Sit in the cells all day, killing fleas? That's what I've been doing ever since I was brought here."

The doctor commanded the orderly to fetch a box of antiseptic powder. When he returned, he squeezed the box again and again, blowing puffs up and down Suzanne's arm.

BY THE TIME THE GFP WAS READY to begin questioning the women again in September, they probably knew Allied forces were continuing to liberate German-controlled territory and that the Nazi empire was on the brink of collapse. Bode and his men, still obsessively investigating what they believed was an ongoing conspiracy of the Solider with No Name, lost valuable hours waiting for Lucy and Suzanne to recover from their suicide attempts. Time was clearly not on the Germans' side.

Ludwig came to fetch Suzanne for her trip to Silvertide. "Don't you want to put your shoes on? You are going out into the town . . . for questioning."

"Oh." Suzanne looked down at her footwear and joked, "Do you think they will stamp on my feet?"

"They will certainly not do that," he replied earnestly.

"Then I'll keep my espadrilles," Suzanne quipped. "It is much too hot for leather shoes." But she did wrap her coat around herself. Despite the warm autumn day, typical of Jersey's temperate climate, it made her feel safe.

Lucy was also being led to the waiting German staff car but did not know that Suzanne had already gone downstairs. As she passed Suzanne's cell, she saw the open door and the empty room and immediately jumped to the direst conclusion, that Suzanne had been deported or killed. The rest of the way to the car, her head spun, thinking about what to say or do with this awful knowledge and how she could deal with her dawning grief and rage.

Then, as the guards walked her out into the sun, she saw Suzanne in the car and felt an overwhelming sense of relief. The Germans had decided to "economize their trouble," Lucy realized. What may have been a time-saving measure on their part brought the women immense joy. "I can't tell you how happy I was to see Suzanne," she recalled. They rode together to the GFP headquarters. It was the first time they had been together in weeks and the last time they would leave the prison for the next two months.

Lucy did not record any description of this second interrogation, but as before, Suzanne wrote down her conversation in detail years later. At Silvertide, guards escorted Suzanne into the room alone, where she sat in the comfortable armchair. This time, she faced Captain Bode directly, although once again Lohse conducted the questioning. If the first interrogation had largely been an attempt to understand Suzanne's motives, this meeting was much more pointed.

"You would say that you are an Aryan?" Lohse began.

"I would not," Suzanne said firmly. "I would say that I am a Celt." She had chosen to play a game, remembering Lohse's earlier insistence that she was Celtic because she had been born in Nantes. They began to discuss racial categories.

"I was at school at the time of the Dreyfus retrial," she told Lohse. "I assure you that no child in the school could have had Jewish forbears and remain[ed] ignorant of the fact." Surely she was thinking of Lucy.

After a few minutes, Lohse decided to move on. "I have spoken to your bank manager."

"I trust he received you kindly," Suzanne replied.

"Oh, quite . . . quite. He told me what I wanted to know."

"I hope you are now satisfied that we have no mysterious sources of income?" Unaccounted-for revenue might have indicated being on the payroll of a foreign intelligence service or participating in the black market.

He nodded. "By the way, do you know that you are living above your income?"

"We were. Yes, I know it. We have been doing so since the devaluation of the franc in 1937." Ever since that point, Lucy and Suzanne had stopped living off interest and investments and instead had begun to spend their capital reserve. Doing so went against everything they had been taught about protecting their wealth as children of the upper class, but they saw no logic in cutting back so far that they could not live as they had become accustomed. Suzanne remembered the promise they had made themselves: "Whatever we did, we would not get into debt and we would leave enough money to pay for our funerals."

"You did not think it was an unreasonable thing to do?" Lohse queried.

"We have no children," she stated flatly, closing the matter.

"Have you any objection to identifying the leaflets we have in our possession?"

"No objection whatever—provided you take my word for it if I tell you that a paper you show me does not come from us." Lohse seemed surprised, Suzanne recalled, and stared at her as though she "had committed a grave breach of etiquette." Matter of factly, she continued, "You will understand that I am prepared to acknowledge anything of ours whether I think it is good, bad, or indifferent. And I know that I can trust myself to recognize at a glance anything that is ours, even if it dates from the early months of the occupation. But if you show me some paper that does not come from us, I can only say that it does not. I have absolutely no means to prove it. I can only tell you a thousand times that it is not. It won't get us anywhere."

Lohse turned to Bode, who nodded. "Very well," Lohse agreed, then suggested they move to the other table in the room because it was much bigger.

"Good heavens," Suzanne thought. "They must have quite a collection."

Lohse opened the fat file and began leafing through it, pulling out document after document and asking Suzanne about each one and if she or

Lucy had created it. For the first several, she answered that the papers were not theirs. One was an anonymous letter in English, which, she observed, was "rather illiterate." Clearly, there were other note writers on Jersey.

"No, I thought not. It is not your way," Lohse said. "By now, when a paper is brought to me, I can tell whether it comes from you or not." He must have been studying the file for some time.

"Then I should like to know why you put it in our file."

Lohse looked sternly at Suzanne as if trying to silence her. Then he turned toward Bode. The two men must have disagreed about the source of that note, with Bode insisting that it be included. Now Lohse set it aside.

Suzanne continued to flip through the file. Of the ones she and Lucy had replicated by hand or with carbon paper, Bode and Lohse had found nine or ten of their copies, while of other notes, they had recovered the lone draft. After weeding out the notes that were not theirs, Suzanne told Lohse that she could attest to the authenticity of the ones remaining in the folder. She estimated that there were some three hundred pieces of paper, representing dozens of different notes; some were in multiple copies, all in the GFP's possession.

"Now," he said, referring to the papers splayed out before them, "I wonder if you could tell us what that represents. Would you say that we have about one-half of your production? Or perhaps one-third?"

"Good heavens, no!" Suzanne shot back impulsively with an off-the-cuff estimate: "One-tenth would be nearer the mark." Bode and Lohse could not believe their ears and had "a look of dismay on their faces," Suzanne remembered. "It is rather difficult to evaluate," she continued, with a tone of apology for making them feel incompetent in their detective work. "But with the tissue paper we used, the Underwood could do ten legible copies at one go!" For any leaflets with current news, she said, they always made at least that many. "But mostly they could be repeated several weeks running. For instance, the one titled 'Alarm!' and the one about the future frontiers of Germany and some of the more doctrinaire ones may have been typed ten or fifteen times. That would mean one hundred or one hundred fifty copies."

They continued to pore over the leaflets and other materials on the table. Suzanne and Lohse exchanged critiques and comments "with that

queer complicity that sometimes occurs between people on the same kind of job on opposite sides." They had almost formed a begrudging respect for each other. The conversation was a revelation for Suzanne, proving just how much she and Lucy had accomplished. "It was only once we were *hors de combat* [out of combat] that we knew how far we had achieved our aim," she realized as she reviewed their work with Lohse.

The Germans must have concluded, she thought, that if Lucy and Suzanne produced as many notes as they claimed, their men had turned in only a fraction of the ones that they had found. Most of the German soldiers, it seemed, kept or destroyed the notes without reporting them to their superiors. "It was, in a way, very comforting to realize that we had annoyed the Germans a good deal more than we ever dared hope," she later wrote. Keeping the Germans busy with searching and wondering was one important part of their plan. "The more time they spent trying to find us, the less they could give to their nefarious pursuits."

Lohse came to a *Heldenlied*, a famous type of poem, sometimes set to music, that celebrated German heroes. Lucy and Suzanne's comic version had turned the genre on its head by telling the story of sexually promiscuous women serving the Fatherland by having children out of wedlock. Suzanne dismissed her own composition as not very good.

Lohse disagreed. "It is very good."

"It is abominably vulgar," Suzanne countered.

"It is vulgar," he acknowledged. "But then there are types of men upon whom that would be very effective."

"That's what I thought," Suzanne replied. "Otherwise I shouldn't have bothered to do it."

"Who wrote it?" he asked.

"But I have just told you. I did."

"Where did you learn to do this kind of work?"

"We never actually learned," Suzanne said, trying not to sound boastful. "But for the past twenty years or so, propaganda of all kinds and colors has been pouring over Europe to such an extent that one could not escape it. The only defensive action was to learn to recognize it, if possible, for what it was. And when you have practiced that for some time, well, if you can write at all, you can write propaganda. That is, of course, if you want to. We had never wanted to before."

BARON HANS MAX VON UND ZU AUFSESS, head of the Civil Affairs unit of Military Administration, had arrived in 1942 to help administer the occupation of Jersey. A Bavarian with aristocratic breeding, he cut a dashing figure in a neatly starched uniform jacket, jodhpurs, and black riding boots. His hair was slicked back, his gaze steady, and his jaw set. A cigarette dangled from his mouth at a jaunty angle. He had no military background.

Like many members of the German nobility, he saw Hitler as a lower-class upstart and was not particularly fond of the Nazi leadership or ideology. Von Aufsess was reputed to be a friend of one of the participants in the assassination attempt on Hitler's life. He also bore a personal grudge against the leaders since his wife was detained for lamenting the failure of the assassination. Nevertheless, he was willing to execute his patriotic duties while on Jersey.

On October 28, 1944, Von Aufsess made an entry in his diary about the pending legal case against Lucy and Suzanne, which fell under his supervision. He described them as "two Jewish women" who had "been circulating leaflets urging German soldiers to shoot their officers." Lucy had already confessed her Jewishness to her interrogators, and although Suzanne was not Jewish, Von Aufsess apparently assumed that she was. Or perhaps, despite not being an ideological Nazi, he was doing what Hitler often did by lumping the terms *enemy* and *Jew* into one category. He clearly saw the women as dangerous. "A search of the house, full of ugly cubist paintings, brought to light a quantity of pornographic material of an especially revolting nature," he wrote. "One woman had had her head shaved and been thus photographed in the nude from every angle. Thereafter she had worn men's clothes. Further nude photographs showed both women practicing sexual perversion, exhibitionism and flagellation."

Von Aufsess exaggerated. Although Lucy appeared nude in some of their photographs, in the ones that remain in existence today, her most private areas are covered. Some of their images had an erotic edge, but there is no evidence that they ever deliberately produced anything they considered pornographic. Someone of Von Aufsess's background and social position may have thought these photos crossed the line. He certainly would have found them deplorable because of their challenges to gender norms and traditional notions of beauty.

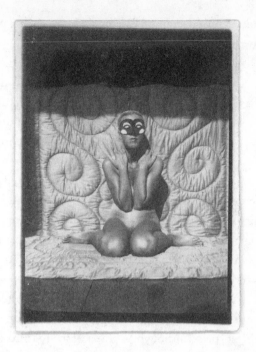

*Lucy (as Claude Cahun)
naked, wearing a mask,
ca. 1928.* COURTESY OF
THE JERSEY HERITAGE
COLLECTIONS.

After Lucy and Suzanne's arrest, the secret police circulated many of their photographs on Jersey to shame them publicly. Lucy seemed to think that no one cared about such things, but Vera had apparently been mildly scandalized. She had undoubtedly seen some of Lucy and Suzanne's work before—a photomontage was hanging in their parlor—but the Germans were now surely distributing some of the most provocative images. According to Lucy, a few even reached Vera's mother, who must have asked why Vera had associated with these strange women.

Despite demonizing Lucy and Suzanne, Von Aufsess ended his diary account with an almost offhanded remark: "At the moment pronouncement of the sentence is being postponed. Normally on the charge of inciting the troops to rebellion, they could be condemned to death, but women cannot be executed here." Von Aufsess was likely referring to a long-standing tradition on Jersey that women would never receive the death penalty for a crime. Because Lucy and Suzanne had refused to sign the confession, the lawyers were now required to prepare a legal case against them.

The guard Heinrich joked with Suzanne, "If they could only send you to France, they would have tried you long ago." However, with the rapidly

sinking morale among German troops, such a prosecution hardly seemed worthwhile.

After the interrogation, the routines of prison continued for the most part. Otto kept some gray wool for darning his uniform. One day, Suzanne offered to help him wind it around a piece of cardboard. When he had tried, the wool became jumbled, and he looked at it sadly, disappointed in his ability to perform such a simple task. "It did look hopelessly snarled up. All my womanly instincts rose to the challenge," she remembered. As she wound it neatly for him, the brutal officer Wölfle entered Suzanne's cell. He seemed pleased that she was performing this task and watched her approvingly. Suzanne thought that this would be a good opportunity for conversation, maybe even to try wheedling some useful information from him.

"Wherever did you get that remarkably American accent?" she asked Wölfle.

"Oh, I spent over ten years in the States and in Canada," he said. He'd spent some of that time as a scoutmaster in Canada. Suzanne looked at him with surprise, although Wölfle seemed to think it was admiration. "If that's the stuff scoutmasters are made of," she thought, "God help the scouts."

ONE DAY, SUZANNE MADE A REQUEST OF OTTO. A kind of trust had developed between them, but she still approached the subject carefully so as not to embarrass him. "There is something I urgently need," she said, "and you must try to understand me because I can't remember the German word for it." He looked at her blankly. She was clearly uncomfortable. "Sheer despair drove me on," she later recalled. "I need what women need each month," she finally managed. Otto, though, still didn't seem to understand. "It was like speaking to a waxwork figure."

Suddenly Otto's face lit up. "Monatsbinden! Ich gehe sofort!" Sanitary napkins! He'd retrieve some right away. He slammed the door behind him and shuffled downstairs. Ten minutes later, he came back with a large cardboard box with a Red Cross symbol on it. Suzanne does not say in her writings whether at age fifty-two she still needed them or if, ever resourceful, she wanted them to use only for writing notes. Either way, Otto was obliging.

"From that day onward," Suzanne remembered, "he considered me as a kind of bank in emergencies." If a young woman was imprisoned and had not brought supplies from home, Otto knew he could count on Suzanne to deliver.

Despite their growing relationship and the fact that Otto was still a German guard, Suzanne occasionally found ways to assert herself. Once, while she was sweeping her cell, Otto demanded the broom. He was generally polite, so his gruffness on this occasion was unusual. "I thought I had better discourage this new domineering style," Suzanne recalled. "I drew up stiffly and said, with all the haughtiness I could muster, 'I shall give you the broom when I have finished with it.'"

Otto stepped back and held up his hands. "Schön! Schön!" he said, placating Suzanne. Fine! On his way out, he slammed her cell door like a frustrated husband, she thought.

On another occasion, there was some talk about forcing Suzanne to take on cleaning or other light chores in the prison block. Suzanne told him in a reproachful voice, "Otto, you must not ask a political prisoner to work. The Geneva Convention forbids it." This was a bluff. She had not read the Geneva Convention, but she was pretty sure that Otto hadn't either.

Otto could also be the source of some unwitting comedy. On one occasion, with Suzanne out of her cell, perhaps on her way to exercise, Otto entered the empty cell next door to make sure everything was in order. With no warning, a draft shut the door behind him, locking him inside. Suzanne could have taken advantage of the situation, but she decided to help him. Turning the key and opening the door, she found a visibly shaken Otto. He had a pleading look on his face. Suzanne realized that if the other guards found out, they would tease him mercilessly. To put him out of his misery, Suzanne looked Otto in the eye and assured him, "There is no need to mention this." His smile was one of relief.

Otto did not like prisoners' questions deviating from the usual routine, so Suzanne often got information directly from the chief jailer, Heinrich Koppelmann, the Chef. As they talked, he revealed to her some of his personal struggles. "Each day lost was to him," Suzanne recalled after the war, "one more possibility of his wife being whisked away to some unknown destination where he could never reach her," although she didn't explain the details of what she saw as his sad, burdensome story.

The Chef did his duty but did not seem committed to the cause. One day, Suzanne asked him, "Do you think it is true that Hitler is dead?" With a sly but cheerful grin, he quipped, "I haven't seen the body."

For her part, Lucy never liked the Chef. When he came for daily

inspection, he would open the cell door and bark, "*Alles* okay?!" The experience always unsettled her. She looked at him with fixed eyes but said nothing. In a note she slipped to Suzanne, Lucy warned her to be careful when it came to the man who ran the prison. Suzanne responded that she had a little more faith in human goodness than Lucy did.

OCTOBER 25, 1944, was Lucy's fiftieth birthday. She had forgotten it, but others remembered. The guard Heinrich Ebbers told Lucy that Mrs. Armstrong had brought a gift to Gloucester Street but wanted to deliver it herself. Normally, this would not be allowed, but the Chef was not around, and Heinrich checked to make sure no one was watching.

"On your birthday," he told her in broken English, "and when the old lady come from far I like not to refuse."

Heinrich took Lucy down to where Mrs. Armstrong was waiting, and they embraced. Clearly, their relationship had improved from earlier days, when Lucy bristled at her neighbor's self-proclaimed anti-Semitism. Anything that might have come between them was long forgotten.

Mrs. Armstrong gave Lucy a French-themed blue, white, and red bouquet of flowers and a package containing a gingerbread birthday cake as she had done in years past. She also relayed news from the BBC and, despite Heinrich's presence, denounced the monstrous crimes that had taken place in Poland. She recounted to Lucy the liberation of the Majdanek extermination camp three months earlier by the Soviet army. This was likely Lucy's first knowledge of the Holocaust.

Heinrich, perhaps worried that someone would catch Mrs. Armstrong on a forbidden visit, told them to hurry. The two women hugged again, and Heinrich took Lucy back to her cell. Later, Lucy asked Otto if the cake could be cut and shared with the other inmates as well as himself and Heinrich. Otto agreed, and the treat made its way through the cells.

One rainy day, while Suzanne was exercising along the corridor, she saw that the door to the cell between hers and Lucy's was wide open. Otto was letting it air out after someone's departure. Out of curiosity, she stepped inside. It was different from the others, having once been used as the library when this block of cells had been the women's section many years earlier. The walls had been plastered and painted brown and pea green. Suzanne was struck by its ugliness.

But the considerable graffiti on the walls caught her eye. She read with fascination the names and initials of people who had been locked in here. She also found a makeshift calendar that someone had scratched onto the wall to mark off the days. "I went out of this unattractive cell with something to think about for the rest of my exercise time." It had not occurred to her to make a calendar. Perhaps only prisoners who could anticipate their freedom thought about counting the days until their release. Suzanne had no such hope.

One of the nearby cells housed a Jerseywoman whom Suzanne knew as Mollie. One day, she observed Mollie asking Heinrich to escort her to the lavatory. "She stood, looking up at him, her hands clasped behind her back and her chest thrown out, gently rubbing her large breasts against his tunic and murmuring in the tones of a cooing pigeon." Please, may I go to the toilet? she coyly implored. Heinrich was taken with her. He giggled and blushed "like an embarrassed schoolboy," thought Suzanne. She found it disgusting to see a woman ask to use the toilet in the same way she might invite a man into her bedroom.

Although Suzanne had come to dislike Mollie's ways, for some reason Mollie seemed to be fond of Suzanne. Otto had occasionally allowed them to "accidentally" bump into each other in the hallway; sometimes he would take them to exercise together. But Suzanne was tired of talking with this woman. "In this particular case," she told him, "I should like you to remember that I am supposed to be kept in solitary confinement."

A few days later at mealtime, Otto came into Suzanne's cell with a small dish, which he placed on the iron shelf in the corner of her cell. The plate had the name of Jersey's Ritz Hotel on it and was just like the ones she had seen many times outside Mollie's door. The occupation forces had been using the Ritz as the garrison commander's headquarters and as a place to billet troops. It did not take too much imagination to realize that Mollie was very well connected among the German officers. Someone was looking after her. Now she was trying to make nice with Suzanne by sending her dessert across the hall.

"What is this, Otto?"

"She told me to bring it," Otto replied, flustered.

"So? Well, I tell you to take it away. Do what you like with it. Eat it yourself if you want to. But don't let me see it again." Otto scooped up

the dish but remained standing silently in the cell, unsure of what to do. "Look," Suzanne said, "I don't care what you tell her. If it's any help, you can say when you return the dish that I ate the pudding and that I thank her. Only if she gives you anything else, don't bring it here. Understood?"

He smiled a little and left. "We were making his life very difficult," Suzanne acknowledged with a bit of regret.

Another woman behind bars in C Block was also getting special attention from the guards. She was buxom and wide hipped, with dark crinkly hair and full lips. Suzanne remembered that she was "fed like the German officers" and that pastries and other treats often appeared at her cell. "She would have looked overweight in normal times, but we were so used to seeing underfed people that she seemed shockingly fat."

BOTH LUCY AND SUZANNE HAD MOMENTS OF HOPE as the days went by. Lucy was able to make some tentative connections with other prisoners, several of whom were foreigners and in bad shape. Despite largely believing that she would not survive the war, she still dreamed of working with them to create a political organization if by some miracle they all got out alive. Lucy smuggled letters to them, and they wrote back, talking about finding one another after the war was over. They offered their contact information and the promise of meeting in freedom in brighter days to come.

Suzanne's optimism showed itself in smaller, more limited ways. One day, while exercising in the yard, she heard a distinct buzzing, "a sound from another world." She stopped and looked for the source, discovering a bumblebee that had landed on the black heart of a sunflower. "It must have been at least three minutes before he took off again and faded away against the sky. I might never see another," she pondered, realizing that every minute might be her last, "but I would remember this one as long as I lived."

Such peaceful, meditative moments did not last too long. "In the night," Suzanne recalled, "I was woken by a shot. A second shot followed almost at once. I plunged straight from deep sleep into a state of wild excitement."

15

"GOOD NIGHT, MY POOR LITTLE CHICK"

HAROLD GIFFARD, A LOCAL JERSEY LAWYER, whom Lucy affectionately called "Mr. G.," represented Lucy and Suzanne in their personal affairs on the island. Giffard had had his own run in with the occupation authorities and served two months in jail in 1940–41 for insulting the Germans. Now he was putting himself at risk again, this time by smuggling papers so that Lucy and Suzanne could conduct some of their financial business. He also loaned them books of French literature from his own library.

What he could not do, however, was represent the women in their upcoming trial. Military regulations required that an officer defend them before the tribunal.

Their German defense attorney arrived at the prison on October 31 with no previous warning. The Chef came to fetch Suzanne from her cell to introduce her to their new counsel. "I did not know we had one," she said with surprise.

"There is always a defender," replied the Chef.

"Of course. I just hadn't thought about it."

As they walked downstairs together to the meeting room, the Chef slowed down his pace as he tried to decide whether to say something or not. At the bottom of the stairs, he stopped, unsure of how to express himself. "You know," he whispered, "at the military court . . . prosecutor . . . defender . . ."

"A curious swirling movement of his hand," Suzanne recalled, "told me as clearly as any words might have done that I would find both equally hostile." She thanked him for his warning, adding, "That is rather what I would have expected." They smiled at each other and continued walking.

Soon Lucy joined them. Since she and Suzanne were still kept apart in solitary confinement, she would have loved for them to have some personal time together, but the lawyer was there, and Suzanne, always practical, wanted to get down to business.

The lawyer's demeanor was, as the Chef had predicted, very confrontational, even prosecutorial. He simply could not understand why they had written their notes, nor did he really want to defend Lucy or Suzanne from the charges. He made plain that he would do nothing more than play his role within the military legal system, which pretended to be impartial but was not.

"But why did you do it? . . . Why?" he questioned.

Suzanne recalled that he stressed the word "like a man confronted with the incomprehensible, and utterly baffled." To her, the answer was obvious. "I cannot see what you find so difficult to understand," she replied. "After all, you are fighting for your country, in your own way! Of course, you get paid for it. We are doing voluntary work. Apart from that . . .'" Suzanne shrugged.

He sat silently for a while, digesting the comparison she had drawn between his work and theirs. "Is that all you have to say?"

"I cannot think of anything else," Suzanne concluded.

He pressed her to sign the confession that Lohse had previously presented them, but she again refused. Shortly afterward, he recused himself from the case and was no longer their defender.

The Germans tried again a few days later, appointing a second officer to defend Lucy and Suzanne. Their meeting with him did not go any better.

"First, I must tell you that I find it extremely painful to have to defend people who have done what you have done," he began. Suzanne nodded and waited for him to continue, not seeing much point in translating for Lucy what he had said. "Please translate," he ordered.

"As you wish." She turned to Lucy. "This young man wants us to know—"

"Tell him to go to hell," Lucy calmly interrupted. "He could not help us even if he wanted to." Turning her back to the lawyer, she went to the window. The branches of the little cherry tree in the prison yard were blowing in the autumn wind.

Suzanne now translated for the defender, trying to put Lucy's words into a more diplomatic turn of phrase: "We both think that nothing anyone could say will influence the decision of the court. Therefore, there is no need for you to assume such a distasteful task."

The lawyer stared at Suzanne in astonishment through "those ghastly pink-rimmed glasses," as she later recorded. He released his briefcase, which fell onto the table, making a loud thud.

"But you don't understand!" he shouted, his frustration rising. "I have to do it. It is an order."

Suzanne tried to remain calm. "In that case, we are very sorry for you, but it is no use complaining to us. We can't do anything about it."

The attorney was laboring to hide his disgust. He swallowed hard and tried a different tack. "Perhaps it would help if you told me something about your background." They had already given the police all the relevant information, but he insisted. "I believe you are an artist."

"No," Suzanne replied.

"But I have been to your house, and I have been shown drawings that you have done."

"Oh, I've learned to draw," she replied, downplaying her skill. "But that does not make me an artist. I haven't got the creative urge, and I am just as happy doing other things. In fact, I get more pleasure out of gardening."

Her unexpected answer made the defender seem even more confused and unhappy.

"So you would deny that you have been influenced by Bolshevik art?"

Suzanne nearly laughed. "I certainly would. One cannot be influenced by something that does not exist."

His colorful glasses made his wide-open eyes look even larger. As Suzanne explained her views on the ugliness of socialist realism, comparing it to Nazi art, she deeply offended the attorney, who began to turn purple. "Some of your drawings I have seen, I thought they were *horrible*," he said.

He was trying to get back at her, Suzanne thought, his desire for revenge childish. "I knew very well," she remembered, "that I had never produced anything striking enough to arouse in the beholder extreme emotions one way or the other." Perhaps the attorney was letting the unwanted duty of defending these women color his aesthetic judgment, or maybe what was shocking to him was merely ordinary to Suzanne.

"I had hoped that you might perhaps suggest something I could plead in mitigation," he said with a measure of exasperation.

Lucy turned to Suzanne and smiled. "Self-defense," she muttered.

Suzanne worked to suppress a laugh and turned back to the lawyer, composing her response. "We consider the fact that your army is here against the will of the population as sufficient justification for our activities."

The lawyer's jaw dropped. "But I cannot say that!" These women were astonishing: not only had they refused to sign a confession, but in addition, their suggested defense was preposterous.

"I told you it would not be easy," Suzanne said. "I am afraid that is all we can do for you." She ended the conversation with a curt goodbye, then: "I am sure you will find something to say."

LUCY REACHED UP to the opening of the ventilation shaft and pulled down on a thin string threaded through the ductwork. After carefully scribbling a note on a thin piece of toilet paper, she attached it to the thread and pulled, feeding her letter several feet through the vent. Moments later, the note appeared in the ventilation shaft in Suzanne's cell. Suzanne delicately removed it from the filament. Others had taught them to use this and similar techniques, which they called their "postal system."

Several times each day, Lucy and Suzanne sent messages to each other, occasionally using pages torn from a book or a sanitary napkin or some toilet paper they had stolen from the guards. Pencils smuggled into the prison were usually hidden inside a morsel of food brought by a friend from the outside and then passed between inmates. Suzanne also encouraged Lucy to tap on the pipe above her bed after lights-out to let her know all was well.

Writing and sketching helped them pass the time, but more important, it kept them connected, allowing them to share what was in their hearts. "If we were hermetically separated . . . we presented no less of a united front to our enemies," Lucy later wrote. These notes allowed her to pretend that there was no wall between them: "It's enough to close my eyes and cross from one side to the other and freely sail away."

The few surviving scraps of their correspondence—sent from Suzanne to Lucy apparently in November 1944—provide only a glimpse behind the walls of Gloucester Street. Some letters mention day-to-day aspects of prison life, like cleaning the cells, passing cigarettes between prisoners,

doing the laundry. In one, Suzanne tells Lucy of playing with a cat in the yard during exercise.

Nearly all address Lucy as "Amour," many wishing her "good night," suggesting that Suzanne was writing in the twilight or evening hours to avoid being seen by Otto. In one letter, she drew two intertwined hearts. In another, she included a sketched pair of smiling lips. As she had done for decades, Suzanne, in her messages, was still taking care of Lucy. She offered to send books if Lucy needed some and discussed one she had read a few months earlier in hopes of distracting Lucy from her boredom and her fear. She reminded Lucy of experiences they shared and people they had known, using memories to connect them to the times and places before their arrest. Sometimes she offered to share small comforts. "Tell me if you want a candle," Suzanne wrote. "I don't have any candlesticks, but made one by melting a little one with a small spoon"—a testament to her resourcefulness. "Good night. Courage. Love," she ended.

Suzanne tried to keep Lucy's spirits up, telling her in one letter, "Keep smiling! as B [Bunny Vitel, a fellow prisoner] shouts to me through the floorboards." Another ended, "Good night, my poor little chick. I hope that the migraine passes and lets you sleep." "Good night, my bird-mouth (my cat, my wolf, my monkey), my love, and courage," she wrote in a third.

In some letters, Suzanne gossiped about Otto, joking about how he liked to go to the movies and describing how she teased their guard: "Think of it, Otto. If we had gone to France, you would have had that much more food this winter." She noted that this elicited a chuckle from him.

When Lucy received one of these messages, she could find out about people in other cells. Suzanne usually referred to fellow prisoners by their cell numbers—2, 4, 7—either because she didn't know their names or to save space. Sometimes she'd relate to Lucy the story of why the people behind those doors had been arrested.

Lucy could also read about the messages other prisoners had passed to Suzanne, but frequently the information was not happy. A woman and her brother were taken for interrogation one morning around 11:00 a.m. At 2:30 p.m., the brother returned alone, but then the guards took away another man in hopes of using his testimony to confront the woman about her crimes. "Don't forget," Suzanne instructed Lucy, "to pass her letter to him tonight if you can without danger."

Sometimes Lucy learned shared news about the progress of the war. "In Italy, the Americans are approaching Bologna—the town where we photographed that fountain where the women splashed water on themselves," wrote Suzanne. One note described battle action along numerous fronts, in France, Italy, Holland, even Hungary. Lucy also read Suzanne's detailed account of the night of their arrest, telling of Lohse, Bode, and their men searching the upstairs portion of the house while Lucy had remained downstairs.

Suzanne gave instructions about how to keep the letters. "I don't think that there is a great risk of keeping the ones you want the most. They won't search if there's nothing out of the ordinary. The simplest way perhaps is to empty a carton of Jayes [cleaning cloths] and to put them inside, underneath some blank sheets. A sanitary napkin would be very safe, but I think that it risks erasing the pencil, and you would be very sorry."

A few weeks earlier, one of the guards had brought Lucy a hatbox where she could keep the few items she was allowed to possess. Whenever Lucy finished reading one of Suzanne's secret letters, she opened it and hid Suzanne's letter carefully inside along with some drawings and notes.

THE POSTAL SYSTEM was only one way Suzanne could disseminate information. By the time the two women got to Gloucester Street, ingenious prisoners had already created an information network to keep everyone informed of events inside and outside the jail.

Some inmates managed to procure knives and drilled small holes in their cell walls through which they passed notes or talked. These openings were particularly useful for groups of friends or family members who had been arrested together and were anxious to stay in touch. The hole in Suzanne's cell was old, and the guards had plugged it with cement, but someone who occupied the cell before her had chipped out a piece of the filling and replaced it with paper. Others knocked out larger portions of the walls between cells, so they could pass books and other materials. A few of the more daring prisoners trafficked in parts for a crystal-set radio and built it out of sight.

November nighttime temperatures in the dark cells of Gloucester Street dropped to around 50°F. Lucy used her Burberry coat to stay warm. Fortunately, along with the Red Cross parcels delivered to prisoners, the

Germans were still allowing outsiders to supplement the meager rations. Edna used money Lucy and Suzanne provided to her through Harold Giffard to buy the food and personal luxuries she brought them every Saturday. Vera sent a blue-and-white angora scarf as a gift. Lucy wrapped it tightly around her neck to fight the cold.

Lucy and Suzanne sometimes smuggled notes to the outside world with the help of Vera, who would come to take some of their clothes on the pretext of laundering them. Inside the lining, they hid messages for their friend to deliver. If they pulled themselves up to look out the high windows, they could watch the nurses signaling news in the hospital across the street. Assisting in Anglican religious services also allowed them time out of their cells to talk with inmates and guards.

As the jail became increasingly crowded, political prisoners sometimes mixed with civilian inmates, who had fewer restrictions on outside visitors. A secret note or a whispered word between the two populations might then reach others. The civilian exercise yard backed onto the political prisoners' wing, an arrangement that also permitted the passing of messages. Even though the yard stank, exercise was welcomed because it provided an opportunity to gather intelligence. During exercise one day, Suzanne needed to use the toilet. Toilet paper was becoming increasingly scarce, and the guards had set aside what remained for the women. But on this occasion, the guards apparently let Suzanne into the toilet inside the warder's lodge, which was located just off the yard. There, she discovered that they had been using the island's German-language newspaper to clean themselves. "I went into the warder's lavatory and bolted the door. I could allow myself two or three minutes to look at the neatly cut pieces of *Die Inselzeitung*, stuff anything that looked interesting into my pocket, pull the chain, and go back to my exercise."

Passing newspapers in secret provided a lifeline to the outside world. Every so often, the Royal Air Force made its regular drop of the newspaper *Nachrichten für die Truppe*, created by Allied intelligence. Suzanne waited in her cell for someone to smuggle her a copy through some secret channel. With the paper in hand, she sat down to translate the parts that might interest other prisoners. When she finished, she reached up and pulled the string to attach the precious words from outside and send them through the ventilation system.

Learning news also helped Lucy and Suzanne keep their spirits as high as possible under the circumstances. It created a sense of community. The other prisoners "did everything to keep our morale up," Suzanne fondly remembered.

Lucy, despite being in solitary confinement, experienced a strange sense of togetherness inside Gloucester Street. She recalled it with surprising tenderness in her postwar memories: "I would go so far as to say it gives one—when at its best—a kind of approximation of paradise."

On many nights, songs echoed throughout the corridors, including familiar favorites like "There'll Always Be an England," "Alouette," "She'll Be Comin' 'round the Mountain," "The Siegfried Line," and "Vive la compagnie." "The singing does not bring about the wonderful result by the quality of voices," Lucy wrote in a long essay composed during the war while still in prison, likely on paper smuggled in and stashed in her hatbox for just such a purpose. "It is the fraternity in it, the international choice of songs, the cooperation of listeners and singers, the fight to cheer the depressed spirits, the individual callings—we are all more or less indirectly introduced to each other by our Christian names here, even our 'keepers.'" Lucy later remembered Suzanne, who she claimed was not prone to overstatement, saying, "There are nights when [with] all this singing, prison's not deprived of charm."

Prisoners knocked their utensils on the pipes running through their cells to create musical rhythms. A group of teenaged boys arrested for trying to escape Jersey by boat "organized an excellent jazz," Lucy recalled, complete with the sound effects of planes and bombs.

At one point when the music was at full blast, Wölfle stormed into the cellblock with other soldiers. The musicians fell completely silent when they heard the GFP men enter. After the German boots faded into the distance, the singing and playing started up again as if nothing had happened. "At night, jazz and the imitation of the bombardments. We tapped on the pipes, the bowls, the chamber pots, and the doors. They could hear us in the civilian prison and even in the street," Lucy remembered. The guards didn't know what to do.

When the singing and music died down and the cellblocks got quiet and lonely again, Lucy pulled her stool up to the high window so she could look at the world outside, imagining the horizon, the ocean, the beautiful

Jersey landscape. As she climbed down, she would daydream that she and Suzanne were back in Paris attending a show. She might sing through the spy-hole a few lines from the opera based on Shakespeare's play *Hamlet*. It included the phrase "never doubt," and her voice echoed down the corridor. She had to believe that Suzanne might be listening. Sometimes, she thought, that was all it took to keep their link—"united since childhood and resolute to go ahead to oppose a common dangerous front, whatever it is"—going.

Most of the political prisoners with whom Lucy and Suzanne shared information and camaraderie were much younger than the two women. Many of these Jerseymen and Jerseywomen in Gloucester Street were in their late teens and twenties and had been engaging in the same kinds of activities as Lucy and Suzanne, especially spreading BBC reports, but more daring acts as well. Some of the more politically radical were angry at the Jersey government for its cooperation with the Germans, and they wanted to challenge the island's authorities as soon as the war was over.

It was in prison that Lucy and Suzanne realized the scope and scale of the resistance that had taken place on Jersey. They met people like twenty-one-year-old Belza Turner, who had been arrested several times during the war and was this time serving six months following a daring escape attempt from Jersey after the D-Day landings. Over the years, the Canadian-born Turner had committed acts of sabotage, spread news about the war, and attempted to escape the island. Lucy came to admire what she called Turner's "outspoken patriotism," and she remembered her as a particularly courageous and heroic figure. Guards put Turner into solitary confinement for starting a singalong of "Rule Britannia" inside Gloucester Street. There were so many others, too, whose names Lucy and Suzanne noted in their postwar reminiscences: Joe Mière, Peter Curwood, Frank Killer, Hugh La Cloche, Yvette and Charles Grunchy, Mickey Neil, brothers Bunny and Raymond Vitel, to name just a few.

Lucy and Suzanne became good friends with a twenty-five-year-old Jerseywoman named Evelyn Janvrin (née Costard). She was being held, along with numerous members of her family, for helping a group attempting to leave the island with information that might be useful to the Allies. The Germans questioned Evelyn at length, especially during mealtimes,

which meant that she often didn't eat. According to Lucy, Evelyn just laughed at the soldiers. She was often heard singing in the corridors to keep up her spirits and those of everyone else.

When Evelyn received her Red Cross package, Otto searched it but found only underwear, stockings, and a book, just the same as Suzanne's bundle. "He's got an awfully suspicious mind," Evelyn remarked to Suzanne, which made Suzanne laugh. Of course a guard would inspect a parcel, not out of suspicion but out of duty. In actuality, Otto was not particularly curious. Suzanne had once seen him leaf through a book but not even examine the spine to see what the title was, and she could imagine him not bothering to unroll a pair of stockings simply because it didn't occur to him that something might be hidden there. Despite what Evelyn might think, Suzanne knew that "he simply was not cut out for the job."

Otto did become suspicious of Evelyn, though. When he brought Suzanne to the exercise yard one day, he appeared troubled. "Look at this," he said, holding out his hand. There in his left palm was a full-sized blue pencil. Most of the pencils in the prison were small stubs, so a full-length one was quite rare.

"A pencil?" Suzanne said in feigned disbelief.

"Yes, would you believe it? The girl in number six"—Evelyn—"was writing with it. And she [is] so innocent looking."

"Never!" Suzanne replied, playing along.

"She was writing on the shelf by the little window. Anybody could have seen her."

"Good heavens!" Suzanne was still humoring him, but she was also surprised by Evelyn's poor judgment. "Well, never mind, Otto. She's a good girl and never makes trouble. Now she no longer has a pencil, and there's no need to make a fuss about it. Just keep it quiet."

She finished exercising and told Otto she was ready to go back to her cell. She suspected that the guard wanted to ask her whether she had a pencil, too, but he never did.

After Otto shut her door, Suzanne climbed down on the floor and called through the crack to Mr. Costard, Evelyn's father, in the cell below. Your daughter has lost her pencil, Suzanne told him. Do you have an extra? Each of us has one, Mr. Costard told Suzanne, speaking of himself and the two men who shared his cell. We can spare one for Evelyn.

From her hiding place among the cigarette stubs in the air vent, Suzanne took out a little reel of cotton thread, possibly one Evelyn had smuggled to her, and began to unspool it. On her knees, she crawled to a spot near the window to find the wide gap in the floorboards and wiggled the loose end of the thread. It slowly descended to the men waiting below. This was another manifestation of the so-called postal system at work. "They got as excited as schoolboys when they saw it come down because," Suzanne recalled, "we had never yet had occasion to use this means of communication."

Mr. Costard tied the thread around the middle of the pencil, and Suzanne slowly pulled it up, but the pencil got stuck across the crack. She lowered it back down, and he tried again. This time, he tied it as close to the unsharpened end as he could. Now the pencil, dangling straight down, slipped between the boards into Suzanne's waiting hands.

That night, during the after-dinner chores, Suzanne delivered the pencil to Evelyn. She also took the occasion to give her young friend some tips on secret letter writing that she had learned during her time behind bars.

ON NOVEMBER 14, 1944, some three months after their first interrogation, Lucy and Suzanne were called for one more round of questioning. This time the prosecutor himself came to Gloucester Street.

The Chef had already told Suzanne that German soldiers who had been arrested were deeply afraid during their interrogations. "They go like this," he said, and he started to shake and shiver to demonstrate the extreme level of anxiety. Then he nodded several times very dramatically to make sure Suzanne understood what he was talking about.

Now on their way to meet the prosecutor, the Chef warned Suzanne that the prisoners were especially afraid of this man. He had tried numerous cases against German soldiers for desertion and other crimes. All were executed.

"These boys have been trained to fear anything that wears an officer's uniform, and we haven't," Suzanne told the Chef. "Our brothers and cousins were officers at the time of the First World War. We cannot imagine that an officer is a superman."

"This is Lieutenant Lung, prosecuting officer," the interpreter said, introducing Suzanne as they entered the warm room in the warder's lodge, a nice change from her cold cell. A typist sat nearby. "He is not satisfied

with the statement the police sent him and would like to ask you a few questions." The interpreter paused for a moment. "That is, of course, if you have no objection. You are not obliged to answer."

"No objection at all," Suzanne said. She almost admitted that this questioning was a welcome relief from the boredom of prison life, but she held back. The Chef took a seat and, Suzanne thought, "assumed the dutiful smile of the employee."

Lung was a young man with "dark, close-cropped hair" who took time to arrange his accoutrements meticulously on the table; these included "a sheaf of papers, one tin box half full of tobacco, a little cigarette machine, and a small carton of cigarette papers." Apparently he would be rolling his own during the interview. Once everything was in place, they began. He lit up and proceeded to smoke throughout the questioning.

"I have your statement here," he began. "I want you to look at it and tell me if you can suggest a reason why the police should have given me a carbon copy and not the typescript you signed."

"Perhaps they lost it," Suzanne offered.

"That is very unlikely," he replied, smoke curling in the air around his head. Both she and Lung knew the real reason: she hadn't signed it.

"Yes, I suppose you are right. Of course . . ." Suzanne smiled coyly.

"So there is something."

"Toward the end," Suzanne instructed, "not on the last page, the one before, I think, one of my answers should [have been] crossed out and another version written at the bottom of the page."

Listening to Suzanne, Lung cocked his head to one side, as was his habit. She thought how much he looked like the famous fox terrier from the logo for "His Master's Voice" records.

"You can see for yourself," he said, fanning out the pages on the table and picking up the page that Suzanne mentioned. She found the correction, but she still had no intention of signing the document.

Lung grew tired of playing games and turned to more serious questions.

"Are you sorry for what you have done?"

"You speak as if I had broken a teacup," she replied. "I am sorry we were caught. But what we did was not done on the spur of the moment. It was regular work, a considered and planned activity, spread over several years. If I could regret it, I should not have done it."

Three months ago, Lohse asked her how she and Lucy had learned to make their propaganda. Now Lung followed up on that question: "How did you come to think that you could do it?" Suzanne reminded him just how much propaganda there was in every newspaper of the day, from advertisements and advice columns to "Eat more sugar. . . . Eat more rice. . . . Eat more bananas," she recalled. No one could escape it. "We became convinced that commercial publicity was abusive," she told him, "and that political propaganda, which often used the same methods of irrational suggestion, was downright dangerous. . . . I should like to say that, as I see it, our propaganda was honest."

"So you think propaganda is evil, but you undertook it all the same?"

"I also think that killing is evil, but it is unavoidable in a defensive war. Moreover, our propaganda had one redeeming characteristic. At least I believe so. Most political propaganda is designed to prevent people from thinking. Ours was designed to make them think." Here, she was articulating Lucy's concept of indirect action, that a work of art could change people by making them see the world differently.

"Did you realize that this propaganda could undermine the German soldiers' morale?"

Suzanne wondered what else he thought they might have been trying to accomplish, but she realized that he was just following his script. "That is exactly what we were doing it for," she said.

"So, you would say that you are responsible for your actions?"

"From a legal point of view, certainly."

Suzanne looked down at her hands resting in her lap and realized that after several months in prison, they were as white and smooth as they had been when they lived in Paris, before they had been tanned by the Jersey sun and calloused by gardening.

"From a legal point of view?"

"Because if you were to put the question at another level, I should not care to commit myself. I am inclined to think that between heredity and conditioning, there is not much room left for what we call free will."

Lung threw up his hands. "But we cannot go into that kind of thing!"

"Of course not. You should not have asked."

Lung chuckled, and the interpreter, sitting behind the lieutenant, looked at the back of Lung's head with reproach.

The Chef sat with his arms folded and his chair tilted back so that he could recline his head and look up. "He was apparently lost," Suzanne later wrote, "in the absorbing study of a damp stain on the ceiling, a large stain yellow with age and wonderfully like a map of Ireland."

Lung wanted to know about Suzanne's politics. Was she a communist or a royalist?

"I've never belonged to a party," she replied, "and I've never voted. Women don't vote in France. But if I did vote, it would not be for the Right or the Left. It would be for the center, the middle of the road. I would say that I'm a democrat." She conveniently left out her and Lucy's association with communists in their Paris days.

Lung had been rolling another cigarette with his little machine, but now he stopped. "You believe that democracy is the ideal form of government?"

"Before we can have ideal government," Suzanne said with a shrug, "we must have ideal men, and we don't seem to be heading that way. No, I just think it's the lesser evil. If the people are dissatisfied, they can usually get rid of a democratic government without bloodshed. With a dictatorship, it is more difficult."

In June 1940, following the invasion, Lung told her, France had signed an armistice that allowed the Germans to occupy much of the country. Did Suzanne know about this? Not waiting for the translation, she cut in sharply. "Marshal Pétain . . . signed an armistice with Germany. That is not binding for the French people who do not recognize Pétain's authority." Suzanne knew that Philippe Pétain, leader of the remaining domestic French government headquartered in the southern town of Vichy, was openly collaborating with the Nazis.

"But the population . . . tacitly agreed to surrender."

"We accepted terms that were printed for all to read and that were not respected. A contract which does not bind both parties is not binding at all."

"Of course one may look at it that way. You are a pacifist?"

"Only fifty percent," she answered. "I am against wars of aggression."

"On what grounds?"

"I think it is wrong to kill and to rob, and it does not become right simply because you do it on a large scale."

Lung finished rolling his cigarette and put it in his box. "So you would have been against Napoleon?" If Suzanne had an answer to this question, she did not later record it. Perhaps she just let Lung's words hang in the air.

Lung then asked about Allied bombing raids, but Suzanne turned it back on him by referring to German raids.

"But surely you know that it was England who declared war on Germany," Lung said.

"Yes, you always manage these things very nicely."

"What about colonial wars?"

"What do you expect?" Suzanne shrugged. "I believe that colonialism is morally wrong, on the same moral level as theft, burglary, and murder, that colonialism is business—a rather unsavory kind of business—with a camouflage of heroism and adventure."

She had one concluding remark: "And moreover, now that I know what it is like to be colonized, I have strong personal feelings against it.

16

"WE ARE AT THE SHOW"

AS THE TRIAL APPROACHED, Suzanne lay on her bed or perched on the small stool in her cell late into the night, scratching out letters to Lucy. She labored to keep Lucy's spirits up but revealed her own anxieties as well. "What I fear is a 'magnanimous' sentence, ten or twenty years in prison," she wrote. She speculated that they might even have to serve time in Germany "to show . . . that the sentence of the military court was not a joke." She confessed, "Maybe I'm putting things a bit too darkly, but when I learned that their planes go back and forth twice a month, it was a blow. To be shot here, that's nothing compared with what one fears will happen over there." She did not say exactly what frightened her, but she likely meant a concentration camp, torture, or execution. "But the only thing one can do is wait, isn't it, trying to conserve one's serenity—not too easy, my little chick. If one all of a sudden falls ill, maybe that simplifies things, but it's not easy anymore to really get sick at will. We still have courage, concentration on stable and precious ideas to forget this difficult present, patience. . . ."

Suicide no longer seemed to be an option. There was little more they could do than wait.

No matter what Suzanne wrote to comfort her, as "foreign women of bourgeois backgrounds, with a nonconformist ideology," Lucy knew the many strikes against them. In all, 739 islanders appeared before the military court on Jersey, and Lucy and Suzanne would soon be among them.

NOVEMBER 16, 1944, was warmer than usual on Jersey. Guards swung open Lucy's cell door and her "chauffeurs," whom she described mockingly

as "of the 'blonde beauty queen' sort," took her downstairs. It amused her that "they all looked like funeral directors."

Suzanne joined her in the car for the trip to the German court-martial at Kings Cliff House in St. Helier. Suzanne later recorded her memory of the sky that day, describing a "large salmon pink sun in a pearl grey sky shorn of its rays by the morning mist."

The three men who would judge them—two older officers and a young soldier—loomed at a baize-covered table. Someone introduced them to the presiding judge, Dr. Heinz Harmsen, using his title as the chief lawyer of a German court-martial with a rank equivalent to major—Oberstabsrichter Harmsen. He would be assisted by a major, whose name neither Suzanne nor Lucy remembered, and Lance Corporal Schmidt.

As they came in, Harmsen looked at Lucy and Suzanne over the top of his glasses. One of the soldiers at the prison had told Suzanne that Harmsen was "all right" and had a good reputation. "He was a tall, slim man," she later wrote, "middle-aged and greying, with a lean face and clear eyes that looked straight at you but without a trace of aggressivity. He looked much more like a scholar than a soldier. I took to him at once." By contrast, the major serving on the tribunal was "a most unpleasant type," she recalled. "He was red-faced and very pimply with an unpleasant leer and looked as though he overdid most of the things a man should not do." Lucy remembered him simply as "fat, red, and blond."

Lance Corporal Schmidt had "a mop of fair hair," according to Suzanne, and wide eyes. He was "very young and looked like a cherub. He also looked anxious and embarrassed," trying to make sure he did not upset his superior officers by doing or saying the wrong thing. When Suzanne smiled at him, he quickly glanced around to see whether anyone had noticed, fearing potential repercussions. "I believe he would have fled had it been at all possible to do so." For his sake, she tried to avoid further eye contact.

Lieutenant Lung was in place as prosecutor, joined by Captain Bode, the only witness. An interpreter sat nearby to translate between German and English. Some note takers and a nurse were present as well.

The judges and lawyers convened in large imitation-leather armchairs on one side of the table. The soldiers escorted Suzanne and Lucy to "two astonishing monuments to tapestry and carved oak," Suzanne recalled, "so highbacked that when you rested your head against the padding, it was

surrounded by eighteen inches of carved wood scrolls." The chairs, placed opposite the Germans, were so large that the women could not use the armrests without spreading themselves unnaturally wide, so Suzanne rested her hands in her lap. Lucy, thinned by illness and lack of nourishment, "was curled up in one corner of her chair like a child who climbed in a seat made for a large adult." Behind them were two rows of spindly gilt cane chairs. Captain Bode, wearing a white jacket and smoking his cigar, balanced on one of them.

On a table lay all the items confiscated at La Rocquaise during the raid, including their Philips radio, Underwood typewriter, and Kodak camera; two guns; books; articles published by Lucy's father; one of Suzanne's wooden crosses that Lucy had planted on a soldier's fresh grave; pieces of fabric; and a few of the coins painted with nail polish on which the women had etched "Down with war!" These once familiar things now seemed strange, so out of context in a courtroom rather than at home in La Rocquaise. "This collection [looks] like a sort of junk shop," Lucy wryly thought.

Also on the table sat Bode's fat file, which was packed with their notes. The approximately three hundred scraps of paper now entered into evidence were only a fraction—"one-twentieth"—of what they had produced, Lucy claimed after the war. Her estimate was different from what Suzanne had recalled, but of course neither had really been counting.

The other noteworthy feature in the room was the three-quarter-length portrait of Hitler that hung over the fireplace. He appeared to be presiding over the trial.

"The slanting rays of the November sun streamed in through the two French windows, picked out every curve of the gilt chairs, every flower of the light-colored carpet, and glittered on the tiles of the big stove that stood at the far end of the room," Suzanne remembered. "What with the stove and the sun, this large room was delightfully warm as if there had never been a war."

Lucy, too, recalled the large windows filled with the sunshine from the beautiful day outside, even describing the room as hot—"What a luxury!" she thought—compared with their cold cells. "Two large comfortable armchairs in the front row, next to one another, what a delight. We are at the show," she remembered with more than a bit of sarcasm. "The decor, the actors, did not disappoint us."

Rather than reading the indictment or inviting the prosecutor to begin, Oberstabsrichter Harmsen began by questioning Lucy and Suzanne in German about their responses during their interrogations. Then he asked about some of the evidence he felt Lohse and Lung had ignored, peppering the women with a string of additional queries.

"Any previous convictions?" Harmsen asked. "Have you ever appeared before a court?"

"Never," Suzanne answered in German, speaking for both herself and Lucy.

Harmsen turned the proceedings over to Lieutenant Lung so that he could make the formal case against the women, and for the next few hours, he did just that. Lung began by focusing on several of their leaflets and messages to the German troops. One of those was their darkly funny version of a *Heldenlied*. Lohse had asked them about it during his interrogation, and Suzanne had not denied that it crudely shamed German women and embarrassed German men. Lung read the song, in its entirety, to the court. The refrain joked:

> And when I came home on leave,
> My wife was pregnant.
> Don't be cross, my little boy, she said,
> The Fatherland needs soldiers!

"This is an insult to German womanhood," Harmsen declared. Lance Corporal Schmidt, deeply offended, refused to look at Lucy and Suzanne.

"By no means," Suzanne protested. "I have simply tried to show the kind of situation that would arise if a woman actually followed the directives of the party." The men at the table sat silently as Harmsen shuffled his papers. "Perhaps I should have made it clear that the father [of the many children the poem went on to mention] was always an Aryan?" she quipped slyly. Harmsen put the leaflet down and picked up another.

"I watched the darkened faces examine the illustration where we announced to them the defeat at Stalingrad before it took place," Lucy later wrote, "where we announced the landing of the English in France, the retreat from the boundaries of the greater Reich, where we asked the question: where are our borders?"

ODDLY, THE TRIAL DID HAVE ITS MOMENTS of levity. The major look-
ing over the women's illustrations, many in the form of fake advertisements,
laughed out loud and showed them to Lieutenant Lung's secretary, who
also broke out laughing. The court found the jokes about Knackfuss—
Colonel "Cracked Feet"—particularly funny. The pun on the man's name
was indeed clever, and since Knackfuss had been taken from Jersey in
March 1944 to face a court-martial over defeatist remarks and what some
had seen as anti-Nazi behavior, laughing at his expense was not a problem.
Knackfuss, they chuckled, had run off despite his "cracked feet."

Then Harmsen brought up documents that seemed to promote rebel-
lion among the troops, and the tone of the proceedings turned very serious.
One of Lucy and Suzanne's notes was especially controversial, and it came
up frequently in the course of the trial:

—Alas, I rather wish I were captured!
—If you surrender, then you will be shot dead by the officer.
—Let him come then! With such an officer, I will be the first to
shoot!

Lucy insisted to the court that their text was a pacifist one: "Incitement
to desertion, certainly! With violence if needed, but a minimum of violence."

Bode sat in one of the small chairs in the back of the room, puffing
cigar smoke. Harmsen finally called him to testify, and he launched into an
attack. Suzanne recalled the anger in Bode's accusations. You have violated
all the occupation decrees! No, she responded. We haven't violated the cur-
few; we haven't hoarded food. (Neither of her claims was actually true.)
Bode, as Suzanne remembered, then accused the two of one particularly
"immoral act": putting the crosses onto soldiers' tombs.

"An abominable sacrilege!" he shouted.

"No," Lucy protested in all earnestness, "we had only the greatest
respect for the dead. Our crosses and the fresh flowers we attached were
nothing but an homage."

As Bode talked about the symbolism of the flowers they had placed, a
smile began to creep over Harmsen's face. When he saw it, Bode became
quiet, his chair creaking as he settled back into the seat.

"Don't you know that a revolution can't succeed by only addressing the
soldiers?" Harmsen asked the women. "They are only the followers, and in

the army, it's the officers who must start the reversal that you are imagining. What do you have to say on this point?"

"I did also address the officers," Lucy responded, and she reminded him of the fake magazine issue the women had made and left for Colonel Knackfuss in the St. Mary and St. Peter Church. "But we were not so ambitious, really. What we tried to do was to make the soldiers stationed on the island aware of the general situation, so that as many of them as we could reach should become unwilling to fight for a cause that was already lost. We thought that when the officers realized the men's unwillingness, they would give up any idea of making a glorious last stand."

"So, it was deliberately calculated on your part?"

"Of course," Lucy replied.

Lucy and Suzanne did not offer any defense for their actions, nor did they plead for their lives in front of the tribunal. They merely maintained their right to stand by their opinion. This attitude puzzled the court, but to the women it made perfect sense. "We belonged by the power of our formative years to a world that had died in 1914," Suzanne recalled, looking back after the war, "and our conviction that abstract values could only exist as long as mankind cherished them made it . . . more imperative to fight for their survival."

If Lucy and Suzanne did not defend themselves, their court-appointed attorney at least carried out his minimal duty by presenting an explanation on their behalf. As he stood up in front of Harmsen and the others, Suzanne thought he looked like "a small wizened monkey in a resplendent uniform. He would have been pathetic if his eyes had not held so much hatred."

"These poor misguided women," the defender announced to the court, his words dripping with contempt for Lucy and Suzanne, "have been listening to English propaganda. And everyone knows that the lying English propaganda appeals to the lowest instincts of human beings." This was his attempt at mitigating circumstances.

Suzanne grew livid listening to his statement. She found it profoundly insulting to their intelligence. To assert that she and Lucy were acting on anything other than their own deeply held convictions hurt her to the core. Then the lawyer switched tacks, no longer even pretending to be helpful. He began to interpret the controversial document in which they advocated

insurgence among the troops in the least favorable light for their case, even though the punishment for inciting mutiny was death.

Suzanne wanted to interrupt but thought better of it. Instead, she twisted sideways in her enormous chair, turning her back to the attorney. It was her silent protest against this man, who was growing more detestable with every word, and an attempt to distance herself from her own defense lawyer's claims.

When she spun away from him, Suzanne now faced Lucy, who was looking around in amazement. She paid little attention to her German defender—she could not understand him in any event without the lagging translation. Suzanne observed that Lieutenant Lung was smiling and biting his lip to keep himself composed in the face of the defense attorney's ridiculousness. Harmsen raised his eyebrow, and the major looked at the defense with curiosity. When her lawyer stumbled over his words at one point in his pontification, Suzanne took vengeful pleasure in his embarrassment, but then she tried to shut out his voice, thinking about when and how she might be able to get even with him.

Their defense attorney finally concluded his lengthy and damning statement with a mild attempt at swaying the court in its sentencing discretion. The German Reich can afford to be generous, he claimed. A sentence of hard labor for life would be appropriate justice for the crimes committed. At least he had not asked for the death penalty, Suzanne thought to herself.

When he sat down in his chair, Suzanne turned back toward the table to face Harmsen, but her blood boiled again as she heard the translation given for Lucy's benefit. The translator gave "such a charmingly bowdlerized version" that Suzanne could barely contain her anger. Lucy, still not really knowing what was going on, kept looking at Suzanne, trying to figure out what was upsetting her.

Harmsen turned to the women and asked whether they had anything to add in their defense.

Suzanne coolly raised an interesting hypothetical question: "If, at the present time, in Aachen, two German women were doing for the American soldiers what we have done here for yours, would you blame them?"

Lung smiled and jerked his chin toward Harmsen. I told you these women are smart, he seemed to be saying, and they can argue back far better than their lawyer. "Our counsel had achieved the seemingly impossible,"

Suzanne recalled of his growing frustration and embarrassment in defending two women whose actions he hated, "in flushing a still deeper shade of red."

Suzanne's question turned the tables on Harmsen and made a powerful point. Aachen, the first German city to be captured by Allied forces, had fallen only a few weeks earlier. If two German women were circulating propaganda to subvert and protest the Allied occupation of a German city, how could Harmsen possibly blame them? Not only did she pose an ethical question about the morality of occupation and resistance to the men sitting in judgment of her, by discussing a devastating German military defeat in open court, she also demonstrated her ability to have acquired forbidden details about the war. Her question was a simple but significant act of defiance.

Harmsen thought carefully about what Suzanne asked, his pause stretching out to an uncomfortable length. "But if they were caught," he finally replied, "they would be judged by an American court, and they would probably be sentenced to death."

"Very likely," Suzanne shot back. "We know it is the custom in wartime. But we have never questioned your right to shoot us. The point I wish to make is that, even by your own standards, it would be absurd to blame us on moral grounds. I am glad to say that the prosecution did not attempt to do so."

Harmsen wondered aloud whether Suzanne thought the proceedings had been reasonable. "You have asked me if I was satisfied that our trial had been fair," she answered. "I could not help taking exception to some of the things our counsel said, but I found nothing to criticize in the prosecutor's speech." Lieutenant Lung smiled, looking pleased with himself.

"In the New Reich," Harmsen said, "the role of the defense is not, as in other countries, to pretend against all truth that the guilty are innocent. It is limited to stressing extenuating circumstances and pleading in mitigation."

"That is very reasonable," she replied. "But in our case, it does not apply. We have never denied the facts, and if our counsel had tried to do so, we would not have allowed it. However, even if a defense counsel in the Third Reich must not tell lies for his clients' sake, I don't suppose that means he is expected to insult them."

"But your counsel has not insulted you," Harmsen protested.

"Well, of course I realize that feeling insulted is a personal reaction, and that different people will resent different things. But all the same, if someone said that you had allowed yourself to be influenced by a propaganda which appealed to the lowest instincts of human beings, I think you would not like it." Suzanne paused for a moment, then succinctly summed up her opinion of the proceedings: "It seemed to me that the defense was a good deal more hostile than the prosecution."

The fat major broke into laughter, along with the two note-taking soldiers. Harmsen put his hand over his mouth to stifle his own chuckle. Lance Corporal Schmidt eyed his superiors, not quite knowing what to do. Suzanne thought he might burst into tears.

The defense attorney hung his head, his pink-rimmed glasses sliding down his nose. He sat as still as a stone, "fists tightly clenched and purplish red against the white papers and the green tablecloth, with the knuckles standing out like ivory knobs." As Suzanne remembered it, "I did not care whether he broke a blood vessel or not. That man had brought me closer to hatred than I had ever been in my life, and I blamed him for it."

Lucy put her hand on Suzanne's arm, her eyes filled with questions. Suzanne gave a nod of reassurance and whispered that they could talk later about what had just happened. "Suddenly it seemed they were all talking at once and so fast that I could not catch a word," she recalled. Harmsen, the major, Lung, and the interpreter chattered away. Lance Corporal Schmidt managed only to appear confused. The NCOs taking notes watched in silence. "Our counsel sat still, wrapped in despondency," Suzanne observed.

Once things settled down, Lung recommended a stern sentence for the various charges: nine months' detention for possession of the guns and the camera and ten years' detention with hard labor for the illegal radio with the intention of using the information they heard on it against the Reich. In addition, their remaining property would be confiscated. For distributing their leaflets, Lung declared, the punishment should be death.

The court adjourned to consider the sentence, although guilt was a foregone conclusion. The soldiers who had driven Lucy and Suzanne to the trial reappeared and hung a sign on the door where the court was deliberating. They escorted the women to a nearby sitting room with watercolors of Swiss mountains on the wall. The men brought them a café Kneipp, a malt

coffee substitute used during the war, and talked with them casually about philosophy as silver spoons clinked porcelain cups—so strange under the circumstances.

Suzanne asked the nurse who had sat through the entire trial to take her to the toilet. The two women moved through a crowd of uniformed officers in the hallway. A short way up the staircase, the nurse opened a door, revealing a tiny lavatory that "obviously could admit only one person—the user," Suzanne described. The men in the hallway—"a sea of upturned faces"—watched as the two women stood in front of the open toilet door, negotiating an awkward situation.

The nurse could not leave Suzanne, the prisoner who had attempted suicide, alone. But as a woman, she surely sympathized with Suzanne at this moment and the need for propriety. "The nurse looked in despair at the lavatory," Suzanne recalled, "then at the officers, all silent now, and staring at me she spoke in a whisper, though with considerable agitation: 'You must close the door, but please don't push the bolt!'" The nurse seemed to be begging Suzanne not to make a scene, especially in front of a hallway full of officers. Suzanne's reply surely calmed the nurse, but it was also a statement about something larger: "Don't worry. . . . We have no intention of missing the end."

Suzanne would not fight back by locking herself in the toilet but by standing up in open court to defy her accusers. For her part, the nurse merely smiled, relieved.

WHEN EVERYONE GATHERED AROUND THE TABLE once again and the court reconvened, Harmsen proclaimed the verdict.

"You are *francs-tireurs*," he declared, using the French term for guerrilla fighters or irregular military shooters, "even though you used spiritual arms instead of firearms." He gave a brief summary on why their actions were so significant and why he had condemned them as dangerous political criminals. "It is indeed a more serious crime. With firearms, one knows at once what damage has been done, but with spiritual arms, one cannot tell how far reaching it may be."

Harmsen had just given a nice summary of Lucy's "indirect effect," and Lucy could not help but think, "We couldn't have put our defense any better ourselves."

The tribunal's severe verdict was in some ways welcome. Such damning words from a high-ranking German officer proved to Lucy and Suzanne just how important their work had been these past few years. Their notes were not insignificant, nor had they gone unnoticed. Instead, those efforts had become such a thorn in the side of the occupation that the German officers were forced to take action. Like Lucy and Suzanne, they knew that strong words mattered, especially in occupied territory. Words had the power to move hearts and minds and to rally people's spirits. The Nazis knew this from their experience with master propagandists like Hitler and Goebbels. Allied propaganda leaflets dropped behind the front lines or in occupied territories had been of great concern to German commanders on every battlefront throughout the war. On Jersey, even pieces of paper with poems or slogans punctured the illusion that Germany was in complete control of the strategically important island.

Then Harmsen announced the sentence. First, all their property would be officially confiscated, including their large collection of artwork. Suzanne was tempted to ask whether the confiscation of property was retroactive in order to legalize the looting of La Rocquaise that took place immediately after their arrest, but she decided not to make the situation worse. In addition, for having an illegal radio, guns, and a camera, they would serve six years of forced labor and nine months in prison. For creating and distributing propaganda with the intent of undermining the morale of German forces, they would be put to death.

Listening to the translation of Harmsen's condemnation, Lucy was confused: Why not just execute them and be done with it? She asked the court for some explanation of the punishments for the lesser offenses, likely with more than a bit of sarcasm in her voice. Are we to do our time in prison, and then the hard labor, and then be shot?

The interpreter jumped in. "No, no!" he exclaimed, sounding stunned. "The death penalty cancels the others." Lucy turned to Suzanne and looked at her with wide, curious eyes. "I thought she was going to ask me what I thought of this nonsense," Suzanne remembered, "but she gave up and just shook her head."

The interpreter approached them with a piece of paper, placed it on the green cloth covering the table, and offered them his fountain pen. "There

is no appeal against the verdict of this court, but you can make a plea for clemency," he told them.

"There were a few typewritten lines at the top of the sheet and, below, a kind of ornamental squiggle," Suzanne recalled. She did not bother putting on her glasses to read the paper he had presented to her but just left her hands in her lap and said politely, "No, thank you."

"But it is always done!" the interpreter shouted. Who would not wish to ask for clemency? Still, Lucy and Suzanne refused.

"But your counsel has already signed it," he said, referring to the scribbling at the bottom.

"That's his own business," Suzanne replied indifferently.

The defense attorney did not wait for the interpreter this time. In English, he jumped in: "It is not my business! It is my duty!"

"But why won't you sign?" the interpreter pressed.

"I cannot tell you," Suzanne responded. "I mean, it never occurred to me that you would ask us to do this, so I haven't thought about it, and I should want a little more time to reason it out. For the moment, I can only say that I do not wish to sign that paper." Later, she thought, "The one clear idea in my mind was it was unthinkable, considering my opinion of the Nazi leaders, that I should ask any favor of them. But that would have been a rather offensive remark, and I did not wish to offend these men, who had been on their best behavior in their dealings with us, all save our counsel, and that account was nicely settled."

The interpreter pushed the paper toward Lucy, pleading, "You will sign it, won't you?"

Lucy replied gently, "I can't."

"But one can always ask for mercy!"

"It does not matter much when one has been fighting over lands or markets," Lucy replied. "But when you are fighting on ideological grounds, it is out of the question."

"There," Suzanne chimed in. "I knew there was a good reason."

The interpreter turned back toward Harmsen, and the soldiers began discussing the situation among themselves. By this point, the whole ordeal had been going on for some five hours, and Suzanne suddenly realized how tired and stressed she was. She began to wonder whether the warders would put their dinner aside if they were not back in time. The

physical need for food suddenly outweighed the thought of facing the death penalty.

At last, the interpreter addressed the women. "If you will not sign it, it is finished. You will be taken back to the prison."

Suzanne, happy at the thought of returning to Gloucester Street, stood. But Lucy was not satisfied and wanted to know more. "When are we going to be executed?" she asked.

"Oh, not for some time. The judgment has to be confirmed by the high command."

"Can we be together while we wait?" Lucy asked.

The interpreter turned and looked at Oberstabsrichter Harmsen, who began to discuss the matter with Lung and the major. A mute Captain Bode still sat behind Lucy and Suzanne, watching and smoking.

"We cannot decide that here. Orders will be transmitted to the prison."

"But we were told—" Lucy started.

Suzanne grabbed her hand and pulled her close, whispering, "Don't mention the Chef. It [will] make trouble." Lucy drew in her breath sharply and stayed quiet.

"It is all over; you may go out now," the interpreter told them.

Suzanne bowed slightly toward Harmsen as Lung opened the door, cocked his head to one side, and grinned. They crossed into the narrow hallway, and one of the young soldiers who had given them ersatz coffee during the break opened the front door for them and smiled "like an old friend." Suzanne remembered, "We walked down the garden path quite alone as if we had been completely free. It was very odd. . . . The car that had brought us was waiting. The gendarme who sat by the driver jumped up, opened the garden gate, and then the car door. I began to have a queer dreamy feeling that we should never again be allowed to open a door for ourselves. We settled down for the drive."

In an interview many years later, Harmsen recalled telling the defense attorney that after the trial he should go ahead and file the appeal for mercy.

"Why? It is right that they are being sentenced to death," the lawyer replied.

"But you are their defending counsel," Harmsen reminded him. "Of course, you must file a petition for mercy. I hereby give you an official order to file a petition for mercy."

17

"THIS STRANGE DREAM"

AMONG THE MORE THAN SEVEN HUNDRED PEOPLE convicted of various crimes by the occupation court on Jersey, many were sent to prisons in Germany, with women usually going to a facility in Cologne. By the middle of 1944, some thirty Jersey citizens had been executed in those prisons, and several more died in concentration camps. Given the severity of the charges against Lucy and Suzanne and the faltering war effort, which left the police little to lose, the two women would be lucky to survive.

Back at Gloucester Street, the driver got out of the car and rang the bell. Ludwig opened the door. "His whole face was like a question mark," Suzanne recalled.

"Death," she told him.

"No!" Ludwig's eyes shot wide open, and his dense black eyebrows arched in disbelief.

She nodded. "They wanted us to sign a paper, but we refused. I hope you kept our dinner for us."

"Of course. It is on the corner of the stove. We'll bring it upstairs as soon as you are ready."

There was no need for Lucy and Suzanne to tell others the verdict because word of it spread quickly among the political prisoners, some yelling the sentence down the corridor.

A little later, Otto let Lucy out to stretch her legs in the hallway and peek through the spy-holes of other cells so that the inmates could convey their sorrow. Wassili had a "tender and sad" expression on his face, she recalled. Others had blank looks or shouted their defiance at the Germans on Lucy and Suzanne's behalf.

Lucy looked in on two German prisoners, Hassell and Wolkoff. When she peered through their window, Hassell was lying on his mat. He looked up at her and held up one finger. "One year?" he was silently asking. He had not yet heard the outcome.

Lucy shook her head. He held up two fingers. Again, she gave a shake of her head.

Three? Four? Six? Ten? Each time Lucy shook her head no. Then he made a gesture of the knife across his throat. She nodded yes. Both men clenched their fists in anger.

Lucy asked Otto to take Hassell some of her bread wrapped in a piece of paper since she was only able to eat half her ration those days. Hassell later slipped the very same piece of paper, still with the bread inside, back under her door. She was moved by the gesture.

"I felt so fed up with everything," Lucy wrote of her frustration. "I needed all the spirit of fraternity of the place to pull me out of hatred's hell." Later that evening, their downstairs neighbors sang some songs just as she had asked them to do. The nostalgic words to the wartime hit "The Last Time I Saw Paris" and the rousing chorus of "La Marseillaise," among others, wafted up from below, accompanied by the plaintive sound of a lone harmonica the musicians passed from cell to cell.

The singing lifted Lucy's spirits, especially when they crooned, "Pack up your troubles in your old kit bag, and smile, smile, smile!" Another of the songs also echoing throughout the corridors that night was "The Quartermaster's Store" ("My eyes are dim, I cannot see"), about a short-sighted quartermaster who can't see the snakes, rats, roaches, and other pests running around him. The singers in the cells below them substituted the names of the interrogators and the jailers for the snakes, rats, roaches, and other creatures.

There had been some talk among the guards of moving Lucy and Suzanne into the same cell after their trial. Quite a few of the overcrowded rooms housed three people. During the day, these inmates would keep kept their mats rolled up and stored in small pigeonholes to save space. On cold mornings, water ran down the walls of those crammed cells as the inmates' warm breath condensed against the cold, whitewashed stone. The situation was so bad that the Jersey Board of Prisons petitioned the occupation authority to build a new facility to address the "excessive congestion

of prisoners." But neither Lucy nor Suzanne moved anywhere. "The Chef resented the fact," Suzanne noted, "that his superiors should complicate his work by insisting out of sheer spite that we should be kept in *Einzelhaft*," or solitary confinement. He could have used one of their cells to ease the overcrowding a bit.

As Suzanne prepared for bed, she heard the creaking of the large iron door downstairs as someone entered C Block. A loud clomping usually indicated Otto's heavy boots, but these lighter footfalls belonged to the Chef. He opened the door, poked his head inside, "and smiled at me tenderly, like a mother smiling at a sick child," she remembered. Suzanne returned the smile.

"Don't be afraid," he said. "They will never dare. Sleep well." He put his fingers to his lips and closed the door slowly and quietly. Suzanne was touched by his sympathy—of all people, the commanding officer in a Nazi jail!—and struck by how humanity found its way into the most unlikely places.

The metal door did not make the heavy, clanking sound it normally did when Otto slammed it. Whether by accident or on purpose, the Chef had closed the door to her cell so quietly that it remained unlatched. She hesitated, then pushed, and it swung open. Amazed, Suzanne sat down on the bed and stared out into the corridor for a few moments. If she wanted, she was free to move about the hallway and speak to the others, a rare opportunity. Perhaps she could even escape. But instead, she took the cold steel into her hand and pulled until the door latched properly, locking herself back inside her cell.

"LUCY WAS CONVINCED that we might be called to account any day in the sinister winter dawn," Suzanne recalled of the day after their sentencing, "and that when it happened, we would probably not be allowed enough time to get comfortably dressed. Lucy decided to sleep in her jodhpurs, which was just as well considering the total lack of heating." She kept the blue-and-white angora scarf that Vera had given her under her head as a pillow.

The German army legally seized their property on November 21, 1944, and although Edna and George had been able to continue caring for the property, La Rocquaise was now officially occupied territory. Harold Giffard came to break the news.

About a week after the verdict, Suzanne was curled up inside her blanket on the hard cot, book in hand, when a German chaplain arrived. As he entered the cell, she did not bother to shut the book's cover, only putting her fingers in the pages to keep it open to her place. She did not intend this to be a long conversation.

"Many people drift away from the religion of their childhood," he told her, "but most of them return to it at the last moment."

During her interrogation, Lohse had asked Suzanne about her religion, and she told him that despite being raised Catholic, she did not practice any faith. Her experience with religion as a child, as she put it, had "not been an emotional one, but merely one extra school subject added to the others over a period of two years." She had no desire to engage in a theological discussion about deathbed repentance, or any other topic, so she just sat quietly, unsure of what to say.

"I have often had the pleasure of rendering this service to Frenchmen since the beginning of the occupation," the chaplain said.

She smiled at him, thinking how he appeared cruel and tactless, even though she knew he was only trying to offer comfort. His very presence and all his words suggested that her death was imminent. Suzanne unwrapped herself from her blanket, placed the book facedown on the bed, and stood. She crossed the small cell and banged loudly on the door. Otto opened it, surprised that she was the one ending the conversation, not the chaplain. Suzanne stood by the door, waiting silently for the chaplain to leave.

"If you want to see me, at any time, just tell your warder. I shall come at once," he told her.

"Thank you. It was kind of you to come," she replied politely. Otto slammed the door shut, and Suzanne went back to her book.

When one of the soldiers behind bars drowned in the bathtub, the chaplain pronounced at his funeral, "Thou hast died the Hero's death in a foreign land." Suzanne later wrote, "I knew the notion of heroism had the delightful elasticity of all abstractions, but I had never expected it to stretch so far."

AT DUSK AND DAWN, Lucy took out the pencil and some precious paper she had secretly stashed in her cell. The guards were less likely to discover her at these times. For the next several days after their conviction,

in the dim light she began to compose a description of the actions she and Suzanne had taken, thoughts about the trial that had just unfolded, and reflections about her life. She supposed it would be her final statement to the world and referred to it as her "testament."

Her emotional words took the form of a letter to Vera. She spoke directly and personally to the woman whom she had so often found annoying but who had proved herself to be such a good friend during their time in prison through her visits and gifts. Lucy confessed her deep worries and reflected on her own shortcomings. She could not help feeling at least some remorse for all the danger she put Suzanne through.

In her testament, Lucy also tried to explain her view of the world to Vera, something they didn't always agree on, especially since Vera's conversion to Catholicism. Doing so led Lucy to write about politics again. She and Suzanne had thought about going back to France when war broke out, but if they had gone anywhere, Lucy admitted, she would have preferred it to be England. "I feel that so keenly, have felt it so from childhood, that I drop more easily in English than French patriotism," she wrote.

Despite pouring her heart into the letter, there is no evidence it was ever delivered.

BY THE END OF 1944, Germany was losing ground rapidly as the Allies advanced and Hitler felt the crushing weight of a looming defeat. "It was a tired, broken man who greeted me," noted a senior army officer after his audience with the Führer, "then shuffled over to a chair, his shoulders drooping, and asked me to sit down. He spoke so softly and hesitantly, it was hard to understand him." In early November, the Allies sank Germany's last warship in the West, the *Tirpitz*, drowning at least a thousand sailors. The opening of the Battle of the Bulge, Germany's final offensive push on the Western front was only a few weeks away. Designed to split the advancing Allied forces, this would be Hitler's last-ditch effort to stop the bleeding.

The bailiff of Jersey, Alexander Coutanche, knew a different set of burdens during the war, having performed a delicate balancing act since shaking hands with the arriving German forces in 1940. He had always struggled to resolve the tension between the pragmatic need to cooperate with the occupation and a desire to protect the civilian population, all while

preserving local control and his own authority. He surely thought that the Germans were within their rights as military governors of the island to condemn prisoners to death, but he also worried that executions of civilians, which were relatively rare, could have serious repercussions for morale.

On November 22, 1944, less than a week after Lucy and Suzanne's trial and sentencing, Coutanche penned a letter to the current German military leader on Jersey, Major Wilhelm Heider, who had taken up the post only a few months earlier. He wanted to convince Heider to treat these women mercifully. The bailiff claimed no particular personal sympathy for Lucy or Suzanne. They were not well known on Jersey, he believed, and had no political or social influence, but the execution of women would surely generate a "feeling of repugnance" against the Germans. Perhaps he was trying to shame them. "In view of the great difficulties which are facing the civilian population," he wrote to Heider, "and my desire to avoid anything calculated to arouse passion, I desire strongly to appeal for mercy on behalf of the two women in question."

Coutanche was not the only one to speak for Lucy and Suzanne. Shortly after the sentence was handed down, Henry Duval, the French consul to the Channel Islands visited Baron von Aufsess, the Bavarian who oversaw the civil administration of Jersey, to see what he could do. The few remaining French people on the island and those with ties to France would be horrified that two of their own were about to be shot, he proclaimed, adding that not since eighteenth-century witch trials had women been executed on Jersey. Surely the occupation forces would not want to be associated with such barbarity.

Von Aufsess, who had denounced Lucy and Suzanne in his private diary, told Duval that he did not believe the sentence would be carried out, but that since communication with Berlin was difficult these days, he could not be sure. In any event, he noted, some of the officials involved had recommended clemency, or at least they were not in favor of execution. Duval asked to visit the women but was instead directed to their local attorney, Harold Giffard. He hoped Giffard would be able to get him into the prison for a visit, but there is no evidence that Duval ever met with them.

The Germans continued to pester Lucy and Suzanne about asking for lenience, but the women always refused. To them, an appeal for clemency was a form of collaboration that would only give the Nazis an opportunity

to look more merciful than they truly were. Such a request would mean turning their backs on a four-year fight by suggesting that Lucy and Suzanne disagreed with the verdict. They knew they were guilty. That was the point—to be guilty according to Nazi law, which they believed was immoral—but their guilt had a very deep significance. Groveling for compassion would be a kind of self-denial of who they knew themselves to be. It would require them to abandon everything they believed.

"Think of your sister!" the callous Wölfle needled Lucy one day, playing on her earlier admission that she had been the mastermind despite what the evidence had shown. "You have put her in grave danger. You don't have the right to pass up an opportunity to help her out. She's too proud to sign; at the very least, you must. You can do it: you write a petition in your own words. Would you like me to find something for you to write with?"

A few days later, Wölfle returned to twist her arm a little more. "They have announced a departure for Alderney," he said, referring to the concentration camp on the neighboring island. "The camp is very bad on Alderney, much, much worse than even the work camps in Germany." Signing would gain some extra time, he suggested.

Lucy was tempted to sign the paper, she later admitted, but Suzanne wrote her a note with some "affectionate scolding." Together, they would stay strong in their refusal.

ONE DAY IN MID-DECEMBER, Suzanne heard steps outside her door, then the key clanking in the lock.

"You have a visitor," Otto told her.

"Who is it?" Otto ignored the question and led her through the living room of the warder's lodge. He opened the door to a small back room, where she found her German attorney whom she hadn't seen in a month. Last time, he was rough and offensive, and Suzanne burned with hatred for him because of his feeble attempt at a defense. Now his demeanor was quite pleasant, although he still clearly did not like Suzanne or the task at hand.

"I hope that you are well," he greeted her. She looked at him with puzzlement. Blushing, he opened his briefcase. "I have come to ask if you will not reconsider your decision."

"What decision?"

The attorney stared at Suzanne reproachfully through his pink glasses.

"If it is about that paper, I'm sorry, but I have not changed my mind." She shook her head at the page he was now holding out to her.

"You understand that it is your only chance of survival?"

"I am willing to risk it."

"It is not a risk," he declared. "It is a certainty."

Suzanne nodded, then refused again.

Later that month, the Chef came to tell Suzanne that their defense attorney was once again at the prison to see her and Lucy.

"What does he want?"

"He did not tell me," the Chef replied with a wry grin. "But I think he could no more refuse to come than you could refuse to see him."

Suzanne laughed. "I suppose it is about their confounded paper."

"I think so too. Are you going to sign?"

"No," she said resolutely. The Chef nodded his approval.

Suzanne had another brief conversation with the lawyer, but after he failed once again to convince her to sign the plea for mercy, he prepared to leave. Before going, he stuck out his hand. "I looked at it," Suzanne remembered. "The palm was broad, pink, and shiny with sweat. I did not want to touch it. But I reflected that we must have been something of a nightmare to the man, and it would be ungenerous to take leave of him with a final insult. So I shook hands with him. Thus we parted, never to meet again."

ON DECEMBER 24, 1944, Lucy sat all alone in her cell for what she thought would be a dreary vigil of Christmas. Edna had brought a cake and some milk for the holiday, but someone else at Gloucester Street had gotten hold of them first.

Suzanne smuggled a note to Lucy, recounting a dream she had the previous night. The chaos of the war caused the heavens to collapse, and all along the earth's equator lay dead or dying stars. The people prayed that God did not see the mess and dug two huge pits to bury the remnants of the sky. This strange dream was the only Christmas present that she could offer.

Around midnight, Lucy heard someone singing outside her door, followed by several brief knocks. She got up to look through the spy-hole and saw Suzanne standing outside in the hallway. The Chef had once again left her cell door unlatched.

Through the small opening, Suzanne told Lucy of how she had encountered an American aviator in the hallway; the Chef had also left this man's cell unlocked. She had sat with him on the staircase, talking about the Allied advance.

We have been sentenced to death, she told the American. As Suzanne recounted their story, he became visibly upset at the injustice of the sentence. I will tell my colonel about this, Suzanne recalled him saying. Maybe he could intervene with the Germans on your behalf.

"It doesn't work that way," Suzanne said, and advised that it was probably in their best interests that he just keep quiet.

The American then confided in her that he was planning an escape from Jersey. Can I deliver anything for you? Letters to friends or family? he asked. He promised he would mail them when he got to France. When Lucy heard this, she decided to give the aviator a letter to take with him as he left the island. She was reaching out, hoping to let others know that they were still alive. But during his flight from Jersey, Lucy and Suzanne later found out, the American destroyed her letter. He didn't want to be holding any compromising documents in case he was caught.

On Christmas Day, Otto opened the cells so that the prisoners could greet one another. When he was called elsewhere for a moment, the inmates were left to themselves. Christmas packages from the Red Cross were on their way. The sense of solidarity buoyed Lucy's spirits, at least for a little while. Their friend Evelyn gave them some bright paper to decorate their cells. They added holly and eucalyptus, sticking everything to the wall with beetroot syrup, the only kind of glue they had. To go with these decorations, they began carving inscriptions onto the walls with nails.

On December 30, the Red Cross ship SS *Vega* arrived on Jersey, and soldiers distributed the packages. The relief was truly welcome, since the liberation of France had cut off the Channel Islands from further resupply by the German navy.

Just after the new year, the Chef came to see Lucy and Suzanne. Contrary to their wishes, he told them, the judges had submitted the appeal for mercy to officials in Berlin. "Since you would not [sign] it, they had to do it themselves." Not even Harmsen knew what the response would be, and he seemed at least as eager as Lucy and Suzanne to find out.

Shortly afterward, Otto came to Suzanne's cell and announced that she had visitors. He led her downstairs to the living room of the warder's lodge. There, she was greeted by two middle-aged civilian Jerseymen she didn't know. "There was something very pleasant about them," she remembered. "They were so not German."

We've come to inform you that civilian authorities have submitted a petition on your behalf, they told her, referring to Bailiff Coutanche's letter to Heider. But why? Suzanne inquired. To appeal your death sentence, one of the visitors said.

The news was a bit disappointing. The Germans themselves had already submitted that very request, and the local petition would surely make no difference in how the Germans proceeded with the case. There were correct military procedures that had to be followed.

Suzanne politely thanked them, although she later wrote, "I could not suppress the nagging idea that I would have done . . . much better if they had only brought me a pound of apples."

At least people on the outside were thinking about them.

18

"LULLABY FOR ONE CONDEMNED TO DEATH"

IN JANUARY 1945, the Soviets launched one of their last major offensives, sending Hitler back to Berlin and to the headquarters from which he would never depart. Within days, the Red Army took Warsaw and then arrived in Auschwitz to liberate the remaining seven thousand inmates who barely survived from among the million murdered in the infamous death camp.

In the months after D-Day on June 6, 1944, hundreds of German soldiers had fled the nearby French ports, heading for the Channel Islands, the last redoubts of occupied territory. But their morale was collapsing. One Jerseyman who had escaped the island told MI-19 about an encounter he had with a German soldier who said, "You think you are going to get Hitler, don't you?"

The Jersey informant replied, "I bet my bottom dollar we'll get Hitler."

"You'll never get Hitler," the German retorted. "I'll tell you why you'll never get Hitler. Because WE are going to get him."

This Jerseyman noted that soldiers on the island were "rabid for our leaflets" and always read them secretly. If only the Allies could drop more, he noted, it would further demoralize the occupiers. "A German soldier once told informant," according to the debriefing notes, "that Jersey held the record among all German-occupied territories for rumor spreading."

By mid-February, as the British and American air forces began fire-bombing Dresden, supplies on the island were running desperately short. Dinner in Gloucester Street had become especially meager, according to Lucy: "a little brown water" that substituted for coffee, some boiled root vegetables with no salt, and every other day some gray meal the Germans called porridge, also with no salt. There were never any potatoes or bread.

Red Cross rations were supposed to make the prisoners' diet a little better, but Lucy and Suzanne never seemed to receive any of what came. Although Red Cross parcels eased the civilian hunger, the troops continued tightening their own belts. No one could be sure when the next transport plane would arrive. "The soldiers lost weight," writes historian Madeline Bunting, "and were ordered to take a rest every afternoon to conserve energy. Virtually all exercises and training came to an end because the men were too weak to drill. Their uniforms and boots were disintegrating, and replacement shirts were made from sheets and curtains." Gas and electricity were also in short supply, and water could be used for only two hours in the morning and two hours in the evening.

The Germans used the little coal that remained for more important things than keeping prisoners comfortable, so the cells were always freezing. Suzanne sat alone inside hers, watching her breath turn to steam in the winter cold. "No, I'm not really suffering from cold feet anymore," she told Lucy in a letter. "They're cold during the day, but I never go to bed like that. I do exercises with [them] when evening comes, and if that isn't enough, I rub them just when I'm going to lie down until they're warm again. After that, they stay warm all night long."

Otto had caught a cold, but because of the lack of handkerchiefs, Suzanne remembered that he wore "an off-white bath towel draped like a stole round his shoulders and used the two fringed panels that covered his chest to wipe his nose." He spread his germs everywhere, "but we were immunised for the rest of the winter," she wrote.

In his role as the island's chief public health official, Dr. Robert Noel McKinstry and his colleagues filed a report on the horrible state of Gloucester Street, highlighting the utterly inadequate kitchen, overcrowded cells, and insufficient medical facilities for inmates. The committee argued that the Red Cross should undertake an inspection to provide much needed oversight. One group of political prisoners who were serving their time on the civilian side because the military side was overflowing wrote to Bailiff Coutanche, imploring him to visit and intervene. The Germans were not distributing Red Cross parcels according to the proper rules, they charged. If only he would come see for himself.

In mid-February, the bailiff arrived, along with other Jersey officials. He visited the political prisoners and communicated their requests to

those in charge. Later, he met with Baron von Aufsess and Dr. Heinrich Koppelmann, the Chef. "I stated that I had received formal complaints of cruelty," he wrote in his notes of the meeting. "Dr. Koppelmann said he would make immediate inquiries."

ALONE IN HER ICY CELL, the singing of her comrades now faded, Lucy's mood sank once again. She put pencil to paper in the dim winter light to begin composing a poem titled "Lullaby for One Condemned to Death." It began:

> In the white cell
> It's the eternal Sunday
> Where Monday
> Never breaks the boredom

Over the course of two days, she captured in verse a vision of her sad, tired self in the midst of winter. She finished the poem on February 20, 1945, filled with defeat, perhaps wishing for more Gardenal.

Later that day, a plane carrying correspondence from German high command in Berlin, including the final status of Lucy and Suzanne's legal case, landed at the Jersey airport. A solider brought a stack of messages to Harmsen, and he sorted through it carefully until he found what he was looking for—the official judgment on the appeal for clemency filed by the military court.

In an interview after the war, Harmsen remembered being very nervous about what the letter might say, although we can't know how truthful he was in that statement. He had sentenced these women to death for what he told his superiors were extremely dangerous acts, but he had also ordered their attorney to file an appeal on their behalf, almost seeming to contradict the severity of the sentence. Had he done so out of compassion or mere protocol? He really didn't know what Berlin would think about the case, especially now that the war effort was clearly collapsing.

Harmsen recounted how he had paced around his desk, turning the envelope over in his hand. If they were executed, he would be responsible, he thought. Finally, he slipped his letter opener into the envelope and removed the document inside. He quickly read the revised verdict: ten years' penal servitude. Lucy and Suzanne's death sentence had been commuted.

Harmsen breathed a sigh of relief. "They will never do ten years' penal servitude," he recalled thinking. The war would be over long before then. But Harmsen knew that executions were still taking place in Gloucester Street.

Officially, according to the order, Lucy and Suzanne were to remain in solitary confinement, but the next day guards moved Suzanne into Lucy's cell. After months of being apart with only scattered instances in each other's company, as when they rode to Silvertide, sat in the courtroom, or talked with their lawyer, they could finally share an embrace in private, look into each other's eyes, and talk for hours, which they surely did. The guards separated them again when they discovered, likely for the first time, that Lucy and Suzanne were more than sisters. As the guard Heinrich put it, "They do like a man and a woman." After a short time, though, Lucy and Suzanne were reunited.

Suzanne described their situation this way: "We were, in a way, taboo—as we had been during the first months of our incarceration. Then, we were the women who must be allowed no contact with anyone. Now, we were the women their masters did not dare to kill. It was a far more convenient taboo." Despite the sheer joy they felt at their moment of reunion and the official reprieve, their deep fears about deportation and death lingered. No one really knew what the next weeks and months would bring. Outside the prison, life went on as well, with Edna bringing her second child, Robert, into the world.

Lucy and Suzanne worked to pass the time and keep their minds sharp. They played a word game, called "*jeu des assonances*." One would select a phonetic syllable, and the other would build a coherent sentence using that syllable in as many words as possible, writing them down on paper smuggled into the prison. They had also acquired a map, which they used to chart the Nazi empire's fall by marking the battles they heard about through the grapevine. Sometime in March 1945, they produced a document that stated in an official-sounding way, but written only for themselves, what they had done: "Sole members of an organization known to the enemy as 'die Soldaten ohne Namen,' the Nameless Soldiers. This underground movement calling the German soldiers to overthrow the Nazi and militarist regime lasted from 1941 to 1944." Lucy also drafted a plan for a short story, never completed, about a young girl reassembling a stained-glass window shattered by the war.

Suzanne saw Heinrich one day at exercise. "How goes it?" he asked her in a friendly manner.

"All right," Suzanne answered, "although we're a bit short of *Lebensraum*"—"living space" was the long-standing euphemism that the Nazis, like many before them in Germany, used for their eastern territorial expansion. Although Mrs. Armstrong had told the women about the carnage at death camps in Poland, Suzanne probably did not fully realize that in the current context the term also referred to the land where a genocide had taken place. He smiled at the dark humor but then got serious again, uncomfortable at making fun of a concept so much at the heart of Nazi thinking.

"Ach!" Heinrich said. "Such is life. Now you are in a small cell that is too full, and soon you will be back in a big house that is too empty."

"He laughed delightedly," Suzanne remembered. He was probably looking forward to going home himself.

BY THE BEGINNING OF APRIL 1945, the Soviets advanced into crucial Hungarian oil fields, and German forces did not have enough fuel to carry out orders to retake the territory. A few days later, Allies fully surrounded German troops in the Ruhr, and the fight only lasted for a short time. By the middle of the month, the Soviets launched their attack on Berlin. German territory was falling quickly to the Allies. British, American, and Soviet forces advanced, liberating more concentration and extermination camps. Allied troops came face-to-face with the horror of corpses and the near-dead who had barely survived the ordeal. Although they didn't realize it, Lucy and Suzanne's fears of being sent to a camp were now completely unfounded.

Their friend and fellow prisoner Evelyn Janvrin sent a letter from the civilian jail to "Miss Schwob and Miss Malherbe," as she called them, on April 4, 1945. The guards had transferred Evelyn there to serve out her sentence. Lucy and Suzanne had written to her a few times, but it was difficult for the prisoner acting as a go-between to deliver the correspondence.

"We had a Gerry bag"—throughout her letter Evelyn used this derogatory term for a Jersey woman sleeping with a German soldier—"in with us for one night we were jolly glad when she was moved her teeth and scent were both obscene, we have an elderly lady in with us now, she was in the

room next to us has been here two months has two more to do is 64 years old in for makeing [sic] butter, shame isn't it, we are rather crampt [sic] but it wont [sic] be for long Muriel"—Evelyn's sister—"goes out in nine days it will make more room but we will miss her."

Evelyn then asked Lucy and Suzanne to sign an autograph book she was circulating among the inmates as a memento. One of the stories written in Evelyn's book, which Suzanne wrote down later, was that of Mikhail, the Ukrainian OT worker who had been behind bars since August and had sometimes brought Lucy hot water. Due to be released on May 1, 1945, he wrote with trepidation, "And I don't know what will happen then."

On the back of Evelyn's letter, Suzanne jotted down a long list of more than twenty Jerseymen and Jerseywomen in Gloucester Street, including their "crimes" and their sentences. One attempted to kill a collaborator, others listened to the radio or passed leaflets, some insulted Hitler or possessed weapons, and one attempted to blow up a hairdresser's shop. One fellow inmate was caught trying to escape the island; the man who had been fleeing with him was killed. These were their neighbors in the surrounding cells.

On April 9, Lucy wrote a note in Evelyn's autograph book. It was a message of hope in the midst of dark times:

> In the name of the nameless who stood against Evil, each to the
> utmost of his power and conscience, of those who in spite of all
> odds have found Truth and acted accordingly, of those who do so
> outside this jail and even perhaps inside, of those who fell in the
> fight and died—but not in vain, in the name of those who cannot
> yet or nevermore speak for themselves, I say: Let us keep united
> in the making of a better life for the individual, common man or
> woman, a life with more comfort, leisure and freedom of choice.
> Let us keep sincere and united in this purpose for it is the only way
> to prevent the perpetual recurrence of tyranny and war.

Ten days later, BBC listeners heard reporter Richard Dimbleby's emotional description of the liberation of the Bergen-Belsen concentration camp by troops from Britain's Eleventh Armoured Division. Still reluctant to address German atrocities and unsure of how listeners might respond, the BBC delayed the report for four days, only proceeding with the broadcast when Dimbleby threatened to quit.

"I've seen many terrible sights in the last five years," Dimbleby told listeners, who were surely stunned by what they were hearing, "but nothing, nothing approaching the dreadful interior of this hut at Belsen. The dead and the dying lay close together. I picked my way over corpse after corpse through the gloom, until I heard one voice that rose above the gentle, undulating moaning."

Perhaps as many as seventy thousand people had died there, worked to death or perished from abuse or malnourishment. Others had passed through Bergen-Belsen on their way to Auschwitz or another extermination camp to the east. Dimbleby broke down repeatedly in the course of his reporting.

Along with everyone else, many clandestine listeners of the BBC around the island of Jersey were learning about the mountains of corpses, mass graves, and crematoria at the sites of what we now call the Holocaust. Despite previous reluctance to talk about the murder of Jews, the BBC simply could no longer ignore the story. Lucy and Suzanne heard even more about the horror as bits and pieces of information filtered into the jail through secret channels.

In addition to the guards like Otto and other prisoners like Evelyn, Lucy and Suzanne had made friends with some of the Germans who were arrested on charges of desertion or mutiny. A marine named Karl Niedermayer became close to them. Suzanne always referred to him as Karlchen, "little Karl," a familiar form of address that one might use for a family member or a very good friend. Karlchen and Suzanne would often switch back and forth between French and German, the same way that she and her brother had talked when they were children.

He also seemed quite attached to her. One day in the exercise yard, Karlchen was telling Suzanne and Lucy about his girlfriend back home. "Look," he said to Suzanne, pulling out from underneath his shirt a heart-shaped locket that hung around his neck. Opening the clasp and showing her the photograph inside, he had "the intense gravity of a small child who has found a treasure," Suzanne described.

"Why were you arrested?" Lucy asked him.

"As a thief," he replied. He and several men had been caught stealing food from the German army. "What could you do? The officers stuff their faces, but the ordinary soldiers of the superior race have to tighten their belts," he

told them. Before their arrest, Lucy had watched soldiers digging up potatoes and rutabagas in the fields around St. Brelade's after dark, so Karl's story rang true. It was the point they repeatedly made in their notes: ordinary soldiers suffered at the hands of the German leadership. "Demotion and three years in a reeducation camp for taking canned goods and giving them to those who would never have taken it for themselves," he lamented.

Karlchen soon became the one to bring Lucy her hot water, and he smuggled the German newspaper to Suzanne whenever she asked. Like many of the German prisoners they encountered, Karlchen was not a rabid Nazi, nor was he particularly enchanted by the war effort, especially by the spring of 1945, when the Allies were making sweeping advances. He had grown up in the Rhineland near the French border, and though he had no love of Nazi ideology, he became a highly decorated soldier, earning a black, red, and white ribbon for his service on the Eastern front in Russia as well as an Iron Cross. Suzanne asked Karlchen what he had done to earn these honors. He shrugged and told Suzanne that everyone got them. "They did not seem to think much of their Russian campaign," Suzanne realized.

Karlchen gleefully told the women a story of how he and others had to ride bicycles from Cherbourg to Saint-Malo because the trucks were already filled with items the officers looted from people's homes: "beds, armchairs, cabinets, carpets, even pianos, and old-fashioned things like an *armoire à glace*." The story surely reminded Lucy and Suzanne of what had happened to their own home. But when the Germans arrived at the ships to load all their stolen goods, the captains told them that they could only take on board what they could carry. "They were furious," Karlchen said. "They tried to discuss the order, but there's never been much love lost between the army and the navy. . . . I wish you could have seen their faces. You would have laughed."

"All the same," Lucy said to him sarcastically, "your officers have a quality that one has to recognize. They are optimists if they thought that they could bring pianos and armchairs back to Germany at the beginning of August [1944]."

"They are pigs," Karl said, shrugging his shoulders. "When they take something, they don't want to let it go."

Two Germans, a signals technician (whom Lucy and Suzanne referred to by his rank of *Feldwebel*, "technical sergeant") and a sailor, shared cell

4, next door. The *Feldwebel* looked like he could play the role of Siegfried, Lucy joked, referring to the powerful but tragic hero in Wagner's famous opera cycle *The Ring of the Nibelung*, so that's what she called him. His real name was Georg Kiel. In her postwar writing, Lucy described Kiel as "a strong, robust man, who looked as gentle as a lamb." He had been arrested for talking about deserting in a private conversation with his commander.

The two men had been there only a few days when Lucy and Suzanne started passing them English-language novels, but Otto confiscated the books. One day, Lucy and Suzanne were in the hallway and saw the door to cell number 4 wide open. Kiel was there, but his cellmate was gone. Would you exchange my pencil for a cigarette? Kiel asked Otto. Now that I've been condemned to death, I won't need it any longer. Otto obliged his request.

"He is scared," Lucy thought to herself. "He doesn't hide it. He is young, twenty-five years old; he doesn't want to die." His eyes were bright, but he was crying.

Otto kept the door to cell 4 open, knowing that Lucy and Suzanne would go in and comfort him. They were supposed to execute us months ago, and we are still alive, they told Kiel. The Allies are advancing, so surely the war will be over soon. Maybe you will not be killed after all?

That night, Lucy couldn't sleep, again the victim of insomnia. Her mind was troubled by Kiel and the courage they had tried to give him. "I asked myself whether we might have been wrong," Lucy reflected after the war. Had the women merely given false hope to the man they still lovingly called Siegfried in his final hours?

During the night, she heard the squeaking and grinding of the metal key in one of the locks, the sound of boots in the corridor, slamming doors, and a rustling next door. Later, when Karlchen was bringing Lucy's regular supply of hot water, he told her and Suzanne that Kiel had been shot—Lucy would later say "murdered"—at dawn on April 7, 1945. He was buried not in the St. Brelade's Church cemetery but in the Stranger's Cemetery, where the Germans put soldiers they executed for crimes.

"Lucy was very upset," Suzanne recalled, "and when the Chef came on his inspection tour, she flared up. We were not supposed to know about it." Lucy was venting in English, so the Chef did not understand what she was saying. It was up to Suzanne to translate. He looked at them silently, then opened his hands as if to say that he was helpless to do anything. "The boy

was crying," he told them, "and he could not button his clothes. I had to help him." With Lucy still visibly upset, the Chef spoke in a low voice to Suzanne. "It is fortunate that the little one," as he called Lucy, "cannot see all the things I see. It would break her heart!"

Then the Chef's demeanor changed completely. Kiel's death seemed to push him to the breaking point. This war is horrible! It makes us live and act like dogs! The Nazis are awful! Why didn't the French march all the way to Berlin in 1923 when they occupied the Ruhr! They could have stopped all of this before it started!

The door was wide open, and anyone who walked past could hear the Chef's raging insults. Suddenly he stopped. He clicked his heels and gave a salute. Then he held his finger up to his lips, turned, and left the cell, closing the door quietly behind him. Suzanne translated what had just been said to Lucy, who listened in disbelief. Years later Lucy would record the Chef's rant in her writings.

While she lay in bed, shivering under her wool blanket despite the warmth that spring was starting to bring to Jersey, Lucy also worried about the sailor who had been Kiel's cellmate. "Was he still there?" she wondered. "Not a sound. When we went out into the hallway, we didn't dare lean over to look through the spy-hole." Otto refused to say anything. Finally, she worked up the courage to look through the hole in his cell door. "He was there. Sitting on his bunk, holding perfectly still like a wax figure." His lips moved, but no sound came out as he stared at the empty bed on the other side of the cell.

Lucy decided to give him a gift, so she took some of the tobacco that had been smuggled to her, rolled two cigarettes, and tucked them under the door. She knocked to get the sailor's attention. Later, Otto asked Lucy and Suzanne whether they had a piece of bread and a book for their neighbor, which they hurried to give to Otto so he could take the gifts next door.

The sailor was clearly distraught at what might happen to him now that Kiel had been killed. Lucy and Suzanne had been trying to convince the Chef to move him to another cell, but to no avail.

On her way to exercise one day, when they were near the warder's lodge, she asked Otto to take her to see the Chef. Otto was a little surprised, but he opened the door to the living room where the Chef was sitting at a table by the window, working on his ledger and managing the payroll. He smiled

as he stood up to greet Suzanne, but then his smile disappeared, expecting a problem. "Is there anything wrong?"

The sailor who was with Kiel should not be left alone, she told him. "You must put someone with him or move him to another cell. I think it would be better to move him." The Chef thought a moment, then agreed. He left the room to make the arrangements.

Suzanne followed him out and rejoined Otto who had waited for her. He was thoroughly amazed by what had just happened. He was used to soldiers, so the actions of the "politicals" and what they could get away with, always seemed to surprise him.

The sailor was relocated to cell 8, the dirtiest of the cells, with two other soldiers.

As the days went on, Otto invited Lucy and Suzanne to deliver presents to other German prisoners. Otto—probably seeing little point in enforcing the regulations now—began to open more and more doors for them, including ones that Suzanne specifically requested. They brought food and tobacco, and they even began to pass notes openly, no longer feeling the need to take precautions as they had done for so long.

ONE DAY, WHILE OTTO WAS DOWNSTAIRS, Lucy and Suzanne conversed with a group of German prisoners about what was happening in Gloucester Street, trying to provide some solace by recounting their efforts to comfort Kiel before his execution. One of these men was named Kurt Gunther, a noncommissioned artillery officer who had only recently arrived. A few days later, a note appeared under their cell door from Gunther, and in days to come he sent them more.

Kiel's execution had deeply upset Gunther. He wrote about how he had come to hate the Nazis and was planning to desert the German army, what he called "this Nazi gang," after his upcoming release from jail. He asked Lucy and Suzanne to let him know whether he could deliver any letters for them or do other tasks, and he shared what news he had of the war. Only 1 percent of the soldiers on the island were actually willing to fight, Gunther believed, and there was a conspiracy afoot to disarm the officers.

"The mighty '*Herren*' "—"men," by which he meant the Nazis—"have slowly become aware that I would only give my life for a peace-loving State," he wrote to them. He ended one of his letters "God bless your king,"

thinking that they must have been British, "and the United Nations with liberated Europe."

Without warning one day, Otto opened Lucy and Suzanne's cell door and escorted Gunther inside, then shut the door behind him. He was clearly nervous and stiffened up a bit. The sun coming through the small high window was at just the right angle to illuminate the cell as it reflected off the white walls. When Gunther finally relaxed, he approached the women, taking their hands and looking into their eyes.

Lucy and Suzanne both remembered the moment. Thank you for the bread you sent to me, Gunther began. Then they talked of what he had written in his notes and their mutual hatred of the Nazis. Be careful, Lucy warned, or you will end up like Kiel. When I desert, could I go to your house? he asked them. Maybe I could use it as a hiding place for a little while? La Rocquaise is German territory, Suzanne told him. It might not be safe. But she also thought that Edna and George, who were still staying there as caretakers, might be able to help, though she advised Gunther not to tell Edna any sensitive information.

Gunther handed them another letter, and they shook hands. The whole meeting lasted only a few minutes. He went to the cell door and called out to Otto, who took him back downstairs.

Lucy and Suzanne sent a note to Edna to let her know that a German soldier whom they had met in prison was on his way but that she should use her judgment and not take any risks on his account.

Soon another note from Gunther arrived. He had been released. "I must tell you that I have left my battery and am on my way to Brelades," he wrote.

A few days later, Edna delivered a package containing cigarettes and tobacco to the jail from Gunther. He was safe, Edna told Lucy and Suzanne. Although the language barrier didn't allow Edna to communicate directly with him, George was able to converse a little. Gunther didn't stay long but asked whether he could come back if things got difficult, maybe to hide in one of the sheds. Gunther wasn't the first German soldier to seek their help, Edna revealed. George was usually a pretty good judge of character, and the risk seemed less these days.

Kurt Gunther was not the only one Lucy and Suzanne had influenced. Back in March 1945, the Palace Hotel—a fine old home that had served as

a convent and school before being turned into a luxury hotel in the 1930s—erupted into a blaze just as the Germans were meeting to plan an action. In an attempt to put out the fire, soldiers used explosives to create a firebreak but miscalculated and destroyed the entire hotel. The mystery of how the fire started was never fully solved, although many believed Jersey resisters connected to the Communist Party were involved.

Suspicion—almost certainly false—fell on a disgruntled German soldier and socialist named Paul Mühlbach who had been trained as an industrial chemist and spoke five languages. After fighting as a member of the International Brigades during the Spanish Civil War in the 1930s against General Francisco Franco, he might have been sent to jail had he not chosen to join the German army instead.

Mühlbach had created his own anti-Nazi leaflets in English and German to incite his fellow soldiers to mutiny on May Day. Norman LeBrocq of the JDM printed Mühlbach's notes for him. Much like Lucy and Suzanne, Mühlbach then distributed his messages to other soldiers stationed on Jersey, eventually coming under suspicion of the occupation authorities. If anyone had a claim to being some kind of real-life "Soldier with No Name," it was probably him.

Mühlbach deserted the German army, and the JDM helped him go underground. The mutiny was discussed and planned in a bookstore that Germans frequented, and LeBrocq brought the leaflets he printed to the shop for Mühlbach to pick up. Because a young man of Polish descent named Paul Casimir worked there, the store also drew Poles who had been drafted into the German army. Casimir—who would become Vera's nephew by marriage after the war—could speak to them and try to recruit them for the mutiny.

Mühlbach had very possibly read Lucy and Suzanne's notes, as well as the notes of others who were circulating clandestine messages, and drew inspiration from them. Lucy recalled a tract that circulated after the fire at the Palace Hotel: "At an agreed-upon signal, the (German) insurrection will seize Nazi officers and force them to capitulate." According to Lucy, she and Suzanne repeated this phrasing frequently in their pamphlets. After the war, Lucy met with Mühlbach and talked with him about the fire and his hatred of Germany, although she gave no details of their conversation.

IN LATE APRIL 1945, as Lucy walked back from the sink at the end of the hall, she saw a surprising sight through the spy-hole of one of the cells. Two men held a friend up to the high window so that he could look down and see how far his jump would be—over eight feet, she estimated. The man peering outside seemed crazy. He spoke in a frantic mixture of German and English as he told her of his plan to wedge through the bars at midnight.

The man at the window was Nicolas Schmitz, but everyone called him Nikki. He was "very slim and supple," Lucy thought. The twenty-three-year-old German gunner from Dusseldorf was, according to Lucy, "a great guy: brown hair with blue eyes, body of a young athlete without any Germanic heaviness, an open gaze, intelligent." He was accused of murdering a Jerseywoman and deserting. A local family had taken him in, and he fell in love with their daughter, Alice. The military tribunal had sentenced Nikki to death. Alice was also behind bars, for sheltering him.

The night after the court-martial handed down Nikki's sentence, he sat in his cell sobbing. "Meine Mutter!" he called out. My mother! When Otto opened Lucy and Suzanne's door the next morning so they could set out their chamber pot, he let them slip out to try to comfort Nikki a bit. Knowing he would soon be shot, Nikki had every reason to try to escape the prison, and he was becoming desperate.

One of his cellmates had greased the windowpane hinges with Red Cross butter and loosened its screws so that when the time came, they could try to remove it in hopes that Nikki could jump down into the yard below. Suzanne couldn't believe that it would really work. "I examined my own window and realized with a sigh that this operation would not give more than an extra half inch." Despite her doubts—"By no stretch of the imagination could I imagine an adult human skull pushing its way through the narrow opening allowed by the mobile pane," she wrote—Suzanne contributed a tin of butter to the effort as a show of moral support.

Lucy asked the Chef to intervene with his superiors and try to convince them that Nikki's execution wasn't worth it. He refused. After all, if the Chef didn't follow his orders, he might be the one who would be shot.

19

"ANY MINUTE NOW"

"[HEAR] ANY SCREAMING LAST NIGHT?" Lucy asked some of the Jersey prisoners in C Block toward the end of April 1945. She had been awake listening to the cries and shouts that to her seemed to go on forever.

"It's the German bloke," someone told her, referring to Nikki. "They say he swallowed some old nails to put off his trial. But he's eating his food; he's not gone to hospital. He'll go to court today or tomorrow."

"Nails," Lucy repeated, aghast. She arranged to take him some tobacco and something to eat, but he was out of the cellblock. Later, when he came back, Otto let her out to give Nikki the provisions, but he couldn't eat anything. Otto gestured that Nikki had a stomachache.

In the early morning hours of April 27, 1945, from the small wooden overflow hut where he was still housed, Joe Mière watched three guards taking Nikki away. Mière had gotten to know Nikki when they were in adjacent cells in C Block weeks earlier. Mière could see Nikki's familiar face in the yard, his hands cuffed. As they passed nearby, Mière heard a woman's shriek, which pierced the night silence: "Nikki!"

Evelyn Janvrin and another woman were lifting Nikki's girlfriend, Alice, up to one of the high windows. Alice desperately waved a white handkerchief in what she surely knew were Nikki's final moments. He called out to her, perhaps one last declaration of love, but the soldiers shoved him toward the gate and carried him out.

Mière suspected the worst. "I knew this was the final chapter for him, and being a Roman Catholic, I crossed myself."

Nikki's body was buried in the Stranger's Cemetery.

Bunny Vitel, a fellow prisoner who befriended Lucy and Suzanne in jail, wrote to Suzanne later that day, telling of the fall of Bremen, Mussolini's arrest, and Hermann Göring's resignation. "I have been told that the German deserter has been shot," he reported in his note. He did not know Nikki's name, only his alleged crime. "He was taken out early this morning." Lucy heard that they hadn't even allowed Nikki to stand up to take the bullets. Karlchen later told Suzanne that Nikki "was very brave at the end."

A few days later, Lucy and Suzanne encountered an angry and haggard Karlchen in the shed by the warder's lodge. He showed them a package that one of the German guards had given to him to destroy. It was filled with rusty penknife blades and nails found in Nikki's cell. Apparently, Nikki had been swallowing them, and this was his leftover stash. Lucy could not believe what Karlchen was showing her. "You don't know the stomach of a soldier of the Führer," Karlchen replied.

Karlchen slipped inside the warder's lodge and returned with a paper. It was an administrative report on Nikki's death, which one of the guards had dictated while Karlchen was assisting in the office. Apparently, unable to squeeze through the narrow window of his cell and jump as he had planned, Nikki's self-inflicted torture had dragged out over several days before he was shot. They believed he was trying to gain time before his execution, but the guards dismissed his stomach pains as indigestion.

Also in the package was a little wooden box with an inscription on it. "Niko left this too," Karlchen said. "Take it, or I'll burn it." Lucy took the box for her collection.

Lucy recalled her agony years later at the thought of both Kiel and Nikki having been shot. "I waited day after day to see who was next."

Karlchen was still extremely upset about Nikki's execution. Lucy and Suzanne watched him chopping wood with his shirt off near the exercise yard. Venting his anger, each time he raised the ax, he made a hissing sound as he breathed in through closed teeth and then said in French for their benefit, "*Sssalaud!!!*" Bastard! Then, when he took a swing at the log he was chopping: "*Ça pour Hitler!*" That one's for Hitler! Karlchen pulled the ax out of the chopping block and took another swing: "*Sssalaud!!! . . . Ça pour Himmler!*" He took another swing. "*Encore un pour Himmler!*" Another for Himmler!

WITH THE ALLIES SWIFTLY ADVANCING and the German army in a final retreat, Harmsen spoke with Major Jacob Kratzer, the commanding officer since Knackfuss's departure in May 1944, and Charles Duret Aubin, the attorney general of Jersey, about releasing the political prisoners, and they agreed to start the process. Men and women began to leave one by one. As each inmate departed, those who remained shouted their goodbyes or broke out into a rousing chorus of "For He's a Jolly Good Fellow!"

Lucy and Suzanne, however, were not among those being considered for freedom. After the war, Harmsen suggested, perhaps with a sense of shame, that the reluctance to send them home was because the Germans had stolen their furniture. Aubin encouraged him to let Lucy and Suzanne out of Gloucester Street anyway. They had friends they could stay with until they figured out what to do, he reasoned.

"But when peaceful times come," Harmsen recalled Aubin saying, "I will make sure they leave the island. They are bad women." Perhaps Aubin just wanted to soothe Harmen's conscience, or maybe he did in fact think that Lucy and Suzanne had caused enough trouble.

Meanwhile, Lucy began gathering prison souvenirs. On April 27, 1945—the day of Nikki's death—she circulated a booklet (as Evelyn had done) for others to sign. Lucy wrote her name and "Political Prison—Autographs" inside. Along with forty-seven signatures, she collected brief statements from the remaining inmates. Some explained why they had been jailed. Others wrote notes or sayings. The book reminded them that they had not been the only ones fighting back. Suzanne had also been collecting various objects, tangible keepsakes of their time, so that she would not forget what had happened. She worried that one day it might all just seem like an "absurd dream."

The next day, a band of Italian partisans hanged Mussolini in northern Italy.

At the building that housed the court where Harmsen and his men had found Lucy and Suzanne guilty, rising smoke suggested that evidence from the wartime trials was being burned, either by the Germans themselves or perhaps by some of the local Jersey population. Back at Gloucester Street, Evelyn handed out tricolor ribbons as an early celebration. Suzanne embroidered onto Lucy's ribbon the word *liberté*. They began to add little flags of the Allied powers as new decorations to their cell. With a nail, they

wrote a saying on their wall that Lucy noted was common among the Jersey prisoners: "Any minute now."

ON MAY 1, 1945, when word arrived on the Channel Islands that Hitler had shot himself in his bunker the previous day, the Germans flew their flags at half-mast. On nearly every Jersey house, Union Jacks started to appear. Prisoners were now emerging quickly from the jail. The following day, the Allies took Berlin. Meanwhile, Lucy and Suzanne continued to sit together in their cell, waiting.

On May 5, while they were talking with several German prisoners, Karlchen expressed his great gladness that the war was finally ending. "Thank heaven that's done with and I'm no longer a soldier," Suzanne remembered him saying.

"But you're still wearing the bird," another said to him, referring to the German eagle on every German uniform.

Karlchen took off his tunic, reached into his pocket, and pulled out a pair of nail scissors. He cut the bird off his uniform. According to Lucy, he called it "the dirty bird."

"What shall I do with it?"

"Give it to me," Suzanne said, thinking it would make another souvenir for her collection.

Karlchen smiled at her. "I did not know whether you would like to have it."

Gloucester Street was nearly empty now. Lucy believed that she, Suzanne, and a Jerseyman named Mickey Neil, who had plotted to steal German weapons while attempting to escape the island, were the only civilians still inside. They were all being fed extremely meager rations at this point, and when Lucy and Suzanne walked down the hallway, the few soldiers who remained behind bars called out to them through their spy-holes, asking for a bit of bread or some tobacco. Mickey Neil departed around 12:30 a.m. on May 8, leaving Lucy and Suzanne alone in the dreary, quiet prison with a few German men.

Although Germany had officially capitulated the previous day, Lucy still expected that they would all be shot before the handover of Jersey. Maybe, she thought, that explained why they were still in jail.

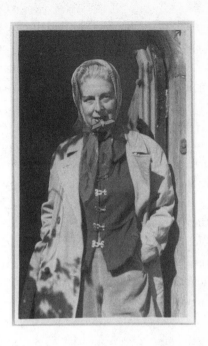

Lucy after the war with Karlchen's "dirty bird," ca. 1945. COURTESY OF THE JERSEY HERITAGE COLLECTIONS.

THE CELEBRATION OF THE GERMAN unconditional surrender spread across Europe and the United States on May 8, 1945—V-E Day. Inside the prison was nothing but chaos and confusion among the Germans. The guards were uncertain about what to do and which orders to follow, and many GFP officials gathered at Gloucester Street as a kind of last refuge in the hours before the transfer of power. The guards who remained finally received the order to release Lucy and Suzanne at 2:45 pm, just fifteen minutes before the official surrender of the Channel Islands to the Allied forces.

Vera waited for them outside. She had proven her friendship throughout the war by visiting and bringing them food and other items. Lucy decided to call Vera "Faith" from now on, the Slavic translation of her name, for her loyalty and devotion to them. The guards let Vera come up to see their cell.

Lucy was impatient and wanted to rush for the door into the sunlight and freedom. Suzanne told her to go ahead; Suzanne would stay behind to gather up the surprising number of things they had collected. Suzanne reached into her hiding places to retrieve the secret messages they had

passed, a few sketches she had drawn, Karlchen's "dirty bird," Lucy's autograph book, likely Nikki's little box, and other personal effects, including the hatbox in which Lucy kept Suzanne's letters and other papers. She made sure to take the Red Cross packages so that they could eat in the coming days.

As Suzanne packed, Lucy and Vera searched for a handcart so they could more easily carry their things home to La Rocquaise. The Union Jacks flown earlier by excited Jersey residents continued to brighten the fronts of most homes, and once-illegal radios now also sat on windowsills across the island, tuned to the BBC. Lucy and Vera joined a huge crowd in Royal Square in the center of St. Helier, where they tearfully listened to the voice of Winston Churchill over loudspeakers. At 3:00 p.m., broadcast live from the War Cabinet Office, Churchill's words rang out in his announcement of the unconditional surrender of Germany, and then he delivered the long-awaited news: "Our dear Channel Islands are also to be freed today." The crowds in the square and across the island burst out into cheers. The prime minister continued:

> After gallant France had been struck down we, from this Island and from our united Empire, maintained the struggle single-handed for a whole year until we were joined by the military might of Soviet Russia, and later by the overwhelming power and resources of the United States of America. Finally, almost the whole world was combined against the evil-doers, who are now prostrate before us. Our gratitude to our splendid Allies goes forth from all our hearts in this Island and throughout the British Empire.

Lucy, overwhelmed with emotion, sat down on the sidewalk while Vera stood by her, listening. When Churchill's speech finished, Bailiff Coutanche addressed the crowds and led them in a prayer. Strains of "God Save the King" could be heard from the cheering throng. After a few minutes, Lucy collected herself, and she and Vera resumed their search for a handcart. Later, Lucy recalled that Vera lectured her about her responsibilities to Suzanne and, now that the war was over, responsibilities to God too. Lucy thought that Vera was proselytizing her newfound Catholicism.

Lucy's mind was a whirlwind of thoughts. Hadn't she already considered these issues? She was well aware of her faults and shortcomings,

but she vowed to try to take on more of life's hassles and lessen Suzanne's burden. Her ill health, life's distractions, and even her incompetence at darning socks all posed challenges, but she would try harder.

Lucy didn't really want to think more right now. Between Vera's vague exhortations and the exhilaration of being free, she just wanted to hurry back to the prison so she could usher Suzanne out into this paradise of sunshine and share her joy with the woman she loved.

The loudspeakers continued to broadcast the live BBC feed from London, and once again Lucy and Vera heard Churchill, who was now addressing the throngs gathered outside the government offices in Whitehall. The "island" he referred to in his V-E Day speech was Britain, but his words resonated across Jersey just as powerfully: "I say that in the long years to come not only will the people of this island but of the world, wherever the bird of freedom chirps in human hearts, look back to what we've done and they will say 'do not despair, do not yield to violence and tyranny, march straight forward and die if need be unconquered.'"

When Lucy and Vera returned to Gloucester Street, they found Suzanne chatting in German with some of the guards who themselves would soon be the captives. One of the local Jersey jailers finally helped Lucy find a handcart, and the women filled it with their cargo. Edna arrived at the prison and escorted them to Dr. McKinstry's house, about a half mile away, for a bit of recuperation. Lucy and Suzanne took turns pushing their cart through the shouting, singing, celebrating crowds.

As they walked through the streets, they suddenly encountered a familiar face. In front of them stood the woman from the newsagent's shop. Lucy and Suzanne had last seen her just before their arrest when they bought the cigarette papers. She was the one they believed had tipped off the secret police. "She stopped dead, and so did we," Suzanne remembered years later. "For a few seconds she stared at us, her eyes widening with fear, then she turned and ran. We watched her go. It was then, I think, that we realized that we had not the slightest wish to retaliate in any way." Lucy and Suzanne watched the woman recede into the winding, narrow streets of St. Helier. "We looked at each other and smiled," Suzanne recalled. "I was a hundred miles from any hatred. I would have had a hard time not hugging the entire world with my heart."

IV

LUCY AND SUZANNE IN PEACETIME

20

"A PLACE MORE DESERTED
THAN THE DESERT"

AFTER RESTING AT DR. McKinstry's house for a few hours, Lucy and Suzanne finally headed home to La Rocquaise. When they opened the door, they saw just how thoroughly the Germans had looted it. The rooms had been emptied of their furniture; the walls, once adorned by paintings, photographs, and other art, were now bare.

The grief was too much for Lucy. Despite her desire to lighten some of Suzanne's load, Lucy decided she would move into a hotel in St. Helier for a little while and leave it to Suzanne to put things back in order. George, Edna, Vera, and Mrs. Armstrong tried to put Lucy's mind at ease, saying that they would lend a hand. Despite their anguish over the state of the house, Lucy and Suzanne surely slept well in comfortable beds during that first night of freedom.

The next day, May 9, Allied forces arrived to take official control of Jersey and to place the occupation forces in custody. Across the island, swarms of ecstatic people filled the streets to welcome the British troops with enormous hugs, excited handshakes, and words of immense gratitude.

Captain Bode briefly went into hiding when the British troops arrived, but he was soon found and arrested. Wölfle was arrested too, but given his fluency in English, the Allies made use of him as a translator and put him to work on an investigation of an unsolved island murder that took place during the war.

Lucy walked through the streets, making her way to the waterfront. There, she joined a throng of islanders who had gathered to watch British forces from the destroyer HMS *Beagle* landing on the island. She observed,

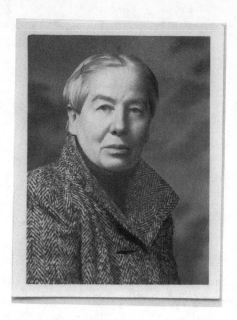

with a bit of cynicism, that many of the people who turned out today to welcome the Tommies were the same ones who had greeted the Jerries a few years earlier.

At the dock, Lucy ran into many of the men and women she and Suzanne had spent time with in prison. Everyone was sharing news and passing along juicy gossip, catching up on what had been happening. Remember the woman Edna saw wearing your clothes after the Germans took over your house? Lucy recalled someone asking. She had a German boyfriend but somehow rediscovered her virginity and has now married an Englishman!

Despite the celebratory atmosphere, the mobs of people gathered at the port made Lucy anxious and even a little ill, so she climbed the nearby promontory, Mount Bingham, which afforded her a clear view of the harbor. The fresh, cool sea breeze washed over her, and the sun warmed her face. From there, she could watch the events at the dock from a safe distance and gaze out over the vast expanse of green water. She hadn't known the feeling of being in a wide, open space for some time. Now the crisp, spring air was wonderful.

In the days following the liberation, faithful Vera brought some of their belongings—an old chest, some glass trinkets, personal papers—out of

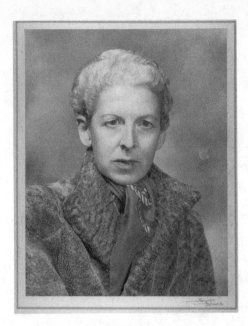

Lucy Schwob, 1945.
COURTESY OF THE
JERSEY HERITAGE
COLLECTIONS.

hiding and back to the house. While they were in jail, she had ridden her bicycle from St. Helier to La Rocquaise several times, risking her own safety, to help Edna and George rescue as many of Lucy and Suzanne's possessions as they could from various locations around the island.

The Germans had issued Dr. McKinstry a pass that allowed him into homes they requisitioned, so he, too, knew where many of Lucy and Suzanne's stolen things were. With his car, he helped start what Lucy called the "furniture race," a series of frantic trips around the island in the weeks after liberation. They soon unearthed a box of Suzanne's illustrations and a few of their books. A Jersey resident told them that more books, including their three-volume French Bible, were at Government House, the home of the lieutenant governor, which the Germans had used as the residence of the commandant of the Channel Islands. Others, including several rare editions, were at the Metropole Hotel. A few pieces of their furniture turned up in another hotel, near Silvertide. Even after Dr. McKinstry could no longer help them, Lucy, Suzanne, and Vera continued to scour the island for weeks.

Whenever they found something, they contacted the authorities, hoping either to get their possessions returned or to at least be compensated for the loss. But Lucy soon began to realize that neither the British troops

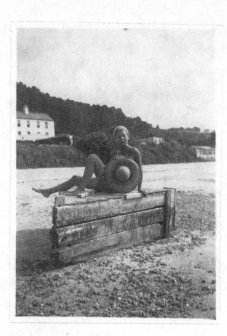

Lucy on the beach enjoying her freedom, ca. 1945.
COURTESY OF THE JERSEY HERITAGE COLLECTIONS.

who liberated Jersey nor the Jersey authorities had time to assist with such matters. In addition, most of the islanders she approached were not particularly helpful either; some were outright indifferent, even hostile. Not all the looting at La Rocquaise had been done by the Germans, it turned out. Jersey residents, many trying to survive in a time of extreme shortages and some simply taking advantage of the situation, were also complicit. After all, no one expected Lucy and Suzanne to return home. Now, of course, few locals wanted to acknowledge their part in the theft.

Going through some of these recovered items, Lucy ran across a notebook containing a lyric poem about solitude, which was penned by an old Parisian friend. When she read it, she broke down and wept. Her emotions only deepened when she saw a copy of the muckraking, satirical magazine *Le crapouillot*. It was where she had gotten the idea for using *ohne Ende* in their messages to the German troops.

As island residents tried to return to normal, they also retreated back inside their own worlds, leaving Lucy feeling like she was in "a place more deserted than the desert," she wrote later. In moments of isolation, she thought back to the depths of the previous winter and remembered the feeling of solidarity that enveloped her and kept her going through her

darkest days in prison. The sense of community that had formed in the midst of danger has now vanished.

Lucy was not alone in sensing this change. As another Jerseywoman recalled at the war's end, "I had a very mixed feeling inside because I knew that something valuable in a way was going . . . and everybody suddenly started becoming very selfish again." Evelyn discovered the same thing. Her sister had made a badge on which she stitched "Political Prisoner 12516" and "Victory 1945" as a sign of what Evelyn had survived. A few days after the liberation, a friend noticed that Evelyn had taken off the badge because, he recalled, "she had discovered that in post-war Jersey, former political prisoners were not being hailed as heroes."

ONE DAY IN ST. HELIER, Lucy and Suzanne encountered a woman whom they had never met before. She stopped them and proclaimed, "I am so happy to see you alive!" Several others also gathered around to greet Lucy and Suzanne. They were in disbelief to learn that the women had survived their ordeal. "It must have been a dreadful experience," the woman continued. "Now, you must forget all about it." Lucy and Suzanne were left dumbfounded by her blithe advice, and it must have shown since the woman added by way of explanation, "I always forget unpleasant things."

Suzanne took Lucy by the arm and guided her down the street before Lucy had a chance to recover from her surprise and perhaps say something cutting to the well-meaning woman.

"How do you suppose she has managed to keep alive so long?" Lucy wondered aloud to Suzanne.

"She does not forget her experiences," Suzanne said. "Even a mollusk wouldn't keep alive if it did. Either she is unaware that she remembers them, or she believes one should pretend not to. Probably does the latter, I should say."

"Does it matter?" Lucy asked.

But it did matter to her. Once Suzanne, Vera, Edna, and George had put La Rocquaise back in some kind of order, Lucy finally moved back into the house. She sat on her bed, leafing through a stack of papers. Next to her, on a small table where she placed her tea tray, sat the square hatbox one of the German guards had given to her last August as a place to keep her personal items. Other than her memories, the miscellaneous mementoes

inside this box were all she had left of their months behind bars. "Of all our baggage," she said, the hatbox was "the only one that had any value."

She determined that she would organize all the prison communications—"letters, drawings, and notes"—between her and Suzanne. Few of the documents from their earlier lives had survived the occupation of La Rocquaise. She speculated that the soldiers had used them to light fires in the fireplace.

Lucy gave Vera some of the papers and other souvenirs as thanks for being such a good friend to them, and she sent a few other items to friends back in Paris, but the ones with the most personal meaning did not leave that box. The memories were too precious.

When Lucy couldn't sleep, she reread the notes Suzanne had written to her, some of them on sanitary napkins, and felt strangely nostalgic. But as the days went on, her thoughts began to darken. Lucy had always been the more pessimistic of the two, prone to depression and suicidal feelings, and her gloomier meditations in the aftermath of the war echoed that part of her personality. She later wrote about how she had become possessed in those days by an overwhelming fear that all her struggles had been for nothing, that there were no greater lessons to learn from all the experiences she had lived through: Suzanne's suicide attempt, their home plundered, illness, death, the double-talk of politicians. In the months after the war, they even had to put their beloved cat to sleep. Lucy likened herself in her reminiscences to a "repeat-offender Lazarus," rising from the dead over and over, only to witness still more suffering. She railed against those who didn't know what it was like to lose everything, saying that even those who merely kept their fortunes during the war were as bad as profiteers. Now everyone wanted to forget the occupation. Like the woman in the street, they kept telling her that she should forget too.

But she couldn't. Throughout the years that followed, she wrote about the war in lengthy letters to friends and in early drafts of what might have become a memoir had she lived longer. These writings were not the sort of quest for personal identity that she had composed in the 1920s and 1930s but were rather an attempt to make sense of what the war and their time in Gloucester Street had meant in broader, more universal terms—despite her underlying fear that there was no such meaning to be made.

But there had been a point behind what they did, Lucy wrote in a 1950

letter to Paul Lévy, her father's old friend who would eventually help them recover money they had left behind in France: "From July 1940 (the invasion of Jersey) until May 1945 (the liberation of the Channel Islands)—yes, even in prison, even 'in secret,'—I wrote to encourage men—including the German soldiers—to liberate themselves."

Whether such self-liberation took place was easy to doubt. Yet there were occasional glimpses of something that might offer a larger perspective and a sense, perhaps, of vindication. In January 1946, for example, Suzanne received a letter in German at La Rocquaise from a POW military hospital in Naburn, in northern England. It was from Heinrich Ebbers, one of the men who had guarded Lucy and Suzanne in prison. Surely German jailers did not typically write to their former inmates. His family was alive and in good health, he reported, and the British were treating him well. He asked Suzanne to greet "Miss Schwob," along with George and Edna Le Neveu, and asked Suzanne to write him back. In some strange way, perhaps Heinrich had liberated himself and wanted them to know it.

Lucy and Suzanne had liberated themselves through their resistance work too. Lucy in particular had struggled with the question of identity her whole life, from her youth in an assimilated Jewish household during the heat of the Dreyfus affair to her struggles with her mother's mental illness and her own poor health. Her early writing was inwardly focused and tortured, extended attempts to answer the question "Who am I?" which neither her essays and book nor her evolving self-presentation, her numerous aliases, and radical politics could ever seem to resolve. She was always looking for more, always the harlequin camouflaging herself, always "in training," as she and Suzanne had inscribed on her strongman costume in their photographs.

Lucy finally found her identity through the Soldier with No Name. The war was the one moment in her life when she seemed to have the strongest sense of purpose and the most direct vision about who she wanted to be. Against the Nazis, there was a moral clarity and certainty, which her earlier work did not always have. The Soldier with No Name finally, but perhaps only temporarily, liberated her to speak as loudly and distinctly as she wanted.

AFTER THE LIBERATION, everyone's lives changed. Vera married Arthur Robinson, a retired schoolteacher, widower, and geology enthusiast, in

1948. His nephew, Paul Casimir, had been active in helping recruit for the May Day 1945 mutiny, which never took place.

Dr. Heinz Harmsen, the chief judge at their trial, wanted his old life back. In 1950, when he reapplied for membership in the International Law Association, headquartered in London, officers of the organization sent inquiries to Jersey, checking up on his record. The response was that Harmsen had been "invariably correct" and professional during the occupation.

Lucy took a turn for the worse as her illnesses flared up severely. "I had suffered an emotional shock," she wrote. "Understanding history did not prepare me for the emotional reality of history." Being sick was "agony" for her: "In the trap of the manor [La Rocquaise], I am relapsing into convalescence so that I don't know what is more decrepit: the spirit, the body, or the wall against which I am leaning to write." Suzanne remained the steady rock whose serenity, Lucy wrote to their old friend André Breton, was as calm as the sky was blue. Through it all, Suzanne was there to take care of her. Lucy named Vera the executrix of her will in the event that the primary person, her "friend" Suzanne, as the will put it, could not carry out the task.

As time went on, Lucy and Suzanne did rebuild their lives, reconnecting with old friends like Breton, but the war was now fundamental to how they saw themselves. They had wanted to apply for official recognition of their participation in resistance activities, just as those in France were doing. But instead of a Carte de Résistance, which would have officially acknowledged their role as members of the French Resistance during World War II, the French consul in Jersey sent a request for a less prestigious Medal of Recognition, which acknowledged anyone who worked in the public interest during the war but whose actions were not military in nature; they received it in 1951. After a visit to Paris, they even thought of moving back to France permanently. But by 1953, Lucy's health was deteriorating too quickly. Her doctor had diagnosed her with an inoperable kidney tumor.

Lucy died on December 8, 1954, aged sixty. Perhaps with Vera, Edna, George, and others huddling around the grave, Suzanne buried her in the St. Brelade's Church cemetery, just across the graveyard from the German soldiers whose funerals they watched during the war.

On her tombstone, between Stars of David was her name, Lucy Renée Mathilde Schwob, and an epitaph in English—"And I saw new heavens and

a new Earth"—a blend of quotations from the Hebrew scriptures and the Christian New Testament that tell of the new Jerusalem descending from heaven and an omnipotent God enthroned and dwelling with humankind. The Hebrew origin of the text plus the Jewish stars, brought her back to her roots, to her father and grandmother, and to those she called the "obscure Jewish forefathers" who had inspired her to take the name Cahun.

IN AN INTERVIEW given many years after the war, Judge Harmsen couldn't seem to forget Lucy and Suzanne. He showed no remorse for his actions on Jersey when he reminisced about sitting in judgment of the local population. There had been minimal resistance and few significant problems, he recalled. However, two cases of what he called "sabotage" still stood out in his mind. One involved two young men who had stolen dynamite in an effort to blow up the Jersey government building; their aim was to punish local authorities for collaborating with the occupation. The only other case, he told his interviewer, was that of two women: "They were Frenchwomen by birth, who had a house in St. Brelade's Bay, they were very interested in art—I first saw Max Ernst pictures in that house. . . . They were arrested one day because it was discovered that for years they had been typing challenges on cigarette paper: 'Kill your officers! Put sand in your engines! The war is lost!' And for them the penalty was death."

Harmsen said that he and his wife had gone back to Jersey in peacetime to celebrate the wedding anniversary of friends on the island, probably people they had met during the war. "One of my first trips was to St. Brelade's Bay to see what had become of the two women," he claimed. Lucy and Suzanne's story still seemed to nag at him, perhaps out of curiosity or guilt. "Tradesmen were working there and told me, 'Yes, the two women, they sold the house, they went off to France.'" Harmsen didn't mention what he might have said had he found Lucy and Suzanne. He did not know that Lucy had died.

In fact, Suzanne had not gone back to France. Not long after Lucy's death, she sold La Rocquaise and moved elsewhere on Jersey. The smaller house, in the village of Beaumont, which overlooks St. Aubin's Bay, still faced south toward France. She continued taking photographs, as she had done for years with Lucy, but now she trained her camera on landscapes devoid of people. Art historian and Jersey Heritage Trust curator Louise

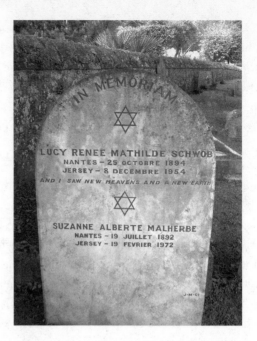

Lucy and Suzanne's gravestone, St. Brelade's Church cemetery. AUTHOR PHOTO.

Downie described them "as lonely in atmosphere as Moore seems to have been without her lifelong lover, Claude Cahun." In 1969, Suzanne gave a collection of Lucy's papers, drawings, and letters to an old friend, as Lucy had wished.

On February 19, 1972, at seventy-nine, old age, a bout of appendicitis, and life itself became too much. Suzanne lay down in her bed and finally let the overdose of a sedative finish the job she had intended in 1944 to slip the trap of prison. According to the article announcing her death in the *Jersey Evening Post*, she had left a note for her doctor, but the paper did not reveal its contents.

Her body now lies alongside Lucy's in the St. Brelade's Church cemetery, their names—Lucy Renée Mathilde Schwob and Suzanne Alberte Malherbe—forever inscribed on the same headstone.

By the time of Suzanne's funeral, the remains of the German soldiers from the two world wars were no longer nearby. In 1961, the Reburial Service of the German War Graves Commission relocated their bodies to the German war cemetery at Mont-de-Huisnes near Saint-Malo, France.

Lucy and Suzanne were free of the Germans forever. For them, the war was finally over.

EPILOGUE

Why Resist?

LUCY AND SUZANNE'S STORY is one small part of a much larger narrative about how people pushed back against German occupation during World War II. Across Europe, that fight took many forms. Highly organized, systematic acts challenging Nazi imperial authority and aiming to overthrow the regime—what many scholars formally label "resistance"—varied according to local circumstances and national contexts. Some of these acts, like the work of the French Communist Party or de Gaulle's London-based Free French were organized in a top-down fashion. In other cases, grassroots efforts by the Maquis guerrilla fighters throughout the French countryside or by Yugoslav partisans or by the Greek resistance were more effective.

Defying the Nazis meant denying their complete control over one's life. Although most people in occupied zones were not full-time resisters, many participated in occasional subversive acts, including theft or sabotage, short-term disobedience to specific orders, and passing bits of intelligence to the Allies. Others pulled pranks, such as deflating German bicycle tires or turning street signs the wrong way, or they engaged in private forbidden behavior, like listening to the jazz music the Nazis hated. Still others offered more dangerous but still quiet and covert support by hiding Jews or Allied soldiers behind the lines. Historians sometimes use the terms *dissident* or *nonconformist* to describe such people, but ultimately anti-Nazi actions were as varied as the participants.

But for Lucy and Suzanne, fighting the German occupation of Jersey was the culmination of lifelong patterns of resistance, which had always borne a political edge in the cause of freedom as they carved out their own

rebellious ways of living in the world together. For them, the political was always deeply personal.

Early on, they challenged assumptions about masculinity and femininity, gender and sexuality, and the power relations that come with those categories. Their writing, drawing, and photography made the familiar seem unfamiliar, upending expectations about identity and beauty. For them, life was far more complex than what meets the eye or what it means to look like—or to be—a man or a woman. Evoking her Jewish heritage with the name "Cahun" defied the ongoing anti-Semitism of the era after the Dreyfus affair. In their Paris days, both Lucy and Suzanne protested against capitalism, imperialism, and militarism through their association with surrealism and communism. Resistance was not an afterthought but the peak—and the point—of their creative lives.

Their activism on Jersey extended the struggles they fought in Paris, allowing them to express their long-held and long-practiced beliefs most clearly and directly to the world. They purported to speak with the voice of a "real" soldier who was stuck in the moral quagmire of war and articulating the struggle in black and white, with bright moral lines drawn between us and them, between ordinary Germans and unmerciful Nazis, between right and wrong. The war allowed Lucy and Suzanne's political engagement, stamped with their own personalized artistic style, finally to come to fruition.

Most resisters who deeply dedicated themselves to the cause throughout occupied Europe shared common characteristics. According to historian Michael D. Bess, resisters valued the dignity of the individual; believed in "critical thinking, open-mindedness, and grassroots democracy"; cherished "equal rights and equal opportunities for all citizens"; and understood "civic duty, honesty, transparency, and taking responsibility for everyone in our community." They found ways to create unity, cooperation, and connection across lines of division, which the Nazis had exploited. In other words, they were fighting *for* something, not merely against something.

Lucy and Suzanne had fought for their beliefs for decades, using writing and art to make a better world. They truly detested all the Nazis stood for, but their resistance wasn't based purely on anger or hatred. "I continue to believe," Lucy wrote in her scrapbook, "that, if fascism . . . had been beaten by everyone remaining at their post and with all their heart . . . all postwar imperialism would have been impossible."

Lucy and Suzanne were among many writers and artists who, through their creative output, grappled in one way or another with the moral dilemmas posed by the war. French author Jean Guéhenno simply went silent, sharing nothing for four years and writing only in his diary. Some intellectuals published their views in underground newspapers or circulated their works in secret while at the same time writing for officially approved publications, using coded or veiled language to criticize the Germans. Many writers and thinkers navigated a complicated middle ground, trying to continue their work or defend academic institutions without running afoul of authorities. By contrast, Lucy and Suzanne's friend, the American expatriate writer and longtime Paris resident Gertrude Stein, translated speeches by Marshal Philippe Pétain, the leader of the Nazi-aligned Vichy regime, into English. Stein believed that only a strong, conservative leader could provide the kind of stable atmosphere in which writers and artists could work.

Lucy and Suzanne found themselves in a different situation from that of other French intellectuals. Although under direct German occupation like those in Paris and northern France, the women were cut off from their networks and friends, unable to share ideas or debate strategies with others, even in secret. There were like-minded people on Jersey, but Lucy and Suzanne chose to wall themselves off. They had no publishers or newspapers to disseminate their ideas, and they never faced the dilemma of whether to write for a Nazi-controlled publication in order to stay intellectually active or make money. For Lucy, that isolation was a blessing. War inevitably draws writers into the fray, she wrote in her "testament," and "no obligation can be so painful." Had they been in France, she thought that her and Suzanne's work would have been tainted with compromises: either they would have tempered their writing so as not to endanger the lives of others, or, perhaps worse, they would have simply fallen silent. "Perhaps Jersey," she wrote as she reflected on the uniqueness of their circumstances, "was almost the only place where that luxury could be indulged in."

In other words, their physical distance from the difficult choices facing friends back home in France provided the crucial context for everything they did—the "luxury" of resistance. They may have been working alone, but Lucy believed that Jersey was the only place where they could truly act on their consciences.

Like other intellectuals engaged in serious resistance, a deep human-ism ultimately motivated Lucy and Suzanne. In his classic book *The Intellectual Resistance in Europe*, historian James D. Wilkinson describes the realization of many thinkers who put their talents to use against the Nazis: "They had rediscovered humanism at first hand; it ceased to be 'abstract' for them and took on the shape of the friendship, sacrifices, daring, and fulfillment of the underground. Man's basic worth and dignity were ideals they defended against the moral relativism preached by the Fascists, and relied on for sustenance and inspiration in their daily lives."

The difference for Lucy and Suzanne was that this sense of dignity was extended to the Germans they were trying to convince through their notes to be human once again. Lucy and Suzanne's lifetimes as outsiders allowed them to empathize with their occupiers, and they expressed that empathy by "becoming" one of the enemy and speaking through his voice as the Soldier with No Name.

Empathy always requires seeing others—even enemies—as part of oneself and connected to one's own fate rather than as radically different. It breaks down the barriers between self and other, linking everyone's well-being in an understanding of a common human condition. Empathy is also one of the central principles of nonviolent political action advocated by Gandhi, Martin Luther King Jr., and Thich Nhat Hanh. Some scholars have analyzed how resisters created a wider "universe of obligation," which even brought those persecuting them into an ethical understanding of who needed help. Others use the phrase "disruptive empathy" to understand how many resisters evolved from those who stood by while others suffered or died into people willing to intervene in a situation even when doing so put themselves at risk. Such terms point to breaking the inertia that prevents us from acting in morally challenging situations. It also speaks of a shattering of ordinary social boundaries and expectations. Empathy requires a radical reappraisal of human relationships.

Lucy and Suzanne's ability to empathize with soldiers who were serving an abhorrent ideology may seem difficult for us to understand today, and we may have a hard time following their logic. Yet by trying to liberate the island of Jersey, Lucy and Suzanne also yearned to rescue ordinary German soldiers from Hitler and Nazism. This work to save the Germans

from themselves exemplifies the communal bond across time and space that Susan Sontag describes of those who engage in principled resistance: "You don't do it just to be in the right, or to appease your own conscience; much less because you are confident your action will achieve its aim. You resist as an act of solidarity. With communities of the principled and the disobedient: here, elsewhere. In the present. In the future."

Lucy herself pointed to these universal values in her testament. In trying to explain to Vera, the recently converted Catholic, why she could not share her friend's faith, Lucy outlined the moral principles that guided her during the war. Many ideas had motivated her actions, she told Vera, including those of Havelock Ellis, the Buddha, Socrates, Leonardo da Vinci, Karl Marx, and Jesus. But the idea of a mystical self-sacrifice held no appeal.

> I have tried to do my share but you cannot call me a Christian.
> . . . I do not believe in the virtue of scapegoats. I do not believe
> in redemption by proxy. . . . There have been millions of Christs.
> There should be no more. But if Christ is too much, Jesus is not
> enough. Let him be brought up to date. Let his spirit of revolt
> against oppression of the poor and the weak, his love for joy and
> freedom, his power to create fraternity, be born anew, increase
> and multiply. Let Jesus live. Defend him against the High Priests.
> Mankind depends on man, on each and all.

Rather than seeing herself as a sacrificial lamb, Lucy had come to a kind of existentialist belief, based on a hard-won sense of hope, about the common human condition. People rely on each other for salvation, she was saying, not in an eternal life but in this one.

LUCY AND SUZANNE'S STORY does not easily align with how Europeans have remembered the war. Until relatively recently, residents of Jersey thought of the occupation as a time of trial through which people simply soldiered on with a stiff upper lip. Channel Islanders subsumed their experience into a British war memory shaped by politicians like Winston Churchill. According to historian Paul Sanders, the British and Channel Islanders together thought of themselves "not a nation of victims, but a nation of victors."

Seeking to suppress the recollection of Britain's abandonment of the Channel Islands in 1940 and highlighting continuities with the years before the war, many on Jersey chose to recall only the collective strength of the population. Doing so, however, meant downplaying—and in some cases actively forgetting—resistance and dissidence, thereby writing out people like Lucy and Suzanne who were, in any event, not from Jersey but French.

France, however, sometimes has the opposite problem. After the war, far more men and women contended they had participated in the French Resistance than actually did. Their claims allowed France to blame wartime collaboration on a few bad actors at the top while preserving the myth that the majority of the population actively fought back. Lucy and Suzanne really were resisters. However, since they were not in France, they have not been linked with the well-known accounts of the French Resistance or integrated into the complicated debates about how to remember the war.

Yet recovering their story highlights the variety of ways in which people fought the Nazi empire across Europe. We have long known that soldiers clashed on World War II battlefields and beaches with daring assaults, conducted vast bombing raids that demolished cities, and piloted legions of tanks rolling across the European countryside. But in the towns and villages throughout the Continent, a different kind of soldier—many of whom remain nameless in the history books—also waged war in small daily activities. Ordinary men and women in France, Germany, Italy, Poland, Russia, Jersey, and elsewhere contemplated the choice of whether to collaborate with fascists or to resist through acts of theft, disobedience, lying, looting, hoarding, sabotage, spying, harboring fugitives, or protecting Jews.

Those personal and local battlegrounds often had a significant impact on how these ethical and political choices played out. Lucy and Suzanne's story invites us to look at a history of the war from the bottom up, to think about the complexities of ground-level responses to conquest. It means thinking about the day-to-day predicaments of civilians who survived in occupied territory while facing tough, sometimes gut-wrenching, choices. It also requires us to realize that the histories of women, artists, lesbians, expatriates, and intellectuals mattered to the overall history of the war.

Lucy and Suzanne's experience also raises a broad, human question of why and how two people with so many secrets and with everything to lose

resisted in such extraordinary circumstances. The women they were—as lesbians, as artists engaged in left-wing politics—helped them resist the Nazis in their own unique way because they had been pushing against social norms, political values, and legal strictures for years.

In the end, Lucy and Suzanne remind us that a private life lived in struggle can prepare us for the larger battles to come. And they show that love can carry us through just about anything.

THE STORY BEHIND THE STORY

A Note on Sources

I HAVE TRIED TO REMAIN AWARE of my positionality as a heterosexual cisgender male with regard to the story of Lucy Schwob/Claude Cahun and Suzanne Malherbe/Marcel Moore, two people whose gender and sexual identities were what we might now call queer or nonbinary. I wanted to respect their relationship by not attempting to read into their story emotions or details that the sources did not indicate and for which I have no historical or personal context. Finding the right words to describe them has sometimes been a challenge in this book. Lucy and Suzanne never described themselves as lesbians, perhaps not surprising since the word was not necessarily used the same way in their day as it is in ours; while other terms for women loving women did exist, Lucy and Suzanne didn't employ them either. Regardless of the terminology, this intimate part of their lives was clear and significant to the story. As discussed elsewhere in the book, I have retained the use of feminine pronouns, as those were the pronouns they used too.

I have reconstructed aspects of their lives and experiences from their writings, attempting to re-create a narrative out of what is often a fragmented set of reminiscences. In addition, I have selected elements of their biographies that seem especially relevant to thinking about their resistance experience, in essence rereading their lives in Nantes and Paris in light of their later lives in order to see connections. Doing so creates an artificial linearity to lives that were remarkably nonlinear. However, the practice of history often requires narration to make sense in hindsight of what may not have made sense at the time to the people involved in the story.

Not only have Lucy and Suzanne—Cahun and Moore—been written out of the history of World War II resistance, but for decades, scholars ignored them in histories of surrealism, interwar literature and art, gender, sexuality, Jewishness, and the avant-garde.

The loss of their papers silenced them, but so did the challenging nature of the photographs and writings they produced. They never tried very hard to disseminate their work outside their artistic circle of friends, so they were never widely known.

The only public exhibition of their photography during their lifetimes—other than the photomontages in Cahun's book and a handful of other photographs that made it into print—took place in 1930 in the Right Bank bookstore owned by their friend José Corti. He allowed the women to use his display window for the launch of *Aveux non avenus*. Standing on the street gazing into the wide frame facing the rue de Clichy near the Gare Saint-Lazare, Lucy surveyed the copies of her book, several of the original photographs from which the montages were made, and her photograph in the harlequin coat that Suzanne had taken in 1927. We have no way of knowing how many people saw them.

Following Suzanne's suicide in 1972, the Langlois auction house on Jersey sold what remained of their estate. "The lots were housed in tea chests and cartons," according to Louise Downie at the Jersey Heritage Trust, "and as people had rummaged through them, items had become dislodged and had spilt into other boxes and onto the floor. Having fielded questions by potential bidders wishing to be assured that particular books were in particular boxes, the auctioneer decided to sell all ten lots together."

John Wakeham, a local Jersey collector with an interest in surrealism, purchased much of the collection, according to Downie, for £21. "When he went to collect his tea chest and cartons," Downie writes, "Mr. Wakeham had to retrieve several items that had fallen onto the floor and some of them had already been swept into a pile ready for the bin."

Two exhibitions, one in 1980 in Geneva and another in 1985 at the Corcoran Gallery of Art in Washington, DC, helped attract a broader audience to the women's photography. The handful of images that appeared in these exhibits was credited to Claude Cahun alone. Cahun's biography in the show at the Corcoran claimed erroneously that she had died in a concentration camp.

Sometime in the 1980s, French philosopher François Leperlier discovered the entry for *Aveux non avenus* in an old catalog from José Corti's bookstore. When he saw the book, he was impressed by the photomontages, although he believed that Cahun was the sole artist. "At the time, I knew nothing about Cahun. I even thought she was a man," Leperlier said in an interview for an exhibit he helped to curate of Cahun and Moore's work at the Jeu de Paume museum in Paris. He took out an advertisement in the Jersey newspaper, seeking more information, and found an antiques dealer who was selling Suzanne's estate, which he'd previously bought at auction.

Moved by the photographs he saw, Leperlier researched and published a book in 1992, bringing Cahun (and, to some extent, Moore) wider acclaim; a substantially revised version of the book was published in 2006. Also in 1992, the first solo exhibition of work, again credited only to Cahun, opened in New York at the Zabriskie Gallery.

Leperlier and others privilege the image over the word. Cahun and Moore's photographs, while considered ugly by some, are nonetheless far more accessible than Cahun's extremely challenging prose. Those striking images continued to attract attention in subsequent years from collectors, museums, and art dealers. Musician David Bowie, well known for his own gender ambiguity, mentioned a 2007 show of Cahun and Moore's photography on his blog, writing, "I find this work really quite mad, in the nicest way."

In the wake of Leperlier's attempt to restore Cahun to the art historical—although not literary—canon through his book and subsequent museum exhibitions in which he has been involved, Cahun (but not Moore) became the subject of what art historian Astrid Peterle calls "an 'academic hype.'" Peterle and others have pointed out that the "rediscovery" of Cahun coincided with the growing attention to gender performativity, itself fueled by the publication of Judith Butler's now-classic 1990 *Gender Trouble: Feminism and the Subversion of Identity*, a founding text in queer theory. Butler and others analyze the social-cultural construction of gender and sexuality, the self, and the body.

In that light, Cahun—because she appears in the photographs as a fractured, constructed and reconstructed, performed, and fluid self who seems to be displaying multiple identities and crossing gender lines—came to be

seen as "queer" *avant la lettre*. She is often described as a precursor to feminist photographers, notably Cindy Sherman, who also deal with issues of women's self-representation in their work. Had Cahun and Moore been rediscovered in a different time, the images they produced might have been thought of in a very different light.

Back on Jersey, Mr. Wakeham brought the collection he now owned to the attention of the Jersey Heritage Trust in the early 1990s, which then purchased it in 1995. When another, smaller collection, also held on Jersey, came to light a few years later, the Jersey Heritage Trust purchased it in 2002.

The collection currently held at Yale University's Beinecke Library was previously owned by Basil Bigg, having been purchased by his mother at the 1972 auction, according to the provenance statement. A careful reading of that entire collection led me to confirm that what the Beinecke has cataloged as Suzanne's words are, in fact, hers. In many discussions of Lucy and Suzanne's lives and work, misattribution of sources has effectively silenced Suzanne's voice in the mistaken belief that only Lucy was the creative genius. However, in the Yale manuscripts, Suzanne refers to herself, offers memories of her own family and childhood, mentions being addressed directly by the GFP agents, and refers to Lucy in the third person (including one instance when Lucy is in the toilet). All these documents are in the same handwriting; those that are clearly Lucy's are in a different handwriting. My account attempts to correct some of the errors of attribution by other scholars and to restore something of Suzanne's agency to the story.

Because Lucy is the one in most of the photographs, many scholars, likely following the lead of the Jersey Heritage Trust and François Leperlier, have shifted the "authorship" of the women's pieces entirely to her under her artistic name, Claude Cahun. Some mention Suzanne as Marcel Moore, and a few talk about the work as a collaboration, but Suzanne is largely absent from most discussions of their life and labor. However, many other scholars—myself included—have come to believe that their entire body of work was collaborative.

In her written work, Lucy is clearly an innovator, and it seems logical to many observers that the creator of avant-garde literature would also be the creator of avant-garde photography. Suzanne's illustrations are beautiful

works, but they are not particularly groundbreaking and instead simply reflect the art nouveau and art deco styles of the era. Hence, Lucy—the troubled, chronically ill, kooky, introverted personality—is thought of as the "artist" while Suzanne—the down-to-earth, practical one—seems to be an imitator. Ultimately, Lucy more comfortably fits our narrative of the bohemian artist.

A simpler explanation for Suzanne's absence within the scholarship is that she did not leave behind nearly as many traces. Lucy is the one pictured in all the photographs that can reasonably be called artistic, and she is almost always in the more candid shots. There are far fewer images of Suzanne, and they are nearly always snapshots rather than artistic constructions. This, of course, implicitly suggests that Suzanne was usually the one clicking the shutter. Normally, that person is called the photographer and, hence, the artist. In their case, however, the artistic vision is regularly imputed to Lucy as Claude Cahun. Yet of the two, Suzanne was the only one who had formal training in the visual arts; she attended art school in Nantes. Lucy always thought of herself as a writer first and foremost.

To me, it makes sense to see their work as a full partnership, with Lucy, the actress, performing in front of the camera in a kind of "show" that they had discussed and arranged together, and with Suzanne, the photographer, choosing the moment to snap the shutter when the light was perfect or the expression on Lucy's face was right. These are aesthetic judgments of the sort that portrait photographers such as Richard Avedon or Annie Leibovitz are famous for; they understand when the looks on the faces they are shooting capture the idea the photograph is to convey. It is also easy to imagine that if Lucy and Suzanne took multiple exposures of a photograph, they looked at the prints together and decided which ones worked best. Neither could develop film, so they always relied on commercial laboratories to print their images. With cameras forbidden on Jersey during the occupation, they most likely developed the photographs they took during the war only after 1945.

Lucy wrote extensively, and much of her work is autobiographical in some way or other. If Suzanne wrote at all, almost nothing remains except for her unpublished reminiscences of their wartime experience; there is a substantive biography of Lucy (as Claude Cahun) but very little on Suzanne

(as Marcel Moore), in part because the texts simply do not exist. Lucy's family was already famous through its literary activities and connections in Nantes and Paris, and many supporting documents and correspondence survive; Suzanne's family was locally prominent but essentially remained a rather typical bourgeois family in Nantes.

However, to see only Lucy as the author and to subordinate—or erase—Suzanne from the picture fails to capture the complexity of their decades-long relationship and misunderstands the nature of creative production.

Despite new critical and cultural approaches, much of Western art and literary history remains bound up in the Romantic-era myth of the "genius"—the solitary figure who toils alone to produce a masterpiece. But that has rarely been the model for creativity historically. For instance, as the contributors to *The Thinking Space*, a comparative study of cafes, show, certain kinds of spaces that sustain both private thought and public conversation have been instrumental in creative endeavors. Individuals may work and think on their own, but cafes have provided the social contexts in which artists could then turn and discuss their ideas with others, refining, debating, and receiving inspiration from the dialogue. Likewise, the artistic partnerships described by the authors in the edited volume *Significant Others* show that despite the fact that spouses and lovers have been crucial to the creative process throughout history, they often get pushed to the margins of an artist's story.

In some ways, the collaborative photographs from Lucy and Suzanne's Paris days pale in comparison to their work during the war as resisters. We will never know how many pamphlets, drawings, leaflets, or other kinds of messages Lucy and Suzanne actually made for the German soldiers on Jersey. Judging only by the sheer volume of examples the GFP collected, the war seemed to represent the peak of their creative productivity. Their resistance activity was arguably also the work seen by the most people during their lifetimes.

Most of their now-famous photographs taken in Paris were originally private or for friends. By contrast, their wartime leaflets were intended for a wide audience of German soldiers, who numbered as many as fifteen thousand on Jersey at one point in the war. Of course, it is impossible to know how many people actually saw them.

THERE IS STILL MUCH THAT REMAINS UNKNOWN about the docu-
ments that illuminate Lucy and Suzanne's lives and their resistance work.
In Lucy's case, descriptions of their activities during the war exist in manu-
script form, often on unnumbered loose leaves of paper, from the late 1940s
and early 1950s. They seem to be the beginnings of what she intended to
be a memoir. These thoughts are impressionistic and often rambling, not
a cohesive work but notes, sketches, scenes, and strings of thoughts—a
stream-of-consciousness attempt to put it all down on the page before it was
too late—all filtered through her memory in the years after the war. Some
of her writing consists of secondhand accounts of events that happened
to Suzanne and were told to Lucy later (for instance, her retelling of the
chaplain's visit to Suzanne in chapter 17). The only surviving document that
dates from the war is a typescript copy of a portion of Lucy's "testament."
However, it is incomplete; Lucy quotes an excerpt of this letter in untitled
and unpublished notes labeled in the Jersey Heritage Trust as her "wartime
diary," but that excerpt is not found in the typescript version. In addition,
several of Lucy's lengthy letters written to friends after the war and her
reminiscences elaborate on their wartime lives. Most of these have been
reprinted in François Leperlier's 2002 edited volume, *Claude Cahun: Écrits*.

Suzanne's writings retain a great deal of the immediacy of her experience
in that she recounts dialogue, gives specific dates, and offers descriptions
of people and places in a way that Lucy does not. When she remembered
those days—in fragmented thoughts jotted down on scraps of paper years
later—she tended to be more matter of fact than Lucy, who often mused
on death or philosophical issues. Suzanne also claimed responsibility for
many of the actions they undertook, such as making the wooden crosses
planted on soldiers' graves, which many scholars often attribute to Lucy
alone. Reading Suzanne's account, the truly collaborative nature of their
resistance activities becomes much clearer.

But Suzanne's documents are also problematic. The surviving hand-
written manuscripts were either composed, transcribed, or rewritten much
later. She often wrote on scraps of paper, including the backs of envelopes
featuring her address later in life; in one case, she wrote on the back of a
calendar from 1960. Not all the reminiscences are complete, and pages seem
to be missing. Many of the stories are fragmented, while in others, details
are recounted multiple times (with slight variations), clearly being reworked

and made into the literary form of a memoir, although the project was never achieved. In one note, she misidentifies the date of their arrest by one day; there are other discrepancies as well between the accounts.

There are several possibilities: She may have recalled to the best of her ability the facts and details from memory across time and with advancing age (Lucy marveled at Suzanne's precise memory, unlike her own). She may have been slightly fictionalizing her memory for literary effect. Perhaps she was working from notes that she kept during her time in prison. Lucy did recall Suzanne's collecting notes and belongings that she had hidden in her cell as they were being released in May 1945, and many of the documents from the Jersey Heritage Trust filed under "prison correspondence" read as nearly exact renderings of these clearly later documents.

The main difference is that the stories Suzanne tells in the prison correspondence are in French (with German dialogue rendered in English, perhaps for Lucy's benefit since she didn't speak German), whereas the later documents are all in English. Suzanne also suggests in one of these documents that perhaps the Gardenal may have made her forget some of the details of the night of their arrest. But exactly when these documents were written remains a mystery, although many appear to be copies (or copies of copies).

Some documents, especially the prison correspondence, may not be originals but perhaps were all rewritten later by Suzanne (they are in her handwriting). They are unsigned, so are they all Suzanne's, or are some Lucy's? Likewise, many of the extant versions of their notes to the Nazis were likely written later from memory. On what is probably their most frequently reproduced flyer—"Alarm! Alarm!"—the copy in the Jersey Heritage Trust contains a note at the bottom written in Suzanne's hand: "This one was much longer but I can't remember." On another, she wrote an annotation indicating where she thought they had stuck the note; that explanatory note helped me to reconstruct the opening scene of this book.

Given Lucy's well-documented penchant for shaping her persona in her writing, in addition to the simple problems of relying on memory, one might begin to question how accurate their telling of the story is. In some sense, she is a classic unreliable narrator.

Because so much self-fashioning is built into Lucy's writings (as Cahun), this requires one to keep in mind the practices of the "new biography" to

interpret these documents. As historian Jo Burr Margadant has argued, this approach highlights the fact that life stories are not cohesive, coherent, and whole but are attuned to how the people who lived those lives worked to shape and fabricate new understandings of themselves. Margadant and the contributors to her volume *The New Biography: Performing Femininity in Nineteenth-Century France* argue that elite Frenchwomen fashioned a new self, or selves, which allowed them to have a space of freedom within the gender confines of their day. Historians working as new biographers recognize the constructed nature of a person's life by pointing out how the notion of the self is not only ever evolving but also replete with multiplicities, contradictions, and performances. It helps draw larger connections between the individual and his or her historical contexts since people have used the cultural vocabularies of their moment to create these selves, often for political purposes.

This means fact-checking Lucy and Suzanne's accounts against other sources while also being sensitive to the ways in which they, as women, lesbians, and artists, created themselves through storytelling in order to claim both identity and power. Suzanne, for instance, presents herself as polite and rational, even in the face of interrogation. One wonders just how polite and rational she really was.

ACKNOWLEDGMENTS

AS THE LIVES OF LUCY AND SUZANNE show us once again, all creative and intellectual work is a collaboration, and this book is no different.

Funding for this project came from Rhodes College in the form of the J. J. McComb Chair of History, which I held for a crucial period while researching and writing. I conducted research for this book at Yale University's Beinecke Library, Sterling Memorial Library, Bass Library, Manuscripts and Archives Division, and Haas Art Library, thanks to an Edith and Richard French Fellowship. Additional research also took me to the Imperial War Museum, the UK National Archives in Kew, and the Jersey Archive. The digital Cahun and Moore collection at the Jersey Archive and its paper holdings in St. Helier were a wealth of information. I also benefited from visits to the Société Jersiaise and the Jersey Public Library. I am grateful for the assistance of librarians and archivists in all these locations, especially Janne White at the Jersey Archive and Sue Groves in the Office of the Superintendent Registrar, both of whom provided me with additional information via correspondence. My thanks also to Anthony Pezet, a local Jersey genealogist, and Bob Le Sueur, MBE, himself a survivor of the occupation period and active resister who helped shelter escaped OT workers. Both of them corresponded with me and pointed me in extremely useful directions. My hearty thanks go out once again to Rhodes College's Barrett Library, especially Kenan Padgett of the interlibrary loan office.

I benefited from the hard work and insight of several student research assistants at Rhodes College, including Sumner Richter (who championed and assisted with this project in more ways than one), Samantha Smith,

Matthew Broussard, and Cameron Sandlin, and I am grateful that they took part in this research.

Thanks to Margot Lueck-Zastoupil, who translated the surviving leaflets from German into English and offered linguistic insight into interpreting them.

I appreciate the time and insight of numerous colleagues who read some or all of the manuscript and gave me feedback, including Jean Pedersen, Aram Goudsouzian, Robert Saxe, and Marcus Bruce. I am also thankful for conversations, email exchanges, and advice I received from Hampton Sides, Bonnie Smith, Carolyn Dean, Jann Matlock, Holly Tucker, Michael Bess, Helmut Smith, Jill Richards, John Merriman, Michelle Gewurtz, Sandrine Sanos, Emily Yellin, Erin Harmon, David McCarthy, Joel Parsons, Ari Eisenberg, Shira Malkin, Duvall Osteen, and Judith Ehrlich, as well as for the feedback from audiences at talks I gave at Rhodes College, the Society for French Historical Studies Conference in Colorado Springs, and the Creative Women at the End of the First World War Conference at the University of Guelph.

Many thanks to my agents, Rick Richter and Lane Zachary, at Aevitas Creative Management, to my editorial team of Amy Gash and Abby Mueller at Algonquin Books, and to Jude Grant for her copyediting prowess. I am so glad to have benefited from their support and mentorship.

My family has always supported me in everything that I do, and I am eternally grateful for their help. This book could not have been written without them, and I only wish that my father had lived long enough to see the final product.

Most important, there is Ellen, because this book was her idea in the first place. She was the one who first told me about Cahun and Moore, showed me their photographs, and mentioned their resistance activities. She discussed the ideas contained within this book repeatedly, helped refine my thinking, told me about things I didn't know, gave me practical research advice, suggested books to read, translated the occasional German, and encouraged me when I thought I should give up. Meanwhile, she took care of the kids, kept our house running, taught her own courses, undertook amazing amounts of administrative work at her institution, and did her own research and writing. I hope I have done my share in return and that she will think all the effort was worth it. Thank you.

NOTES

FRANÇOIS LEPERLIER'S BIOGRAPHY of Lucy Schwob, *Claude Cahun: L'écart et la métamorphose*, did more than the work of any other scholar to resurrect Lucy (Claude Cahun) and, to some extent, Suzanne (Marcel Moore) from the obscurity into which they fell after the war. I have drawn on the much revised and expanded second edition of Leperlier's work, titled *Claude Cahun: L'exotisme intérieur*, as well as that of several other scholars listed in the notes below.

However, unlike many authors who have written about these women, I have tried to bring together all the sources: archival sources on both sides of the Atlantic, work Lucy and Suzanne published, and writings published posthumously. To my knowledge, no one else has cast such a wide net in telling Lucy and Suzanne's wartime story. All translations drawn from these sources are my own.

Much of the basic biographical information here comes from a combination of archival and genealogical sources; Lucy's own writings about the war, reprinted in the massive but still selective volume of her work edited by Leperlier (*Claude Cahun: Écrits*); and sources quoted by Leperlier himself. In the revised edition of his biography, Leperlier relied on a more recently discovered letter from Lucy to Charles-Henri Barbier that was written in 1951. The letter contains details not previously mentioned in other writings. That document is in Leperlier's possession and is not available to scholars other than through quotations in his text. Occasionally in his book, Leperlier offers information or a quotation without providing the source. In cases such as these, where I'm unable to backtrack and locate the original source, I must rely on his evidence alone.

Lucy and Suzanne's experience in prison and at their trial is told by Suzanne in cluttered, unnumbered pages contained in Yale University's Beinecke Library. I have not cited them extensively in the notes because of the lack of any easy way to reference them given their state. Unfortunately, the footnotes appear to again privilege Lucy's words, but the reader should be advised that essentially everything attributed to Suzanne in the text comes from that Yale collection. Quotations drawn from Suzanne's handwritten documents have been lightly edited in this book for style, consistency, and clarity.

The story of the occupation on Jersey and the Channel Islands is told by numerous historians, and I have relied on their accounts as well as additional primary sources, including oral histories at the Imperial War Museum in London and declassified MI-19 files at the National Archives in Kew. Michael Ginns, in *Jersey Occupied: The German Armed Forces in Jersey 1940–1945*, provides amazing details of the military side of the occupation. Madeline Bunting's *The Model Occupation: The Channel Islands under German Rule, 1940–1945*; Paul Sanders's two books, *The British Channel Islands under German Occupation, 1940–1945*, and *The Ultimate Sacrifice: The Jersey Twenty and Their "Offences against the Occupying Authorities," 1940–1945*; and Peter Tabb's *A Peculiar Occupation: New Perspectives on Hitler's Channel Islands* offer valuable information at every level of the story. Powerful accounts of resistance are chronicled in Gilly Carr, Paul Sanders, and Louise Willmot's *Protest, Defiance, and Resistance in the Channel Islands: German Occupation, 1940–1945*. Joe Mière's remembrances and collection of other stories in *Never to Be Forgotten* were also essential. The Frank Falla Archive (https://www.frankfallaarchive.org/) and the William Brown Ledger, made available online by the Channel Islands Occupation Society (https://www.cios.org.je/assets/downloads/scans/william-brown-ledger-web.pdf), are also important sources of additional information.

Copies of Suzanne and Lucy's remaining leaflets can be found in the Jersey Archive, St. Helier, Jersey, JHT/1995/00045/53 (https://catalogue.jerseyheritage.org/collection/Search/archive/JHT/1995/00045/53/); and Yale University, Beinecke Library, Claude Cahun and Suzanne Malherbe Papers, GEN MSS 721, box 1, folder 11. They are also transcribed in Kristine von Oehsen's 2003 doctoral dissertation, "'Claude Cahun'—Published/Unpublished: The Textual Identities of Lucy Schwob—1914–1944," University of East Anglia.

PROLOGUE

1 **On the morning** The account of placing their notes comes from Lucy's postwar remembrances published posthumously in François Leperlier, *Claude Cahun: Écrits* (Paris: Jean-Michel Place, 2002), including 627, 630, and 724. I have reconstructed a narrative account of that morning from these sources.

1 **The cowardly bureaucrats** Jersey Archive, JHT/1995/00045/53. Written on the surviving copy of the note (which is likely a reproduction Suzanne created later): "This one was typed on gummed paper, and stuck on the windows of the police cars."

2 **an experience we** Edward Le Quesne, *The Occupation of Jersey Day by Day* (n.p.: La Haule, 1999). For Le Quesne's biographical information, see the foreword to his book by Michael Ginns. For Le Quesne's account of the incident on the bus, see 242–43, although he places the events a few days later. Le Quesne gets basic information about Lucy and Suzanne wrong (for example, he calls them "daughters of the proprietors of the newspaper 'Le Matin'"). In addition, his account does not correspond with Lucy's memory: he claims that Lucy and Suzanne did not have their papers, whereas Lucy recalls an exchange with the Nazi soldier about her papers, which she had in her possession.

5 **The soldier noticed** Lucy's and Suzanne's cards: Jersey Archive, D/S/B1/3599 and D/S/B1/1939, respectively. One can track their visits to and departures from Jersey using this document. According to the Jersey Archive note about collection D/S/B, "On 17th February 1920 the States of Jersey enacted the principles of the 1914 English Aliens Restrictions Act. Under the law all aliens over the age of sixteen resident in Jersey has to register with the Immigration Officer. Every alien in the Island had to register, no matter how old they were or how long they had been living in Jersey." Visits before 1920 are not registered.

5 **They have not caught** "Sentenced to Death by Island Nazis: The Story of Two Gallant French Women," *Jersey Evening Post*, July 14, 1945.

CHAPTER I

10 **In her memoirs** Sylvia Beach, *Shakespeare and Company* (New York: Harcourt, Brace & World, 1959), 209.

10 **She posed** "Sylvia Beach at Rue Dupuytren by Claude Cahun," Princeton University, Firestone Library, Sylvia Beach Papers, series 7, subseries B, box 175, folders 1–4. The photograph bears an inscription: "Photograph by Lucie Schwob and Suzanne Malherbe, Sylvia at Bookshop Shakespeare and Company, 8, rue Dupuytren, 1919." It is unclear who wrote the inscription, although it reflects one of the variant spellings of the name that Lucy sometimes used.

10 **Beach and Monnier hosted** Leperlier, *Claude Cahun, Écrits*, 593. See also Adrienne Monnier, *Rue de l'Odéon* (Paris: Albin Michel, 1960).

11 **Stein recalled** Gertrude Stein, *The Autobiography of Alice B. Toklas* (New York: Vintage, 1990), 196.

11 **firm ground, calm** Quoted in François Leperlier, *Claude Cahun: L'exotisme intérieur* (Paris: Fayard, 2006), 383. The description comes from André Breton's second wife, Jacqueline Lamba, who visited Lucy and Suzanne on Jersey with her daughter, Aube Breton.

11 **None of these women** World War I had put women into many traditionally men's positions, whether in the factory or in political leadership. After the war, many people in France believed that lesbians continued to invert sexual roles, supposedly becoming inordinately powerful and sexually voracious at a time when many sought a return to the normal social order. To conservatives, lesbians were further evidence of the decadence of the "modern woman" famously symbolized by Victor Marguerite's novel *La garçonne*—the "boy-girl" or "bachelor girl"—which described the seeming reversal in men's and women's place in society. Often they were compared with foreigners and Jews, those who were outsiders threatening an imaginary cohesiveness of the French community. Commentators fantasized and fretted about secret erotic worlds of women and hoped to expose them for the sake of the common good, even as they complained about how difficult it was to identify lesbians because they blended into everyday life. On understandings of lesbianism, see Whitney Chadwick and Tirza True Latimer, "Becoming Modern: Gender and Sexual Identity after World War I," in *The Modern Woman Revisited: Paris between the Wars*, ed. Whitney Chadwick and Tirza True Latimer (New Brunswick, NJ: Rutgers University Press, 2003); Jennifer Terry, "Lesbians under the Medical Gaze: Scientists Search for Remarkable Differences," *Journal of Sex Research* 27 (August 1990): 317–39; George Chauncey Jr., "From Sexual Inversion to Homosexuality: The Changing Medical Conceptualization of Female 'Deviance'" in *Passion and Power: Sexuality in History*, ed. Kathy Peiss and Christina Simmons (Philadelphia: Temple University Press, 1989); Lilian Faderman, *Surpassing the Love of Men: Romantic Friendship and Love between Women from the Renaissance to the Present* (New York: William Morrow, 1981). On the supposed challenge that lesbians posed, see Carolyn Dean, *The Frail Social Body: Pornography, Homosexuality, and Other Fantasies in Interwar France* (Berkeley: University of California Press, 2000); Julian Jackson, *Living in Arcadia: Homosexuality, Politics, and Morality in France from the Liberation to AIDS* (Chicago: University of Chicago Press, 2009); Florence Tamagne, *A History of Homosexuality in Europe: Berlin, London, Paris 1919–1939*, 2 vols. (New York: Algora, 2004); Claudie Lesselier, "Silenced Resistances and Conflictual Identities: Lesbians in France, 1930–1968," *Journal of Homosexuality* 25 (1993): 105–25; and Jeffrey Merrick and Bryant T. Ragan Jr., *Homosexuality in Modern France* (New York: Oxford University Press, 1996).

12 **their address book** Jersey Archive, JHT/1995/00045/60A.

13 **All the women** Tamagne, *History of Homosexuality*, 1:68. On lesbian visibility in Paris, see Leslie Choquette, "Homosexuals in the City," *Journal of Homosexuality* 41 (October 2008): 149–67; and Nicole G. Albert, "De la

topographie invisible à l'espace publique et littéraire: Les lieux de plaisir lesbien dans le Paris de la Belle Époque," *Revue d'histoire moderne et contemporaine* 53–54 (October–December 2006): 87–103; Nicole G. Albert, *Lesbian Decadence: Representations in Art and Literature of Fin-de-Siècle France* (New York: Harrington Park Press, 2016); Martha Vincinus, "Fin-de-Siècle Theatrics: Male Impersonation and Lesbian Desire," in *Borderlines: Genders and Identities in War and Peace, 1870–1930,* ed. Billie Melman (New York: Routledge, 1998), 163–92; Shari Benstock, "Paris Lesbianism and the Politics of Reaction, 1900–1940," in *Hidden from History: Reclaiming the Gay and Lesbian Past,* ed. Martin Duberman, Martha Vicinus, and George Chauncey Jr. (New York: Meridian, 1989), 332–46; Laura Doan and Jane Garrity, eds., *Sapphic Modernities: Sexuality, Women and National Culture* (New York: Palgrave Macmillan, 2006); Catherine van Casselaer, *Lot's Wife: Lesbian Paris, 1890–1914* (Liverpool: Janus Press, 1986); and François Buot, *Gay Paris: Une histoire du Paris interlope entre 1900 et 1940* (Paris: Fayard, 2013).

14 **Lucy penned** Wendy Janvrin-Tipping, *Any Day Now* (London: Austin Macauley, 2016), 77. Lucy mentions this unpublished manuscript in Evelyn Janvrin's prison notebook.

14 **A teenaged Bob Steel** Lucy's description and account of her relationship with Bob appears in Claude Cahun, *Disavowals* (Cambridge, MA: MIT Press, 2008), 7. Bob's Jersey Occupation Registration Card and identification form provides additional information about him. See Jersey Archive, D/S/A/12/A981 and D/S/A/12/B981. Also in the Jersey Archive are photos of Bob that were taken by Lucy and Suzanne.

14 **I'd have gaily** Cahun, 7.

15 **They flirted** Leperlier, *Claude Cahun: Écrits,* 674.

15 **Her cousin René** Lucy discusses her cousin in Leperlier, 440–41.

15 **In 1908** The Schwob family decided to send Lucy off to the Parsons Mead School, a relatively new and elite all-girls school, in Surrey for the 1907–8 academic year. England was a logical choice. The Schwob family had English housekeepers, and this school would allow Lucy to continue working on her language skills. The family had vacationed in England, and Lucy's brother had also spent some time in school there. She thrived at Parsons Mead, distinguishing herself in writing and in acting. It was the first place she spent any significant time away from Nantes by herself, and it likely provided her with a sense of calm compared with the family and political drama back home. It was also the first time she had lived exclusively among women and girls, away from the influence of the powerful and influential men in her family. See Marcus Williamson, *Claude Cahun at School in England* (self-published, Lulu, 2011).

16 **A new feeling** Quoted in Leperlier, *Claude Cahun: L'exotisme,* 90.

16 **We, Suzanne and I** Quoted in Jennifer L. Shaw, *Exist Otherwise: The Life and Works of Claude Cahun* (London: Reaktion Books, 2017), 24; and Leperlier, 30.

17 **discover, after having** Quoted in Leperlier, 29.

18 *idée maîtresse* Quoted in Tirza True Latimer, *Women Together/Women Apart: Portraits of Lesbian Paris* (New Brunswick, NJ: Rutgers University Press, 2005), 68.

18 **One day, she** Latimer, 69–70.

19 **Lucy's first major** Much of Lucy's early work was published in Leperlier, *Claude Cahun: Écrits*, including a reprint of "Vues et visions" (see 21–122).

19 **artistic coming out** Latimer, *Women Together*, 80.

19 **For their creative** Lucy's choice of artistic name was more convoluted than Suzanne's. Initially, she went by "M," the first of many pen names. When "Vues et visions" was first published in a literary journal, she adopted the more ambiguous nom de plume, Claude Courlis. Claude was a name in French commonly used by both women and men, and Courlis is the French name for the curlew bird, known for its long, curved beak. The name allowed her to deliberately play on the stereotype of the Jewish nose, perhaps rejecting at least in part the assimilation that her father had undergone in order to claim a Jewish identity at a time when being Jewish was dangerous in anti-Semitic Europe. On Lucy's relationship to names and Jewishness, see Michelle Sara Gewurtz, "Three Women/Three Margins: Political Engagement and the Art of Claude Cahun, Jeanne Mammen, and Paraskeva Clark," PhD diss., University of Leeds, 2010.

20 **In turn-of-the-century** "Whether a name designates a character's sex or not, it evokes a number of implicit and coded meanings." Albert, *Lesbian Decadence*, 177.

21 **Except for a thin** Photographs of Lucy with her head shaved are in the Jersey Archive and are also reprinted in Louise Downie, ed., *Don't Kiss Me: The Art of Claude Cahun and Marcel Moore* (London: Aperture/Tate, 2006). For discussion of the shaved head, see also Lizzie Thynne, "'Surely You Are Not Claiming to Be More Homosexual than I?' Claude Cahun and Oscar Wilde," in *Oscar Wilde and Modern Culture: The Making of a Legend*, ed. Joseph Bristow (Athens: University of Ohio Press, 2008), 180–208. According to art historian Viviana Gravano, Cahun and Moore use "the classic iconography devised for the lunatic: the same shaved cranium, the half-open mouth, the attitude of being closed in on herself." See Viviana Gravano, "Explorations, Simulations: Claude Cahun and Self-Identity," *European Journal of Women's Studies* 16 (2009): 363. Marcel Duchamp was also playing with gender identities through head shaving, in part as a response to a crisis of masculinity after World War I. See Giovanna Zapperi, "Marcel Duchamp's Tonsure: Towards an Alternate Masculinity," *Oxford Art Journal* 30 (2007): 289–303.

21 **I shave my head** Cahun, *Disavowals*, 30.

22 **Shuffle the cards** Cahun, 151–52. On the issues of sexual and gender fluidity, gender terminology, and pronoun use, see Lisa M. Diamond, *Sexual Fluidity: Understanding Women's Love and Desire* (Cambridge, MA: Harvard University Press, 2009); Judith (Jack) Halberstam, *Female Masculinity* (Durham, NC: Duke University Press, 1998); Emily Skidmore, *True Sex: The Lives of Trans*

Men at the Turn of the 20th Century (New York: New York University Press, 2017); Simon D. Elin Fisher, "Pauli Murray's Peter Panic: Perspectives from the Margins of Gender and Race in Jim Crow America," *TSQ: Transgender Studies Quarterly* 3 (May 2016): 95–103; Trudy Ring, "Exploring the Umbrella: Bisexuality and Fluidity," *Advocate*, February 11, 2014; and Richard A. Friedman, "How Changeable Is Gender?" *New York Times*, August 22, 2015. Many scholars also compare Cahun's work with the theories of the psychoanalyst Joan Riviere who published her famous article "Womanliness as a Masquerade" in 1929 to describe, in Freudian terms, what she saw as the role-playing that women who wished to enter into traditionally men's worlds—intellectual endeavors, various professions, business—had to do in order to do their work without upsetting the traditional gender order. "Womanliness therefore could be assumed and worn as a mask, both to hide the possession of masculinity and to avert the reprisals expected if she was found to possess it—much as a thief will turn out his pockets and ask to be searched to prove that he has not stolen goods." Cahun is not exactly doing the same thing in her on-camera performances, since they were so private, but she and Moore clearly had to navigate the complicated masculine art world as women who were often treated as outsiders. Joan Riviere, "Womanliness as Masquerade," *International Journal of Psychoanalysis* 10 (1929): 303–13.

23 **Les jeux uraniens** Leperlier, *Claude Cahun: Écrits*, 489. The introduction to "Les jeux uraniens" contains a discussion of "friendship," but Lucy means something more than the term would normally imply. Unlike mere love, this kind of friendship is "infinite, always improving, begins mysteriously and never finishes." Lucy wrote: "My friend, I will find out how to study you with the same enjoyment as breaking down a classical period. . . . I will compare you to taste your smallest differences, and, to understand you word for word, I will translate you literally. Then I will study my notes so that I don't lose anything. Friend, you will pose for me since you want to serve as my model; I will put into prose in order to love you as if I had you." This notion of friendship was a deep intimacy and passion linked to same-sex love, and she quoted the poem "Two Loves" by Alfred Douglas, Oscar Wilde's lover, which contains the famous line "I am the love that dare not speak its name."

23 **doctor-philosopher-poet** Leperlier, 710. See also Chadwick and Latimer, *Modern Woman Revisited*, 12, for reference to a letter from Cahun to Adrienne Monnier discussing the influence of Havelock Ellis.

23 **To Havelock Ellis** Cahun's inscription on Ellis's personal copy of *Aveux non avenus* is available at http://www.christies.com/lotfinder/books-manuscripts/cahun-claude-aveux-non-avenus-paris-editions-5626098-details.aspx. *The Task of Social Hygiene* was not about homosexuality, but in large part about eugenics, the idea of achieving greater racial perfection by regulating reproduction. Ellis argued that women in particular needed to have greater control over their sexuality and their bodies as well as the ability to shape their own lives, including becoming economically independent. Such a book—with chapters titled "The Changing Status of Women"

and "The Emancipation of Women in Relation to Romantic Love"—must surely have appealed to Lucy and Suzanne, especially since Ellis supported education, votes, and sexual freedoms for women. In addition to his feminism, Ellis's leftist politics also came through as he identified the "tasks" of social hygiene as including ending war between classes and nations and the creation of an international language as well as racial improvement. See A. B. Wolfe, review of *The Task of Social Hygiene, American Journal of Sociology* 19 (November 1913): 395–98. There is some speculation that Ellis himself might have been gay. His wife, Edith Lees, was certainly a lesbian, and their open marriage allowed her to pursue many relationships with other women. One of Ellis's chief collaborators, John Addington Symonds, was also gay. For more on Ellis's work, see Chiara Beccalossi, *Female Sexual Inversion: Same-Sex Desires in Italian and British Sexology, c. 1870–1920* (New York: Palgrave Macmillan, 2011). Lucy published the first volume of her translation in 1929 as *La femme dans la société* (Woman in society) using a variation of her birth name (Lucie Schwob), but the second volume never appeared. Fluent in English as well, Suzanne likely helped with the translation and certainly worked on the index as she indicates to the German soldiers when La Rocquaise was raided in 1944.

24 **Although some women** Modernism in the arts had been connected with homosexuality for some time—and given a boost thanks to Lucy's family friend Oscar Wilde—but there was still a need for subterfuge and coded language and behavior. The avant-garde needed secrets, "simultaneously shocking audiences by suggesting what was usually unspoken," according to art historian Christopher Reed, "and wrapping itself in various stylistic guises of inscrutability." They had begun to come out from behind those veils in "Vues et visions," but keeping secrets, shifting identities, and choosing friends carefully likely had become second nature to Cahun and Moore as they sought to navigate a Paris and an avant-garde that both embraced them and kept them at arm's length. See Christopher Reed, *Art and Homosexuality: A History of Ideas* (New York: Oxford University Press, 2011), 136–37. See also Chadwick and Latimer, *Modern Woman Revisited*, xiv, on modernity and modernism as masculine. On the ambivalence toward lesbians among bohemian artists more generally, see Leslie Choquette, "Paris-Lesbos: Lesbian Social Space in the Modern City, 1870–1940," *Proceedings of the Annual Meeting of the Western Society for French History* 26 (1998): 122–32. See also Lisa Tickner, "Men's Work? Masculinity and Modernism" *Differences* 4 (1992): 1–33; Whitney Chadwick, *Women Artists and the Surrealist Movement* (Boston: Little, Brown, 1985); Mary Ann Caws, Rodolf Kuenzli, and Gwen Raaberg, eds., *Surrealism and Women* (Cambridge: MIT Press, 1990); and Amy Lyford, *Surrealist Masculinities: Gender Anxiety and the Aesthetics of Post-World War I Reconstruction in France* (Berkeley: University of California Press, 2007).

24 **a curiously somber** Quoted in Leperlier, *Claude Cahun: L'exotisme*, 178.

24 **a civilization without** There is an extensive literature about gender and sexuality in France in the 1920s, although the phrase is most commonly associated

with Mary Louise Roberts, *Civilization without Sexes: Reconstructing Gender in Postwar France, 1917–1927* (Chicago: University of Chicago Press, 1994).

24 **Trespassers will be** Jersey Archive, JHT/1995/00045/70.

25 **My opinion on** Quoted in Gilles Barbedette and Michel Carassou, *Paris Gay 1925* (Paris: Non Lieu, 2008), 209. On the journal *Inversions* and the controversy surrounding it, see also Jackson, *Living in Arcadia*; Tamagne, *History of Homosexuality*, 179ff; and Scott Eric Gunther, *The Elastic Closet: A History of Homosexuality in France, 1942–Present* (New York: Palgrave Macmillan, 2009). Havelock Ellis also responded to the magazine's call for comment on the issue.

CHAPTER 2

26 **Suzanne, as Marcel Moore** The Jersey Archive contains many examples of Suzanne's work, several of which are reprinted in Louise Downie, ed., *Don't Kiss Me: The Art of Claude Cahun and Marcel Moore* (London: Aperture/Tate, 2006), and available on its website.

26 **It was the only** The photography of Cahun and Moore has received by far the greatest attention from scholars. See James Stevenson, "Claude Cahun: An Analysis of Her Photographic Technique," in Downie, *Don't Kiss Me*, 46–55, for his discussion of the type of camera and the fact that all the negatives in the Jersey collection are consistent with single-camera use. This simple camera may have belonged to one of their fathers, or they may have purchased it themselves. Wherever it came from, they never seem to have replaced it with a more expensive, professional model.

26 **The lens tracks** Claude Cahun, *Disavowals* (Cambridge, MA: MIT Press, 2008), 1.

27 **Both women became** See Miranda Welby-Everard, "Imaging the Actor: The Theatre of Claude Cahun," *Oxford Art Journal* 29 (March 2006): 1–24; and Michelle Sara Gewurtz, "Three Women/Three Margins: Political Engagement and the Art of Claude Cahun, Jeanne Mammen, and Paraskeva Clar," PhD diss., University of Leeds, 2010.

27 **the primary creative** Joshua Wolf Shenk, *Powers of Two: Finding the Essence of Innovation in Creative Pairs* (New York: Houghton Mifflin Harcourt, 2014).

28 **Often missing** Whitney Chadwick and Isabelle De Courtivron, eds., *Significant Others: Creativity and Intimate Partnership* (New York: Thames & Hudson, 1993).

28 **But their work** Art historian Tirza True Latimer makes a strong case for Cahun and Moore's collaborative relationship in her book *Women Together/ Women Apart: Portraits of Lesbian Paris* (New Brunswick, NJ: Rutgers University Press, 2005), and in "Looking Like a Lesbian: Portraiture and Sexual Identity in 1920s Paris," in *The Modern Woman Revisited: Paris between the Wars*, ed. Whitney Chadwick and Tirza True Latimer (New Brunswick, NJ: Rutgers University Press,

2003), 127–44. Jennifer Shaw also makes a similar argument in "Singular Plural: Collaborative Self-Images in Claude Cahun's *Aveux non avenus*," in Chadwick and Latimer, *Modern Woman Revisited*, 155–68. See also Jennifer L. Shaw, *Exist Otherwise: The Life and Works of Claude Cahun* (London: Reaktion Books, 2017); and Julie Cole, "Claude Cahun, Marcel Moore, and the Collaborative Construction of a Lesbian Identity," in Norma Broude and Mary D. Garrard, eds., *Reclaiming Female Agency: Feminist Art History after Postmodernism* (Berkeley: University of California Press, 2005), 343–59. On creative communities and collaboration, especially among women in Paris, see Shari Benstock, *Women of the Left Bank, Paris 1900–1940* (Austin: University of Texas Press, 1987).

29 *Aveux non avenus* Lucy wrote to Adrienne Monnier suggesting that she would be following her friend's good advice to write something about herself: "You have told me to write a confession because you know only too well that this is currently the only literary task that might seem to me first and foremost realizable, where I feel at ease, permit myself a direct link, contact with the real world, with the facts." But in reality, the book she was then writing bore little relationship to "the facts" at all. It would be confessional but not in the way Monnier had suggested. "Don't get your hopes up," Lucy ultimately told Monnier. She later wrote back to Monnier with hopes that the famous bookseller would support her endeavor, but Monnier declined despite Lucy and Suzanne's long relationship with Monnier and Sylvia Beach (see Cahun, *Disavowals*, xiii; and Downie, *Don't Kiss Me*, 67). The photomontages from *Aveux non avenus*, which were probably Cahun and Moore's best-known work in their own time, are the clearest way to see why one should think of the work as collaborative. The first photomontage is signed by Moore in the lower-right corner. The title page of the volume states: "Illustrated with heliogravures composed by Moore after the plans of the author." An advertisement for the book in the avant-garde journal *Bifur* repeats Moore as the creator of the photomontages. The European edition of the *Chicago Tribune*, which ran a piece on Cahun on December 23, 1929, in the Who's Who Abroad column had already run, the previous Wednesday, December 18, an article in that same column about "Suzanne Moore," a talented young artist. "At present, the artist is engaged in making a series of distorted photographs of her sister," the article read, "which will probably be used to illustrate the volume *Aveux non Avenus*, which Claude Cahun is publishing this year" (Jersey Archive, JHT/2003/00001/109). The *Chicago Tribune* article, for which Cahun was likely interviewed, refers to them as "some extraordinary photographic studies of the author by the artist Moore, her half-sister, who has illustrated her earlier works."

29 **Even while she was still** Lucy finally visited the asylum in Paris where her mother was hospitalized. Her brother, Georges, had been in charge of their mother's health for some time and had convinced the doctors not to let Lucy see her mother. "For the patient's sake," Lucy had been told, "she must avoid anything that might recall her past. Therefore, no member of the family is admitted to see her" (François Leperlier, *Claude Cahun: Écrits* [Paris: Jean-Michel Place], 2002], 606). But now

Lucy was determined to encounter face-to-face the woman who still haunted her dreams and find out whether her mother was as happy in the hospital as Georges had led her to believe. A friend of the family from Nantes, who originally came from the Antilles "with skin almost black," went with her. When doctors would not let them in, Lucy became increasingly suspicious of the situation. Eventually, she found out that her brother had taken their mother out of the hospital several years earlier, and she died after only a few weeks. "My memory of her while she was alive is of an almost childlike carefree happiness, laughing through her tears even while screaming" (François Leperlier, *Claude Cahun: L'exotisme intérieur* [Paris: Fayard, 2006], 24). A few years later, Lucy and Suzanne would go with a friend to the Salpêtrière Hospital; observing psychiatric patients gave them a way to think about questions like mental health and alienation (Leperlier, 222). Lucy later became friends with well-known psychiatrist Gaston Ferdière, to whom she wrote much about her wartime experience as well as her troubled early life. In late nineteenth century, many French comic actors drew on well-publicized theories of mental illness. Inspired by the hysterical patients whom the famous psychologist Jean-Marie Charcot put on display in his weekly audiences at the Salpetrière Hospital, actors and humorists used the exaggerated gestures and grimaces of the "insane" to create a sense of comic craziness. Performers also employed notions of hypnotism and sleepwalking as part of their method. These techniques supposedly dramatized the workings of the unconscious mind, which existed within all humans and were ultimately in control. Madness, in other words, became entertainment; the asylum, a site of comedy (Rae Beth Gordon, *Why the French Love Jerry Lewis: From Cabaret to Early Cinema* [Stanford, CA: Stanford University Press, 2001]). Some of Cahun's theater roles emphasized this sort of approach. In early 1929, Cahun and Moore began working with Pierre Albert-Birot's modernist theater company called Le Plateau. Albert-Birot advocated an acting style that emphasized artificiality and masquerade, and he turned his actors into stiff, robotic, slow-motion marionettes with exaggerated movements and monotonous speech. In one production, Cahun, her face painted white and her eyes staring blankly at the audience, appeared as a sexually dead woman rejecting her husband's advances.

30 **black humor, provocation** Leperlier, *Claude Cahun: Écrits*, 710. *Aveux non avenus* was a very expensive art book available in a limited, numbered edition of five hundred, including a few that were printed on very expensive paper for three hundred francs each—not something most readers in a France beginning to feel the effects of the Great Depression could afford. The volume had artistic typography with decorative elements such as hearts, lips, eyes, and stars dividing sections of text. With a preface by well-known author Pierre Mac Orlan obtained through mutual friends, the publisher Pierre Levy launched a publicity push in two issues of *Bifur*, the journal he had created. Cahun and Moore's friend José Corti, who had published important works by surrealist authors, lent the display window of his Right Bank bookstore for the launch. On *Aveux non avenus* as performance, see

Gayle Zachmann, "Claude Cahun and the Politics of Culture," *Contemporary French Civilization* 35 (2011): 27.

30 **When Lucy and Suzanne** Laurie J. Monahan, "Claude Cahun," in *Dictionary of Women Artists*, ed. Delia Gaze (London: Fitzroy Dearborn, 1997), 340.

31 **If you love** See copies of this flyer at the website of the Museum Boijmans Van Beuningen, https://www.boijmans.nl/en/exhibitions/collection-surrealism and further discussion at "How to Make a Modern Art Library: Selections from the Éluard-Dausse Collection," MoMA.org, accessed November 23, 2019, https://www.moma.org/interactives/exhibitions/2009/modernlibrary/. See Leperlier, *Claude Cahun: L'exotisme*, 393, on the influence of the *"papillon surréaliste"* on Cahun and Moore. On the idea of the surrealist butterfly, see Jonathan P. Eburne, "Locked Room, Bloody Chamber," in *Surrealism: Crossings/Frontiers*, ed. Elza Adamowicz (Oxford: Peter Lang, 2006), 149. The communists in France used the same term for the small anti-Nazi stickers and leaflets they hung up around Paris during the war. See Alejandro Rossi, *La guerre des papillons: Quatre ans de politique communiste (1940–1944)*(Paris: Îles d'Or, 1954). See also Margaret Collins Weitz, *Sisters in the Resistance: How Women Fought to Free France*, 1940–1945 (New York: John Wiley, 1995), 70, for a discussion of butterflies during the war.

31 **You are well** Cahun, *Disavowals*, 213; Leperlier, *Claude Cahun: L'exotisme*, 261. Claude Cahun is often referred to as a surrealist, but she had finished most of the manuscript for *Aveux non avenus* by 1925, the year after André Breton had written his *Manifeste du surrealism* (http://www.ubu.com/papers/breton_surrealism_manifesto.html).

31 **Association of Revolutionary** For more information on the AEAR, see Nicole Racine, "L'Association des Écrivains et Artistes Révolutionnaires (A.E.A.R.): La revue 'Commune' et la lutte idéologique contre le fascisme (1932–1936), *Le mouvement sociale* 54 (January–March 1966): 29–47. The AEAR itself was torn apart by heated ideological struggles between different factions as intellectuals tried to decide the best way to pursue the fight against fascism and Nazism. Ultimately, most of the surrealists under Breton's leadership broke with the French Communist Party while Louis Aragon, himself one of the key surrealist originators, sided with the official communist line. Cahun and Moore aligned themselves with the more radical Trotskyite position of continuing revolution in art led by André Breton. On their relationship to communism, see also Michael Löwy, *Morning Star: Surrealism, Marxism, Anarchism, Situationism, Utopia* (Austin: University of Texas Press, 2009).

31 **I want to scandalise** Cahun, *Disavowals*, 163.

32 **Vera was a few** Information about Vera Tanner Wimshurst is drawn from Cahun's descriptions (Leperlier, Claude Cahun: *Écrits*, 670) as well as from sources in the Jersey Archive: her German Occupation Registration Card (D/S/A/4/A12669), Blue Registration Form (D/S/A/4/B12669), her mother's Occupation Registration Card (D/S/A/4/A12668) and Blue Registration Form (D/S/A/4/

B12668), her mother's will (D/Y/A/118/52), Vera's own will (D/Y/B1/327/17), the marriage register for the St. Mary and St. Peter Church (H/B/A2/3), confirmation records for St. Mary and St. Peter Church (H/B/A4/3) and the UK probate calendar for 1947.

32 **The shy Lucy** In one of her writings after the war, Lucy wrote of Vera: "It's brutal—but true—to say that my relationship with Vera was the same as I would have with a dog," she recalled. "I don't like dogs" (Leperlier, 670). Lucy's views about Vera changed significantly during the war, although she always found Vera annoying for reasons that she never articulated.

34 **Several public scandals** On changes to gay life in Paris, see Julian Jackson, *Living in Arcadia: Homosexuality, Politics, and Morality in France from the Liberation to AIDS* (Chicago: University of Chicago Press, 2009), 35–36.

35 **Lucy finally broached the subject** Leperlier, *Claude Cahun: L'exotisme*, 378.

CHAPTER 3

36 **You're emigrating?** Quoted in François Leperlier, *Claude Cahun: L'exotisme intérieur* (Paris: Fayard, 2006), 379. The entire exchange with Breton and the surrealists is recounted here. On Jersey as a tax haven in the early twentieth century, see articles in the *Times* (London) from 1926 to 1927, when the issue was addressed as a constitutional question concerning the relationship between the United Kingdom and the Channel Islands, especially with regard to whether the British government could tax its citizens living on the islands or those who had established companies there in order to avoid paying taxes. See also Assaf Likhovski, "Tax Law and Public Opinion: Explaining IRC v. Duke of Westminster," in *Studies in the History of Tax Law*, vol. 2, ed. John Tiley (London: Hart/Bloomsbury, 2006): 183–222. Likhovski notes that the British government tried to tighten the reins in 1927 but that "the islanders proved very stubborn" and was only able to strike a compromise wherein island governments would inform the United Kingdom's Inland Revenue about "residents and companies who might be liable to mainland taxation" but would go no further (206–7).

38 **the farm with** François Leperlier, *Claude Cahun: Écrits* (Paris: Jean-Michel, 2002), 588. Lucy's description of La Rocquaise (Leperlier, 666) is also very useful for getting a feel for the place, but so are the many photographs they took, which are in the Jersey Archive. Architectural plans for the house, dated 1957, are in the Jersey Archive, L/A/06/A/53.

39 **We don't want** "Diary Written by Claude Cahun about Her Time in Prison in Jersey Having Been Imprisoned and Sentenced to Death for Inciting the German Soldiers to Rebellion," Jersey Archive, JHT/1995/00045/1 (see pages numbered 64 and 65). These loose-leaf pages (whose pagination does not start with 1) replicate some of the material published in Leperlier but not entirely. Likewise, there is additional material here not published in that volume. Some of the text here is similar to text published or in archival material elsewhere but slightly different.

In other words, this is one of the many versions of the many retellings that Lucy created in the years after the war.

40 **Edna Langtry** In addition to Lucy and Suzanne's descriptions of Edna throughout their writings, see her Occupation Registration Card and Blue Registration Form, Jersey Archive, D/S/A/1/A961 and D/S/A/1/B961.

41 **They were nature** Quoted in Kristine von Oehsen, "'Claude Cahun'— Published/Unpublished: The Textual Identities of Lucy Schwob—1914–1944," PhD diss., University of East Anglia, 2003, 158. Mr. Bob Le Sueur, MBE, indicated in a personal correspondence that he also recalled Lucy and Suzanne largely keeping to themselves.

41 **the practical down-to-earth** Dr. Lewis's descriptions of both Lucy and Suzanne appear in Dr. John Lewis, *A Doctor's Occupation* (St. Helier, Jersey: Starlight, 1982), 200–204. Lewis's account has several factual errors about Lucy and Suzanne, such as stating that their maid's name was Hilda rather than Edna.

42 **It seemed that** Leperlier, *Claude Cahun: Écrits*, 666.

42 **Lucy and Suzanne ventured** Jersey Archive, JHT/1995/00032/p. Lucy and Suzanne almost always used natural light since they did not appear to have lighting equipment. See James Stevenson, "Claude Cahun: An Analysis of Her Photographic Technique," in *Don't Kiss Me: The Art of Claude Cahun and Marcel Moore* (London: Aperture/Tate, 2006), 48–50.

43 **Judeophobia** On this term, see "AHR Roundtable: Rethinking Anti-Semitism," *American Historical Review* 123 (October 2018): 1122–38, in particular the introduction by Jonathan Judaken.

44 **her hometown of Nantes** For a discussion of Nantes during the Dreyfus affair and of Maurice Schwob as the target of anti-Semitic rhetoric, see Pierre Birnbaum, *The Anti-Semitic Moment: A Tour of France in 1898*, trans. Jane Marie Todd (Chicago: University of Chicago Press, 2011). On the Schwob family's politics and Republicanism, see Patrice Allain, "La famille Schwob: Des lettres de la République à la république des lettres," *Europe* 84 (May 2006): 32–49. On the impact of the Dreyfus affair on Cahun, see also Gayle Zachmann, "Claude Cahun and the Politics of Culture," *Contemporary French Civilization* 35 (2011): 19–36.

45 **think about her** Lucy described her mother's cruelty in a letter to a friend (quoted in Leperlier, *Claude Cahun: L'exotisme*, 24; see also Leperlier, *Claude Cahun: Écrits*, 618–19). On the "Jewish nose," see Sander Gilman's "The Jewish Nose," in his *The Jew's Body* (New York: Routledge, 1991), 169–93. Gilman notes a connection between the stereotype of the Jewish nose and male sexuality. See also Michelle Sara Gewurtz, "Three Women/Three Margins: Political Engagement and the Art of Claude Cahun, Jeanne Mammen, and Paraskeva Clark," PhD diss., University of Leeds, 2010; and Angela Woodlee, "Evidence of Jewish Identity in the Photographic Works of Claude Cahun," MA thesis, University of Georgia, 2012.

46 **She also taught** On Lucy's connection to her Jewish heritage, see Gewurtz "Three Women." In addition to outlining Lucy's Jewish family connections,

Gewurtz makes a very compelling case that Cahun's "disavowals" are rooted in the Jewish Kol Nidre declaration. Recited before Yom Kippur, congregants nullify any personal vows in preparation for the Day of Atonement. Although the six-pointed star was not always associated with Jewishness as a Star of David, Cahun likely used the association self-consciously in this photograph as another way to emphasize her Jewish identity. The effect of the light bounding her head is reminiscent of the bell jars under which scientists would place specimens for study. At a time in the early twentieth century when many scholars believed that race was a biological category that could be measured in the human body and that Jewishness had a physiological component, Cahun displays herself as a specimen of the "Jewish race," claiming that identity at a moment when to do so was dangerous.

46 **a child of** Quoted in Leperlier, *Claude Cahun: L'exotisme*, 52.

47 **the name of** Leperlier, *Claude Cahun: Écrits*, 711.

47 **incontestably "*youtre*"** Leperlier, 593. On her decision about naming, see also 704 and 711. In *Disavowals*, she quips: "I, Jewish to the point of using my sins for my salvation" (Claude Cahun, *Disavowals* [Cambridge, MA: MIT Press, 2008], 26). In two photographs from 1928 with her head shaved, Lucy sits cross-legged looking at the window. Her face is illuminated with other parts in shadow, and an oversized black corduroy shirt or jacket masks the shape of her body. The profile once again highlights the "Jewish nose." These shots mimicked a portrait of her father in which he struck the same pose with the same lighting.

47 **I sensed the war** Leperlier, 668.

47 **In 1939, along** "A bas les lettres de cachet! A bas la Terreur grise!" reprinted in *Tracts Surréalistes et declarations collectives, 1922–1939*, vol. 1, ed. Eric Losfeld (Paris: Le Terrain Vague, 1980), 352–54.

48 **I suspected** Leperlier, *Claude Cahun: Écrits*, 696. Information about the Armstrongs also comes from their Occupation Registration Cards (Jersey Archive, D/S/A/1/A44 and D/S/A/1/A43) and their Blue Registration Forms (Jersey Archive, D/S/A/1/B44 and D/S/A/1/B43).

CHAPTER 4

51 **Germany has invaded** "News—Invasion of Poland," BBC Archive, originally broadcast September 1, 1939, https://www.bbc.co.uk/archive/news -invasion-of-poland/zmd68xs.

51 **somewhat remote** Madeline Bunting, *The Model Occupation: The Channel Islands under German Rule, 1940–1945* (London: HarperCollins, 1995), 15. My discussion of the German takeover of Jersey relies on Bunting's account as well as that of Michael Ginns, who provides great detail about military affairs in his book *Jersey Occupied: The German Armed Forces in Jersey 1940–1945* (n.p.: Channel Island Publishing, 2009).

52 **watched the most** François Leperlier, *Claude Cahun: Écrits* (Paris: Jean-Michel Place, 2002), 668.

53 **Just try to** Quoted in Bunting, *Model Occupation*, 16.

53 **Jerseymen would do** Quoted in Bunting, 16.

53 **Do you think** Leperlier, *Claude Cahun: Écrits*, 680.

54 **Whatever happens** Quoted in Robert Gildea, *Fighters in the Shadows: A New History of the French Resistance* (Cambridge, MA: Harvard University Press, 2015), 23.

54 **minor acts** Imperial War Museum, interview with Tony Faramus, MISC 2826 189/1. For more information on Faraums, see "'Anthony' Charles Chevalier Faramus," Frank Falla Archive, accessed November 23, 2019, https://www.frank fallaarchive.org/people/anthony-charles-faramus/.

55 **Lucy read more** Leperlier, *Claude Cahun: Écrits*, 669.

55 **You can't do anything** Leperlier, 669.

55 **a "tidal wave"** Quoted in François Leperlier, *Claude Cahun: L'exotisme intérieur* (Paris: Fayard, 2006), 384.

55 **repugnant now** Quoted in Bunting, *Model Occupation*, 19.

56 **For strategic reasons** Quoted in Bunting, 19–20.

57 **There was no** Quoted in Bunting, 12.

57 **instant nervous tension** Leperlier, *Claude Cahun: Écrits*, 673.

58 **Another Dornier Do 17 P** See Ginns, *Jersey Occupied*, 17–19.

58 **They were singing** Imperial War Museum, interview with Joe Berry, MISC 2826 189/1. Joe Berry eventually became deputy chief of police on Jersey. See Jersey Archive, p/03/131/08.

59 **Now the paper** Ginns, *Jersey Occupied*, 42.

59 **a portly, middle-aged** Ginns, 42–43.

60 **Among the crowd** Leperlier, *Claude Cahun: Écrits*, 675. Bob and another man would be arrested by the Germans for illegally chopping down a tree in December 1944, likely because of the wood shortage, and fined £1, 10s. See Jersey Archive, B/A/W50/187.

61 **I was shaking** Leperlier, *Claude Cahun: Écrits*, 675.

61 **the islanders called** Quoted in Leperlier, *Claude Cahun: L'exotisme*, 386.

62 **With this strategy** Bunting, *Model Occupation*, 94.

62 **a country where** Imperial War Museum, interview with Werner Grosskopf, MISC 2826 189/1. Grosskopf had served as a soldier on Jersey during the war and fell in love with the island. See Jersey Archive, L/C/152/135 and L/F/353/A/3.

62 **were enchanted by** Bunting, *Model Occupation*, 41.

63 **velvet glove** Paul Sanders, *The Ultimate Sacrifice: The Jersey Twenty and Their "Offences against the Occupying Authorities," 1940–1945* (n.p.: Jersey Museums Service, 1998), 45.

63 **respect the population** *Jersey Evening Post*, July 2, 1940. See Jersey Archive, B/A/W91/9; and William Brown Ledger, https://www.cios.org.je/assets/downloads/scans/william-brown-ledger-web.pdf.

64 **One informant told** Military Intelligence Reports (MI-19), UK National Archives, WO199 2091A.

64 **Hundreds of individuals** On activities to resist the occupation, see Gilly Carr, Paul Sanders, and Louise Willmot, *Protest, Defiance, and Resistance in the Channel Islands: German Occupation, 1940–1945* (London: Bloomsbury, 2014); Paul Sanders, *The British Channel Islands under German Occupation, 1940–1945* (St. Helier, Jersey: Société Jersiaise, 2005); Sanders, *Ultimate Sacrifice*; Joe Mière, *Never to Be Forgotten* (n.p.: Channel Island Publishing, 2004); and the interviews with many Jerseymen and Jerseywomen at the Imperial War Museum, MISC 2826 189/1.

64 **approximately four thousand** Sanders, *British Channel Islands*, 104. Sanders is drawing on research conducted by Joe Mière found in the Jersey Archive, L/C/24/A/5.

CHAPTER 5

65 **Suzanne captured** Jersey Archive, JHT/1995/00044/e.

66 **Although Nazis were** William J. Spurlin, *Lost Intimacies: Rethinking Homosexuality under National Socialism* (New York: Peter Lang, 2009); Claudia Schoppmann, *Days of Masquerade: Life Stories of Lesbians During the Third Reich* (New York: Columbia University Press, 1996); and Erica Fischer, *Aimee and Jaguar*, trans. Edna McCown (Los Angeles: Alyson Books, 1994).

67 **implementation of the Reich's** On treatment of Jews on Jersey, see Bunting, *The Model Occupation: The Channel Islands under German Rule, 1940–1945* (London: HarperCollins, 1995), 105ff; and Sanders, *The British Channel Islands under German Occupation* (St. Helier, Jersey: Société Jersiaise, 2005), 135ff.

68 **You're free, idiot** François Leperlier, *Claude Cahun: Écrits* (Paris: Fayard), 614–15.

68 **We saw** Leperlier, 714.

69 **You can't go** Leperlier, 615.

69 **A poster displayed** Leperlier, 678.

69 **She often fantasized** Leperlier, 388.

69 **politics and the danger** "Politique et danger de guerre," *Le crapouillot*, January 1931, 99. See Lucy's description in Leperlier, 679.

70 **as though it were** Quoted in François Leperlier, *Claude Cahun: L'exotisme*, 389; Leperlier, *Claude Cahun: Écrits*, 679. In other writings, Lucy remembers this differently, attributing the phrase to a version of a Hitler slogan.

70 **This is ridiculous** Leperlier, *Claude Cahun: Écrits*, 680.

71 **The soldiers in the photo** Leperlier, 681.

72 **This little adventure** Leperlier, 681.

72 **The work was long** Leperlier, 682.

72 **The GFP was** On the GFP, see Paul B. Brown, "The Senior Leadership Cadre of the Geheime Feldpolizei, 1939–1945," *Holocaust and Genocide Studies* 17 (Fall 2003): 278–304.

74 **The military court** Ben Macintyre, *Agent Zigzag: A True Story of Nazi Espionage, Love, and Betrayal* (New York: Three Rivers, 2007), 23–24.

74 **Bode was short** Descriptions of Bode come from Lucy and Suzanne's writings as well as a photograph of him found at UK National Archives, WO 208/4643. This photograph is reproduced in Joe Mière, *Never to Be Forgotten* (n.p.: Channel Island Publishing, 2004), 198. See also Michael Ginns, *Jersey Occupied: The German Armed Forces in Jersey 1940–1945* (n.p.: Channel Island Publishing, 2009), 51; and Michael Ginns, "Wolff of the Gestapo," *Channel Islands Occupation Review* 31 (2003): 112–25.

74 **our worthy** Hans Max von und zu Aufsess, *The Von Aufsess Occupation Diary*, trans. Kathleen J. Nowlan (Chichester, UK: Phillimore, 1985), 61, 100.

75 **Young Edna** Leperlier, *Claude Cahun: Écrits*, 682, 700–701.

76 **And Edna always seemed** Yale University, Beinecke Library, Claude Cahun and Suzanne Malherbe Papers, GEN MSS 721, box 1, folder 13. The issue of Edna's drinking comes up regularly in Lucy's and Suzanne's writings, although there is no additional evidence to support or contextualize the claim.

76 **Edna married** Information about George can be found on his Occupation Registration Card and Blue Registration Form, Jersey Archive, D/S/A/1/A963A and D/S/A/1/B963A.

76 **George wasn't the only** Leperlier, *Claude Cahun: Écrits*, 633–34.

77 **Never in the field** Winston Churchill, speech to the House of Commons, HC Deb, August 20, 1940, vol. 364, cc1132-274, https://api.parliament.uk/historic-hansard/commons/1940/aug/20/war-situation#S5CV0364P0_19400820_HOC_284.

77 **Frenchwomen, by gearing** See Hanna Diamond, *Women and the Second World War in France, 1939–48: Choices and Constraints* (Harlow, UK: Longman, 1999); Paula Schwartz, "Redefining Resistance: Women's Activism in Wartime France," in *Behind the Lines: Gender and the Two World Wars*, ed. Margaret Randolph Higonnet, Jane Jenson, Sonya Michel, and Margaret Collins Weitz (New Haven, CT: Yale University Press, 1987), 141–53; Margaret L. Rossiter, *Women in the Resistance* (New York: Praeger, 1986); Julian Jackson, *France: The Dark Years, 1940–1944* (New York: Oxford University Press, 2001); Anne Sebba, *Les Parisiennes: How the Women of Paris Lived, Loved, and Died under Nazi Occupation* (New York: St. Martin's Press, 2016); Lucie Aubric, *Outwitting the Gestapo*, trans. Konrad Bieber and Betsy Wing (Lincoln: University of Nebraska Press, 1993); Caroline Moorehead, *Village of Secrets: Defying the Nazis in Vichy France* (New York: HarperCollins, 2014); Lynne Olson, *Madame Fourcade's Secret War: The Daring Young Woman Who Led France's Largest Spy Network against Hitler* (New York: Random House, 2019); Robert Gildea, *Fighters in the Shadows: A New History of the French Resistance* (Cambridge, MA: Harvard University Press, 2015); and Margaret Collins Weitz, *Sisters in the Resistance: How Women Fought to Free France, 1940–1945* (New York: John Wiley, 1995).

78 **What are you** Leperlier, *Claude Cahun: Écrits*, 683.

CHAPTER 6

79 **subtle and precise** François Leperlier, Claude Cahun: Écrits (Paris: Jean-Michel Place, 2002), 627.

80 **convince the soldiers** Leperlier, 580.

80 **Each note appeared** Leperlier, 628; "Diary Written by Claude Cahun about Her Time in Prison in Jersey Having Been Imprisoned and Sentenced to Death for Inciting the German Soldiers to Rebellion," Jersey Archive, JHT/1995/00045/1 (pages numbered 51–52); François Leperlier, Claude Cahun: L'exotisme intérieur (Paris: Fayard, 2006), 390.

81 **I wanted to achieve** Leperlier, 628.

81 **typographical montages** Leperlier, Claude Cahun: L'exotisme, 390; Leperlier, Claude Cahun: Écrits, 627. Yale University, Beinecke Library, Claude Cahun and Suzanne Malherbe Papers, GEN MSS 721, box 1, folder 8, contains examples of these typographical montages.

81 **I did not write** Leperlier, Claude Cahun: L'exotisme, 396.

82 **their "news service"** "Sentenced to Death by Island Nazis: The Story of Two Gallant French Women," Jersey Evening Post, July 14, 1945.

84 **a deeply ingrained** "The Unspeakable Atrocity," BBC Radio 4, originally broadcast August 26, 1993.

84 **What is the point** Quoted in Stephen Ward, "Why the BBC Ignored the Holocaust," Independent, August 22, 1993, https://www.independent.co.uk /news/uk/why-the-bbc-ignored-the-holocaust-anti-semitism-in-the-top-ranks -of-broadcasting-and-foreign-office-1462664.html.

84 **Their doctor remembered** Dr. John Lewis, A Doctor's Occupation (St. Helier, Jersey: Starlight, 1982), 201–2.

85 **If necessary, we** Leperlier, Claude Cahun: Écrits, 671–72.

CHAPTER 7

87 **a deep-seated tension** See George Mosse, The Image of Man: The Creation of Modern Masculinity (New York: Oxford University Press, 1996); and Joan W. Scott, "Women and War: A Focus for Rewriting History," Women's Studies Quarterly 12 (Summer 1984): 2–6.

88 **a white full bodysuit** These photographs appear in Louise Downie, ed., Don't Kiss Me: The Art of Claude Cahun and Marcel Moore (London: Aperture/ Tate, 2006), 115–17. See Jersey Archive, JHT/1995/00030/j. The phrase "Totor et Popol," a reference to the heroes of the comic strip The Adventures of Totor that was serialized in the Belgian Boy Scout magazine, is written on one of the weights along with some additional text, hearts, and a painting of a house. The other weight appears to bear the names Castor and Pollux, the twin brothers from ancient Greek mythology, along with decorations and a painting whose subject cannot be determined. Cahun's slicked-back hair recalled the style made famous in France by Josephine Baker in her 1925 debut at the Théâtre des Champs-Elysées production

of *La Revue Nègre*, which included a little curl on the forehead similar to the ones that Cahun now wore on hers. In photographs from this period, Baker often had two curls on her forehead, and she was sometimes asked whether she was a boy or a girl. Baker even marketed a hair pomade called Bakerfix, which allowed women to achieve the sleek, modern, boyish look. Referring to her hair, Josephine Baker noted that she first got her hair cut short in New York when she switched from the women's dressing room to the men's because she was not getting along with the women in the show. The gay men in the cast showed her their women's clothes and also cut her hair short. To deal with its new length, she used hair straightener: "The only thing I could do was just plaster it down. I looked like a boy, but I loved it. It was just like patent leather, it was so black and shiny, and that night when I went on in the show, I caused even more of a sensation. They even wrote about it in the papers the next day." A critic in *Variety* mentioned her "regulation boy's haircut." "When I walked out of the theatre, they didn't know if I was a boy or a girl. Then, when I got to Paris, that's what caught their attention first; it was my hair. They even said, when they first saw me, 'Are you a girl, or are you a boy?' I never would answer them. I would just laugh." Later, after a few performances in Paris, she recalled Yvette Guilbert saying to her: "Are you a boy? Are you a girl? No matter. . . . Here, take my crown, and take my stage, you beautiful black queen of the music hall . . . and long may you reign upon it!" Quoted in Steven Papich, *Remembering Josephine* (Indianapolis: Bobbs-Merrill, 1976), 46–47, 59. One of her costumes in *La Revue Nègre* was "a shredded shirt and ragged shorts." Baker would also perform in men's clothes, often in a tuxedo. See Catherine Smith and Cynthia Greig, *Women in Pants: Manly Maidens, Cowgirls, and Other Renegades* (New York: Harry N. Abrams, 2003).

88 **By dressing Cahun** The "strongman" was a familiar and powerful symbol in turn-of-the-century popular culture. Made famous by the music hall and the circus, weight lifters' superhuman shows of strength emphasized the manly idea of mastery, an important part of national identity for a colonial power like France but one that had been called into doubt after its stunning defeat in the Franco-Prussian War in 1870. Around the turn of the century, famous French strongman Pierre Gasnier performed with the Barnum and Bailey Circus in the United States and claimed to be the strongest man in the world despite his short stature and light bodyweight. Gasner lifted a special barbell over his head with one hand. Alongside the strongman was the strongwoman, a phenomenon with a long history but that didn't gain notoriety until the late nineteenth century. Weight-lifting and muscle-flexing women were on the same popular entertainment circuit and, like the strongman, their presence involved a freakish display of mastery. But for them, it was also a gender-based spectacle. Performing the same kinds of feats a strongman did, muscular women crossed gender lines by trying to look feminine at the same time. A Belgian strongwoman named Athléta toured around Europe in the early twentieth century lifting barbells—and occasionally men—into the air to the delight and

amazement of audiences. She trained her three daughters to be strongwomen as well. The image of Cahun's thin, nonmuscular figure—even antimuscular, since it is covered by a bodysuit—exerting the same power as Athléta's clearly muscular body was deeply ironic. She performed the idea of strength without actually possessing strong muscles and, in the process, emasculated the barbell as the symbol of the strongman, both by turning it into a woman's accessory and by revealing the barbell as a mere prop. Instead, in the photo Cahun's strength comes from her feminine qualities, the hearts, the hairstyle, the lips. She makes a deeply satirical comment on the notions of manliness and effeminacy and where true "strength" lies. See David L. Chapman and Patricia Vertinsky, *Venus with Biceps: A Pictorial History of Muscular Women* (Vancouver, BC: Arsenal Press, 2010). On the importance of physical strength in France, see Joan Tumblety, *Remaking the Male Body: Masculinity and the Uses of Physical Culture in Interwar and Vichy France* (Oxford: Oxford University Press, 2012).

89 **They produced their** Robert Gildea notes that Guillaume Apollinaire had reworked the Lorelei poem in 1904, inspiring one female French resister to take the name as her nom de guerre as a way of seeking a kind of revenge on the Germans. See Robert Gildea, *Fighters in the Shadows: A New History of the French Resistance* (Cambridge, MA: Harvard University Press, 2015), 156.

91 **Les paris sont** Claude Cahun, *Les Paris sont ouverts* (Paris: José Corti, 1934).

92 **conclusions that** Quoted in Michael Löwy, *Morning Star: Surrealism, Marxism, Anarchism, Situationism, Utopia* (Austin: University of Texas Press, 2009), 73. The surrealists split from the French Communist Party, attacking official strategy as a set of tactics for which the working class would pay the price in a coming war. By the spring of 1936, such a war was close to becoming reality in Europe as the political factions in Spain lined up against one another, with the military, royalists, conservative Catholics, and Spain's home-grown fascist organization (the Falange) opposed to the democratically elected Republican government. Cahun wrote a statement, "The Order of the Day: War," for the group Contre-Attaque (founded by Breton and Bataille), to which she and Moore belonged after they left the AEAR. It encouraged an all-out effort to prevent what many people felt was an inevitable war, not just in Spain but throughout Europe. "Let's exalt defeatism, violently opposing the slogans of an aggressive pacifism on behalf of crusades to defend democratic colonialism and a remilitarized USSR," Cahun wrote (François Leperlier, *Claude Cahun: Écrits* [Paris: Jean-Michel Place, 2002], 564–65). Only then could the real focus on revolution be maintained to create "a complete moral freedom, a general consciousness of an uncleansed reality for the sake of people and innocence." The alternative was a false patriotism, the result of which would be that people "sooner or later would become puppets of imperialism," whether that was from capitalism or from the official Communist Party line (Leperlier, 563). The victims, many of the surrealists believed, were the men being drafted into the army, regardless of which side they were on, because these men were

the ones who would give their lives for someone else's ideology rather than for their own best interests.

92 **one can only hear** Typescript of newspaper article titled "Anchored Fortresses In Front of the Atlantic Wall" at Imperial War Museum, MISC 183, Item 2763.

93 **From their shopping** François Leperlier, *Claude Cahun: L'exotisme intérieur* (Paris: Fayard, 2006), 393.

CHAPTER 8

94 **people on the island** Madeline Bunting, *The Model Occupation: The Channel Islands under German Rule, 1940–1945* (London: HarperCollins, 1995), 212–13. See, for example, Imperial War Museum, interview with Stella Perkins, MISC 2826 189/1. For parallel activities on Guernsey, see L. E. Bertrand, ed., *A Record of the Work of the "Guernsey Secret Active Press,"* Imperial War Museum, MISC 183, item 2763.

94 **Jewish groups maintained** Michael R. Marrus, "Jewish Resistance to the Holocaust," *Journal of Contemporary History* 30 (1995): 96–97; and Vesna Drapac and Gareth Pritchard, *Resistance and Collaboration in Hitler's Empire* (London: Red Globe Press, 2017), 20.

94 **In occupied France** See Caroline Moorehead, *A Train in Winter: An Extraordinary Story of Women, Friendship, and Resistance in Occupied France* (New York: HarperCollins, 2011); Alan Riding, *And the Show Went On: Cultural Life in Nazi-Occupied Paris* (New York: Alfred A. Knopf, 2010); Robert Gildea, *Fighters in the Shadows: A New History of the French Resistance* (Cambridge, MA: Harvard University Press, 2015); Margaret L. Rossiter, *Women in the Resistance* (New York: Praeger, 1986); and Margaret Collins Weitz, *Sisters in the Resistance: How Women Fought to Free France, 1940–1945* (New York: John Wiley, 1995).

95 **In 1942** Drapac and Pritchard, *Resistance and Collaboration*, 93.

95 **In 1942–43** On the White Rose, see Michael H. Kater, *Hitler Youth* (Cambridge, MA: Harvard University Press, 2004).

95 **For nearly three** On the Hampels, see Hans Fallada's novel, *Every Man Dies Alone*, trans. Michael Hofmann (New York: Melville House, 2009; originally published 1947).

96 **According to sociologist** Jacques Semelin, *Unarmed against Hitler: Civilian Resistance in Europe, 1939–1943*, trans. Suzan Husserl-Kapit (Westport, CT: Praeger, 1993).

96 **All over Europe** BBC Broadcast, July 31, 1941. For recordings, see "Douglas Ritchie," Discogs, accessed November 23, 2019, https://www.discogs.com/artist/496682-Douglas-Ritchie. There was an active V for Victory campaign on the Channel Islands. See Gilly Carr, Paul Sanders, and Louise Willmot, *Protest, Defiance, and Resistance in the Channel Islands: German Occupation, 1940–1945* (London: Bloomsbury, 2014), 43–59; Bunting, *Model Occupation*, 203–4; and

"Colonel Britton and the 'V-for-Victory' Campaign," *Army Talks* 4 (September 16, 1945), accessed November 23, 2019, http://www.psywar.org/v_for_victory.php.

97 **Deciding on** François Leperlier, *Claude Cahun: Écrits* (Paris: Jean-Michel Place, 2002), 693.

98 **After World War I** George Mosse, *Fallen Soldiers: Reshaping the Memory of the World Wars* (New York: Oxford University Press, 1990). For the Nazis, the idea was especially important since their ideology glorified war, and the men who fell defending the Fatherland and the race took on a sacred character.

98 **I wanted not** Leperlier, *Claude Cahun: Écrits*, 693.

98 **to pass into** Quoted in François Leperlier, *Claude Cahun: L'exotisme intérieur* (Paris: Fayard, 2006), 395.

98 **To enter into** Gildea, *Fighters in the Shadows*, 157.

98 **Historian Paula Schwartz** Paula Schwartz, "Partisanes and Gender Politics in Vichy France," *French Historical Studies* 16 (Spring 1989): 126–51. See also Julian Jackson, *France: The Dark Years, 1940–1944* (New York: Oxford University Press, 2001), 490–94.

99 **black butterflies** Leperlier, *Claude Cahun: Écrits*, 623.

99 **Although same-sex** See Christine Bard, "Le 'DB58' aux Archives de la Préfecture de Police," Clio: Histoire, femmes, et sociétés 10 (1999): 155–67. See also Nicole G. Albert, *Lesbian Decadence: Representations in Art and Literature of Fin-de-Siècle France* (New York: Harrington Park Press, 2016), 152–53. On Sarah Bernhardt, see Mary Louise Roberts, *Disruptive Acts: The New Woman in Fin-de-Siècle France* (Chicago: University of Chicago Press, 2002). On other spaces of cross-dressing such as the Magic-City ball, see David Higgs, ed., *Queer Sites: Gay Urban Histories since 1600* (London: Routledge, 1999) and Julian Jackson, *Living in Arcadia: Homosexuality, Politics, and Morality in France from the Liberation to AIDS* (Chicago: University of Chicago Press, 2009), 32. On the power and freedom of women cross-dressing, see Susan Gubar, "Blessings in Disguise: Cross-Dressing as Re-Dressing for Female Modernists," *Massachusetts Review* 22 (Autumn 1981): 477–508; and Wanda M. Corn and Tirza True Latimer, *Seeing Gertrude Stein: Five Stories* (Berkeley: University of California Press, 2011).

100 **Marcel Duchamp** In 1921, Man Ray photographed Duchamp in drag as his alter ego, Rrose Sélavy, a phonetic pun in French, which is pronounced as "Eros, c'est la vie" (Eros is life) but can also be rendered phonetically as "arroser la vie," the verb *arroser* being slang for urination or ejaculation. On Duchamp, including "arroser la vie," see Paul B. Franklin, "Object Choice: Marcel Duchamp's Fountain and the Art of Queer Art History," *Oxford Art Journal* 23 (2000): 23–50. See also Giovanna Zapperi, "Marcel Duchamp's Tonsure: Towards an Alternate Masculinity," *Oxford Art Journal* 30 (2007): 289–303.

100 **Instinctively I looked** Claude Cahun, *Disavowals* (Cambridge, MA: MIT Press, 2008), 7. Elsewhere on that page, she offers a humorous exchange: "I'm going to buy some socks. —Do you really wear socks? —No (what are they

called?) . . . stockings. It's just a way of speaking really." The last sentence is her punch line, as though "socks" and "stockings" are interchangeable and have no gendered associations. Likewise, the person purchasing socks (likely Cahun herself) seems to have "forgotten" the proper name for stockings, suggesting that she has so thoroughly associated them with the masculine "socks" that she cannot switch back to the feminine equivalent without some effort. In doing so, she points out that the gender difference doesn't really matter because it's artificial—only the name is different.

100 **fashion statements** Elizabeth Carlson, "Cubist Fashion: Mainstreaming Modernism after the Armory," *Winterthur Portforlio* 48 (Spring 2014): 1–28, https://www.jstor.org/stable/10.1086/675687.

100 **fully asserted** Leperlier, *Claude Cahun: L'exotisme*, 90, n3. Pastoureau's use of Suzanne's name (rather than calling her Marcel Moore) indicates once again that their names were fluid.

100 **In what has** Much has been written about this photograph, which appears in Louise Downie, ed., *Don't Kiss Me: The Art of Claude Cahun and Marcel Moore* (London: Aperture/Tate, 2006), and in the Jersey Archive, JHT/1995/00041/n. In some ways, the jacket looks similar to one of Moore's fashion drawings from 1915. See Louise Downie, "Marcel Moore, Her Art and Life," *Heritage Magazine* 52, https://www.jerseyheritage.org/media/PDF-Heritage-Mag/Marcel%20 Moore.pdf. Only a few scholars have made the link between this photograph and a harlequin. Lizzie Thynne mentions the harlequin connection in her essay "'Surely You Are Not Claiming to Be More Homosexual than I? Claude Cahun and Oscar Wilde," in *Oscar Wilde and Modern Culture: The Making of a Legend*, ed. Joseph Bristow (Athens: University of Ohio Press, 2008), 180–208. Abigail Solomon-Godeau also mentions it in her essay "The Equivocal 'I': Claude Cahun as Lesbian Subject," in *Inverted Odysseys: Claude Cahun, Maya Deren, Cindy Sherman*, ed. Shelley Rice (Cambridge, MA: MIT Press, 1999). For the Parisian avant-garde, the harlequin had another powerful meaning, thanks to the writer Jean Cocteau, who was also an acquaintance of Cahun and Moore's, according to their address book. In 1917, Cocteau debuted his cutting-edge ballet collaboration, Parade, with musician Erik Satie. The ballet included sets and costumes by Picasso, many of which looked like a sort of cubist harlequin. Cahun and Moore had seen the production. The next year, Cocteau published *The Cock and the Harlequin*, a manifesto about music and the need to develop a uniquely French sound freed from foreign, especially German, influences. The cock, the traditional symbol for France, needed to liberate itself from the "harlequin," the sonic patchwork in Paris that obscured what Cocteau called "the music of the everyday." The harlequin "wears a black mask and a costume of all the colors," Cocteau writes. "After denying the cock's crow, he goes away to hide"—a biblical reference to Peter's denial of Christ after the cock had crowed three times. But, citing the Larousse dictionary, Cocteau also offers up this definition of harlequin: "a dish composed of various scraps." The

word also had other colloquial meanings in French, including someone who was fickle and changeable, the scraps of meat one might feed to an animal, or a work composed by many authors. With her darkened, bronzed face, almost a kind of blackface, perhaps playing on the racial context of a slave-trading city like Nantes in which she grew up, Cahun wears the harlequin's "black mask" of foreignness to which Cocteau alludes. The gender-switching is another kind of "foreignness," a self-proclaimed outsider identity that is itself a patchwork made of many different selves and constantly under revision—masculine and feminine, Jew and Gentile. She is changeable, not able to be pinned down, disrupting the viewer's perception, constantly flipping and twisting like the acrobatic and clownish harlequin. The harlequin's coat of scraps signifies the multiple selves inside, created not just by Cahun herself but by many others too: Moore, her family (especially her father and uncle but also her grandmother), her artistic peers. According to Miranda Welby-Everard, Cahun (and, I would add, likely with Moore's participation) seems to have designed a costume for one of the theatrical productions in which she appeared as the devil, a costume that featured "glittering exterior nipples, as parody perhaps of the signs of sexual difference." The costume featured "Prince Charming breeches, luscious fabric, harlequinesque diamond-patterning and fancy court bows." See Welby-Everard, "Imaging the Actor: The Theatre of Claude Cahun," *Oxford Art Journal* 29 (March 2006): 21.

101 **C'est nous qui** Gertrude Stein, *The Autobiography of Alice B. Toklas* (New York: Vintage, 1990), 90.

101 **If they want** Roland Penrose, *Picasso: His Life and Work*, 3rd ed. (Berkeley: University of California Press, 1981), 199. Penrose appears in Lucy and Suzanne's address book. On Penrose's time painting and teaching camouflage, see Roland Penrose, *The Home Guard Manual of Camouflage* (London: G. Routledge, 1942 [1941]), https://catalog.hathitrust.org/Record/002022333; and Peter Forbes, *Dazzled and Deceived: Mimicry and Camouflage* (New Haven: Yale University Press, 2009), chap. 10. For more on the link between surrealism and camouflage, see Ann Elias, "Camouflage and Surrealism," *War, Literature, and the Arts* 24 (2012): 1–25, https://www.wlajournal.com/wlaarchive/24_1-2/Elias.pdf. Elizabeth Louise Kahn points out that the connection between cubism and camouflage is more complex than Picasso suggests. Cubism and camouflage had different objectives, and modernist art came under assault during the war; none of the camoufleurs was considered a cubist. "In short, the attraction to modernist language at the front did not follow any consistent pattern between prewar aesthetic experience and wartime art production, nor between one's military job and a serious decision to experiment with a new style." Elizabeth Louise Kahn, *The Neglected Majority: "Les Camoufleurs," Art History, and World War I* (Lanham, MD: University Press of America, 1984), 126. Thanks to Erin Harmon for bringing the comparison with camouflage to my attention.

102 **Along the side** Leperlier, *Claude Cahun: Écrits*, 629.

103 **a true overbearing** Edward Le Quesne, *The Occupation of Jersey Day by Day* (n.p.: La Haule, 1999), 124; For more on Knackfuss, see Ginns, *Jersey Occupied: The German Armed Forces in Jersey 1940–1945* (n.p.: Channel Island Publishing, 2009), 42–43.

104 **Germans were going** Leperlier, *Claude Cahun: Écrits*, 694. See also "Requisition Order for Four Stables at La Rocquaise Required by the German Forces," Jersey Archive, JHT/1995/00045/55.

105 **This is dynamite!** Yale University, Beinecke Library, Claude Cahun and Suzanne Malherbe Papers, GEN MSS 721, box 1, folder 13.

105 **Mimi the Spy** See UK National Archives, WO/199/2091A. Mrs. Baudains's name recurs in several debriefings of people who escaped from Jersey and identified her as a regular informant for the occupation forces. See also Joe Mière, *Never to Be Forgotten* (n.p.: Channel Island Publishing, 2004), 245–46.

106 **Nacht und Nebel** On the NN decree, see Paul Sanders, *The Ultimate Sacrifice: The Jersey Twenty and Their "Offences against the Occupying Authorities," 1940–1945* (n.p.: Jersey Museums Service, 1998), 34–35.

107 **Fortified areas** Directive number 40, OKW/WFST/OpNo 001031, quoted in Patrick Delaforce, *Smashing the Atlantic Wall: The Destruction of Hitler's Coastal Fortresses* (London: Pen & Sword, 2006), 21.

108 **the strongest sea** Quoted in J. E. Kaufmann and H. W. Kaufmann, *Fortress Third Reich: German Fortifications and Defense Systems in World War II* (Cambridge, MA: DaCapo, 2007), 198.

108 **bristle with iron** Typescript of newspaper article titled "Anchored Fortresses in Front of the Atlantic Wall," Imperial War Museum, MISC 183, item 2763.

108 **Quite literally** Paul Sanders, *The Ultimate Sacrifice: The Jersey Twenty and Their "Offences against the Occupying Authorities," 1940–1945* (n.p.: Jersey Museums Service, 1998), 94.

108 **On the rare** Louise Willmot, "The Goodness of Strangers: Help to Escaped Russian Slave Labourers in Occupied Jersey," *Contemporary European History* 11 (2002): 213–14. On African prisoners, see George Forty, *Channel Islands at War: A German Perspective* (Shepperton, UK: Ian Allan, 1999), 126.

109 **We were treated** UK National Archives, WO/199/2090A.

109 **She passed through** François Leperlier, *Claude Cahun: Écrits* (Paris: Jean-Michel Place, 2002), 698.

110 **We need to** Leperlier, 687.

111 **She approached slowly** Leperlier, 689.

112 **Gordon Prigent was** Imperial War Museum, interview with Gordon Prigent, MISC 2826 189/1.

113 **Knackfuss outlawed radios** On the radio ban, see Madeline Bunting, *The Model Occupation: The Channel Islands under German Rule, 1940–1945* (London: HarperCollins, 1995), 207–12; and Sanders, *Ultimate Sacrifice*, 98–105. According

to Sanders, the Channel Islands were the only place where wireless radios were banned completely. For Lucy's comments, see Leperlier, *Claude Cahun: Écrits*, 701.

114 **Mrs. Baudains** UK National Archives, WO/199/2019B. Her name is mentioned numerous times by escaped Jerseymen who were debriefed by MI-19. Joe Mière also discusses her in *Never to Be Forgotten* (n.p.: Channel Island Publishing, 2004), 245–46.

114 **Declaration of Members** Jersey Archive, JHT/1995/00045/54.

114 **useless eaters** Sanders, *Ultimate Sacrifice*, 7, 103; see Bunting, *Model Occupation*, 100–104.

115 **Soon the two hundred** Mière, *Never to Be Forgotten*, 54–55. Lucy also wrote about the singing, according to Leperlier, *Claude Cahun: Écrits*, 703. Bob Le Sueur (who was awarded an MBE [Member of the Order of the British Empire] for his resistance activities) mentions the singing in a postwar interview found at "Bob Le Sueur Interview about Occupation Years," Island Wiki, August 2001, http://www.theislandwiki.org/index.php/Bob_Le_Sueur_interview_about_Occupation _years. Mière had been only fourteen years old when the occupation started. Raised Catholic on a Jersey farm and promised by his mother to the priesthood, in 1940 Mière's father took him out of school so he could begin to train as an engineer. He was active in various resistance efforts throughout the occupation.

115 **The soldier lashed** Imperial War Museum, interview with Joe Berry, MISC 2826 189/1.

116 **We know how** Mière, *Never to Be Forgotten*, 56.

116 **From that time** "Bob Le Sueur Interview."

116 **You are not welcome** Mière, *Never to Be Forgotten*, 240.

117 **put their wicked** Leperlier, *Claude Cahun: Écrits*, 607, 610, 700.

118 **This English-speaking** Although there were numerous Catholic churches on the island, St. Mary and St. Peter was the English-speaking church in the area near Vera's home; thanks to Mr. Anthony Pezet for helping point me in this direction (the church has since moved locations). According to Lucy, Vera converted to Catholicism during the war, although Vera was not confirmed until July 5, 1945. She took the confirmation name of St. Veronica, who reputedly wiped the brow of Christ on his way to the crucifixion. Jersey Archive, H/B/A4/3. The church may have suspended some of its regular activities during the war, or perhaps Vera did not make her conversion official until that time.

118 **Unsubstantiated rumors** Imperial War Museum, interview with Normal LeBrocq, MISC 2826 189/1.

118 **Jersey Democratic Movement** For more on the group's leafleting activities, see Imperial War Museum, interview with Normal LeBrocq.

119 **the categories** Bunting, *Model Occupation*, 102.

119 **Lucy received** Leperlier, *Claude Cahun: Écrits*, 630.

120 **Edna called** Lucy and Suzanne's own doctor, John Lewis, does not report this incident in his memoirs. It is Lucy's recollection that Edna summoned the doctor, and

given their common Irish heritage and the fact that they were both from the north of Ireland, it seems reasonable to conclude that they knew each other. Information about Dr. McKinstry can be found in Francis L. M. Corbet, *A Biographical Dictionary of Jersey*, vol. 2 (St. Helier, Jersey: Société Jersiaise, 1998), 288–90.

120 **I look tired** Cahun, *Disavowals* (Cambridge, MA: MIT Press, 2008), 30. She continued, "Already as a child, I was playing this game of being an invalid."

120 **She and Suzanne had** Jersey Archive, JHT/1995/00043/v.

120 **a rather bureaucratic** Leperlier, *Claude Cahun: Écrits*, 630.

120 **their first child** Names and dates of the births of Edna and George's two children come from the birth records in the Office of the Superintendent Registrar of Jersey: St. Helier Births, vol. 68, p. 47, no. 461; and vol. 69, p. 18, no. 174.

121 *Nieder mit Krieg* Leperlier, *Claude Cahun: Écrits*, 692.

CHAPTER 10

122 **Jesus Is Great** The incident is recounted in François Leperlier, *Claude Cahun: L'exotisme intérieur* (Paris: Fayard, 2006), 394.

123 **Alarm! Alarm! ALARM!** One of a variety of original and carbon-copied propaganda leaflets produced by Lucy and Suzanne during the occupation, including die Soldaten ohne Namen, Jersey Archive, JHT/1995/00045053. My translation.

124 **now carrying** Anthony Eden, speech to the House of Commons, HC Deb, December 17, 1942, vol. 385, cc2082-7, https://api.parliament.uk/historic-hansard /commons/1942/dec/17/united-nations-declaration. Quoted in Stephen Ward, "Why the BBC Ignored the Holocaust," *Independent*, August 22, 1993.

124 **In his studies** James C. Scott, *Domination and the Arts of Resistance: Hidden Transcripts* (New Haven, CT: Yale University Press, 1990).

125 **propaganda produced** Yale University, Manuscripts and Archives, World War II Collection, group 688, series II, box 38, folder 13.

125 **the outer edge** Allied Force Headquarters Psychological Warfare Branch, "Confetti," typescript, 1943. Yale University, Manuscripts and Archives, World War II Collection, group 688, series II, box 43B, folder 108, "Reports: Allied Force Headquarters, Psychological Warfare Branch," and folder 113, "Manuals." The typescript in folder 108 appears to be a draft of the final printed manual found in folder 113. The language of the typescript is much bolder and brasher compared with the toned-down language of the printed manual, which is much shorter. I have quoted from the draft because the language is more striking.

127 **All propaganda literature** Allied Force Headquarters Psychological Warfare Branch, "Report on the Interrogation of German PS/W taken in the Salerno Area, 26th September 1943." Yale University, Manuscripts and Archives, World War II Collection, group 688, series II, box 43B, folder 109, "Mimeographed Reports: Allied Force Headquarters, Psychological Warfare Branch." This folder contains numerous transcripts of interrogations with prisoners of war aimed at

judging the effectiveness of Allied propaganda as well as other reports, which indicate the general pattern of effectiveness of leaflets.

127 **Dr. Robert Noel McKinstry** "Survey Compiled from Various Investigations and Reports Entitled: 'The Effects of the Occupation on the Health of the People of Jersey,'" Jersey Archive, B/A/W49/14/20.

127 **Studies done** George T. H. Ellison and Michael Kelly, "Growth of Jersey Schoolchildren during the 1940–1945 German Occupation: Comparison with Schoolchildren on Mainland Britain," *Human Biology* 77 (December 2005): 761–72.

127 **We got so hungry** Madeline Bunting, *The Model Occupation: The Channel Islands under German Rule, 1940–1945* (London: HarperCollins, 1995), 244–45.

128 **As she held Kid** François Leperlier, *Claude Cahun: Écrits* (Paris: Jean-Michel Place, 2002), 689.

128 **I had my papers** Leperlier, 691.

128 **The Germans made** On the cemetery, see Tom Willans, *The German War Cemetery, St. Brelade, Jersey* (Warwick: Bessacarr Publications, 2007). On Lucy and Suzanne's activities in the cemetery, see Leperlier, 683, and Leperlier, *Claude Cahun: L'exotisme*, 393.

130 **very intelligent** Quoted in Bunting, *Model Occupation*, 64. On Zepernick, see also Willans, *German War Cemetery*, 27–29.

131 *Für Sie* Leperlier, *Claude Cahun: Écrits*, 738. Suzanne tells the story in her own way in her reminiscences housed at Yale. In her postwar memoirs, Lucy claims that the "tin crosses," as she puts it, were a passing fancy. See Leperlier, 630. It is unclear why she says they were made of tin unless the crosses were made from both tin and wood, or perhaps she misremembered. On the image of the cross after World War I, see George Mosse, *Fallen Soldiers: Reshaping the Memory of the World Wars* (New York: Oxford University Press, 1990).

131 **All along** Roland Dorgelès, *Wooden Crosses* (New York: G. P. Putnam's Sons, 1921), 169. The novel won the Prix Femina and was a finalist for the prestigious Prix Goncourt. It was turned into a film in 1932. On Dorgelès, see Laurence Campa, "Roland Dorgelès," in *International Encyclopedia of the First World War*, ed. Ute Daniel, Peter Gatrell, Oliver Janz, Heather Jones, Jennifer Keene, Alan Kramer, and Bill Nasson (Berlin: Berlin Freie Universität, 2015), https://doi.org/10.15463/ie1418.10534.

131 **the crosses had** Leperlier, *Claude Cahun: Écrits*, 684–85, 738.

132 **One day, the mailman** Leperlier, *Claude Cahun: Écrits*, 597.

132 **Pyotry Botatenko** Joe Mière, *Never To Be Forgotten* (n.p.: Channel Island Publishing, 2004), 74; Gilly Carr, Paul Sanders, and Louise Willmot, *Protest, Defiance, and Resistance in the Channel Islands: German Occupation, 1940–1945* (London: Bloomsbury, 2014), 187–88, 190. Louise Willmot, "The Goodness of Strangers: Help to Escaped Russian Slave Labourers in Occupied Jersey," *Contemporary European History* 11 (2002): 211–27 n20, refers to a May 19, 1945,

Peter Botatenko article in the *Jersey Evening Post.* There is some discrepancy among the sources. Mière says that Peter went to the Le Cornu family after being sheltered by Lucy and Suzanne. Botatenko wrote letters to the Le Flem family who housed him. These are archived at the Société Jersiaise, MIL/GO/4.1. Lucy implied that they may have had more than one Russian or eastern European visitor: "sharing everything we had with the Russians in rags, our bread, our tobacco" (Leperlier, 580). On escaped Russians, see Willmot, 211–27; and "Bob Le Sueur Interview about Occupation Years," Island Wiki, August 2001, http://www.theislandwiki .org/index.php/Bob_Le_Sueur_interview_about_Occupation_years.

133 **The lords** Leperlier, 630.

133 **I should tell** Yale University, Beinecke Library, Claude Cahun and Suzanne Malherbe Papers, GEN MSS 721, box 1, folder 10.

CHAPTER II

137 **This is London** "BBC Broadcast's D-Day News Bulletin," YouTube, posted by Norm Robitza, https://www.youtube.com/watch?v=4nnjGjGuRjo, also quoted in John Buckley, ed., *The Normandy Campaign 1944: Sixty Years On* (London: Routledge, 2006); and "D-Day as the BBC Reported It on Radio News, BBC, June 5, 2019, https://www.bbc.com/news/av/uk-48525818/d-day-as-the-bbc-reported-it -on-radio-news.

138 **Many individual Germans** UK National Archives, WO/199/2091B.

138 **Needless to say** Quoted in Joe Mière, *Never to Be Forgotten* (n.p.: Channel Island Publishing, 2004), 166.

139 **If there is** See Yale University, Beinecke Library, Claude Cahun and Suzanne Malherbe Papers, GEN MSS 721, box 1, folder 14.

140 **Suzanne got up** This scene and all the dialogue in it is reconstructed from Suzanne's postwar remembrance with occasional additions from Lucy's posthumously published reminiscences. For Suzanne's notes, see Claude Cahun and Suzanne Malherbe Papers, GEN MSS 721, box 1, folders 13–15. See also François Leperlier, *Claude Cahun: Écrits* (Paris: Jean-Michel Place, 2002), esp. 655.

143 **To top it off** Unfortunately, Lucy's wartime journal no longer survives, undoubtedly destroyed by the Germans.

146 **He would** The specifics of this moment in the story come from the postwar account written by Lucy and Suzanne's doctor, John Lewis. In his version—which is rather uncharitable to Lucy, as he calls her a "first-rate hypochondriac"—Lucy fainted upon being told that they were under arrest, and the soldiers gave her water to revive her. Neither Lucy nor Suzanne mention the fainting in their reminiscences. See Dr. John Lewis, *A Doctor's Occupation* (St. Helier, Jersey: Starlight, 1982), 203.

146 **From these cells** Paul Sanders, *The Ultimate Sacrifice: The Jersey Twenty and Their "Offences against the Occupying Authorities," 1940–1945* (n.p.: Jersey Museums Service, 1998), 59. For a general description of the prison, see Leperlier,

Claude Cahun: Écrits, 736. Some documents in the Jersey Archive refer to the prison as Gloucester Street while others refer to it as Newgate Street; the prison sat on the corner of those streets but was officially called HM [His Majesty's] Prison. The commemorative plaque honoring those who served time in jail during the occupation faces Gloucester Street. There is some discrepancy in the sources as to the organization of the prison. Claire Follain, "Lucy Schwob and Suzanne Malherbe—Résistantes," in *Don't Kiss Me: The Art of Claude Cahun and Marcel Moore*, ed. Louise Downie (London: Aperture/Tate, 2006), n20, draws on the oral testimony of Sidney Jordan, identified as a "Jersey prison warden during the Occupation." He speaks of three cellblocks, and I have relied primarily on his description. Mière, *Never to Be Forgotten*, 209, also speaks of C Block, thus implying that there were three distinct blocks. The Jersey Heritage Trust describes things slightly differently, saying that the German troops had taken over two blocks of cells—A Block for "rowdies" and B Block for military prisoners and prisoners doing forced labor (see document at Jersey Archive titled "Jersey and Its Prisons"). Suzanne speaks of only two blocks, one military and one political. See Jersey Archive, JHT/1995/00045/7. Lucy also speaks of two buildings (Leperlier, 727). Other sources indicated that Lucy and Suzanne were housed in what had been the women's prison, which was commandeered on April 1, 1942, and had the word *women* inscribed in all capital letters over the door. Information about the prison is contained in Jersey Archive, B/A/W40/8/30. Plans of the prison from 1887 are at Jersey Archive, D/AL/A6/240(C2), and show three groups of cells, one of which housed the women's cells, although none is labeled A, B, or C; however, documents from the occupation clearly refer at least to Block B. One of Suzanne's reminiscences indicates that there was a prisoner across the hall from her, but if that were the case, they could not have been in the former women's section of the prison since, according to the plans, all the cells in that wing were along one wall.

146 **Karl Lohse** On Lohse, see Michael Ginns, "Wolff of the Gestapo," *Channel Islands Occupation Review* 31 (2003): 112; and Michael Ginns, *Jersey Occupied: The German Armed Forces in Jersey 1940–1945* (n.p.: Channel Island Publishing, 2009), 51.

147 **Karl-Heinz Wölfle** On Wölfle, see Ginns, "Wolff"; and Ginns, *Jersey Occupied*; Paul Sanders, *The British Channel Islands under German Occupation, 1940–1945* (St. Helier, Jersey: Société Jersiaise, 2005), 126–27; UK National Archives, WO208/4643.

148 **Fist marks** Leperlier, *Claude Cahun: Écrits*, 630; and Ginns, "Wolff of the Gestapo," 113. The Ginns article says that Wölfle did not beat suspects; Lucy does not claim to witness him beating the men but only sees the effects of a beating and assumes it is Wölfle's fault. One MI-19 informant suggested that he went easy on islanders but also notes his involvement in the black market.

148 **Three Germans had** Mière, *Never to Be Forgotten*, 196.

149 **My last clear** Suzanne's recollections of her time in prison in the remainder of this book are found in Claude Cahun and Suzanne Malherbe Papers, GEN MSS

721, box 1, mostly in folder 13. All dialogue in these episodes is quoted directly from her documents.

149 **wake [her] with** François Leperlier, *Claude Cahun: L'exotisme intérieur* (Paris: Fayard, 2006), 403.

150 **both women had** Lewis, *Doctor's Occupation*, 203–4; and Leperlier, *Claude Cahun: Écrits*, 574 and 724.

CHAPTER 12

151 **Yes, that's the right** François Leperlier, *Claude Cahun: Écrits* (Paris: Jean-Michel Place, 2002), 724.

152 **Of course I** Leperlier, 731.

154 **Although Otto spoke** Leperlier, 648. According to Suzanne, Otto had been in the habit of yelling "Pisspots!" when it was time for prisoners to go to the toilet and "Exercise!" when he was ordering them to the yard. A couple of weeks before Lucy and Suzanne arrived, a prisoner had complained that "pisspots" was offensive and tried to convince Otto to say "chambers" instead. They compromised on "lavatory." Yale University, Beinecke Library, Claude Cahun and Suzanne Malherbe Papers, GEN MSS 721, box 1, mostly in folder 13.

154 **Lady Schwob** "Diary Written by Claude Cahun about Her Time in Prison in Jersey Having Been Imprisoned and Sentenced to Death for Inciting the German Soldiers to Rebellion," Jersey Archive, JHT/1995/00045/1 (page numbered 33).

155 **You've left me** Leperlier, *Claude Cahun: Écrits*, 728.

155 **I am sorry** Leperlier, 729.

159 **All your things** Lucy's account of the interrogation is found in Leperlier, *Claude Cahun: Écrits*, 720–41, passim. Suzanne's account of the interrogation, as with all her other prison recollections, is found in Claude Cahun and Suzanne Malherbe Papers, GEN MSS 721, box 1, folders 13–15.

160 **Finally, I am** Lucy's declaration of her Jewishness is found in Leperlier, 747–48.

160 **I am completely** Leperlier, 747. Many scholars have misread this passage or taken it out of context, believing that Lucy is declaring that she alone deserved or claimed full credit for their resistance work, including writing and distributing all the notes, thereby absolving Suzanne of any responsibility. This idea has reinforced the notion that Lucy (or Claude Cahun) was the sole creative actor at work throughout their relationship. As I have tried to demonstrate in the text, Lucy is trying to take the blame (not the responsibility) in hopes of saving Suzanne from punishment by the Germans. In other words, her claim of complete authorship is not serious but rather a self-conscious attempt at deception.

160 **It was more** Leperlier, 748. This passage is frequently overlooked by scholars who wish to attribute sole authorship of the notes to Lucy.

161 **Hitler had been** Jack E. Reece, *The Bretons against France: Ethnic Minority Nationalism in Twentieth-Century Brittany* (Chapel Hill: University of

North Carolina Press, 1977); and Kristian Hamon, *Les nationalistes Bretons sous l'occupation* (Fouesnant, France: Yoran Embanner, 2005).

CHAPTER 13

169 **enjoying [her] weakness** François Leperlier, *Claude Cahun: Écrits* (Paris: Jean-Michel Place, 2002), 726.

171 **Barely making three** "Diary Written by Claude Cahun about Her Time in Prison in Jersey Having Been Imprisoned and Sentenced to Death for Inciting the German Soldiers to Rebellion," Jersey Archive, JHT/1995/00045/1 (page numbered 36).

172 **You have acted** "Sentenced to Death by Island Nazis: The Story of Two Gallant French Women," *Jersey Evening Post*, July 14, 1945.

172 **German Red Cross** In her own writing, Lucy tells a version of this story, but Suzanne's documents clearly indicate that it had been told to her by Suzanne. Some scholars mistakenly claim that the nurse visited only Lucy. See Yale University, Beinecke Library, Claude Cahun and Suzanne Malherbe Papers, GEN MSS 721, box 1, folders 14 and 15. Unlike Suzanne, Lucy openly labeled the "nurse" a German spy. Leperlier, *Claude Cahun: Écrits*, 735.

174 **a storm of plaster** "Diary Written by Claude Cahun" (page numbered 34); also *Claude Cahun: Écrits*, 634, n2. These seem to be the same or similar text.

175 **I was arrested** Claude Cahun and Suzanne Malherbe Papers, GEN MSS 721, box 1, folder 11, "Correspondence and Other Papers/1943–1945, Undated." See also "Diary Written by Claude Cahun" (page numbered 41).

176 **You get back** Leperlier, *Claude Cahun: Écrits*, 720, n6.

177 **Dr. Heinrich Koppelmann** His name is spelled various ways throughout the archives. Suzanne discusses him and the other guards in documents contained in Claude Cahun and Suzanne Malherbe Papers, GEN MSS 721, box 1, folder 13. Lucy gives his first name in Leperlier, *Claude Cahun: Écrits*, 723, n8. In *Jersey Occupied: The German Armed Forces in Jersey 1940–1945* (n.p.: Channel Island Publishing), Michael Ginns lists a Hauptmann Koppelmann in charge of the soldiers' homes (*Soldatenheime*), but it's unclear if this is the same man. Much of the description of the other guards in the prison come from the same sources.

180 **We did not** Joe Mière, *Never to Be Forgotten* (n.p.: Channel Island Publishing, 2004), 229.

180 **Two Jerseymen had** Suzanne notes "Peter Curwood and Frank [blank space] escaped, but LaCloche injured his ankle and was caught." These men were likely Peter Curwood, Frank Killer, and Hugh La Cloche. See "List of Islanders Who Resisted during the Occupation with their Actions and Punishments," Jersey Archive, JHT/1995/00045/7.

181 **I'll report you** "Diary Written by Claude Cahun" (page numbered 51).

181 **Lucy tried to** Leperlier, *Claude Cahun: Écrits*, 747.

CHAPTER 14

188 **two Jewish women** Hans Max von und zu Aufsess, *The Von Aufsess Occupation Diary*, trans. Kathleen J. Nowlan (Chichester, UK: Phillimore, 1985), 61.

189 **After Lucy and Suzanne's** François Leperlier, *Claude Cahun: L'exotisme intérieur* (Paris: Fayard, 2006), 93; Claude Cahun and Suzanne Malherbe Papers, GEN MSS 721, box 1, folder 10.

190 **Oh, I spent** Paul Sanders argues that Wölfle's claim to be a scoutmaster was dubious and part of his attempt to better position himself after the war, although he seems to have told it to Suzanne during the war. See Sanders, *The British Channel Islands under German Occupation, 1940–1945* (St. Helier, Jersey: Société Jersiaise, 2005), 126–27. See also Michael Ginns, "Wolff of the Gestapo," *Channel Islands Occupation Review* 31 (2003): 117. Suzanne's description of the exchange appears in her reminiscences, Yale University, Beinecke Library, Claude Cahun and Suzanne Malherbe Papers, GEN MSS 721, box 1, folder 13.

191 **Lucy never liked** Leperlier, *Claude Cahun: Écrits*, 732.

192 **She had forgotten** Leperlier, 731–32.

CHAPTER 15

195 **Harold Giffard** On Giffard's arrest, see Jersey Archive, D/Z/H6/1/5. See also Gilly Carr, Paul Sanders, and Louise Willmot, *Protest, Defiance, and Resistance in the Channel Islands: German Occupation, 1940–1945* (London: Bloomsbury, 2014), 100; and François Leperlier, *Claude Cahun: Écrits* (Paris: Jean-Michel Place), 754.

198 **If we were hermetically** Quoted in François Leperlier, *Claude Cahun: L'exotisme intérieur* (Paris: Fayard, 2006), 404, 408.

198 **The few surviving** "Correspondence between Marcel Moore and Claude Cahun when in Prison in November 1944 Talking about What Was Happening in the War and Those in the Prison," Jersey Archive, JHT/1995/00045/22. It is unclear whether these documents are originals or whether Suzanne copied them later, thus explaining why they are in her handwriting. Many of them read more like reminiscences, although they refer to Lucy by talking about "your room" and other such second-person references, as though Lucy was the audience. They repeat and supplement parts of the later account of their arrest, which appears in sketched-out memoir form found in the Beinecke Library collection at Yale University. This suggests that the letters in prison helped form the basis of Suzanne's later reminiscences. Dates are unclear as well. It seems likely that Lucy's account of their arrest is influenced, at least in part, by Suzanne's recounting in these notes, although to what extent is unclear. Suzanne's notes do not indicate whether the soldiers spoke German or English that night; Captain Bode only spoke German.

202 **I would go** so Lucy's "testament," p. 2, Yale University, Beinecke Library, Claude Cahun and Suzanne Malherbe Papers, GEN MSS 721, box 1, folder 12.

202 **organized an excellent** Leperlier, *Claude Cahun: Écrits*, 722, "Diary

Written by Claude Cahun about Her Time in Prison in Jersey Having Been Imprisoned and Sentenced to Death for Inciting the German Soldiers to Rebellion," Jersey Archive, JHT/1995/00045/1 (pages numbered 58–59).

203 **never doubt** Leperlier, *Claude Cahun: Écrits*, 736.

203 **Belza Turner Jersey Archive**, D/Z/H6/8/167; see her obituary at http://www.lifenews.ca/announcement/5952723-greene-belza-althea-turner-.

203 **Evelyn Janvrin** Mentions of Evelyn are scattered throughout both Lucy's and Suzanne's reminiscences. See also Wendy Janvrin-Tipping, *Any Day Now* (London: Austin Macauley, 2016). Evelyn was the author's aunt.

CHAPTER 16

210 **What I fear** "Correspondence between Marcel Moore and Claude Cahun when in Prison in November 1944 Talking about What Was Happening in the War and Those in the Prison," Jersey Archive, JHT/1995/00045/22.

210 **foreign women** Quoted in François Leperlier, *Claude Cahun: L'exotisme intérieur* (Paris: Fayard, 2006), 409; and François Leperlier, *Claude Cahun: Écrits* (Paris: Jean-Michel Place, 2002), 632 (letter to Marianne Schwob, Lucy's niece).

210 **"chauffeurs," whom she** "Diary Written by Claude Cahun about Her Time in Prison in Jersey Having Been Imprisoned and Sentenced to Death for Inciting the German Soldiers to Rebellion," Jersey Archive, JHT/1995/00045/1 (page numbered 33).

211 **Suzanne joined her** There is some discrepancy among the sources as to the location of the court-martial. Lucy says "Kingscliff" House in Leperlier, *Claude Cahun: Écrits*, 626; Paul Sanders, *The Ultimate Sacrifice: The Jersey Twenty and Their "Offences against the Occupying Authorities,"* 1940–1945 (n.p.: Jersey Museums Service, 1998), 5–6, says Victoria College House. Janne White of the Jersey Archive communicated to me in an email that the location was Kings Cliff House, on King's Cliff Road, St. Helier, and I have used that information here.

211 **large salmon pink** Reconstructing this account of the trial required a great deal of assumption. Suzanne's memories, although often quite detailed, are scattered throughout her notes in Yale University, Beinecke Library, Claude Cahun and Suzanne Malherbe Papers, mostly in GEN MSS 721, box 1, folders 13–15, and required me to piece them together carefully. Lucy provides far less description of the scene than Suzanne does and a much more impressionistic sense of what was said; her words and thoughts are found scattered throughout Leperlier, especially 608 and 720, as well as "Diary Written by Claude Cahun." Since the trial was conducted in German and, as Suzanne pointed out, the translation was far from reliable, Lucy likely did not follow much of what was happening. Suzanne describes her as detached and confused. Some of the relevant files in the Jersey Archive (D/Z/H9/1 and H9/2) are closed until the year 2046 because of a one-hundred-year restriction. At least two episodes from the trial (the discussion of Aachen and the visit to the toilet) have been attributed to Lucy by other scholars, part of the larger

trend toward effacing Suzanne and attributing everything in their story to Lucy alone. However, given the full context of the notes contained in the collection at Yale University's Beinecke Library, the notes in the Jersey Heritage Trust archive clearly belong to Suzanne. This approach alters the way in which scholars have thought about the trial, assuming that Lucy was the prime actor there as in other areas of their resistance.

211 **Dr. Heinz Harmsen** In their postwar notes, both Lucy and Suzanne record the judge's name as "Sarmsen," likely mishearing or misremembering the name. Official correspondence on Jersey during (e.g., D/Z/H6/8/193) and after the war, as well as records of his postwar interrogation housed in the Imperial War Museum, note that his name was Dr. Heinz Harmsen.

212 **What a luxury** Leperlier, *Claude Cahun: Écrits*, 609, 721.

215 **I did also** Leperlier, 700.

219 **You are *francs-tireurs*** Claude Cahun and Suzanne Malherbe Papers, GEN MSS 721, box 2, folder 17.

222 **Why? It is right** Imperial War Museum, interview with Heinz Harmsen, MISC 2826 189/1.

CHAPTER 17

224 **I felt so** Claude Cahun and Suzanne Malherbe Papers, GEN MSS 721, box 1, folder 12.

224 **excessive congestion** "Request for cement from the Jersey Prison Board for the construction of additional cells." See Jersey Archive, B/A/W81/1.

227 **Her emotional words** There are several versions of Lucy's "testament." The one I have cited is a typescript found in Claude Cahun and Suzanne Malherbe Papers, GEN MSS 721, box 1, folder 12. A handwritten version of portions of this same document appear in Jersey Archive, JHT/1995/00045/1, although this document contains additional text not in the typescript.

227 **It was a tired** Quoted in Martin Gilbert, *The Second World War: A Complete History* (New York: HarperCollins, 2001), 303.

228 **feeling of repugnance** See Gilly Carr, Paul Sanders, and Louise Willmot, *Protest, Defiance, and Resistance in the Channel Islands: German Occupation, 1940–1945* (London: Bloomsbury, 2014), 259. A copy of this letter is in Jersey Archive, B/A/W50/183.

228 **The few remaining** Letter from Henry Duval to Lucy Schwob and Suzanne Malherbe, June 30, 1945, Claude Cahun and Suzanne Malherbe Papers, GEN MSS 721, box 1, folder 11.

229 **Think of your sister!** Leperlier, *Claude Cahun: Écrits*, 748–49.

230 **The chaos** "Description of a Dream Had on 24th December 1944 by Suzanne Malherbe," Jersey Archive, JHT/1995/00045/73.

231 **Since you would not** François Leperlier, *Claude Cahun: Écrits* (Paris: Jean-Michel Place, 2002), 611, 725. Yale University, Beinecke Library, Claude Cahun and

Suzanne Malherbe Papers, GEN MSS 721, box 2, folder 15; and "Sentences and Prosecutions by the Field Command and Troop Courts 1944–45, Case of Suzanne Malherbe, and Lucie Schwob, Sentenced for (Not Stated on Case)," Jersey Archive, D/Z/H6/8/193.

CHAPTER 18

233 **You think you** UK National Archives, WO/199/2091A.

233 **a little brown** François Leperlier, *Claude Cahun: Écrits* (Paris: Jean-Michel Place, 2002), 722.

234 **The soldiers lost** Madeline Bunting, *The Model Occupation: The Channel Islands under German Rule, 1940–1945* (London: HarperCollins, 1995), 244.

234 **Dr. Robert Noel McKinstry** "Copy of the medical officer of health of the Public Health Department's report on the conditions in the public prison" (typescript bears title "Report on Inspection of Prison,") February 26, 1945, Jersey Archive, BA/W81/9.

234 **In mid-February** "Letter from political prisoners to Bailiff Alexander Coutanche," February 9, 1945, Jersey Archive, BA/W81/5, BA/W/81/6. For the bailiff's handwritten notes of the meeting, see Jersey Archive, BA/W/81/7.

235 **Lullaby for One** Yale University, Beinecke Library, Claude Cahun and Suzanne Malherbe Papers, GEN MSS 721, box 1, folder 11.

236 **They will never** Imperial War Museum, interview with Heinz Harmsen, MISC 2826 189/1.

236 **They do like** Janvrin-Tipping, *Any Day Now* (London: Austin Macauley Publishing, 2016), 80.

236 *jeu des assonances* Claude Cahun and Suzanne Malherbe Papers, GEN MSS 721, box 1, folders 13 and 15.

236 **Sole members** Société Jersiaise, MIL/GO/P/1.2.

237 **We had a Gerry** Claude Cahun and Suzanne Malherbe Papers, GEN MSS 721, box 1, folder 11.

238 **In the name** Janvrin-Tipping, Any Day Now, 83–84.

239 **I've seen many** "Richard Dimbleby Describes Belsen," BBC Archive, April 19, 1945, https://www.bbc.co.uk/archive/richard-dimbleby-describes-belsen /zvw7cqt. Some scholars have argued that in UK war memory, people have focused more on the British soldiers liberating the camp than on the victims themselves. See Rainer Schulze, "Why Bergen-Belsen's 1945 Liberation Is Ingrained in British Memory," *Conversation*, April 15, 2015, https://theconversation.com/why-bergen-belsens-1945-liberation-is-ingrained-in-british-memory-39956.

240 **beds, armchairs, cabinets** Claude Cahun and Suzanne Malherbe Papers, GEN MSS 721, box 1, folders 14 and 15.

241 **a strong, robust man** Leperlier, *Claude Cahun: Écrits*, 746. According to the list of German dead in the Stranger's Cemetery on Jersey, Georg Kiel (the only soldier killed on April 7, 1945) was listed as a *Funkmeister*, or signal supply technician. For rank equivalencies, see War Department Technical Publication

TM-E 30-451, *Handbook on German Military Forces*, 1945, https://archive.org/details/TME-30-4511945.

242 **This war is horrible!** "Diary Written by Claude Cahun about Her Time in Prison in Jersey Having Been Imprisoned and Sentenced to Death for Inciting the German Soldiers to Rebellion," Jersey Archive, JHT/1995/00045/1 (page numbered 34).

243 **this Nazi gang** On Kurt Gunther, including Lucy and Suzanne's copies of his correspondence, see Claude Cahun and Suzanne Malherbe Papers, GEN MSS MISC; grp. 3146, item F-1. See also Leperlier, *Claude Cahun: Écrits*, 739; and Claude Cahun and Suzanne Malherbe Papers, GEN MSS 721, box 1, folder 11.

245 **Paul Mühlbach** Leperlier, *Claude Cahun: Écrits*, 739, 741; Ginns, *Jersey Occupied*, 453; Sanders, *The British Channel Islands under German Occupation*, 108–9; Imperial War Museum, interview with Normal LeBrocq, MISC 2826 189/1; Mière *Never to Be Forgotten*, 273; Peter Tabb, *A Peculiar Occupation: New Perspectives on Hitler's Channel Islands* (Hersham, UK: Ian Allan, 2005), 176–77. Mühlbach's leaflets are reproduced in Michael Ginns, *Jersey Occupied: The German Armed Forces in Jersey 1940–1945* (n.p.: Channel Island Publishing, 2009), 453–55, and can be found in the Jersey Archive, L/C/24/F/3 and 4 and L/F/62. One of these notes is signed "Lt. Colonel Linder"; Ginns, 407, lists him as a coconspirator of the mutiny. See Paul Sanders, *The Ultimate Sacrifice: The Jersey Twenty and Their "Offences against the Occupying Authorities," 1940–1945* (n.p.: Jersey Museums Service, 1998), for other examples of those caught distributing notes and BBC news.

245 **Because a young** It appears that Vera was connected to other resisters on the island and might have been involved herself, although the evidence is only circumstantial. A bookstore owned by John Berger, who had been born in France, came to be known as a gathering place of local intellectuals, including Dr. McKinstry. Based on Lucy's account, Vera and McKinstry were very likely friends. In October 1942, twenty-year-old Paul Casimir began working at the bookshop. Casimir was involved in various resistance activities during the occupation, including the JDM. After the war, Vera would marry Casimir's uncle, Arthur "Rufus" Robinson, in the St. Mary and St. Peter Church. Mr. Bob Le Sueur suggested links between McKinstry and the bookstore in a personal correspondence to me and provided information about Paul Casimir who was a friend of his as well as Rufus Robinson and his family. Mr. Anthony Pezet pointed me toward information about Vera Wimshurst and Rufus Robinson's marriage, address, church, and deaths.

246 **very slim and** Accounts of Nikki are found in Leperlier, *Claude Cahun: Écrits*, 638, 744–45, 752; Claude Cahun and Suzanne Malherbe Papers, GEN MSS 721, box 1, folders 11, 14, and 15; "Diary Written by Claude Cahun," JHT/1995/00045/1, passim; Joe Mière, *Never to Be Forgotten* (n.p.: Channel Island Publishing, 2004), 234–35.

CHAPTER 19

247 **In the early** Joe Mière, *Never to Be Forgotten* (n.p.: Channel Island Publishing, 2004), 234–35.

248 **Sssalaud!!!** "Diary Written by Claude Cahun about Her Time in Prison in Jersey Having Been Imprisoned and Sentenced to Death for Inciting the German Soldiers to Rebellion," Jersey Archive, JHT/1995/00045/1 (page numbered 39); and François Leperlier, *Claude Cahun: Écrits* (Paris: Jean-Michel Place, 2002), 751.

249 **But when peaceful** Imperial War Museum, interview with Heinz Harmsen, MISC 2826 189/1.

250 **the dirty bird** Leperlier, *Claude Cahun: Écrits*, 755.

252 **our dear Channel Islands** Winston Churchill, "The End of the War in Europe," speech delivered on May 8, 1945, https://winstonchurchill.org/resources /speeches/1941-1945-war-leader/end-of-the-war-in-europe/.

252 **Hadn't she already** "Diary Written by Claude Cahun," JHT/1995/00045/1 (page numbered 49).

253 **I say that** Winston Churchill, V-E Day speech, May 8, 1945, https://winston churchill.org/resources/speeches/1941-1945-war-leader/to-v-e-crowds/.

CHAPTER 20

259 **furniture race** François Leperlier, *Claude Cahun: Écrits* (Paris: Jean-Michel Place, 2002), 751.

260 **a place more** "Diary Written by Claude Cahun about Her Time in Prison in Jersey Having Been Imprisoned and Sentenced to Death for Inciting the German Soldiers to Rebellion," Jersey Archive, JHT/1995/00045/1 (page numbered 58).

261 **I had a** Imperial War Museum, interview with Stella Perkins, MISC 2826 189/1. See also Paul Sanders, *The British Channel Islands under German Occupation, 1940–1945* (St. Helier, Jersey: Société Jersiaise, 2005), 257ff.

261 **she had discovered** Quoted in Gilly Carr, Paul Sanders, and Louise Willmot, *Protest, Defiance, and Resistance in the Channel Islands: German Occupation, 1940–1945* (London: Bloomsbury, 2014), 317–18.

262 **Of all our** Yale University, Beinecke Library, Claude Cahun and Suzanne Malherbe Papers, GEN MSS 721, box 2, folder 20.

262 **repeat-offender Lazarus** Leperlier, *Claude Cahun: Écrits*, 716.

263 **From July 1940** Leperlier, 714. Paul Lévy, Lucy's father's old friend, helped Lucy and Suzanne get back the money they had left in France in 1937. Leperlier, 709, n1, discusses how Lévy helped them retrieve their money.

263 **Suzanne received** Letter from Heinrich Ebbers, January 27, 1946, Jersey Archive, JHT/1995M/00045/24A.

264 **invariably correct** "Application of Dr. Heinz Harmsen to the International Law Association, 3, Paper Buildings, the Temple, London," Jersey Archive, B/A/ L24/39.

264 **I had suffered** "Diary Written by Claude Cahun," JHT/1995/00045/1 (pages numbered 63–64).

264 **Suzanne remained** Leperlier, *Claude Cahun: L'exotisme intérieur* (Paris: Fayard, 2006), 444.

264 **Lucy named Vera** "Will and Testament of Lucy Renée Mathilde Schwob, of St. Brelade. Desires to be cremated. Dated 16/06/1941," Jersey Archive, D/Y/B1/29/1. (Archival record indicates a date of March 5, 1955, although Lucy died in 1954.) It is unclear whether she was cremated.

264 **Medal of Recognition** Leperlier, *Claude Cahun: L'exotisme*, 426. See documents in Jersey Archive, B/A/W50/183.

264 **And I saw** The New Testament translation is "Then I saw a new heaven and a new earth" (New International Version [NIV], Rev. 21:1); the translation in Hebrew scripture is rendered "See, I will create new heavens and a new earth" (NIV, Isa. 65:17). Lucy's tombstone is essentially a blend of the two.

265 **They were Frenchwomen** Imperial War Museum, interview with Heinz Harmsen, MISC 2826 189/1.

266 **as lonely in** Louise Downie, "Marcel Moore, Her Art and Life," *Heritage Magazine* 61, https://www.jerseyheritage.org/media/PDF-Heritage-Mag/Marcel%20Moore.pdf.

266 **On February 19, 1972** A news story about Suzanne's death (presumably clipped from the *Jersey Evening Post*, although the source is not identified, and hand dated February 26, 1972) titled "Doctor Finds Patient (79) Dead, Inquest Told," can be found in Jersey Archive, D/S/B1/1939. The article indicates that she had been taking sleeping pills manufactured in France and "knew that they could be dangerous." See also Leperlier, *Claude Cahun: L'exotisme*, 445.

EPILOGUE

268 **critical thinking** Michael D. Bess, *Choices under Fire: Moral Dimensions of World War II* (New York: Vintage, 2008). The literature on resistance is large and contains many debates about the definition. Some argue for a more expansive term, whereas others see a scale of nonconformity culminating in resistance. See Detlev J. K. Peukert, *Inside Nazi Germany: Conformity, Opposition, and Racism in Everyday Life* (New Haven, CT: Yale University Press, 1989), 83, on the range of "dissident behavior." See also Tim Kirk and Anthony McElligott, *Opposing Fascism: Community, Authority and Resistance in Europe* (Cambridge: Cambridge University Press, 1999); Bob Moore, ed., *Resistance in Western Europe* (New York: Berg, 2000); Vesna Drapac and Gareth Pritchard, *Resistance and Collaboration in Hitler's Empire* (London: Red Globe Press, 2017); and Julian Jackson, *France: The Dark Years, 1940–44* (New York: Oxford University Press, 2001).

268 **I continue** François Leperlier, *Claude Cahun: Écrits* (Paris: Jean-Michel Place, 2002), 581.

269　**Lucy and Suzanne were among** Barbara Will, *Unlikely Collaboration: Gertrude Stein, Bernard Faÿ, and the Vichy Dilemma* (New York: Columbia University Press, 2011); Emily Greenhouse, "Gertrude Stein and Vichy: The Overlooked History," *New Yorker*, May 4, 2012; Jean Guéhenno, *Diary of the Dark Years: Collaboration, Resistance, and Daily Life in Occupied Paris*, trans. David Ball (New York: Oxford University Press, 2014); Gisèle Sapiro, *The French Writers' War, 1940–1953*, trans. Vanessa Doriott Anderson and Dorrit Cohn (Durham, NC: Duke University Press, 2014); Tony Judt, "'We Have Discovered History': Defeat, Resistance, and the Intellectuals in France," *Journal of Modern History* 64 (December 1992): S147–72; Tony Judt, *Past Imperfect: French Intellectuals, 1944–1956* (Berkeley: University of California Press, 1992); Alan Riding, *And the Show Went On: Cultural Life in Nazi-Occupied Paris* (New York: Alfred A. Knopf, 2010).

269　**no obligation can** Lucy's "testament," Yale University, Beinecke Library, Claude Cahun and Suzanne Malherbe Papers, GEN MSS 721, box 1, folder 12.

270　**They had rediscovered** James D. Wilkinson *The Intellectual Resistance in Europe* (Cambridge, MA: Harvard University Press, 1981), 265.

270　**universe of obligation** Helen Fein, *Genocide: A Sociological Perspective* (London: Sage, 1993); Drapac and Pritchard, *Resistance and Collaboration*, 92.

270　**disruptive empathy** See Victoria J. Barnett, *Bystanders: Conscience and Complicity during the Holocaust* (Westport, CT: Greenwood Press, 1999).

271　**You don't do** Susan Sontag, "Of Courage and Resistance," *Nation*, April 17, 2003. This is the text of Sontag's keynote address at the Oscar Romero Award presentation in 2003.

271　**I have tried** "Diary Written by Claude Cahun about Her Time in Prison in Jersey Having Been Imprisoned and Sentenced to Death for Inciting the German Soldiers to Rebellion," Jersey Archive, JHT/1995/00045/1 (page numbered 64). This document is very similar to the "testament" but has significant differences compared with the typescript version Claude Cahun and Suzanne Malherbe Papers, GEN MSS 721, box 1, folder 12.

271　**not a nation** Paul Sanders, *The British Channel Islands under German Occupation, 1940–1945* (St. Helier, Jersey: Société Jersiaise, 2005), 256. Channel Islands war memory is complicated. See also Gilly Carr, "Occupation Heritage, Commemoration and Memory in Guernsey," *History & Memory* 24 (Spring/Summer 2012): 87–117; and Hazel R. Knowles Smith, *The Changing Face of the Channel Islands Occupation: Record, Memory, and Myth* (New York: Palgrave Macmillan, 2007).

THE STORY BEHIND THE STORY

275　**The only public** On exhibition history, see entry "Claude Cahun," in *Encyclopedia of Twentieth-Century Photography*, ed. Lynne Warren (New York: Routledge, 2006), 200–203; and Rosaline E. Krauss and Jane Livingstone, *L'amour fou: Photography and Surrealism* (Washington, DC: Corcoran Gallery of Art,

1985). See also Michelle Sara Gewurtz, "Three Women/Three Margins: Political Engagement and the Art of Claude Cahun, Jeanne Mammen, and Paraskeva Clark," PhD diss., University of Leeds, 2010, 22.

275 **The lots were** For details on the history of these sources, see Louise Downie, "Introduction," in Louise Downie, ed., *Don't Kiss Me: The Art of Claude Cahun and Marcel Moore* (London: Aperture/Tate, 2006). Most of this quotation appears (unattributed) in the Yale collection's introduction, as stated in the letter written by a representative of Bernard Quaritch Antiquarian Booksellers in London, who apparently sold the collection to Yale's Beinecke Library. See Beinecke Library, Claude Cahun and Suzanne Malherbe Papers, GEN MSS 721, folder "Vendor Description and Correspondence Relating to Basil Bigg."

276 **At the time** "Claude Cahun," exhibition, Jeu de Paume, accessed November 23, 2019, http://www.jeudepaume.org/index.php?page=article&idArt=1480.

276 **I find this work** "Tonight's High Line—David Bowie Recommends . . . ," David Bowie, May 17, 2007, https://www.davidbowie.com/2007/2007/05/18 /tonights-high-line-david-bowie-recommends.

276 **an academic hype** Astrid Peterle, "'Visible-Invisible-Hypervisible': Sketching the Reception of Claude Cahun and Marcel Moore," in *Indecent Exposures*, vol. 22, ed. V. Walker, (Vienna: IWM Junior Visiting Fellows' Conferences, 2007), http://www.iwm.at/publications/5-junior-visiting-fellows- conferences/astrid-peterle-2/; and Lucy R. Lippard, "Scattered Selves," in *Inverted Odysseys: Claude Cahun, Maya Deren, Cindy Sherman*, ed. Shelley Rice (Cambridge, MA: MIT Press, 1999), 36.

276 **Judith Butler's** Judith Butler, *Gender Trouble: Feminism and the Subversion of Identity* (New York: Routledge, 1990).

277 **She is often** See, for example, Katy Kline, "In or out of the Picture: Claude Cahun and Cindy Sherman," in *Mirror Images: Women, Surrealism, and Self- Representation*, ed. Whitney Chadwick (Cambridge, MA: MIT Press, 1998).

279 **As the contributors** On the importance of collaboration for intellectual and artistic endeavor, see Leona Rittner, W. Scott Haine, and Jeffrey H. Jackson, eds., *The Thinking Space: The Café as a Cultural Institution in Paris, Italy and Vienna* (New Farnham, UK: Ashgate, 2013). See also Steven Johnson, *Where Good Ideas Come From: The Natural History of Innovation* (New York: Riverhead, 2011); and Whitney Chadwick and Isabelle De Courtivron, *Significant Others: Creativity and Intimate Partnership* (New York: Thames & Hudson, 1993).

282 **As historian** Jo Burr Margadant, ed., *The New Biography: Performing Femininity in Nineteenth-Century France* (Berkeley: University of California Press, 2000).